Manet and the Sea

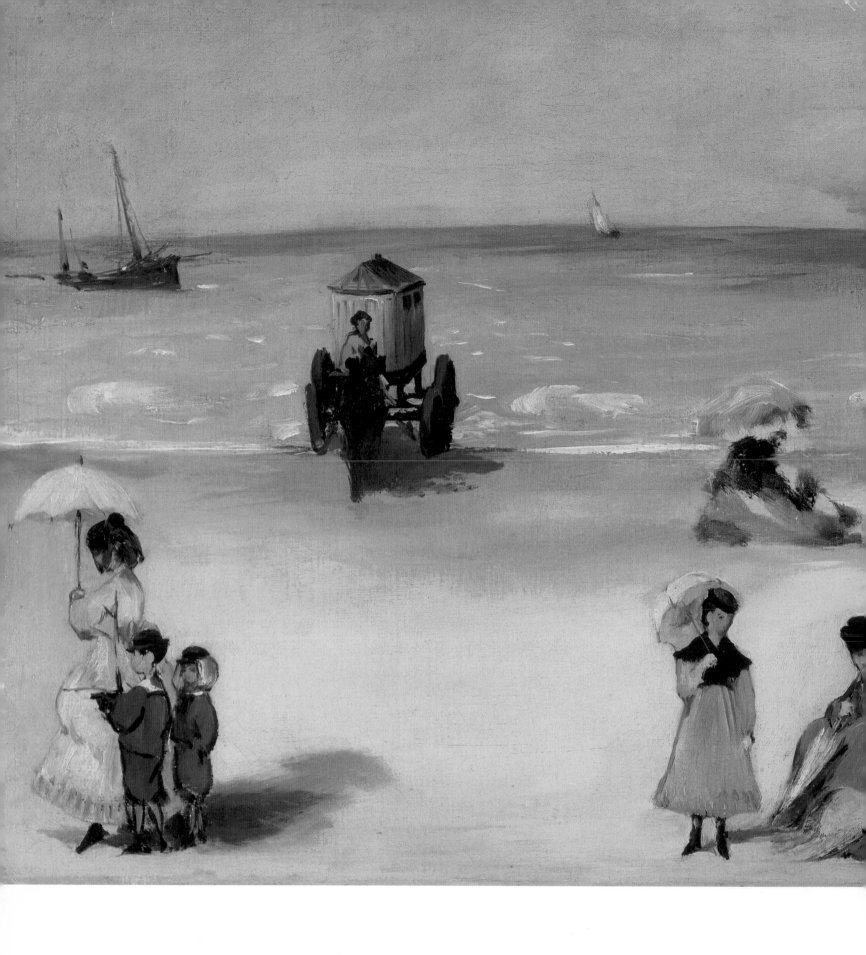

The Art Institute of Chicago • Philadelphia Museum of Art • Van Gogh Museum, Amsterdam

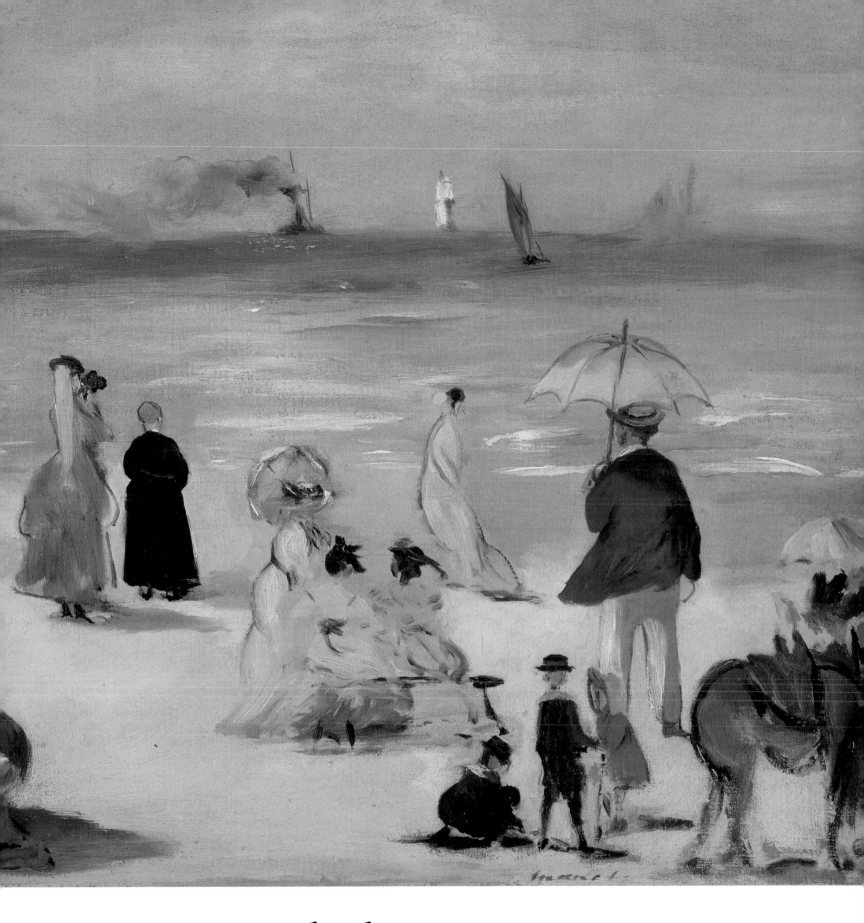

Manet and the Sea

Juliet Wilson-Bareau and David Degener

WITH CONTRIBUTIONS BY

Lloyd DeWitt
Richard Dorment
Douglas W. Druick
Gloria Groom
John Leighton

Joseph J. Rishel
Bill Scott
Ann Temkin
John Zarobell

Published on the occasion of the exhibition
Manet and the Sea:

The Art Institute of Chicago
October 20, 2003, to January 19, 2004

Philadelphia Museum of Art
February 15 to May 30, 2004

Van Gogh Museum, Amsterdam
June 18 to September 26, 2004

The catalogue was supported by an endowment for scholarly publications established at the Philadelphia Museum of Art in 2002 by The Andrew Mellon Foundation.

Produced by the Department of Publishing
Philadelphia Museum of Art
2525 Pennsylvania Avenue
Philadelphia, PA 19130 U.S.A.
www.philamuseum.org

Front cover/jacket: Edouard Manet, *The Battle of the U.S.S. "Kearsarge" and the C.S.S. "Alabama"* (plate 10, detail)
Pages ii–iii: Edouard Manet, *The Beach at Boulogne* (plate 32)
Page v: Edouard Manet, *Jetty at Boulogne* (plate 30, detail)

Edited by David Updike
Designed by Susan E. Kelly
Proofread by Laura Iwasaki
Color separations by iocolor, Seattle
Map (p. xii) by David Noble
Index by Valerie Sensabaugh
Production by Marquand Books, Inc., Seattle
www.marquand.com
Printed and bound in Belgium by
Snoeck-Ducaju & Zoon

Library of Congress Cataloging-in-Publication Data
Bareau, Juliet Wilson
 Manet and the sea / Juliet Wilson-Bareau and David Degener ; with contributions by Lloyd DeWitt . . . [et al.].
 p. cm.
 Catalog of an exhibition held at the Art Institute of Chicago, Oct. 20, 2003–Jan. 19, 2004, the Philadelphia Museum of Art, Feb. 15–May 30, 2004, and the Van Gogh Museum, Amsterdam, June 18–Sept. 26, 2004.
 Includes bibliographical references and index.
 ISBN 0-87633-174-6 (cloth)
 ISBN 0-87633-175-4 (pbk.)
 ISBN 0-300-10164-3 (Yale: cloth)
 1. Manet, Edouard, 1832–1883—Exhibitions.
2. Manet, Edouard, 1832–1883—Influence—Exhibitions.
3. Marine painting, French—19th century—Exhibitions.
I. Manet, Edouard, 1832–1883. II. Degener, David C.
III. DeWitt, Lloyd. IV. Art Institute of Chicago.
V. Philadelphia Museum of Art. VI. Rijksmuseum
Vincent van Gogh. VII. Title.
ND553.M3A4 2003b
759.4—dc21 2003051426

Notes to the Reader

Color plates of works that are not included in the exhibition are indicated by asterisks in the captions. For works that will not travel to all three museums, the venues are listed in the captions by the following abbreviations: AIC = The Art Institute of Chicago; PMA = Philadelphia Museum of Art; VGM = Van Gogh Museum, Amsterdam.

Works by Edouard Manet are sometimes cited by their catalogue number in Denis Rouart and Daniel Wildenstein's *Edouard Manet: Catalogue raisonné,* 2 vols. (Lausanne: Bibliothèque des arts, 1975). We follow the convention of referring to works in the *Catalogue raisonné* by the abbreviations *RW* for paintings (vol. 1) and *RWD* for drawings (vol. 2).

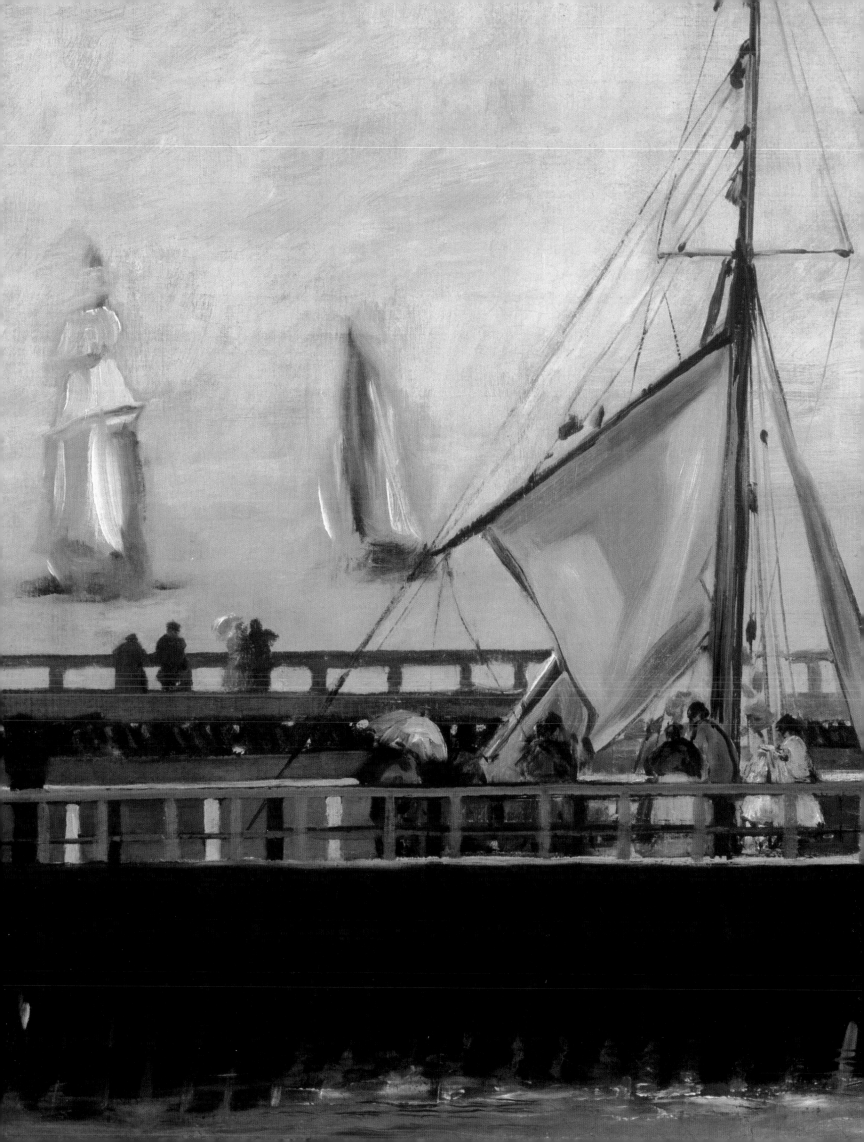

Lenders to the Exhibition

The Art Institute of Chicago
Ashmolean Museum, Oxford
Collection André Bromberg
Carnegie Museum of Art, Pittsburgh
Le Château-musée de Dieppe
The Cleveland Museum of Art
The Detroit Institute of Arts
The Dixon Gallery and Gardens, Memphis, Tennessee
Fine Arts Museums of San Francisco, California Palace of the Legion of Honor
Fogg Art Museum, Harvard University Art Museums, Cambridge, Massachusetts
Fondation Aetas Aurea
Fondation E. G. Bührle Collection, Zurich
Bob. P. Haboldt, Paris and New York
Kimbell Art Museum, Fort Worth, Texas
Kunsthaus Zürich
Kunstmuseum Basel
The Metropolitan Museum of Art, New York
The Montclair Art Museum, Montclair, New Jersey
Musée d'Orsay, Paris
Musée des Beaux-Arts, Brest
Musée des Beaux-Arts, Dijon
Musée des Beaux-Arts, Lyon
Musée du Louvre, Paris
Musée Marmottan Monet, Paris
Musée national des Châteaux de Versailles et de Trianon, Versailles
The National Gallery, London
National Gallery of Art, Washington, D.C.
National Gallery of Canada, Ottawa
National Gallery of Scotland, Edinburgh
National Gallery of Victoria, Melbourne
National Maritime Museum, London
The Newark Museum, Newark, New Jersey
Collection R. Pauls, Basel
Philadelphia Museum of Art
Shelburne Museum, Shelburne, Vermont
Smithsonian American Art Museum, Washington, D.C.
Rudolf Staechelin Family Foundation
Sterling and Francine Clark Art Institute, Williamstown, Massachusetts
Tate, London
University of Kentucky Art Museum, Lexington
University of Michigan Museum of Art, Ann Arbor
Van Gogh Museum, Amsterdam
Virginia Museum of Fine Arts, Richmond
Wadsworth Atheneum Museum of Art, Hartford, Connecticut
Wallraf-Richartz-Museum – Fondation Corboud, Cologne
The Walters Art Museum, Baltimore
and anonymous private lenders

Contents

Foreword

In 1966 the Philadelphia Museum of Art presented the first museum retrospective in the United States devoted to the work of Edouard Manet, organized by its then-Director, Evan H. Turner, who invited Bryn Mawr College scholar Anne Coffin Hanson to assist in the making of this ambitious show. Early on in the planning, John Maxon, Associate Director of The Art Institute of Chicago, enthusiastically took on the project, which traveled to Chicago early in 1967. It proved a watershed exhibition, establishing a plateau in Manet scholarship from which much new information was gleaned. Almost forty years later, Philadelphia and Chicago have again happily joined forces in a new investigation into the work of remarkable French nineteenth-century artists whose centrality in the definition of modern art has only grown since the 1960s, as evidenced by ever-increasing exhibition activity and a rapidly growing bibliography. This time around we are delighted to be joined by our colleagues at the Van Gogh Museum, Amsterdam, in a focused exploration of Manet's sea paintings and their interplay with both earlier and contemporary works in this liberating genre. Each of our three museums rejoices in splendid yet astonishingly different examples of Manet's early prowess as a sea painter in 1864–68: the dramatic scene of *The Battle of the U.S.S. "Kearsarge" and the C.S.S. "Alabama"* (plate 10), purchased by the formidable Philadelphia lawyer and collector John G. Johnson in 1888; the serene *Steamboat Leaving Boulogne* (plate 13), a gift to The Art Institute made possible by the Potter Palmer family in 1922; and the brilliant 2002 acquisition of the Van Gogh Museum, *Jetty at Boulogne* (plate 30), which strikes the most resolute modern note with its austere composition.

This exhibition aims to add a new element to our understanding of Manet's remarkable achievement. His paintings and drawings that take the sea or the seacoast as their subject represent an important and surprisingly unexamined aspect of his oeuvre. While Manet's seascapes are just as modern as his paintings of urban Paris, they often present a more casual appearance and a technique that seems to mirror the immediacy and subtlety of their subject. *Manet and the Sea* revisits the idea that Manet's formal discoveries and innovations helped give birth to Impressionism; it also explores the way in which the subject of the sea was itself given a new artistic meaning in Manet's time as it was taken up and transformed by a variety of artists.

Joseph J. Rishel, the Gisela and Dennis Alter Senior Curator of European Painting before 1900 at the Philadelphia Museum of Art, and his counterpart, Douglas W. Druick, the Searle Curator of European Painting and Prince Trust Curator of Prints and Drawings at The Art Institute of Chicago, have co-organized the exhibition, together with John Zarobell, Assistant Curator of European Painting in Philadelphia, and Gloria Groom, the David and Mary Winton Green Curator of European Painting in Chicago. We join this energetic and talented curatorial team in expressing particular pleasure that we could persuade the distinguished Manet scholar Juliet Wilson-Bareau to work with us on the planning of this project; she has also provided, with her colleague David Degener, the

crucial section of this catalogue devoted to Manet himself. In the course of preparing the exhibition, we have accumulated many debts to scholars, museum colleagues, dealers, auction houses, and librarians who are saluted in the acknowledgments that follow.

We are deeply grateful to the lenders, public and private, who have parted with important and beautiful works of art to share them with viewers of this exhibition, and to the Federal Council on the Arts for granting the indispensable indemnity that would otherwise make the costs of such international projects prohibitive.

Our sponsors are owed gratitude of equal proportion. The Art Institute of Chicago profoundly appreciates the generosity of JPMorgan Chase for its sponsorship, which enables the exhibition to be presented in Chicago. The Philadelphia showing was made possible by our generous corporate sponsor, Lincoln Financial Services, whose early and enthusiastic support enabled the Museum to proceed with this exciting project, and we have also had the invaluable help of The Pew Charitable Trusts, the Delaware River Port Authority, and an endowment for major exhibitions established by a grant from The Annenberg Foundation, as well as the Robert Montgomery Scott fund for exhibitions at the Museum. We are also grateful for promotional support provided by the Greater Philadelphia Tourism Marketing Corporation, NBC 10 WCAU, and Amtrak.

The exemplary work of the staff in all three museums was essential to bringing the exhibition into being. The registrars, the exhibition designers, the art handlers, and the public relations and marketing staff did everything possible to make this project a success. Suzanne Wells, Coordinator of Special Exhibitions in Philadelphia, and Dorothy Schroeder, Assistant Director for Exhibitions and Budget, and Barbara Mirecki, Exhibition Coordinator, in Chicago, deserve our warmest thanks for their diplomacy and efficiency in this, as in so many other instances. This handsome catalogue, produced by Marquand Books, Inc., of Seattle, owes its design to Susan Kelly and its thoughtful editing to David Updike, Associate Editor at the Philadelphia Museum of Art, under the benign and creative eye of Sherry Babbitt, Director of Publishing at that Museum.

Manet, like all very great artists, is an inexhaustible source for scholarship and public delight. New to each generation, his work presents a fresh face yet one not readily understood solely by scrutiny of its seductive surface. In the year 2003, when the Musée d'Orsay and The Metropolitan Museum of Art have given us all the huge pleasure of *Manet/Velasquez*, and the Met alone its illuminating dossier exhibition *Manet and the American Civil War*, it may seem brash to launch a third venture. But irresistible.

Anne d'Harnoncourt
*The George D. Widener Director
and Chief Executive Officer*
Philadelphia Museum of Art

James N. Wood
President and Director
The Art Institute of Chicago

John Leighton
Director
Van Gogh Museum,
Amsterdam

Acknowledgments

For assistance with loans, we owe thanks to Eva Avloniti, Joseph Baillio, Christoph Becker, Guy Bennett, Peter Berkes, Michael Clarke, Marjorie B. Cohn, Michael Conforti, Ina-Maria Conzen, Gérard J. Corboud, Malcolm Cormack, Stephan Custot, Lucy Dew, Walter Feilchenfeldt, Hartwig Fischer, Lukas Gloor, Jean-François Heim, Alan Hobart, Waring Hopkins, Sally Hunter, Ian Kennedy, Christian Klemm, Elizabeth Lane, Isabelle Lhoir, Barbara Lovejoy, Caroline Mathieu, Christian Müller, David Nash, Robert C. Noortman, Christopher Riopelle, Marie-Pierre Salé, Bertha Saunders, Georges Ségal, Ruedi Staechelin, Miriam Stewart, Charles F. Stuckey, Margret Stuffmann, Patricia Tang, Benno Tempel, E. V. Thaw, Catherine Tran, Marie-Caroline Van Herpen, Françoise Viatte, and Guy Wildenstein. We are also grateful to Franck Giraud, who served as third-party evaluator for the U.S. Indemnity Application.

For assistance with research and photographs, we wish to thank Andrea Begel, Dominique Billier, Nicole Casi, Dorota Chudzicka, Therese Dolan, Corwin Ericson, Annie Madec, Xavier Nicostrate, Walid Salem, Robert and Manuel Schmit, Dean Tank, and Noémie de la Vauvre.

At The Art Institute of Chicago, special thanks are due to Dorothy Schroeder, Assistant Director for Exhibitions and Budget, and Barbara Mirecki, Exhibition Coordinator. In the European Painting Department, we are grateful to Irene Backus, Geri Banik, Darren Burge, Adrienne Jeske, Doris Morgan, Jennifer Paoletti, and Mary Weaver Chapin. Credit for the installation design and graphic design in Chicago goes to Joseph Cochand and Lyn Delliquadri. For facilitating loans and shipping, thanks to Mary Solt and Tamra Yost. Faye Wrubel and Frank Zuccari of the Conservation Department examined works and provided research assistance. Thanks also to David Travis for sharing his nautical expertise. Donna Forrest, Christian Serig, and Amy Berman of the Copy Center tirelessly provided copies for study purposes.

At the Philadelphia Museum of Art, we owe particular thanks to Suzanne F. Wells and Bethany Morris in the Special Exhibitions Department, and to Danielle Rice, Associate Director for Program. Special thanks are also due to Jennifer Vanim in the Department of European Painting before 1900 for research assistance, securing photographs and per-missions for the catalogue, and performing myriad other tasks with efficiency and good humor. In the Publishing Department, David Updike edited the catalogue with extra-ordinary skill, with guidance from Sherry Babbitt. The installation design in Philadelphia was created by Jack Schlechter, Andrew Slavinskas, and Ann Kessler. We are indebted to Conna Clark and Jason Wierzbicki in Rights and Reproductions and Lynn Rosenthal in Photography. For web design, we are grateful to Mark Abrams, Lyn Elliott, Hasan Shaheed, and Scott Williams. In the Conservation Department, Teresa Lignelli and Mark Tucker deserve special mention. Irene Taurins, Registrar, deftly coordinated the movement of the exhibition into and out of Philadelphia. Thanks to Jesse Trbovich in the Library for research assistance.

At the Van Gogh Museum, Amsterdam, special thanks go to Andreas Blühm, Head of Exhibitions, and Sara Verboven, Registrar. For assistance with the catalogue, we are grateful to Suzanne Bogman, René Boitelle, and Louis van Tilborgh.

At The Metropolitan Museum of Art, New York, Gary Tinterow, Rebecca Rabinow, Kathryn Calley Galitz, and Dale Tucker have been ideal colleagues.

The catalogue owes its handsome appearance to the folks at Marquand Books, Inc., Seattle, and especially Ed Marquand, Susan E. Kelly, Marie Weiler, Jennifer Sugden, Carrie Wicks, Larissa Berry, and freelance associate Laura Iwasaki.

Juliet Wilson-Bareau and David Degener wish to acknowledge the assistance received from the following institutions and individuals: In Amsterdam: Duncan Bull (Rijksmuseum). In Arcachon: François and Françoise Cottin. In Basel: Bodo Vischer. In Berck: Georges Dilly. In Berkeley, California: Elena Balachova (Doe Library, University of California). In Berne: E. W. Kornfeld and Christine Stauffer. In Bordeaux and Arcachon: André Aubertin. In Boulogne: Karine Berthaud and Danièle Wasselin (Archives municipales); Karine Jay and Virginie Haudiquet (Bibliothèque municipale); Françoise Halley des Fontaines (Château-Musée), with Frédéric Debussche and Valérie Tonnel (Patrimoine); Claude Faye; François Guennoc; Sébastien Hoyer; and Claude Seillier. In Dijon: Hélène Meyer (Musée des Beaux-Arts). In Evanston, Illinois: Donna Lach and Gerald Mead. In Frankfurt: Ruth Schmutzler (Städelsches Kunstinstitut); Margret Stuffmann. In Houston: Mary Morton and Wynne Phelan (Museum of Fine Arts). In Le Havre: Anne Haudiquet (Musée Malraux). In London: John House (Courtauld Institute); Alexander Corcoran and Jacqueline Cartwright (Lefevre Gallery); Michael and Elke von Brentano; Hamish Dewar; and Ronald Pickvance. In Maastricht, Annick Swinnen (Noortman Gallery). In Merion Station, Pennsylvania: Barbara Buckley, Henry Butler, Kimberly Camp, Emily Croll, and Sarah E. Noreika (Barnes Foundation). In New York: Lydia Dufour (Frick Art Reference Library); Inge Dupont and Christine Nelson (Pierpont Morgan Library). In Paris: Sylvie Aubenas, Claude Bouret, René Hardy, Gisèle Lambert, and Madeleine de Terris (Bibliothèque nationale de France, Département des Estampes et de la Photographie); Isabelle Cahn, Anne Distel, and Marie-Pierre Salé (Musée d'Orsay); Catherine Loisel (Musée du Louvre, Département des Arts graphiques); Marianne Delafond (Musée Marmottan Monet); Marjolaine Mourot (Musée national de la Marine); Sophie Pietri (Wildenstein Institute); Caroline Durand-Ruel Godfroy; and Claudie Ressort. In Philadelphia: Bill Scott. In San Francisco, California: Steve Hyman and Ted Miles (San Francisco Maritime National Historical Park). In Washington, D.C.: Beth Joselow and Tom Mandel. In Winterthur: Mariantonia Reinhard-Felice (Foundation Oskar Reinhart "Am Römerholz" Collection). In Zurich: Paul Pfister (Kunsthaus); Christoph von Albertini.

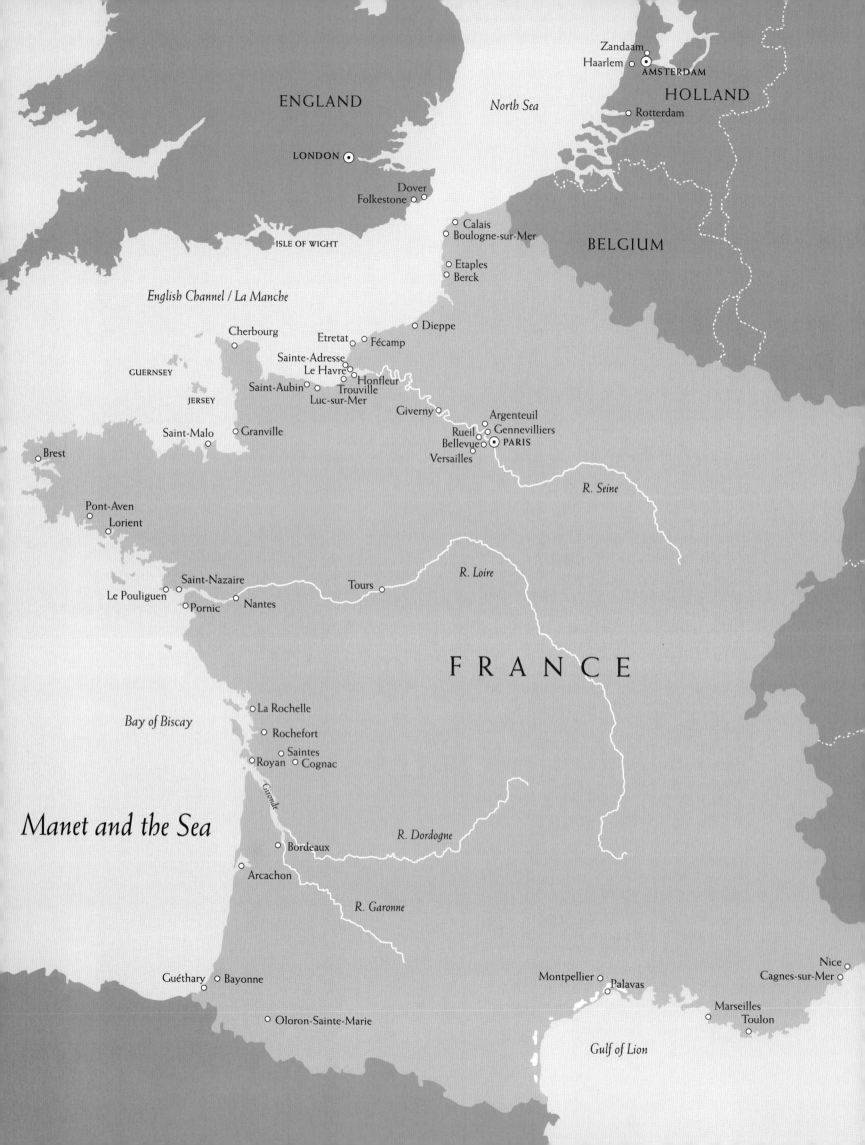

ENGLAND

North Sea

HOLLAND

Zandaam

Haarlem

AMSTERDAM

Rotterdam

LONDON

Dover
Folkestone

Calais
Boulogne-sur-Mer

BELGIUM

ISLE OF WIGHT

Etaples
Berck

English Channel / La Manche

Dieppe

Cherbourg

Etretat Fécamp

Sainte-Adresse
Le Havre
Honfleur
Saint-Aubin Trouville
Luc-sur-Mer

GUERNSEY

JERSEY

Giverny

Argenteuil
Gennevilliers

Rueil
Bellevue PARIS

Saint-Malo Granville

Versailles

Brest

R. Seine

Pont-Aven
Lorient

R. Loire

Saint-Nazaire

Le Pouliguen Tours

Pornic Nantes

FRANCE

La Rochelle

Bay of Biscay

Rochefort

Saintes

Royan Cognac

Gironde

Manet and the Sea

R. Dordogne

Bordeaux

Arcachon

R. Garonne

Nice

Guéthary Bayonne

Montpellier Palavas

Cagnes-sur-Mer

Marseilles
Toulon

Oloron-Sainte-Marie

Gulf of Lion

Introduction

JOSEPH J. RISHEL AND DOUGLAS W. DRUICK

Manet and the Sea is really two things, almost three.

It is, foremost, an opportunity to gather together as many of Edouard Manet's remarkable views of the sea as possible, a task in which we have succeeded well, completely thanks to the generosity of our collector colleagues and fellow museum folks, led in all cases by the truly formidable knowledge and investigative talents of our principal player, Juliet Wilson-Bareau. Of the forty or so paintings listed in Denis Rouart and Raoul Wildenstein's catalogue raisonné[1] that we felt were sufficiently within our claim as seascapes, thirty-three are included in this exhibition, along with numerous works on paper. We'd been so bold as to propose initially that this publication serve as a kind of formal catalogue raisonné of Manet's sea pictures, but we soon realized that such an undertaking was premature given the tremendous amount of new documentary and physical investigation required to advance this critical mass of work to a new plateau. Our catalogue does present the highest concentration of color images of these works to date, along with substantial new information about their historical context, chronology, and physical evolution —again, completely thanks to the persistence of Juliet Wilson-Bareau and her collaborator, David Degener.

With this central goal in place, our second desire—the "our" in this case being a group of museum curators and directors in Philadelphia, Chicago, and Amsterdam, all of whom appear as authors in this catalogue—was to place these core works by Manet at the hub of a selection of other paintings. These include key examples from the history of marine painting, dating as far back as the seventeenth-century Dutch masters Willem van de Velde the Younger and Lieve Verschuier, and continuing with the revival of the genre in France in the first half of the nineteenth century by Eugène Delacroix, Paul Huet, Louis-Gabriel-Eugène Isabey, and others. We also wished to track the interplay of Manet's seascapes with those of his contemporaries—Gustave Courbet, James McNeill Whistler, Eugène Boudin, and Johann Barthold Jongkind—as well as those of the succeeding generation: Claude Monet, Pierre-Auguste Renoir, Berthe Morisot, and Eva Gonzalès. In so doing, we hope to demonstrate the subtle and remarkably rich creative interaction that took place within marine painting during the twenty-year period beginning with Manet's first exploration of the genre in 1864, with his very ambitious *Battle of the U.S.S. "Kearsarge" and the C.S.S. "Alabama"* (plate 10).

In many ways this approach continues a long line of exploration in and around the subject of the "origins of Impressionism."[2] Marine painting—transient and fluid by its very nature—is a particularly potent, perhaps the most liberating, genre. We hope that our focus on sea painting can thus clarify this complex pattern of artistic interaction, with Manet as the pivotal figure through whom so many ideas filtered and against whose work they were tested. This said, we've tried to be alert to the dangers of such a simplistic "hub/spoke/wheel" analogy. With Juliet as our simultaneously elevating and restraining muse, we're sharply aware that Manet is as much a sustaining force as he is a liberating

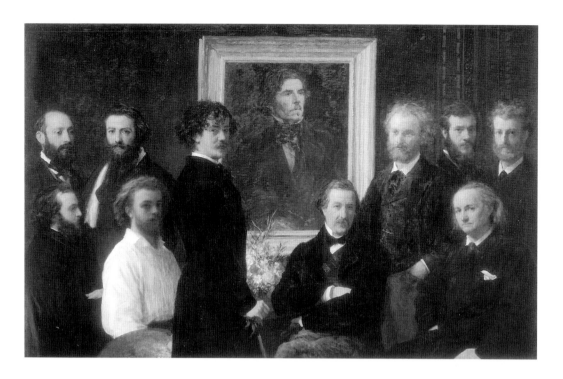

Fig. 1. Henri Fantin-Latour, *Homage to Delacroix*, 1864. Oil on canvas, 63 × 93⅜ inches (160 × 250 cm), Musée d'Orsay, Paris. RF 1664. Depicted in front of a portrait of Delacroix are, left to right, Louis Cordier, Edmond Duranty (seated), Alphonse Legros, Fantin-Latour (seated, in white shirt), James McNeill Whistler, Champfleury (seated), Edouard Manet, Félix Bracquemond, Charles Baudelaire (seated), and Albert de Balleroy.

one, as much a reactionary as a liberal, and much too refined and reflective ever simply to be placed as the first chapter in a synthetic survey of the movement that came to be known as Impressionism.

In this context, it is perhaps pertinent to recall that it was in the windows of Alfred Cadart's establishment (fig. 25) that Manet's *"Kearsage" and "Alabama"* was first presented to the Parisian public in July 1864. More than simply an art gallery and print shop, this was the headquarters of the Société des aquafortistes, the recently formed group devoted to the revival of etching as a painter's medium. Since its founding two years earlier, the Société's reputation—fueled by its highly visible print publications and active endorsement by the likes of Charles Baudelaire, Philippe Burty, and Théophile Gautier—had swelled along with its membership, which by then included such vanguard contemporaries as Boudin and Whistler. Manet himself was a founding member, in the company of artists of his generation, including Jongkind and Henri Fantin-Latour, and such notable senior figures as Delacroix and Courbet.

That Delacroix and Courbet—the leaders of the Romantic and the Realist schools, respectively—were among the Société's founders is telling, given the desire of the group's younger members for an art that would bridge the gap between the values of the two schools. Baudelaire, Burty, and Gautier were attracted to etching by the spontaneous execution it made possible—its perceived capacity to convey an artist's signature gesture. The medium appealed to their nostalgia for the spiritual values of Romanticism, which the aesthetic dominance of Courbet's Realist agenda was seen to have eclipsed. This desire for an art fueled by the imagination was shared by members of the young artistic vanguard involved in the etching revival, including Fantin-Latour and the group of like-minded artists he referred to as "semi-Romantics," chief among whom he placed Manet.[3]

The claim of these young artists to the dual legacy of Delacroix and Courbet forms the subtext of Fantin-Latour's 1864 *Homage to Delacroix* (fig. 1), featuring both Manet and himself. The attempt to incorporate both Romanticism and Realism into a modern style of painting was also an undercurrent of the salon held by Paul Meurice, at which Manet, Fantin-Latour, Félix Bracquemond, and Burty were regulars. Music, the affective art par excellence, featured prominently in these gatherings, with Mme Manet joining Mme Meurice in recitals of Beethoven, Haydn, and Schumann. And in this company it was music—specifically the controversial work of contemporary composer Richard Wagner—that seemed to offer a template for a "painting of the future": at once modern and Romantic.

Manet's *"Kearsarge" and "Alabama,"* with its modern subject set on a roiling sea that recalls Delacroix's canvases of *Christ on the Sea of Galilee* (fig. 2), also speaks to this ambition. With its Romantic associations, the sea afforded Manet the opportunity to put visual experience in the service of formal experimentation and gestural mark-making that dazzles us—as

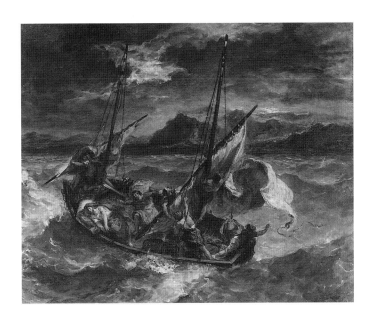

Fig. 2. Eugène Delacroix, *Christ on the Sea of Galilee*, 1854. Oil on canvas, 23½ × 28⅞ inches (59.8 × 73.3 cm). The Walters Art Museum, Baltimore. 37.186

Wilson-Bareau and Degener observe here—with its fluent testimony to the "artist's hand translating an idea from his mind's eye to the canvas."[4] The essentially subjective, "Romantic" aspect of this communication carried over to Impressionism and the seascapes of Monet and Renoir, both of whom would take up the formal opportunities suggested by the fluidity of water itself, although in sometimes very different ways.

The "almost third" part of this project is the happy collaboration with a fourth partner in the exhibition, The Metropolitan Museum of Art. Four years ago, Gary Tinterow, the Metropolitan's Engelhard Curator of European Paintings, proposed a collaborative project with the Philadelphia Museum of Art around two of Manet's most important marine paintings, both prompted by the American Civil War battle off Cherbourg in June 1864, when the Union *Kearsarge* sank the Confederate *Alabama*. The Philadelphia collector John G. Johnson had purchased the celebrated battle painting from Paul Durand-Ruel in New York in 1888; the "pendant" showing the *Kearsarge* at anchor off Boulogne was bought by the Metropolitan from descendants of the Havemeyer family in 2001, having long been on loan in their galleries. These two works were at the center of a summer 2003 dossier show at the Metropolitan that explored the artistic and historical responses to this military encounter—one of the major battles of the war, albeit fought on the other side of the Atlantic. By happy coincidence, four of the other works by Manet in the New York show are from the collections of the Philadelphia Museum of Art and The Art Institute of Chicago, providing the foundation for the agreeable collaboration that allowed us to use the Metropolitan's exhibition as the starting point of our somewhat broader investigations. The catalogue for the dossier exhibition is written by the primary authors of this catalogue, Wilson-Bareau and Degener, bringing our collaboration satisfyingly full circle. Our colleagues at the Van Gogh Museum in Amsterdam joined the project early in its life, noting that both marine painting and Manet hold great appeal for Dutch audiences. This suggested penchant was grandly confirmed by that institution's recent purchase of one Manet's boldest sea paintings, *Jetty at Boulogne* of 1868 (plate 30).

One cannot look at Manet's seascapes without sensing the true delight that nautical subjects—just being near the sea—held for the artist: salt air, bustling harbors, channel crossings, the pleasures of urban tourists at beach resorts. It is a particularly human and affable side to his very complex world. This spirit of delight and seemingly uncalculated experimentation—quite in harmony with the liberality of gesture and painterly experimentation that the painting of water released in Manet—places these works very tenderly within both the historical context of marine painting and the art making of his contemporaries.

1. Denis Rouart and Daniel Wildenstein, *Edouard Manet: Catalogue raisonnè*, 2 vols. (Lausanne: Bibliothèque des arts, 1975).

2. See, e.g., Gary Tinterow and Henri Loyrette, *Origins of Impressionism*, exh. cat. (New York: Metropolitan Museum of Art, 1994); Charles C. Cunningham, *Jongkind and the Pre-Impressionists: Painters of the Ecole Saint-Siméon*, exh. cat. (Williamstown, Mass.: Sterling and Francine Clark Art Institute, 1977).

3. See Groom, p. 42 below; Douglas W. Druick and Michel Hoog, *Fantin-Latour*, exh. cat. (Ottawa: National Gallery of Canada for the Corporation of the National Museums of Canada, 1983); Pierre Georgel, "Le Romantisme des années 1860," *Revue de l'art*, no. 20 (1973), pp. 9–64.

4. See Wilson-Bareau and Degener, p. 81 below.

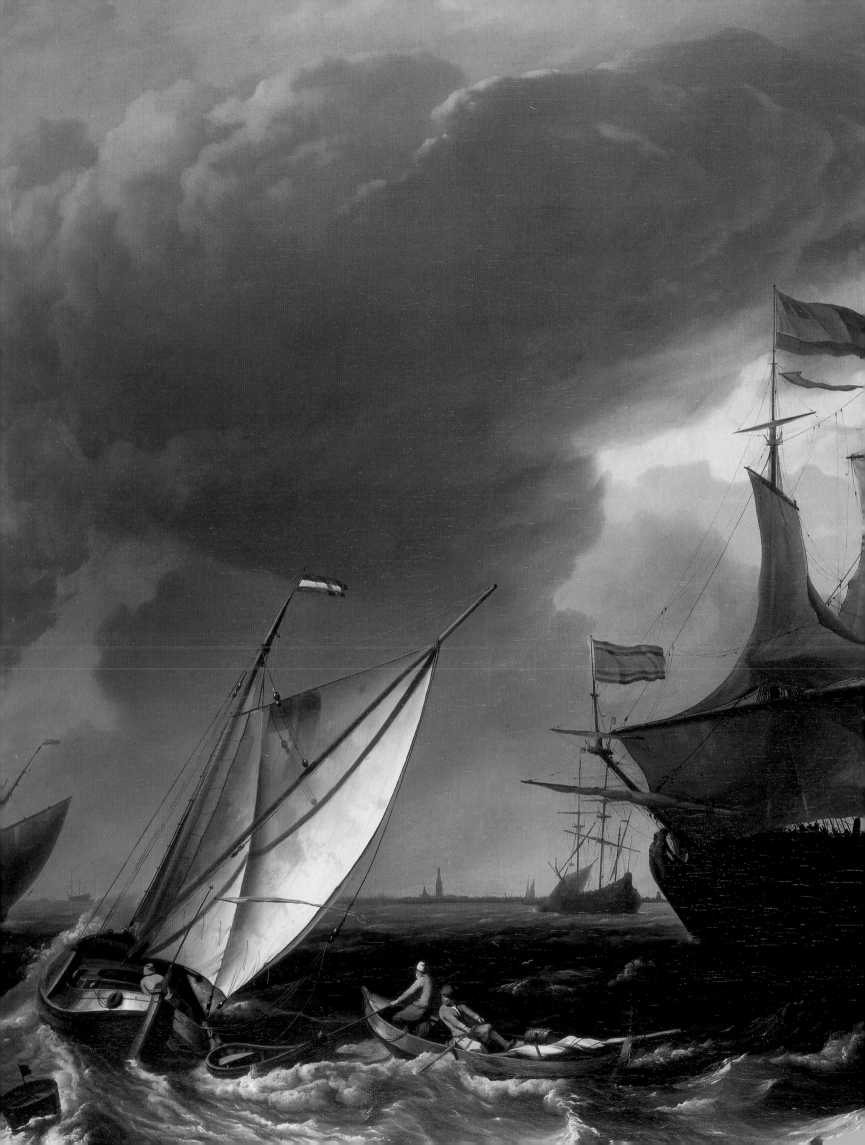

Manet and the Dutch Marine Tradition

LLOYD DEWITT

From overhead we observe a spry sailboat approaching two warships battling in the distance, obscured by clouds of smoke and steam. The smaller boat's sail stands out against the thick green swells of the sea, drawing attention away from the more significant action in the background. Although it is titled *The Battle of the U.S.S. "Kearsarge" and the C.S.S. "Alabama"* (plate 10), the painting's subject seems to be the dense, viscous waves of the sea itself, rather than the sensational battle near Cherbourg, France, on June 19, 1864.

This was not how sea paintings usually were made in nineteenth-century Paris. Unsympathetic critics variously suggested that the artist, Edouard Manet, had chosen a bird's-eye view of the action in order to allow the combatants to flee a poorly painted body of water and "fight in the shelter of the picture frame," or to include the fish of the sea as potential spectators of the battle.[1] In contrast, another contemporary depiction of the same event by the popular French marine painter Henri Durand-Brager (1814–1879) shows the battle in a grand and heroic way, with the *Kearsarge* dominating the foreground (fig. 26).

Although provocatively unconventional, Manet's composition was perhaps not entirely novel, as it recalls that of a much older painting then on exhibit in the Louvre. In *Dutch Vessels on a Stormy Sea* of about 1690 (plate 1) by the Dutch marine painter Ludolf Backhuysen (1631–1708), two warships also face each other in the distance to the right, while a small sailboat enters the picture in the left foreground. Although Backhuysen's scene is not a battle painting but rather a depiction of everyday activity in a Dutch harbor, it shares a number of features with Manet's picture, ranging from the choppy waves in the foreground to such small details as the skiff in tow of the sailboat and a distant ship in the far right corner.

We do not know if Manet ever copied Backhuysen's painting in the Louvre as a student, but he almost certainly knew it.[2] In the weeks during which he produced his first seascape, between the June 19 battle and the July 18 *La Presse* report about the display of the picture in the window of Alfred Cadart's gallery, Manet may even have returned to the nearby Louvre to reexamine the Backhuysens and van de Veldes so familiar to him from his student days. The resemblance between Manet's *"Kearsarge" and "Alabama"* and Backhuysen's *Dutch Vessels on a Stormy Sea* suggests, if not an intentional reference on Manet's part, then at least an affinity between the two works. This is most evident in Manet's dramatic use of the single foreground vessel as a *repoussoir* element. Both artists include such a vessel to enhance the tension and perspective of the scene and to heighten the sense of the accidental and everyday, although Manet additionally uses it to impose a contemplative distance from the tragic battle.[3] Instead of the artificially dramatic staging and privileged point of view of more conventional marine battle paintings, such as that of Durand-Brager, Manet renders the scene the way he imagined observers might have seen it from the cliffs of Cherbourg, with the combatants far off in the distance, shrouded in smoke and the confusion of battle, watched from behind a group of foreground vessels. Manet's vigorous waves also recall the effect achieved by Backhuysen, who, as Charles Blanc noted in his

Opposite page: Ludolf Backhuysen, *Dutch Vessels on a Stormy Sea* (plate 1, detail)

1

1861 volume on Dutch painters, "made the furious ocean the hero of the scene."[4] Back-huysen's dramatic use of chiaroscuro in the cloud shadow that darkens the larger ship diverts attention to the smaller foreground vessel, a characteristic that finds its parallel in the smoke and steam that obscure the battle in Manet's picture.[5]

The similarities between Manet's paintings of 1863 and 1864 and old master works—what Charles Baudelaire dismissed as "these mysterious coincidences"—have in the past been deemed irrelevant to his first marines.[6] However, the idea of a connection between Manet's marine paintings and earlier Dutch models, though previously unexplored, is not at all far-fetched. We know, for instance, that in 1867 Manet owned a nocturnal view by Aert van der Neer (1603/4–1677), who specialized in dramatic, monochromatic moonlit views that closely resemble and could well have inspired Manet's own *Moonlight, Boulogne* of 1868 (plate 28).[7] More so than others in his artistic circle, Manet embraced the art of the past. In his survey of nineteenth-century painting, Lorenz Eitner said of Manet: "Of no other progressive artist of the latter half of the nineteenth century can it be said that a large part of his work was inspired by suggestions from past art, rather than by personal invention or direct experience."[8] From early on, for example, Manet's *Luncheon on the Grass* of 1863 (Musée d'Orsay, Paris) had been clearly recognized as resembling the Louvre's

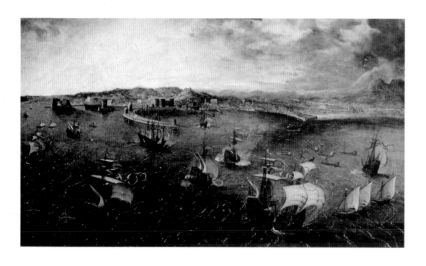

Fig. 3. Pieter Brueghel the Elder, *Battle in the Port of Naples*, c. 1558. Oil on panel, 15⅝ × 27⅜ inches (39.8 × 69.5 cm). Galleria Doria Pamphilj, Rome

renowned *Pastoral Concert* of 1508, long attributed to Giorgione but possibly painted or finished by Titian. The connection between Titian's *Venus of Urbino* of 1538 (Uffizi, Florence) and Manet's *Olympia* of 1863 (Musée d'Orsay, Paris) is even more transparent.

Although these and several other of Manet's paintings of 1863 and 1864 have been connected to the compositions of past masters, his *"Kearsarge" and "Alabama"* of the same period has largely evaded such associations. Instead, it has been most closely tied to contemporary newspaper illustrations Manet may have seen, or to non-Western art such as Japanese landscape prints.[9] And yet it is by viewing Manet's compositional innovations and approach to portraying current events in the context of the marine tradition in European art, and especially in relation to specific Dutch examples he may have imitated, that we can more clearly understand the refreshing novelty of his early seascapes and their lasting impact on his subsequent engagements with the sea.

The Emergence of the Dutch Marine Tradition in the Seventeenth Century

Marine painting is nearly as old as Western art, with seafaring appearing as a subject in Egyptian tomb paintings and Minoan palace frescoes, on Greek ceramics, and in written descriptions of ancient panel paintings.[10] Beginning with Homer's *Odyssey* (itself the subject of a surviving ancient wall painting in Rome), seafaring has evoked human striving, conquest, journey, transformation, and adventure.

The marine genre that emerged in Europe during the Renaissance expressed a uniquely medieval Christian mind-set by depicting the earth from a high, or bird's-eye, point of view that integrated human activity into a greater cosmos ordered by God. Pieter Brueghel the Elder (c. 1525–1569), for example, used a high horizon line and a bird's-eye point of view in an early seascape, *Battle in the Port of Naples* of about 1558 (fig. 3). The battle itself is barely noticeable as human activity is subsumed into a larger order, in a kind of inversion that frequently occurs in mid-sixteenth-century Flemish paintings.[11] The even distribution of the craft across the water, the regular grid-like rows of waves, and the pattern of elegantly

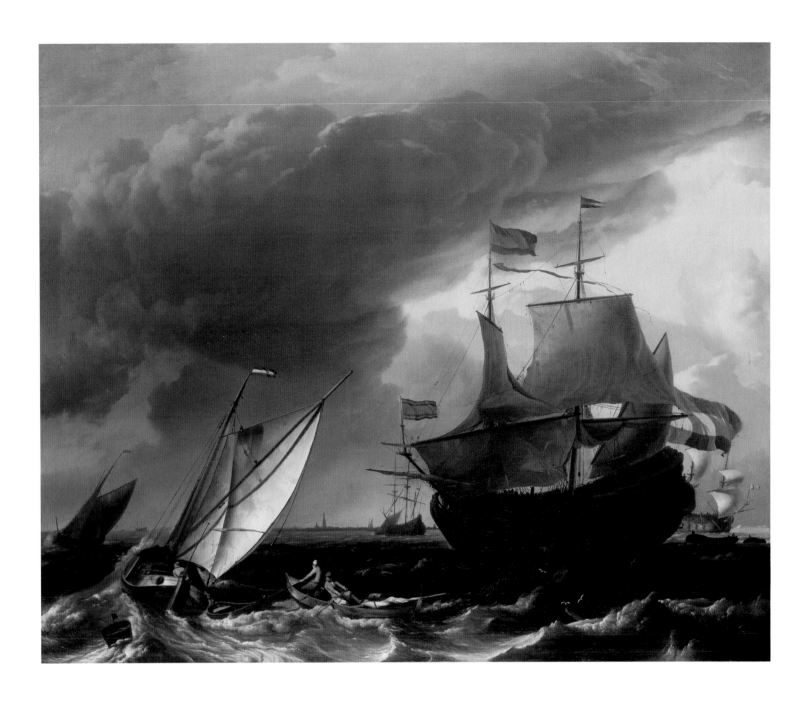

PLATE 1
Ludolf Backhuysen
Dutch Vessels on a Stormy Sea
c. 1690
Oil on canvas
26 × 31½ inches (66 × 80 cm)
Musée du Louvre, Paris. Inv. 990*

arched billowing sails all suggest an ordered universe on which human conflict has little impact.

However, when Manet assumed an elevated vantage point in *"Kearsarge" and "Alabama,"* more than two centuries after it appeared in Northern Renaissance art, he employed it not to refer to the late medieval world of Brueghel, but rather to represent the experience of the spectator. In doing so, Manet wryly suggests what might in fact have been the typical response of nineteenth-century French city dwellers standing on a cliff, transfixed more by the exotic vastness and danger of the open sea than by the battle in the distance. This view of the sea would have resonated with Manet's contemporaries in France.[12] Whereas the major cities of England and Holland where the seventeenth-century painters worked were seagoing ports, the Parisians were a landlocked people. By virtue of the sea's remoteness from their own urban context, the Parisian public of Manet's day might have been inclined to cast the sea as the "other," the exotic and untamed—what Jean-Jacques Rousseau termed the "natural."[13]

To the Dutch, however, the open waters had always been as malleable, fertile, and ubiquitous as farmland, for instance, would have been to the French. The philosopher René Descartes, in exile in Haarlem in 1631, wrote to a friend in Paris: "If there be pleasure in seeing the fruit growing in your orchards, and its abundance before your eyes, think you there is not as much in seeing the vessels arrive which bring us in abundance all the produce of the Indies and all that is rare in Europe?"[14] Descartes saw the Dutch as farmers of the sea, constantly and solicitously replenishing their quayside markets with all things desirable from around the world.

Given the central role that seafaring played in the ascendancy of the Dutch Republic in the sixteenth and seventeenth centuries, it is not surprising that Holland produced some of the first artists to specialize in marine painting, such as Hendrick Vroom (1566–1640) and his pupil Cornelis Claesz. van Wieringen (1577–1633).[15] And since the Republic's greatest victories over imperial Spain were fought on the sea, marine battle scenes in particular came to symbolize the nation's identity through its founding struggle for independence.[16]

Fig. 4. Cornelis Claesz. van Wieringen, *Explosion of the Spanish Flagship at the Battle of Gibraltar, April 25, 1607*, 1621. Oil on canvas, 54⅛ × 74 inches (137.5 × 188 cm). Rijksmuseum, Amsterdam

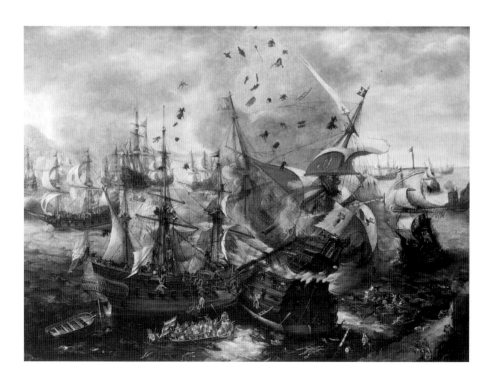

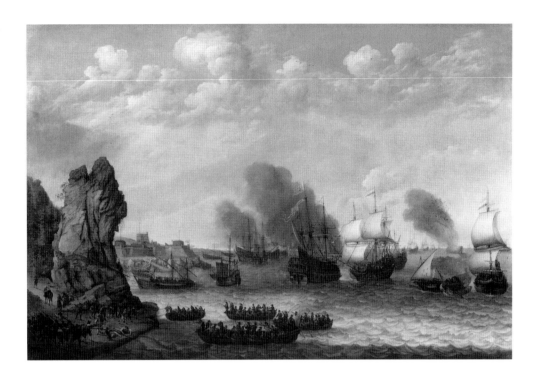

Van Wieringen's 1621 *Explosion of the Spanish Flagship at the Battle of Gibraltar, April 25, 1607* (fig. 4) represents an important development in the marine genre. This painting, produced for the Amsterdam Admiralty as preparation for a much larger picture showing the entire battle,[17] brings dramatic human action to the foreground and center of the composition. The elevated vantage point affords a breathtakingly comprehensive view of an explosion that marked the battle's dramatic climax, with sailors and equipment flung across the picture and high into the sky. By making the ships the main elements of the larger composition, and especially of this excerpt, van Wieringen presents a new way of looking at the sea. Although the horizon line is still more than halfway up the picture, giving the viewer a very high point of view, the affairs of men now supersede the cosmic order as evoked in the marines of Vroom and Brueghel, with their balance between man and nature, land and sea.

The 1641 *Battle of Spanish and Dutch Ships* (fig. 5) by Abraham Willaerts (c. 1604–1669) exemplifies the decorative compositions that endured in Dutch marine painting well into the seventeenth century, as he includes a wide variety of ships and activities in his otherwise traditional picture.[18] The landing and evenly dispersed skirmishes on the shore are balanced against confrontations in the water between warships of all types, including Spanish galleys and Dutch warships. Some of the ships are burning, and one is even exploding. All of this lively detail is set against a rugged and exotic coastline, its bulbous rocks probably inspired by those in the landscapes of Joachim Patinir (c. 1480–1524), the pioneering sixteenth-century Flemish landscapist.

The high horizon and decorative tendencies in earlier Dutch marine painting were gradually phased out as a newer style of seascapes emerged in Rotterdam and Haarlem. There, artists such as Simon Jacobsz. de Vlieger (c. 1600–1653) and Jan Porcellis (c. 1584–1632) had begun painting sea pictures with a more realistic, ground-level point of view.[19] De Vlieger's *Marine* of about 1652–53 (fig. 6) is an example of this shift. This scene employs the ground-level point of view, monochrome palette, dramatic lighting, and simple composition initiated by Porcellis in his stormy marine views.[20] De Vlieger, however, used these elements to develop a pristine, calm kind of composition that marks the beginning of the "classical" style in marine painting eventually epitomized by the seascapes of

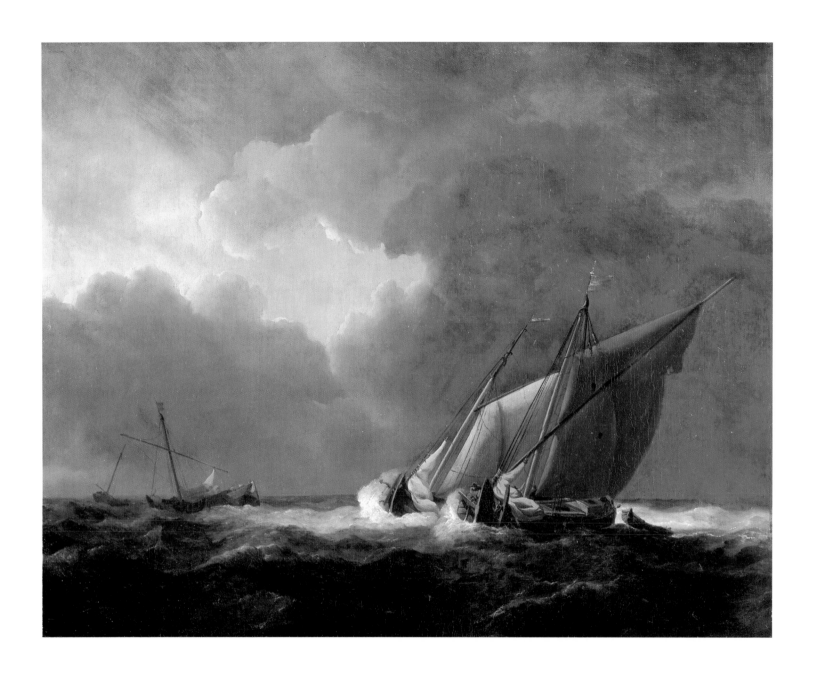

PLATE 2
Willem van de Velde the Younger
Two Dutch Vessels Close-Hauled in a Strong Breeze
c. 1672
Oil on canvas
17¼ × 21⅞ inches (43.8 × 55.7 cm)
Philadelphia Museum of Art. The John G.
Johnson Collection. Cat. no. 591

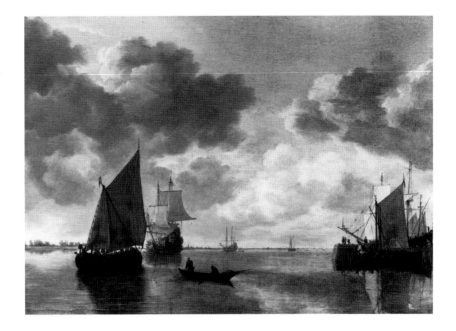

Fig. 6. Simon Jacobsz. de Vlieger, *Marine*, c. 1652–53. Oil on panel, 23⅝ × 32¹¹⁄₁₆ inches (60 × 83 cm). Philadelphia Museum of Art. The John G. Johnson Collection. Cat. no. 593

Willem van de Velde the Younger (1633–1707) and the luminous harbor scenes of Jan van de Cappelle (1626–1679) and Aelbert Cuyp (1620–1691).[21]

In his *Two Dutch Vessels Close-Hauled in a Strong Breeze* of about 1672 (plate 2), van de Velde situates the dramatic action at the center, as he did later in *An English Ship in Action with Barbary Pirates* of about 1680 (plate 3) and *English Warship Firing a Salute* of 1690 (fig. 7). The latter painting, like Manet's *"Kearsarge" and "Alabama,"* focuses on a single combat between two foreign ships, one of which is a privateer that is being destroyed. Unlike Manet's picture, however, in which the combat is obscured in the distance, in van de Velde's painting the two main vessels dominate the scene as they face each other across the middle of the canvas.[22] Van de Velde's grand and monumental compositional style influenced sea painters for centuries to come, including those of the established French tradition in Manet's time, such as Claude-Joseph Vernet, Théodore Gudin, Eugène Boudin, and Johan Barthold Jongkind (see Zarobell, pp. 20–26 below).

Just as Manet's seascapes challenged the dominant style of marine painting in his era, the works of van de Velde's contemporary Ludolf Backhuysen generally form a

Fig. 7. Willem van de Velde the Younger, *English Warship Firing a Salute*, 1690. Oil on canvas, 25½ × 31 inches (63.7 × 77.7 cm). Cleveland Museum of Art. Gift of Mr. and Mrs. Noah L. Butkin. 1975.80

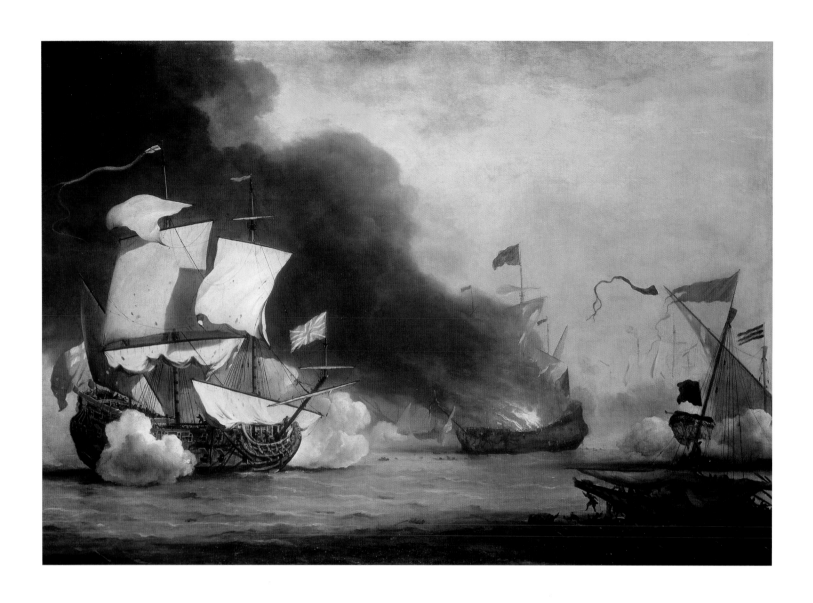

PLATE 3
Willem van de Velde the Younger
An English Ship in Action with Barbary Pirates
c. 1680
Oil on canvas
40⅜ × 57⅞ inches (102.7 × 147 cm)
National Maritime Museum, London. BHC0323
AIC, PMA

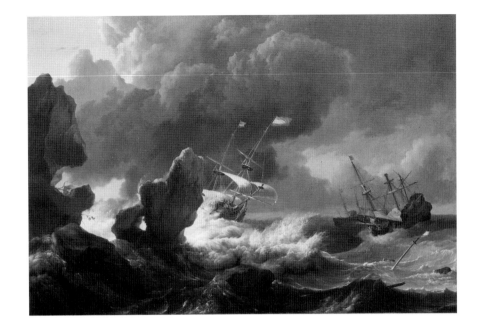

Fig. 8. Ludolf Backhuysen, *Ships in Distress off a Rocky Coast,* 1667. Oil on canvas, 45 × 65⅞ inches (114.3 × 167.3 cm). National Gallery of Art, Washington, D.C. 1985.29.1

counterpoint to the classical style. Backhuysen's seascapes tend to be more colorful, dramatic, and agitated than the works of van de Velde and the other great Dutch marine painters. His 1667 *Ships in Distress off a Rocky Coast* (fig. 8), for example, depicts an epic battle between man and the sea in which God's grace, human skill, and communal effort are all in play.[23] The Dutch ships in this painting are presumably transporting valuable cargoes far from the sandy coast of Holland, exemplifying the risky and ambitious sea ventures that had brought such wealth to the small new country. Backhuysen produces a melodramatic tension through the aggressive play of angles and realistic description of the effects of wind on sea and sail. In contrast to van de Velde's stable compositions of isolated central boats and simple patterns of repeated hull shapes and mast lines, Backhuysen's works typically have more dynamic and attenuated arrangements. In *Ships in Distress,* for example, the small boat's full sail propels it directly forward, while the frigate's sails are being changed to turn the vessel. The limpid sails and large, darkened silhouette of the frigate form an uneasy presence behind the brightly lit foreground boat. Backhuysen seems almost to artificially exaggerate the accidental or momentary character of the scene, especially when compared to the dramatic unity and simplicity of van de Velde's storm scenes.[24]

Backhuysen and Marine Painting in Nineteenth-Century France

Manet had been referring to old master paintings in *Olympia, Luncheon on the Grass,* and other pictures he made in 1863 and 1864. It would be reasonable to expect, therefore, that in devising a marine painting, he would have looked to works familiar to him from his student days of copying in the Louvre. The resemblance between the composition of his first large marine seascape, *The Battle of the U.S.S. "Kearsarge" and the C.S.S. "Alabama,"* and that of Backhuysen's *Dutch Vessels on a Stormy Sea* suggests that he did so. Backhuysen would have represented an interesting and provocative choice for Manet, especially when we consider how the Dutch artist's works were being reevaluated and appreciated in France at the time.

In nineteenth-century Paris, Backhuysen was one of the most visible and familiar— and also controversial—of the seventeenth-century Dutch marine painters. Then on exhibit in the Louvre were his *Boats in Stormy Weather* of about 1660–63, *Dutch Vessels on a Stormy Sea* (plate 1), and the immense *Port of Amsterdam as Seen from the IJ,* which had been commissioned by that city in 1666 as a gift to Hugues de Lionne, minister to Louis XIV.

Dutch Vessels on a Stormy Sea, which Manet's battle painting most closely resembles, was acquired in 1816 from Nicolas René François Baudelaire (unrelated to the poet Charles Baudelaire) and probably shows the Dutch port of Enkhuizen.[25]

Backhuysen's paintings, with their highly detailed style and expressive, agitated compositions, cut across French debates about painting. For instance, his ability to paint the effects of wind on waves and sails was praised by the poet and critic Théophile Gautier but mocked by the French painter and author Eugène Fromentin.[26] The critic Charles Blanc in 1861 recognized Backhuysen's role in helping to inaugurate the taste for the sublime through his violent, stormy seascapes. To Blanc, Backhuysen was a painter who had dispensed with artificial invention and who had "a spirit open to strong impressions that produce great danger."[27] In contrast, Theophile Thoré, known today both for his rediscovery of the Dutch master Johannes Vermeer and for his early interest in Manet's painting, dismissed Backhuysen's seascapes in his 1858 book on Dutch museums:

> His painting seems to me miserable, small, cold, mannered. This counter clerk, this calligrapher who sold his dexterous turns of the pen for 100 guilders—the price of Rembrandt's famous etching *Jesus Healing the Sick*—this professor of handwriting, latecomer to painting, never had, according to me, the feeling for art. If Backhuysen hadn't existed, there would have been no need to invent him, as he's a bad example. In the sublime aspect of the sea, it's the details that preoccupy him! They say, moreover, that he had himself taken onto the open sea in a storm, doubtless in imitation of van de Velde![28]

Thoré's animosity seems to be focused on the painter's controlling personality as recounted in the *Groote Schouburgh* of 1719, a compendium of biographies and information by the Dutch artist Arnold Houbraken. Backhuysen's highly detailed style of painting also would not have accorded with Thoré's preference for a more loosely executed, less finished paint surface.

The historical anecdotes reported by Houbraken about the methods of the Dutch old master landscapists may have been of interest to Manet and his contemporaries, who were themselves experimenting with new ways of painting from nature. The methods of painters such as van de Velde, Backhuysen, Cuyp, and Paulus Potter had even themselves become the subject of a series of Salon pictures by the French landscape artist Eugène Lepoittevin (1806–1870) in the 1840s.[29] At the 1848 Salon, for example, Lepoittevin exhibited a painting celebrating Backhuysen's naturalism by depicting the very story to which Thoré referred, about Backhuysen paying sailors in Amsterdam harbor to take him out during a storm so he could draw the sea and clouds.

However true to nature Backhuysen in fact had striven to be, standard seventeenth-century practice and the limitations of artist's materials required him to compose his finished works indoors, in the studio.[30] Houbraken recounts how, after drawing from nature, Backhuysen apparently locked himself up in the studio in order to set down his impressions as quickly as possible without being disturbed. His artfully tense compositions bear witness to such deliberate methods. It is unlikely that in 1864 Manet, still primarily a studio painter, would have been troubled by Backhuysen's artistic methods; rather, he would have found affinities in the Dutch artist's orchestration of the elements to more powerfully suggest the immediate physical experience of wind, temperature, water, and daily life at sea. Contrary to the accounts of Antonin Proust and Charles Baudelaire, Manet actually composed the *"Kearsarge" and "Alabama"* in a studio after the event, as its careful and deliberate arrangement attests.[31] His dynamic composition, with its "exaggerated diminution

of scale" achieved by moving the ships to the edge of the picture, closely parallels the effects achieved by Backhuysen.[32]

By inverting the compositional hierarchy of traditional marine battle paintings, and by employing challenging angles and formats, Manet upset the academic painting tradition of his day in many of the same ways that Backhuysen's compositions differed from those of van de Velde. The combat scenes of established nineteenth-century French marine painters such as Pierre-Julien Gilbert and Léopold LeGuen (see Zarobell, pp. 20–23 below), like those of van de Velde, situate an action in the center middle ground of a horizontal composition and reinforce the mood of the picture through illumination and atmosphere. The clarity, precision, and luminosity in Durand-Brager's version of the 1864 Cherbourg confrontation, for example, place this work firmly in the tradition of van de Velde, while Manet's more dynamic yet seemingly haphazard setting of the event echoes Backhuysen's innovations of centuries earlier.

The Changing World Shown in Marine Paintings

Marine painting emerged in Holland during a period of great expansion in the scope of human activity at sea, and Dutch sea painters were interested in depicting new technologies. In his *Marine* of about 1675 (plate 4), for example, Lieve Verschuier (1627–1686) portrays a ship with a whale carcass alongside, moored at the blubber-rendering works on Feyenoord Island in Rotterdam's harbor.[33] Whaling was a key industry in seventeenth-century Holland, and whale oil provided an effective, portable liquid fuel that was still in use in Manet's day. Verschuier's detailed depiction of maritime industry exemplifies the interest Dutch painters showed in modern aspects of daily life.

The battle paintings by van Wieringen and Willaerts discussed above (figs. 4 and 5, respectively) document the technological superiority of the Dutch and English fleets over the Spanish ships, some of which were galleys powered by forced labor. Van de Velde's *English Ship in Action with Barbary Pirates* (plate 3), for example, shows a lone English sailing ship prevailing over older-style galleys powered by rowers, as if to highlight the victory of sail, skill, and seamanship over brute strength and cruelty.

The nineteenth century, like the seventeenth, was a time of epochal shifts in marine activity and travel. The most important of these changes was the introduction of the steamship early in the century, probably the most radical advance in seafaring since the advents of the sail and the oar. The allure of exploration and adventure can make us too easily forget how uncomfortable and dangerous seafaring had been prior to this. In several early marine paintings, including *"Kearsarge" and "Alabama," Steamboat Leaving Boulogne* (plate 13), and *The Steamboat, Seascape with Porpoises* (plate 16), Manet documents the transition from slower, passive, wind-driven craft to self-powered steam vessels, which considerably reduced the danger and uncertainty of sea travel.

The *Kearsarge* and the *Alabama* were dual-powered steam and sail vessels that used steam engines during combat, thus liberating themselves from the fickle winds. In contrast to the heroically shot-through sails in van de Velde's painting, the empty main masts that appear through the puffs of smoke and steam in Manet's battle painting call attention to the modern character of these boats, which during the American Civil War were themselves being replaced by a new generation of ironclads. In the sketch *U.S.S. "Kearsarge" off Boulogne* (plate 11), which he made after his battle painting was finished, Manet further explored the shape of this modern dual-powered boat, using silhouette to focus attention on how its novel smokestack gave it a unique contour.

Manet's approach, like that of Backhuysen and other artists in the Dutch marine tradition, values fidelity to everyday life over the idealized style and historical or mythological

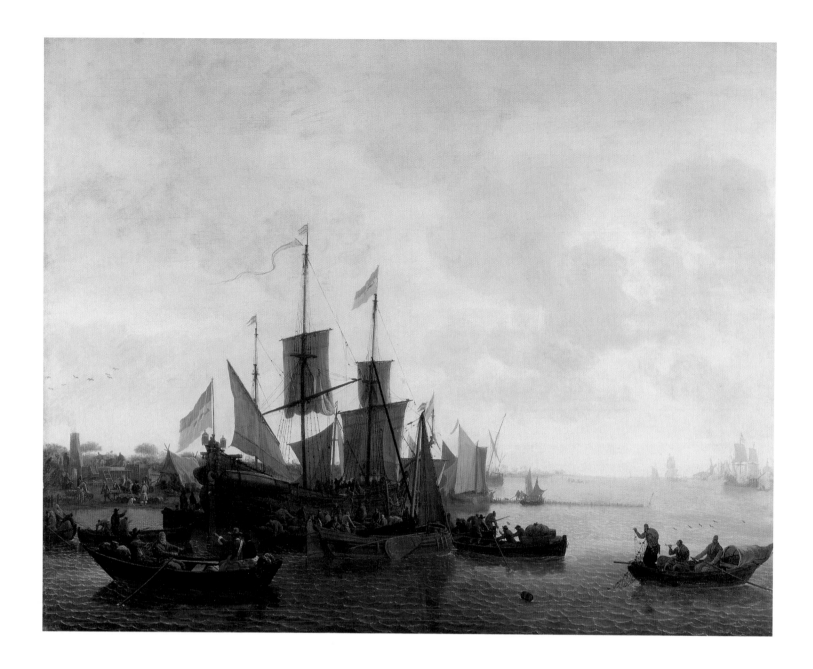

PLATE 4
Lieve Verschuier
Marine
c. 1675
Oil on canvas
35⅛ × 44¹¹⁄₁₆ inches (89.2 × 113.5 cm)
Philadelphia Museum of Art. The John G. Johnson Collection.
Cat. no. 594
AIC, PMA

Flying whaling flags and the banner of the whaling fleet's vice-admiral, this ship has a figure of the Madonna and child on its stern escutcheon, perhaps identifying it as the *Maria*, a whaler documented in Hoorn, Amsterdam, and Rotterdam in the late seventeenth and early eighteenth centuries.

subject matter favored by the dominant nineteenth-century French academic painters. This is a quality he shared with others in the mid-nineteenth-century Realist movement with which he is associated, including Jean-François Millet, Gustave Courbet, and Honoré Daumier and the Barbizon school. These artists, who were responsible for the most devoted revival of landscape painting to date in France, found their precedents primarily in the Dutch landscape tradition of the seventeenth century. Manet too revisits the Dutch tradition, especially in the enhanced sense of tangibility and dynamism he brings to his depiction of the battle near Cherbourg, a tragic current event that had captured the imagination of the public. In his subsequent seascapes, Manet extended this approach, setting a new course for marine painting in France.

1. See Françoise Cachin, Charles S. Moffet, and Juliet Wilson-Bareau, *Manet, 1832–1883*, exh. cat. (New York: Metropolitan Museum of Art, 1983), p. 219.

2. Theodore Reff, "Copyists in the Louvre, 1850–1870," *Art Bulletin* 46 (December 1964), p. 556.

3. See also *Boats in Stormy Weather*, c. 1660–63 (Musée du Louvre, Paris); *Ships in a Fresh Breeze*, c. 1670 (Cannon Hall Museum, Yorkshire); *Ships before Texel*, c. 1670 (Bridgewater House, London); and *Ships before the Roads of Enkhuizen*, c. 1680–85 (Staatliches Museum, Schwerin). Several pictures by Willem van de Velde the Younger, Backhuysen's prolific predecessor in Amsterdam, are similar in composition to *Dutch Vessels on a Stormy Sea* but show the foreground boat at a less aggressive lower angle more consistent with the other vessels in the picture. Even Backhuysen reverted to this more traditional positioning in other versions of the Louvre picture, such as *Stormy Sea with Boats and a Warship*, c. 1690 (Musée des Beaux-Arts, Lille), and *Ships in a Fresh Breeze*.

4. Charles Blanc, "Ludolf Backhuysen," in *Histoires des peintres de toutes les écoles*, vol. 2, *Ecole hollandais* (Paris: Vve. Jules Renouard, 1861), p. 5 (my translation).

5. Blanc almost seems to describe Manet's *Battle of the U.S.S. "Kearsarge" and the C.S.S. "Alabama"* when he notes how Backhuysen's pictures contrast with the artificial balance and complexity for which Vernet strives: "Two or three large waves adorn the foreground of the picture, and often to make for himself a *repoussoir*, the artist imposes on the first surface [the water] the shadow of a cloud that passes . . . and these moving shadows, to which he gives a lot of force, to the point of being almost black, serve him to mark the surfaces of the sea, as you would mark planes in a landscape." Ibid., p. 6 (my translation).

6. Etienne Moreau-Nélaton, *Manet raconté par lui-même* (Paris: Henri Laurens, 1926), vol. 1, p. 59.

7. Cachin, Moffet, and Wilson-Bareau, *Manet*, p. 311.

8. Lorenz Eitner, *An Outline of Nineteenth-Century European Painting* (New York: Harper and Row, 1987), p. 291.

9. On Manet's use of the high horizon and dominating foreground figures, see Anne Coffin Hanson, "A Group of Marine Paintings by Manet," *Art Bulletin* 44 (December 1962), p. 332. On his use of Japanese art, see Theodore Reff, "Manet's Portrait of Zola," *Burlington Magazine* 117 (January 1975); and Jay Martin Kloner, "The Influence of Japanese Prints on Edouard Manet and Paul Gauguin" (Ph.D. diss., Columbia University, 1978), p. 120. On Manet's turn to "grand," Salon-worthy subjects during this period as indicative of his ambition, see Cachin, Moffet, and Wilson-Bareau, *Manet*, pp. 219–21.

10. Pliny the Elder, *Natural Histories* XXXV.40.135, mentions Heraclides of Macedon as a ship painter. See Franciscus Junius, *Lexicon of Artists and Their Works*, vol. 2, *Catalogus Architectorum . . .* , ed. and trans. Keith Aldrich, Philipp Fehl, and Raina Fehl (Berkeley: University of California Press, 1991), p. 200.

11. See Charles D. Cuttler, *Northern Painting: From Pucelle to Bruegel* (New York: Holt, Rinehart and Winston, 1968), p. 459; Lawrence Otto Goedde, *Tempest and Shipwreck in Dutch and Flemish Art: Convention, Rhetoric, and Interpretation* (University Park: Pennsylvania State University Press, 1989), pp. 191–92.

12. "But the sea which surges all around, the sea which spreads out even to the frame of his picture, alone tells enough about the battle. And it is more terrible. You can judge the battle by its movements, by its broad swells, by its great waves wrenched from the deep." Barbey d'Aureville on the Salon, in *Gaulois*, July 3, 1872, reprinted in George Heard Hamilton, *Manet and His Critics* (New Haven: Yale University Press, 1954), p. 160. See also Anne Coffin Hanson, *Manet and the Modern Tradition* (New Haven: Yale University Press, 1977), p. 123.

13. Marie-Antoinette Tippetts, *Les Marines des peintres: Vues par les littérateurs de Diderot aux Goncourt* (Paris: A. G. Nizet, 1966), pp. 38–39.

14. René Descartes, letter to M. Balzac, May 15, 1631, in John Pentland Mahaffy, *Descartes* (1902; reprint, Freeport, N.Y.: Books for Libraries Press, 1989), p. 51.

15. Jeroen Giltaij and Jan Kelch, *Lof der Zeevaart: De Hollandse zeeschilders van de 17e eeuw,* exh. cat. (Rotterdam: Boymans van Beuningen Museum, 1997), p. 13.

16. Simon Schama, *The Embarrassment of Riches: An Interpretation of Dutch Culture in the Golden Age* (New York: Alfred A. Knopf, 1987), pp. 25–50.

17. This picture was a successful *proefstuk,* or artist's sample, for the larger commissioned picture, *The Battle of Gibraltar* (Nederlands Scheepvaart Museum, Amsterdam), a gift from the Amsterdam Admiralty to Prins Maurits to decorate his new quarters in The Hague. The finished work was a panorama of the entire battle and, at nearly six feet high and fourteen feet wide (1.8 × 4.9 meters), was the largest seascape known to have been painted in Holland in the seventeenth century. The modello of the finished work is in a Dutch private collection. Van Wieringen's teacher Vroom was rejected because his fee of 6000 guilders (to van Wieringen's 2400 guilders) was too high.

18. See Giltaij and Kelch, *Lof der Zeevaart,* pp. 15, 125–28, no. 16. The authors also point to the influence of Roelandt Savery's rocky landscapes on Willaerts.

19. Wolfgang Stechow, *Dutch Landscape Painting of the Seventeenth Century,* National Gallery of Art: Kress Foundation Studies in the History of European Art (London: Phaidon, 1966), pp. 110–23.

20. Of all the different kinds of marine views, storms and shipwrecks reflect most directly the ethos of Calvinist Holland, with seafaring serving as an allegory of humankind's dependence on the grace of God for salvation from sin. See Goedde, *Tempest and Shipwreck in Dutch and Flemish Art,* pp. 171–93.

21. Giltaij and Kelch, *Lof der Zeevaart,* pp. 16–18.

22. Van de Velde, like his contemporary Backhuysen, was famously devoted to ensuring the fidelity of his drawings to nature. A favorite anecdote, also illustrated in a mid-nineteenth-century Salon painting by Lepoittevin, relates how, at van de Velde's request, the Admiral Michiel de Ruyter fired an entire broadside from his flagship for the sole benefit of the artist so he could draw it from life and render it accurately. See "Eugène Lepoittevin," *Art-Union* 8 (April 1846), pp. 100–101.

23. See Arthur K. Wheelock, Jr., *Dutch Paintings of the Seventeenth Century* (New York: Oxford University Press, 1995), pp. 18–19 nn. 3–5. Wheelock discusses the varied strategies sailors used in trying to survive a storm, such as removing the top section of the mast, as seen on the ship to the right in Backhuysen's *Ships in Distress* (fig. 8).

24. Van de Velde developed a majestic type of marine view out of the calm and monumental compositional style of his teacher, de Vlieger, exemplified by de Vlieger's *Marine* (fig. 6). Some of van de Velde's compositions closely approach that of Backhuysen's *Dutch Vessels on a Stormy Sea,* particularly *A "Wijdschip" Close-Hauled in a Fresh Breeze, with Other Shipping,* c. 1660 (private collection); however, the position of the foreground vessel does not approach the radical near-vertical angle often used by Backhuysen. Van de Velde's *Three Ships in a Gale* of 1673 (National Gallery of Art, Washington, D.C.) most closely approaches Backhuysen's shipwreck scenes but still highlights a single vessel at its center.

25. I wish to thank Jacques Foucart of the Musée du Louvre for sharing excerpts from his forthcoming revised catalogue of the Dutch and Flemish paintings. The confusion between *Dutch Vessels on a Stormy Sea* and Backhuysen's *Le Coup de vent (Boats in Stormy Weather)* was initiated by a cataloguing error in Frédéric Villot's *Notice des tableaux exposés dans les galeries du Musée Impérial du Louvre* (Paris, 1853), vol. 2, p. 4, no. 8. The mistake was repeated by Cornelius Hofstede de Groot in *Beschreibendes und kritisches Verzeichnis der Werke der hervorraendsten holländischen Maler des XVII. Jahrhunderts,* vol. 7 (Paris and Stuttgart, 1918), no. 253, and was quite fancifully expanded in Pierre Angrand, "Une Mauvaise Affaire de M. Baudelaire," *Gazette des beaux-arts* 86 (October 1975), pp. 110–11. See also Jean Ziegler, "Chronique des arts," *Gazette des beaux-arts,* ser. 6, vol. 125, no. 1512 (January 1995), p. 25; Gerlinde de Beer, *Ludolf Backhuysen: Sein Leben und Werk* (Zwolle: Waanders Uitgevers, 2002), p. 117. On the location shown, compare the harbor view to that in Backhuysen's *Ships before the Roads at Enkhuizen,* in which the towers of the 1649 Drommedaris gate (left) and 1519 St. Pancras's Church (right) can also be easily distinguished.

26. Théophile Gautier, *Guide de l'amateur au Musée du Louvre* (Paris: Bibliothèque-Charpentier, 1899), pp. 150–51; Eugène Fromentin, *Masters of Past Time* (New York: Phaidon, 1958), p. 90.

27. Blanc, "Ludolf Backhuysen," p. 2.

28. Theophile Thoré, *Musées de la Hollande* (Paris, 1858), vol. 1, p. 159.

29. "Eugène Lepoittevin," pp. 100–101.

30. Arnold Houbraken, *De groote schouburgh der Nederlandische Konstschilders en Schilderessen* (Amsterdam, 1719), vol. 2, p. 238. See also Giltaij and Kelch, *Lof der Zeevaart,* pp. 40–41; Hendrick J. Horn, *The Golden Age Revisited: Arnold Houbraken's Great Theatre of Netherlandish Painters and Paintresses* (Doornspijk: Davaco, 2000), vol. 1, p. 200.

31. Cachin, Moffet, and Wilson-Bareau, *Manet,* p. 218.

32. See Hanson, "A Group of Marine Paintings by Manet," p. 332; and Hanson, *Manet and the Modern Tradition,* p. 123.

33. This rendering plant, active 1664–84, consisted of a furnace, cooking vats, and a barrel-making operation and was located offshore to prevent the powerful stench from offending the citizens. See Piet Dekker and Rudolphine Eggink, *De walvisvaarder Prins Willem of de Nieuwe Maas bij Rotterdam: Een schilderij door Lieve Pietersz. Verschuier* (Amsterdam: Rob Kattenburg, 1989), p. 11. These authors date another very similar painting by Verschuier, showing the whaling ship *Prins Willem* docked at the same works, to the year 1675. Ibid., pp. 8–10, 14. See also J. van Sluis, *Lijst van Nederlandse walvisvaarders, eind 17e eeuw tot 18e eeuw* (Amsterdam: Nederlands Scheepvaart Museum, 1929–52).

Marine Painting in Mid-Nineteenth-Century France

JOHN ZAROBELL

The story of French marine painting in the nineteenth century remains largely untold.
Despite a handful of important studies and exhibitions, relatively little has been written
about how and why French painters approached marine subjects in this era.[1] The British
marine tradition has been explored in more depth, with particular emphasis on leading
figures such as Joseph Mallord William Turner and John Constable. However, critics and
historians have insisted for a hundred and fifty years that the most significant development
in French painting in the nineteenth century was the rise of landscape, which has led to
the perception that marine painting was secondary, a sort of footnote for enthusiasts.

Marine painting, in various guises, was actually central to the progress of the arts in
France. Who could imagine a history of French painting that did not include Théodore
Géricault's *The Raft of the "Medusa"* of 1819 (fig. 11)? This is just one of a series of marine
paintings that riveted the public's attention, as history painting caught up with contem-
porary politics and provided a means for viewers to come to terms with burning issues of
the day. Marine painting was often practiced by specialists, and it developed alongside a
burgeoning French navy that sponsored depictions of its present and past exploits. It was
also practiced by countless artists, including Eugène Delacroix and Jean-François Millet,
who were better known for other genres of production. Further, marine painting, like
landscape painting, to which it was closely linked, reflected fundamental changes in artis-
tic practice, as artists moved out of the studio and away from the conventions associated
with it. In the second half of the nineteenth century, artists worked on-site in locations
devoted to leisure and tourism. Most important, sea painting flourished at mid-century
among progressive painters who explored the formal properties and possibilities of their
medium and developed innovative methods and approaches that allowed them to achieve
effects unprecedented in painting.

One reason that the technical and historical significance of nineteenth-century French
marine painting has been overlooked is the difficulty in determining what, exactly, con-
stitutes a marine painting. While a landscape painting is relatively self-declarative—any
depiction of the world outside qualifies—marine painting is more difficult to define. Is it
any scene that includes water, or does it have to be all sea? What about harbor or beach
scenes? Does there have to be a ship or sailboat? Salt or fresh water? The list of potentially
defining questions goes on, and each successive generation of marine painters sought new
ways of answering them.

When Edouard Manet began to paint seascapes in the 1860s, a distinct tradition of
French marine painting had already been established in France. Although a history of this
tradition is clearly outside the scope of this essay, I seek here to provide a historical sense
of what constituted a marine painting in nineteenth-century France and to explore some
of the most prominent examples of the genre at mid-century. In doing so, I hope to set the
stage for Manet's innovative contributions to sea painting.

Opposite page: Louis-Gabriel-Eugène
Isabey, *Fishing Village* (plate 9, detail)

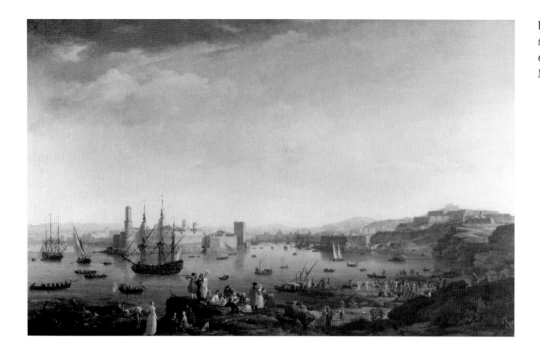

Fig. 9. Claude-Joseph Vernet, *Entrance to the Port of Marseilles*, 1754. Oil on canvas, 65 × 103½ inches (165 × 263 cm). Musée du Louvre, Paris. Inv. 8293

The Genealogy of French Marine Painting

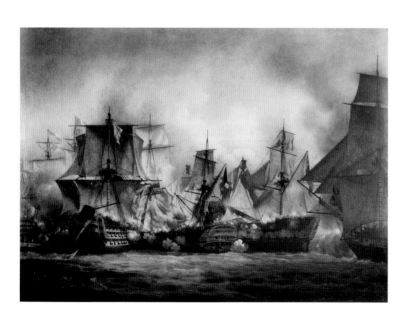

Fig. 10. Louis-Philippe Crépin, *"The Redoubtable" at the Battle of Trafalgar,* 1805. Oil on canvas, 41⅜ × 57⅛ inches (105 × 145 cm). Musée de la Marine, Paris

French marine painting arguably reached its peak in the eighteenth century with Claude-Joseph Vernet's *Ports of France* series of 1753–65.[2] Through this royal commission, Vernet (1714–1789) brought the seaside to central France. One goal of the series was to unify the country by representing its outer limits. While the ports signified France's boundaries, they also symbolized its connection to the outside world through maritime trade, which increased considerably in the eighteenth century. Vernet's *Entrance to the Port of Marseilles* of 1754 (fig. 9), for example, depicts a panoramic view of the Bay of Marseilles including both maritime activities and social life. Unlike his more idealized marine pictures of storm-tossed seas, shipwrecks, and rustic ports, this topographical view provides a more or less accurate representation of Marseilles at the moment it was painted. The infusion of Mediterranean light and the various groups of pleasure seekers add elements of naturalism to this otherwise highly structured composition. The classical balance of Vernet's composition demonstrates both his academic training and his ability to draw upon the example of Claude Gellée, also known as Claude Lorrain (1600–1682). Considered the prototype of French marine painters, Claude often featured mythological scenes or themes drawn from classical history in his seascapes. Vernet, however, dispensed with these classical elements, instead absorbing Claude's pictorial interests in light, atmosphere, and compositional balance and employing these effects to represent scenes of everyday life in the ports of France.

Although the marine painters of the Revolution and Empire periods (1789–1815) never equaled Vernet's groundbreaking achievements in the genre, he continued to serve as an inspiration, and his interest in dramatic themes such as stormy seas and shipwrecks found expression in their work particularly in depictions of naval battles. One such painter was Louis-Philippe Crépin (1772–1841). He, like Vernet, was trained in the academic tradition, but his *"The*

Fig. 11. Théodore Géricault, *The Raft of the "Medusa,"* 1819. Oil on canvas, 193⁵⁄₁₆ × 281⅞ inches (491 × 716 cm). Musée du Louvre, Paris. RF 1667

When this painting was first shown at the Salon of 1819, it caused a scandal due to the graphic nature of the depiction, but also because the notorious incident it illustrated underlined abuses of power in the French navy. When the *Medusa* struck a reef and sank off the coast of Senegal in 1816, there were not enough lifeboats to hold all of the passengers. A raft was built for the excess passengers and tied to the lifeboats. After a day at sea, however, the line was cut, leaving those on the raft to drift for thirteen days on the high seas. Only fifteen of the original 150 passengers survived.

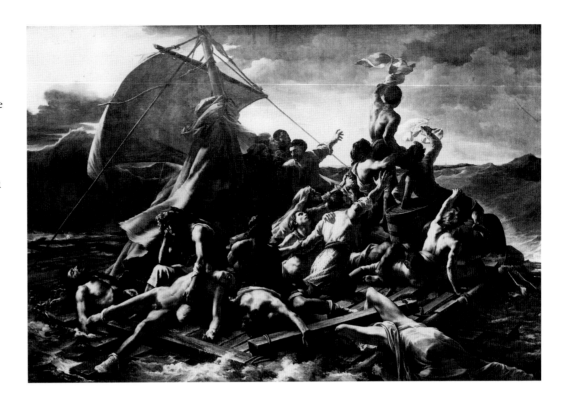

Redoubtable" at the Battle of Trafalgar of 1805 (fig. 10) is entirely different from Vernet's topographical or dramatic scenes. Crépin's painting depicts a battle scene in which the ships cover the length of the canvas, blocking out any sense of the natural environment or atmospheric conditions. His passion was for the details of naval engagement, including the particular ships that participated and the specific events of the battle. Battle paintings such as this one, typical of the late eighteenth and early nineteenth centuries, are distant indeed from Vernet's almost philosophical meditations on nature and the human place within it and were produced with a different sort of patron in mind. For Crépin and other artists of his day, a marine painting was the re-creation of a historical naval battle made primarily for the glory of the state or for a naval officer who could afford a painted commemoration of a momentous engagement.[3] In these paintings, the sea is primarily a field of activity, and, unlike Vernet, the artists did not study the conditions of light and atmosphere so much as reconstruct them from an official account.

In the hands of Théodore Géricault (1791–1824), however, competing detailed accounts of a naval disaster were woven into a shocking and horrifying masterpiece that did not glorify, but in fact vilified, the French navy and the Restoration government under Louis XVIII. *The Raft of the "Medusa"* (fig. 11) turned the standard formula for official marine painting on its head, providing a vivid, grotesque depiction of the official abuse of power.[4] This enormous painting was the crowning achievement of a Romantic artist who worked within the broadly accepted definitions of art in his period but nevertheless visibly rejected the authority of both the Neo-Classical tradition and the Restoration government.

The Raft of the "Medusa" was a sensation when it was first presented to the public at the Salon of 1819. Critical estimation of the work, both in the nineteenth century and today, holds it as not only the defining moment of French Romantic painting but also the most important marine painting of nineteenth-century France. In his intense preparation for this work, Géricault assiduously studied all of the accounts of the 1816 event and even interviewed some of the survivors. Thus, the picture emerges primarily from factual accounts of a real event. In its mood and its graphic depiction of the suffering of the figures on the raft, however, Géricault's marine composition aims to tell a universal story through the

particular details of a raft lost at sea. What is communicated most forcefully is not the event itself, but rather the surging ocean and the human inability to master it. This effect is accomplished through formal means such as the roiling gray swells that surround the raft and the high horizon line with a small ship in the distance. These devices make the sea seem like the main character of the story, against which the pyramid of human figures must struggle for survival. *The Raft of the "Medusa"* represents an unprecedented and powerful depiction of the sea.

A Panorama of French Marine Painting: Three Predominant Styles

PLATE 5
Pierre-Julien Gilbert
Naval Combat between the French Vessel "Formidable," under the Command of Captain Troude, and Three English Vessels, "The Caesar," "The Spencer," and "The Venerable," and the English Frigate "The Thames," in View of Cadix, July 13, 1801
1832
Oil on canvas
29¼ × 46 inches (74.3 × 116.8 cm)
Musée national des Châteaux de Versailles et de Trianon. MV 1439
AIC, PMA

Among the various forms of seascapes that existed in France around the middle of the nineteenth century, the most prominent, in terms of numbers of paintings produced and official commissions, were naval battle scenes. Significant historical developments in the late eighteenth and early nineteenth centuries made official accounts of naval battles likely subjects for marine painting. This was an era of great advancement for the French navy, due in part to France's colonial ventures, and in 1830 the new title and office of Official Painter of the Navy was instituted. Although any number of painters working at the time could have held this title, it was first awarded to Crépin and Théodore Gudin (1802–1880). Other artists to hold the title during the July Monarchy (1830–48) included Pierre-Julien Gilbert (1783–1860) and Antoine Léon Morel-Fatio (1810–1871). These painters and others were charged with the ambitious project of producing a complete history of French naval engagements for the newly created Musée de l'Histoire at the Palace of Versailles. Between the announcement of the museum in 1836 and the fall of Citizen-King Louis Philippe's regime in 1848, hundreds of naval battles were commissioned to decorate the halls of Versailles.[5]

Although it was not commissioned for the museum, Gilbert's 1832 painting *Naval Combat between the French Vessel "Formidable" and Three English Vessels* (plate 5) easily found a home there. While this is clearly a naval battle painting produced for an official audience, it

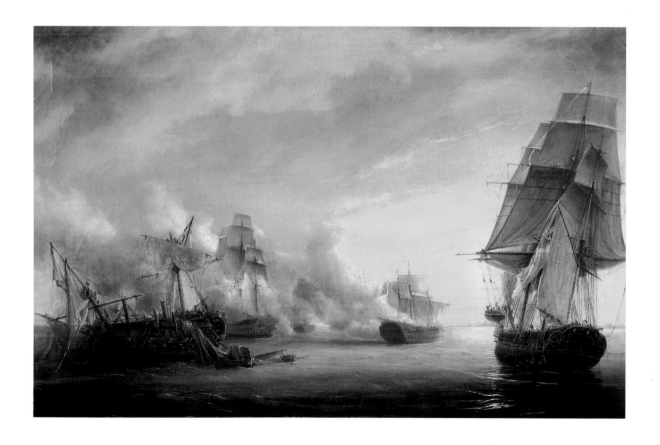

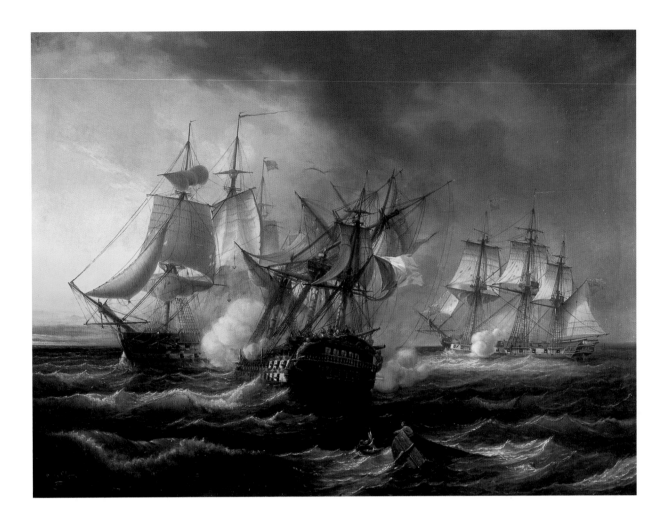

PLATE 6

Léopold LeGuen
*Naval Combat between "The Rights of Man"
and the English Vessel "Indefatigable" and the
Frigate "Amazon," January 17, 1797*
1853
Oil on canvas
38⅜ × 51⅜ inches (97.5 × 130.5 cm)
Musée des Beaux-Arts, Brest. 875.1.2
AIC, PMA

nevertheless seeks to communicate a sense of light and atmosphere in order to evoke the setting, namely the southern coast of Spain. Historical detail is married to atmospheric particularity as the artist attempts to provide a sense of both the time of day and the climate in which this battle was fought. The dynamic of the battle can be read from the position of the ships in the water. The clouds of smoke from the vanquished ships drift up and mix with the clouds in the golden sky. Despite the unfolding story of human victory and tragedy, the water is calm at day's end. A frigate in the right foreground approaches the scene of battle, obscuring the setting sun.

The later work of Léopold LeGuen (1828–1895), another painter in the tradition of official marines, adds a new twist on the theme of naval engagements and demonstrates the persistence of this genre beyond the July Monarchy and into Napoléon III's Second Empire (1852–70). LeGuen's 1853 painting *Naval Combat between "The Rights of Man" and the English Vessel "Indefatigable" and the Frigate "Amazon"* (plate 6) is more mannered than previous battle pictures. Fewer ships are involved and the engagement is more dramatic. It seems that a change in weather is afoot, with gray clouds covering the sky. In addition, the sun is setting and night is about to fall. These atmospheric conditions provide for colorful effects in the water but also presage a shift in the fate of the French vessel, whose demise is forecast by the collapse of the two main masts. Here one can see the particularity of Gilbert's account giving way to a general, more melodramatic style of battle painting, perhaps best demonstrated by the foreground figures attempting to survive on the sinking dinghy. This work may also reflect a change in the times for naval battles, and thus for battle painting. In 1847 the last first-class warship powered solely by sails was built in France. From then on, all warships would be powered by a combination of steam and sail. By the time this

PLATE 7
Eugène Delacroix
Shipwreck on the Coast
1862
Oil on canvas
15¼ × 18⅜ inches (38.8 × 46.7 cm)
Private collection, courtesy of
Richard L. Feigen & Co. 20315-P
AIC, PMA

work was made, LeGuen's painting was a nostalgic re-creation of a lost era of battles between sailing ships on the high seas. By contrast, steam-powered craft would be featured prominently in the marines of Manet and his followers.

Well into the Second Empire, the Romantic tradition offered a competing form of marine painting pitched to a different audience than the one for officially commissioned battle scenes. Although the height of this genre was unquestionably Géricault's *Raft of the "Medusa,"* it also includes a number of seascapes by his friend and follower Eugène Delacroix (1798–1863). Delacroix first made a name for himself with his *Barque of Dante* (Musée du Louvre, Paris), shown at the Salon of 1822, and he continued to paint seascapes throughout his career, notably *The Shipwreck of Don Juan* of 1840 (Musée du Louvre, Paris) and numerous versions of *Christ on the Sea of Galilee* executed between 1841 and 1853 (see fig. 2). Delacroix painted large-scale state commissions during the Second Republic (1848–52) and Second Empire (1852–70), but earlier in his career he had developed an audience of bourgeois and aristocratic patrons who bought less ambitious (though highly developed) works on a smaller scale.

One such painting is Delacroix's *Shipwreck on the Coast* of 1862 (plate 7), which is in many ways emblematic of Romantic seascapes. It is a scene that pairs a representation of the sea with a human drama, in this case the wreck of a small boat. The viewer peers out at a choppy sea through the rocky grotto that forms a frame within the frame. While it is a late work, it is similar to his earlier seascapes in its sense of motion and drama, implicitly connected to the tumultuous sea. *Shipwreck* also benefits from Delacroix's firsthand study of the sea in the immediacy of the touch and the luminous sensation the work produces. In a series of pastel and watercolor studies, culminating in *The Sea at Dieppe* of 1853 (fig. 12), an oil study rendered on panel, Delacroix took on the challenge of representing the immensity and emptiness of the sea with a freshness and immediacy that suggest *plein-air* painting. In this non-narrative work he employed a high horizon line and rhythmic brushstrokes to communicate the movement of the waves, technical innovations that lead the viewer to contemplate the sea as a subject in itself, free from human dramas or naval battles that take place on its surface.

Fig. 12. Eugène Delacroix, *The Sea at Dieppe*, 1853. Oil on panel, 13¼ × 20¹/₁₆ inches (35 × 51 cm). Musée du Louvre, Paris. RF 1979-46

PLATE 8
Paul Huet
Breakers at Granville Point
1853
Oil on canvas
26¾ × 40½ inches (68 × 103 cm)
Musée du Louvre, Paris. RF 1064
AIC, PMA

Delacroix's friend and fellow Romantic painter Paul Huet (1803–1869) also produced numerous marines. Like Delacroix, Huet had been exhibiting in the official Salon since the 1820s but made his living by selling small-scale works to private collectors. Whereas Delacroix was influenced primarily by the human excesses expressed in Géricault's work, Huet was a quieter, more intimate painter whose landscapes derived from Dutch models by way of Georges Michel (1763–1843), an early painter of the landscapes of France. Both Huet and Delacroix were also acquainted with Richard Parkes Bonington (1801–1828), a British watercolorist who introduced them to the seascapes of Constable and Turner. Huet practiced both landscape and marine painting throughout his career, but his most famous marines were produced during the Second Empire. *Breakers at Granville Point* (plate 8), exhibited at the Salon of 1853, is a somber and moody representation of France's seacoast. Gray tones predominate in this somewhat gloomy composition, providing a viewer with the chilly sensation of being on the coast on a stormy winter evening. Though the picture is localized both by its title and by its depiction of the half-light of the Normandy coast in winter, the sea is here presented as a universal force of nature whose power cannot be contained even by the distant cliffs. In Huet's composition, the immediacy of the particular visual experience is more important than the clear delineation of landscape forms.

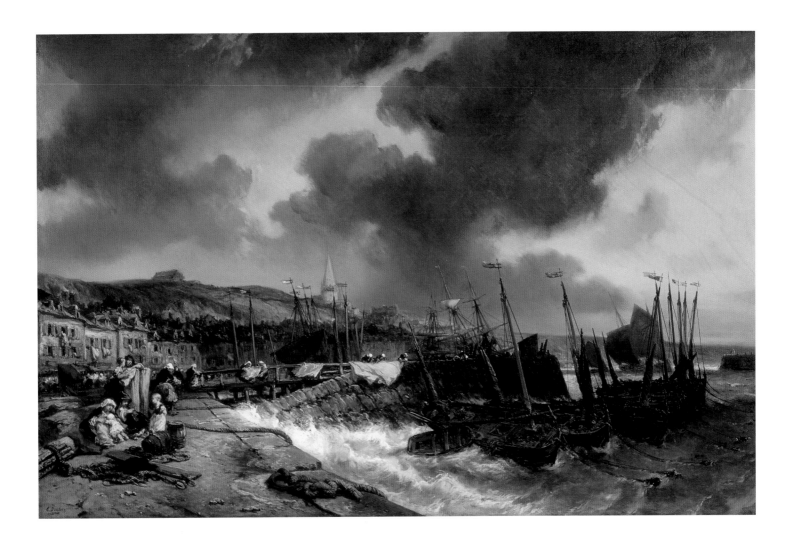

Along with the official and Romantic traditions of marine painting existed a third, the picturesque, which drew its inspiration directly from Bonington as well as other illustrators and lithographers. The most adept proponent of this tradition in France was Louis-Gabriel-Eugène Isabey (1803–1886). Early in his life, as an officer in the French navy, he made sketches that were used by the official Navy painters, including Gudin and Gilbert.[6] By 1855 the critic Théophile Gautier called Isabey "incontestably our best marine painter,"[7] and the influence this artist exercised on the future of sea painting was considerable, as he was the teacher of Eugène Boudin (1824–1898), among others. Isabey's pictorial production was so copious and diverse—including landscapes and historical scenes— that categories such as "marines" or "picturesque seascapes" do not suffice to sum up his oeuvre. His paintings were famous enough to be illustrated in art journals and elsewhere, and he sometimes produced works specifically for illustration.[8] Isabey's *Fishing Village* of 1854–56 (plate 9) is an excellent example of his mastery of the picturesque tradition. This is not a scene from the high seas but a coastal view, the artist's specialty. The almost monotone image is true to the generalized locale (unlike in Huet's work, we do not know what village is pictured), which includes rows of houses climbing a rise in the distance. Isabey is interested in the particularities of the atmosphere here; however, as in Vernet's *Ports of France* paintings, the artist is preoccupied by the everyday activities transpiring on the shore. Like the Romantic artists, Isabey worked predominantly for private collectors. Such a large work was the proper format for the official Salon, but this picture was never shown there. In fact, Isabey rarely participated in Salons during the Second Empire. While this disappearance from the Salon could be attributed to a variety of factors, it takes on a certain

significance as we turn to the more experimental artists who embraced marine painting in the 1860s.

The Sea and Its Representations in Second Empire France

Marine painting is dying, marine painting is dead. Without a doubt, I am not the first to sound this cry of distress. But the sickness increases daily; and, if one does not protect against it, this genre, that was represented by the Ruysdaels and the Backhuysens, that alone made the glory of Joseph Vernet and a large measure of [Claude] Lorrain's, will be completely abandoned. Already the public's indifference surrounds it. Artists with a certain notoriety who are protected from this indifference, Isabey, Gudin, Lepoittevin, cultivate the genre with some success; but the young artists, who have a name to make, do not dare adventure into it. . . . Young artists retire from the genre one by one, like sailors on an imperiled ship; and one sees them pass on to landscape, or portraiture, or interior scenes.[9]

As Jules Castagnary suggests in his review of the Salon of 1861, sea painting seemed to be in decline by the early 1860s, just as the young Edouard Manet was about to begin his investigation of the genre. However, given that critics in Second Empire France had a propensity for bemoaning artistic decline, it would be wise to be skeptical about Castagnary's remarks and further investigate the transformation of marine painting in this period.

To do so, we must take into account some broad historical shifts. During the Second Empire the city of Paris was almost entirely rebuilt under the direction of the enterprising Baron von Haussmann. Paris was also increasingly connected to surrounding regions, both physically and culturally, primarily through the development of the railroad. Emperor Napoléon III, who strove to provide a good climate for business, helped to advance the railroad, and by the 1850s a Parisian could reach the Mediterranean (Marseilles) or the Channel coast (Le Havre, Fécamp) by rail in a matter of hours.

While access to the sea was thus assured even to the middle classes, it is not clear that the general public initially was interested in making the journey. In his book *The Lure of the Sea*, Alain Corbin notes that at least since the late eighteenth century people of means had been taking seaside holidays, and in the early nineteenth century the salubrious effects of sea air were suggested as a salve for those living in increasingly soot-choked cities. Although the British side of the Channel coast was developed first, a resort existed at Dieppe as early as the 1820s. However, the vogue for sea bathing did not really reach the general population in France until it was promoted by Napoléon III and Empress Eugénie, who were passionate about the seaside.[10]

Robert L. Herbert, in his work on the marine paintings of Claude Monet, provides another explanation for this trend. Tracing the development of one of Monet's favorite seaside haunts, Etretat, Herbert concludes that it was artists who first made such places into tourist destinations. The phenomenon of the artist colony on the Normandy coast goes back as far as the 1820s, when Bonington, Isabey, and others traversed the seacoast in order to produce views for illustrated books and travel guides. Herbert points to a hotel in Etretat, known originally as Rendez-Vous des Artistes, as one example of such artist colonies; another is the famous Auberge Saint-Siméon in Honfleur. At the latter, Barbizon artists such as Camille Corot (1796–1875), Constant Troyon (1810–1865), and Charles Daubigny (1817–1878) mixed with a new generation of marine painters, including Johan Barthold Jongkind (1819–1891) and Boudin (see, respectively, Zarobell, pp. 125–29 and 131–37 below). Artistic residency on the coast led to picture-making in the form of both

Salon paintings and popular illustrations. Such images encouraged adventurous travelers to seek out these remote locales, which led in turn to the production of guidebooks, the building of resorts, and, eventually, the transformation of these sleepy seaside towns into flourishing vacation destinations for urban dwellers.[11]

As the sea became more accessible to the larger French public, its cultural meaning also began to shift. While such a broad cultural transformation is difficult to pinpoint, a new sensibility toward the sea was clearly emerging around mid-century, perhaps best exemplified by Jules Michelet's 1861 book titled simply *La Mer* [The Sea]. Michelet, who had begun his career in 1830 by publishing what soon came to be regarded as the quintessential history of the French Revolution, by 1861 was a predominant cultural figure in France. His tribute to the sea, which became an instant classic and was reprinted numerous times, emphasizes the subjective response to an all-encompassing natural world that can serve as a source of personal rejuvenation.[12] For Michelet, the sea was in dialogue, not just with humans, but with the cosmos:

> Great, very great is the difference between the two elements: the earth is mute and the
> sea speaks. The ocean is a voice. It speaks to distant stars, responds to their movement
> in its grave and solemn language. It speaks to the earth, to the coast, with a sympathetic
> accent, a dialogue with echoes; plaintive on one hand, menacing on the other, it grinds
> or sighs. Above all, the sea speaks to humans.[13]

The symbolic dynamic of the sea would perhaps not be fully explored until the poetry of Stéphane Mallarmé (1842–1898), but already in 1855 Charles Baudelaire (1821–1867) had published a poem in *Revue de Paris* titled "L'Homme et la mer" [Man and the Sea]. While the poem is hardly an inducement to visit the seaside, depicting as it does the tragic struggle of humans with the overpowering sea, it does suggest a strong comparison between the power of the sea and the passion of humans and ends by referring to man and the sea as "frères implacables" [implacable brothers].[14] Baudelaire's poem points to one reason that painters and others pursued the sea in this period: it offered a reflection of their own lives and demanded an internal response. The sea became a subject of paintings and a destination for tourists because viewers began to apprehend something in the water they had not seen there before. Further, this new understanding of the sea was something that they wanted to consider and reflect upon. It would open up new realms in the exploration of human existence, yet each individual could understand it personally.

If this social and cultural exploration of the sea was fully under way by 1861, why did Castagnary write of the potential demise of marine painting? There are a number of reasons for Castagnary's comments. Official painting of naval battles had indeed fallen off by this point, and though a few famous practitioners continued to depict engagements at sea, the Versailles commissions had ceased and government support overall had declined considerably. Further, through endless repetition the naval battle motif had become generalized and less than original. The example of LeGuen has already been mentioned; another important figure was Gudin, one of the founding members of the navy's elite group of official painters. By the time Castagnary wrote his review, Gudin was listed as one of the elders of marine painting and, along with Isabey, was certainly considered one of the leading lights of the seascape genre. Gudin's most famous painting, *The Burning of the "Kent"* of 1838 (fig. 13) was an epic work of breathtaking scale. This hugely ambitious picture employed Turner's aesthetic developments in the realm of seascape in order to render a dramatic contemporary tragedy. Though it was an official commission, Gudin clearly aimed to compete with the overpowering sensations created by Géricault's *Raft of the "Medusa"*

Fig. 13. Théodore Gudin, *The Burning of the "Kent,"* 1838. Oil on canvas, 102 × 164 inches (259 × 417 cm). Musée de la Marine, Paris

(fig. 11). Whether a viewer feels that Gudin achieved his goal, this marine possesses a vivid intensity not present in paintings of naval engagements and beach scenes the artist produced in the Second Empire, which were more modest in scale and ambition. While he painted a wide variety of sea motifs in his later years, none approached the impact of his earlier compositions.

Quite apart from any decline of the genre, official marine painting had never held great promise in the eyes of some critics, who found it an inherently false and theatrical staging of supposedly historical naval battles that were, in fact, quite distant from the lives of the cultured urbanites who saw such works at the Salon. For example, despite the sonorous praise heaped on an artist like Gudin by many critics, others saw his works as easy entertainment for an uncritical public. Gudin's use of atmospheric effects, as seen by a critic such as Louis Peisse, was not meant to achieve a sense of verisimilitude but rather to please the viewer through artificial means.[15] In this sense, Gudin's productions could not have been more distinct from the movement among independent artists experimenting with marine painting as a means to explore the intimate and personal response to nature and to place.

There was, in fact, something like an explosion of marine painting in the 1860s among artists not connected with the Academy or bound by official commissions. However, this new movement fulminating on the Normandy coast would likely not have come to the attention of a Salon reviewer, since its products were not, for the most part, Salon paintings, but rather pastels, watercolors, and small paintings (*études*). As the behemoths of official marine painting declined in artistic importance, the field was left open to experimental artists who did not much care about their relationship to the artistic establishment in Paris and who sought, in the sea, a means of furthering their inquiries into the relationship between the self and the natural world. Following the example of established painters such as Delacroix, Huet, and Isabey, all of whom continued to make seascapes during the Second Empire, a number of independent artists began to turn to marine painting, devel-

Fig. 14. Jean-François Millet, *The Cliffs at Gréville*, 1867. Pastel on paper, 17⅛ × 21¼ inches (43.5 × 54 cm). Ohara Museum, Kurashiki, Japan

oping their new techniques in the laboratory of the seacoast. Among them were artists who would eventually achieve fame—and change the course of art history—including Manet, Daubigny, Millet, Jongkind, Boudin, Monet, Gustave Courbet, Berthe Morisot, and Frédéric Bazille. Many of these artists are examined at length elsewhere in this book, so here I will contend with just a few noteworthy examples.

Millet's *The Cliffs at Gréville* of 1867 (fig. 14) is a relatively large pastel rendered with a high degree of finish. For Millet, this is a unique composition that registers a transformation in his thinking on the relationship between worker and natural site. The picture offers a scenic view of the sea from the cliffs above. Millet is widely known for his representations of peasant life, and this work is no exception, but the peasant's position in the natural world is different than we might expect. The peasant here is lying atop the cliff and is placed in the composition in such a way as to dominate the scene. The colors of his clothing do not really distinguish him from his verdant surroundings, and his reclining form is mirrored by a cloud at right. The plow at lower right identifies this man as a farmer, who is here shown at rest, propped on one elbow, taking in the scene around him. This solitary figure is a departure from Millet's traditional compositions of peasants at rest, usually in a pair or group and placed beside either the site or products of their agricultural labor. The mood is one of quiet contemplation, and the picture, taken as a whole, seems to operate as a meditation on the relationship of the man to the cosmos, here represented by land, sea, and air. This composition clearly signals new developments in the meaning of both the peasant and the sea, which appears here not so much as a force to be reckoned with but as a calm background for personal contemplation.

More experimental in technique is Daubigny's *The Sea* of about 1858–65 (fig. 15), a fully developed canvas that takes on the enormity of the sea through a two-tiered composition featuring only sea and sky, with a tiny boat on the horizon. This work forecasts Courbet's wave pictures (plates 76–78) in that it contends directly with the sea without any intermediary figures or picturesque motifs. Here a viewer can see Daubigny applying formal experiments developed at Barbizon to the subject of the sea, so charged with symbolic meaning at this time. French Barbizon artists first made a consistent practice of producing

Fig. 15. Charles-François Daubigny,
The Sea, c. 1858–65. Oil on canvas,
18½ × 31½ inches (47 × 82 cm).
Private collection

finished paintings *en plein air.* This led to various technical innovations, including the use of impasto (thick unmixed paint) directly on canvas and the suppression of linear elements in a composition. Above all, color and tone were used to express a sentiment of the place. In *The Sea,* Daubigny employs a very limited range of tones, but the sense of weather and atmosphere is palpable. He likely produced the painting in a single session, working *en plein air.* The thickly applied pigment bespeaks the immediacy of the painter's apprehension of the scene, and the freshness of the brushstrokes gives the impression of an artist attempting the impossible feat of creating a static image of a body of water constantly in flux. The sense of the artist's internal response is suggested by these technical effects and also by the composition, which places the viewer in the artist's position, looking directly out to sea. The solitary boat on the horizon provides some sense of scale and also a focal point for the viewer. Daubigny's development of a new technical means to represent the sea is in evidence in this work. He is clearly struggling to depict a surging sea, and he employs visible brushwork and scrapes down the thick dry paint with a palette knife. The sky, in contrast, is painted in a much more lucid and casual manner. Equally important, this work represents the development of a new form of marine painting that positions the viewer for a one-on-one confrontation with the sea as a force of nature.

Bathing at Etretat of 1865–66 (fig. 16) by Eugène Lepoittevin (1806–1870), an established master of the seascape genre, is experimental in its bold use of large areas of undifferentiated color. More important in this context, it represents a new genre of painting altogether, the depiction of tourists—some of them identifiable cultural figures—at the seaside resorts that were springing up along the Normandy coast. This work is a picture not just about the sea but also about the social activity of going there and being seen to participate in the new culture of bathing. Lepoittevin had a long history at Etretat. He first bought his own house there in 1851 and thus would have seen the development of the casino and the concomitant growth of this tourist site during the decades of the Second Empire. In this image, the natural and scenic character of the place is subsumed into its role as a site for

leisure. Bathers, among them the author Guy de Maupassant, the caricaturist Bertall, and the actress Eugénie Doche, mount the platform and prepare to dive into the deep water, while other bathers float and swim around them. In this artificial snapshot of leisure activities, the sea is a real social space, where the leisured classes spend vacations, seeing and being seen.[16]

Because they are not ambitious in scale and did not appear to be decisive aesthetic statements, works such as those described in this section were not normally fodder for critics in the Second Empire. An exception was Baudelaire, who concerned himself with more fugitive artistic representations such as Boudin's pastels and Jongkind's etchings. Castagnary's partisan comments about the demise of marine painting were part of a public debate about paintings and thus were prone to a degree of critical posturing. In fact, his remarks were put forward in an evaluation of the works of a certain M. Hintz, now forgotten, who exhibited marines regularly in the Salons of the Second Empire. Castagnary did not devote many lines to evaluating Hintz's works, choosing instead to critique marine painting in general by making suggestions about how painters ought to pursue the subject. The critic's primary interest seems to have been to encourage artists to study the sea from nature and to develop a personal sensibility for it, in keeping with his own aesthetic positions. What is most strange is that Castagnary was arguing for the survival of the marine genre, as distinct from others such as landscape or history painting, at the very moment such artificial divisions were beginning to disappear, despite the renewed interest in classification that accompanied the Beaux-Arts administration of the Second Empire.[17] Even critics close to the official establishment acknowledged the waning significance of genre classification in a new era in which artists could not be pigeonholed so easily. In his review of the Salon of 1861, Gautier wrote, "Classification, even by genres, is no longer possible. Most paintings escape these useful, but old, categories: history, genre, landscape; almost none rigorously delimit themselves."[18] Perhaps the best demonstration of this is that the Salon was organized that year in alphabetical order, ostensibly to provide fair placement to all of the artists participating, but also underlining the difficulty the organizers had in keeping traditional divisions intact. By 1864 the Salon itself had reached a crisis and the Academy had lost its traditional monopoly of the practice of judging Salons.[19]

The erosion of clear genres of painting and the democratization of Salon judging are both examples of the changing terms of contemporary art in France in the 1860s. Previous

Fig. 16. Eugène Lepoittevin, *Bathing at Etretat*, 1865–66. Oil on canvas, 8¼ × 19⅛ inches (21 × 48.5 cm). Musée des Beaux-Arts, Troyes. 898.2.3

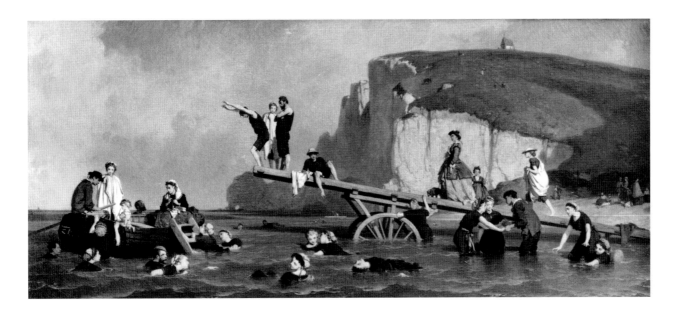

categories, such as "marine painting," were losing significance by this time because ultimately their relevance rested on conventional approaches, not on the burgeoning movement toward experimental painting among younger artists. The very definition of what constituted a marine painting was in the process of being redefined, not by critics and government arts administrators, but by the activity of artists. Marine painting reemerged in this period as a familiar genre, but as one that had been reshaped to allow for artistic experimentation and thus could be powerfully reborn in a world in flux.

The author would like to thank Robert Herbert, Heather MacDonald, and Joseph Rishel for their comments on this essay.

1. Of course, there are exceptions. Scholarly works on French marine painting in the nineteenth century include Robert L. Herbert, *Monet on the Normandy Coast: Tourism and Painting, 1867–1886* (New Haven and London: Yale University Press, 1994); Pierre Miquel, *Eugène Isabey (1803–1886): La Marine au XIXe siècle*, vol. 2 (Maurs-La-Jolie: Editions de la Martinelle, 1980); Alain Tapié et al., *Désir de rivage de Granville à Dieppe*, exh. cat. (Paris: Réunion des musées nationaux, 1994); and *Autour de Claude-Joseph Vernet: La Marine à voile de 1650 à 1890*, exh. cat. (Rouen: Musées de Rouen, 1999).

2. On Vernet, see Phillip Conisbee, *Claude-Joseph Vernet, 1714–1789* (London: Greater London Council, The Iveagh Bequest, 1976); and Marie-Antoinette Tippetts, *Les Marines des peintres: Vues par les littérateurs de Diderot à Goncourt* (Paris: A. G. Nizet, 1966). See also Heather MacDonald, "The Enlightened Landscape: Joseph Vernet's Ports de France" (unpublished manuscript, University of California, Berkeley).

3. Miquel, *Eugène Isabey*, p. 22.

4. The literature on this work is vast, but Lorenz Eitner, *Géricault's "Raft of the Medusa"* (London: Phaidon, 1972), is quintessential. More recently, compelling reexaminations of the painting have been put forward in Serge Guilbault, Maureen Ryan, and Scott Watson, eds., *Théodore Géricault: The Alien Body; Tradition in Chaos*, exh. cat. (Vancouver: Morris and Helen Belkin Art Gallery, University of British Columbia, 1997); and Darcy Grimaldo Grigsby, *Extremes in Paint* (New Haven: Yale University Press, 2002).

5. See *Galeries historiques du palais de Versailles* (Paris: Imp. De Fain et Thunot, 1842).

6. Gabriel Esquer, *Iconographie historique de l'Algérie jusqu'à 1871* (Paris: Plon, 1929), vol. 1, p. x.

7. Théophile Gautier, *Les Beaux-arts en Europe* (Paris: Lévy Frères, 1855), vol. 1, p. 98.

8. See Atherton Curtis, *Catalogue de l'oeuvre lithographié de Eugène Isabey* (Paris: Prouté, 1939).

9. Jules Castagnary, *Salon de 1861*, illus. H. Linton (Paris: Aux Bureaux du Monde Illustré, 1861), p. 61 (my translation).

10. Alain Corbin, *The Lure of the Sea: The Discovery of the Seaside in the Western World, 1750–1840*, trans. Jocelyn Phelps (Berkeley: University of California Press, 1994).

11. Herbert, *Monet on the Normandy Coast*, pp. 61–70. On the development of Honfleur, see Anne-Marie Bergeret-Gourbin, "Honfleur, cité des artistes au 19e siècle," in *Boudin et les peintres à Honfleur*, exh. cat. (Tokyo: Musée des Beaux-Arts, 1996), pp. 22–28.

12. Jules Michelet, *La Mer* (Paris: Hachette, 1861). For more on Michelet, see Groom, p. 45 below.

13. "Grande, très grande différence entre les deux éléments: la terre est muette, et l'Océan parle. L'Océan est une voix. Il parle aux astres lointains, répond à leur mouvement dans sa langue grave et solennelle. Il parle à la terre, au rivage, d'un accent pathétique, dialogue avec leurs échos; plaintif, menaçant tour à tour, il gronde ou soupire. Il s'adresse à l'homme surtout." Jules Michelet, *La Mer* (Lausanne: Editions l'Age d'Homme, 1980), p. 216 (my translation).

14. Charles Baudelaire, "L'Homme et la mer," in *Oeuvres complètes*, ed. Y.-G. Le Dantec, rev. Claude Pichois (Paris: Gallimard, 1961), p. 18.

15. Louis Peisse, "Salon de 1841," *Revue des deux mondes*, 4th ser., 1 (1841), p. 613.

16. Herbert, *Monet on the Normandy Coast*, pp. 66–67; Raymond Lindon, *Etretat, son histoire, ses legendes* (Paris: Editions de Minuit, 1949).

17. This manifested itself in naming artists specialists in specific genres in the Salon *livrets* and giving prizes for more specific categories than had previously been awarded, such as marine painting.

18. "La classification, même par les genres, n'est plus possible. La plupart des tableaux échappent à ces anciennes catégories si commodes: histoire, genre, paysage; presque aucun ne s'y encadre rigoureusement." Théophile Gautier, *Abécédaire au Salon de 1861* (Paris: E. Dentu, 1861), p. 9.

19. See Albert Boime, *The Academy and French Painting in the Nineteenth Century* (London: Phaidon, 1971); and Patricia Mainardi, *The End of the Salon: Art and the State in the Early Third Republic* (Cambridge: Cambridge University Press, 1993).

MA DESTINÉE

The Sea as Metaphor in Nineteenth-Century France

GLORIA GROOM

> To the child in love with maps and prints . . .
>
> —CHARLES BAUDELAIRE, "The Voyage"

Edouard Manet's 1864 debut as a sea painter may have been triggered by the battle of the *Kearsarge* and the *Alabama*—a newsworthy event that played into the artist's program of depicting modern history subjects—but it also came at a time when the sea was taking on an increasingly important role among his contemporaries in both art and literature.

For progressive artists and writers working in France in the second half of the nineteenth century, the sea offered a fertile laboratory for experimentation. With its powerful, inescapably primal associations with creation and destruction, with man's destiny and voyage into the unknown, and above all with unpredictable natural forces, the sea both challenged and nourished the quest for a new expressive language that was so central to Manet's literary and artistic circle. Thus, the artist's forays into marine painting over the course of two decades place him in a rich network of writers (including Charles Baudelaire, Victor Hugo, and Jules Michelet) and artists (including Gustave Courbet, James McNeill Whistler, and Odilon Redon), all of whom, in one way or another, embraced the sea as metaphor and motif.

This renewed aesthetic interest in the sea occurred against the backdrop of political agendas (colonization), technological advances (railways and steam-powered vessels), military initiatives (Louis Philippe's expanded naval fleets), and social shifts (the proliferation of sea resorts) that had brought the sea into the public imagination in mid-nineteenth-century France. But the turn to the sea also had strong roots in the literary and artistic movements of the first half of the century, and particularly among the Romantics, for whom the sea became a symbol of personal freedom.

The Emergence of Sea Themes in French Literature and Art, 1800–1855

The sea is one of humankind's most essential symbols. From antiquity onward, it has suggested mysterious powers, limitless depths, and a path to unknown adventures. It is an awesome natural force—a feminine entity from which all life evolved. Prior to the nineteenth century, its literary expression usually took the form of poetry rather than prose, possibly because its elusive, changeable nature was thought to require figurative rather than descriptive language. The epic tempests of Homer's *Odyssey* and the biblical deluge seemed too sacred, too charmed, and too far outside ordinary experience to be taken on by mere prose. Instead, they were evoked in the poetic stanzas of Horace, Camoëns, and Shakespeare and in paintings by Nicolas Poussin (fig. 17) and Claude Lorrain.[1]

In European art, the sea remained a relatively unexplored motif before the seventeenth and eighteenth centuries, appearing merely as a backdrop for battle pictures and sea voyages. For the Dutch merchant class, seascapes were a source of national pride reflecting

Opposite page: Victor Hugo, *Ma Destinée* (fig. 22, detail)

prosperity from trade (see DeWitt, pp. 1–15 above). In England, Admiral Lord Nelson's naval victories during the Napoleonic Wars (1793–1815) inspired a generation of sea painters and writers. In Catholic and aristocratic France, however, which did not foster extensive sea trade (due largely to the lack of a strong naval presence), the sea remained underdeveloped as a theme in both literature and art.[2]

This is not to say that there was no tradition of sea painting in France, as the depictions of ports and harbors by Claude Lorrain (1600–1682), Claude-Joseph Vernet (1714–1789), and others attest (see Zarobell, pp. 17–33 above).[3] By the 1820s, marine painting, a branch of landscape painting, was an accepted Beaux-Arts category. Its characteristics, requirements, and goals had been carefully laid out in Pierre-Henri Valenciennes's *Elémens de perspective pratique à l'usage des artistes* [Elements of Practical Perspective for the Use of Artists], published in 1800. Valenciennes exhorted young artists to consider the sea not only as a fertile realm for topical scenes of marine battles, shipwrecks, and crowded ports but also as a means to update and enrich the "immortal poems" of Homer, Virgil, Tasso, and Aristotle.[4]

In 1832, novelist and journalist Léon Gozlan similarly encouraged his fellow writers to turn to the sea for inspiration. He lamented that while young French authors incorporated art and science into their works, the sea remained without champion or chronicler—having "neither its Herodotus, nor its Homer, nor its Sophocles, nor its Cooper."[5] Gozlan's examples, which echo Valenciennes's categories of marine painting, point to two opposing approaches to sea imagery in France in the late eighteenth and early nineteenth centuries: a classical approach, in which sea voyages and storms were described in the style of the poets of antiquity; and a Romantic approach, which valued firsthand descriptions of human experiences at sea.

Among the important exemplars of the latter group was the American novelist James Fenimore Cooper, whose *Red Rover*, written in France and first published there (as *Le Corsaire rouge*) in November 1827, set a new standard for nautical imagery and language.[6] This tale

has as its title character a gentlemanly pirate and is set entirely on his ship, the *Royal Caroline*. Its primary theme is the noble and terrible fight for survival in the limitless isolation of the ocean. The young critic (and future Proustian hero) Charles-Augustin Sainte-Beuve praised this immensely popular novel as the first prose adaptation of Romantic poetry, a masterful dramatization of man's battle against vast and unknowable natural forces. "No one has understood the Ocean better than [Cooper], its murmurs, its hues, its calm and its tempests," wrote Sainte-Beuve. "No one has felt so keenly and so truly the ship and its tender relationship with the crew. He is relentless in giving us the subtlest as well as more profound impressions."[7]

The French admired Cooper's sea novel not for its descriptive precision, but for its vivid evocation of the struggle for survival at sea. Like Lord Byron (1788–1824) and René Chateaubriand (1768–1848), to whose poetry Cooper's prose was often compared, Cooper deals with the range of emotions—fear, awe, reverie—in relation to the sea. The plight of the sailors on the *Royal Caroline*, thrust into the limitless expanse of a potentially murderous ocean, appealed to the burgeoning Romantic spirit embodied in paintings such as Théodore Géricault's *Raft of the "Medusa"* of 1819 (fig. 11)—a harrowing image of doomed sailors clinging to a fragile craft adrift in a raging sea—and Eugène Delacroix's *Dante and Virgil in Hell* of 1822 (fig. 18). The latter work, probably inspired by Géricault's masterpiece, was admired and copied by many artists (including Manet) throughout the nineteenth century.[8]

Alongside these Romantic exemplars were French artists and writers who took Cooper's *Red Rover* and other sea stories (*The Pilot*, 1824; *The Water-Witch*, 1830) in a different direction,

Fig. 18. Eugène Delacroix, *Dante and Virgil in Hell*, 1822. Oil on canvas, 74⁵⁄₁₆ × 96⁷⁄₈ inches (189 × 246 cm). Musée du Louvre, Paris. RF 3820

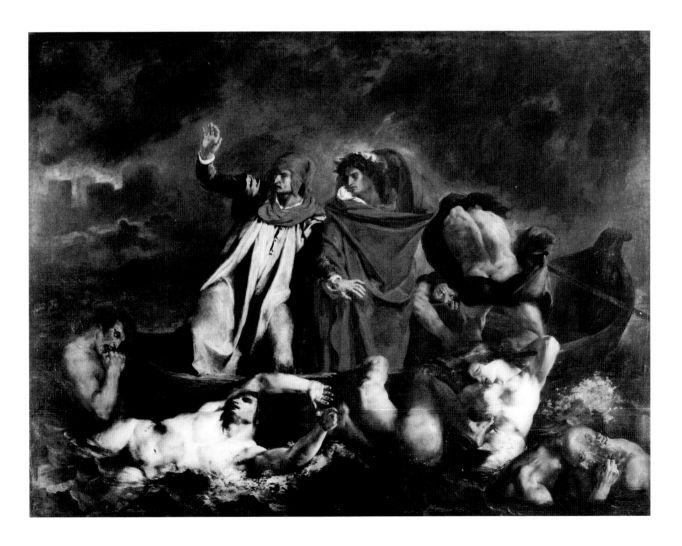

creating a kind of descriptive Romanticism (or Romantic Realism) that used a specialized language drawn from direct experience. Written by former marine officers, including Edouard Corbière (1792–1875), Augustin Jal (1795–1873), and Jules Lecomte (1814–1864), these articles and serialized novels appeared in the *Revue maritime, Le Navigateur,* and other newly founded nautical magazines. Popular but short-lived, their impact on the larger literary world was negligible.[9] In painting, their analogues were the highly accurate representations of contemporary battles and port scenes by marine painters such as Pierre-Julien Gilbert (1783–1860), Louis Garneray (1783–1857), and Théodore Gudin (1802–1880), celebrated in their own time but now largely forgotten.[10] Only the ship's-doctor-turned-author Eugène Sue (1801–1857)—whose story of two pirates, *Plik et Plok* (1831), was directly inspired by Cooper's *Red Rover*—managed to fuse fact with inventive fiction. None of these authors, however, came close to Cooper's indisputable legacy as Romantic chronicler of life at sea. That challenge would be taken up in subsequent decades by the internationally acclaimed heirs of Romanticism: Victor Hugo (1802–1885), Herman Melville (1819–1891), Pierre Loti (1850–1923), and Joseph Conrad (1857–1924).

Of Cooper's sea novels, Conrad observed: "The sea inter-penetrates with life; it is in a subtle way a factor in the problem of existence, and, for all its greatness, it is always in touch with the men, who, bound on errands of war or gain, traverse its immense solitudes."[11] Conrad's pairing of the sea with life's essence directly recalls the high Romantic imagery of Chateaubriand, Alphonse de Lamartine (1790–1869), and the young Hugo, all of whom perceived the sea not so much as a wonderment (as scripted in the tourist guidebooks that proliferated at the time) but as a reflection of their own changing and surging moods—as a natural manifestation of their inner journey.[12] Chateaubriand, for example, said of the violent waters that nearly capsized his ship en route to America in 1791, "The sea bubbled up the breakers like cadavers in the canal."[13] Delacroix had this language in mind when he painted his own treacherous crossing in *Dante and Virgil,* which Manet so admired.[14] However, like Géricault before him, Delacroix painted a storm-tossed craft and sea that are more theatrical than real.

By the middle of the nineteenth century, the Romantic voyage took on different trappings in art and literature. While the sea's power remained paramount, it acquired varied and complex meanings depending on the artist's position with regard to natural forces. For some it took on mystical powers and became a symbol of a transcendent universe. For others it was a backdrop for stories of human endeavor, whether for or against the elements; for still others it presented an aesthetic challenge insofar as it was an awesome and ever-changing phenomenon requiring a special language.

One of the great Romantic modernists, Honoré de Balzac (1793–1850), made the sea the focus of a story, "Un Drame au bord de la mer" [An Incident by the Sea, 1837], and a novel, *L'Enfant maudit* [literally, The Accursed Child; translated as *A Father's Curse,* 1831–37]. In "Un Drame au bord de la mer," Balzac contrasts a young couple's existential encounter with the sea with the experiences of an old fisherman for whom the sea has been both a source of livelihood and a site of violence and untimely death. For Balzac's young lovers, the sea offers two very different metaphors: for the man, it is a voice too powerful to be endured for long, since it "will annihilate you"; for the woman, Pauline, it represents the harmony she seeks in life. In the sea, she observes, "I perceive the causes of the harmonies which surround us. This landscape, which has but three marked colors, —the brilliant yellow of the sands, the blue of the skies, the even green of the sea—, is grand without being savage; it is immense, yet not a desert; it is monotonous, but it does not weary; it has only three elements, and yet it is varied."[15] Their philosophical musings are disrupted by an encounter with the decrepit old fisherman, who relates the disturbing tale of how, having discovered that his son not only stole from the family but also lied about it later,

he bound and gagged him and dropped him in the ocean. Here the reality of the sea, with its potential for danger, insanity, and death, is contrasted with Pauline's view of a better world. Her description of the seascape, simplified into "three marked colors," presages the "language" of Impressionism.

In *L'Enfant maudit*, Balzac paints an even more ambivalent picture of the sea. The title character, the accursed Etienne, is born in the midst of a tempest, with the result that his soul is in complete correspondence with the dynamic life of the sea. Etienne thus has a kind of uncanny affinity for natural elements and feels more comfortable communicating with the sea than with his fellow humans: "Having failed to find someone in whom he could confide his thoughts and whose life could become his, he ended by befriending the Ocean. The sea became for him a living and thinking being."[16] Here Balzac has moved beyond the competing quasi-Impressionist and Romantic views in "Un Drame au bord de la mer," to a Romantic-visionary perspective in which the sea is an alternative universe whose murky depths match Etienne's own fathomless lot in life—a metaphor resuscitated by Baudelaire in his poem "L'Homme et la mer" [Man and the Sea], discussed below. Balzac's depiction of the relationship between man's destiny and the sea is here even direr than that of the Romantics. Whereas for Chateaubriand, the sea, while a constant companion to his soul, took him into the great unknown and changed him forever,[17] for Balzac's Etienne life is so interpenetrated with the sea that it becomes, in Conrad's phrase, a major "factor in the problem of existence."

Balzac, like Baudelaire after him, fluctuated between a mystical language drawing from the Romantics (in the story of Etienne, for example) and a rich Realist vocabulary. As Emile Zola (1840–1902) pointed out, Balzac's series of stories and novels published collectively under the Dantesque title *La Comédie humaine* [The Human Comedy], which presented a varied tableau of Parisian society, was the bible of modern art.[18] Likewise, Baudelaire's prose poems would inspire a generation of Symbolist painters as well as "Realists" such as Courbet and Manet.

For Gustave Courbet (1819–1877), the sea represented an artistic (rather than physical or psychic) voyage with the painter as captain. An avowed Realist, Courbet can be seen as a paradigmatic figure for mid-century sea painting and literature. For no matter how strenuously the post-Romantic artists and writers declared their fidelity to truthful representation, the sea by its very nature conjured up Romantic notions of depths, mysteries, danger, and the elemental force of nature.

Having spent his childhood inland in the mountainous Jura, Courbet took on the sea at about the same time he was taking on the Parisian art market to mixed critical response. In one of his first attempts at marine painting, *Seacoast at Palavas* of 1854 (plate 72)—more popularly known as *Artist Greeting the Sea*—Courbet confronted this new challenge with a kind of blustery bravura: "Oh Sea, your voice is tremendous, but it will never succeed in drowning out the voice of fame as it shouts my name to the world."[19] Lurking beneath Courbet's machismo, however, one senses a man awestruck by the oceanic depths.

In pitting himself against the sea, Courbet charted new territory within Realism, in which subjective scrutiny or self-introspection overlays objective observation. Consider, for example, his *Seascape* of 1865 (plate 74), in which the sea's calm surface is set against an agitated sky, creating an effect of ambivalence.[20] The inescapable metaphoric—and, indeed, Romantic—values that animate Courbet's entire oeuvre here lurk beneath the surface, albeit veiled in the objectified, detached language of Realism.

Although Courbet came to acknowledge the sea's power, he nonetheless continued to assert his mastery over the sea as subject, both in paint and in words. In 1864, for example, he wrote to Victor Hugo:

Yes, I'll come see you. I owe it to my conscience to make that pilgrimage. . . . In your sympathetic retreat I will contemplate the spectacle of your sea. . . .The unfillable void has a calming effect. . . . The sea! The sea with its charms saddens me. In its joyful moods, it makes me think of a laughing tiger; in its sad moods it recalls a crocodile's tears and, in its roaring fury, the caged monster that can not swallow me up.[21]

While clearly taking sea painting out of the sentimental narrative realm of genre painters such as Louis-Gabriel-Eugène Isabey and Eugène Lepoittevin (see Zarobell, pp. 17–33 above), Courbet deliberately remained in confrontation with this most powerful force. It would take the next generation of sea painters and poets to expand upon the new pictorial possibilities of the sea by embracing different aspects of its primal symbolism.

The Sea as Metaphor in French Art and Literature, 1855-80

Manet's leap into sea painting in the summer of 1864 coincided with the historic U.S. Civil War naval battle he had just missed by a few weeks, and whose visual reminder, the U.S.S. *Kearsarge*, was still harbored at Boulogne. To this theme, previously unexplored in his work, Manet brought a great deal of knowledge—not only from his early seafaring experiences, but also from his multiple connections with the literary and artistic avant-garde.

Manet was very much steeped in the literature of his time. His pioneering departure from established modes of history painting, for example, was to a large extent due to his friendship with Charles Baudelaire (1821–1867). However, by the time he first painted the sea in 1864, Manet had moved away from the Baudelairian types depicted in works such as *The Absinthe Drinker* (c. 1858–59, Ny Carlsberg Glyptothek, Copenhagen), *The Street Singer* (c. 1862, Museum of Fine Arts, Boston), and *Olympia* (c. 1860–65, Musée d'Orsay, Paris), which had garnered him the criticism of merely illustrating literature.[22] In 1865 he returned to an old master theme with his monumental *Mocking of Christ* (The Art Institute of Chicago), exhibited in the spring at the Salon.

The 1864 sea pictures thus represent an important detour in Manet's artistic evolution, all the more interesting because this was the first of several painting campaigns on the French coasts in which the artist took up both a new subject and a new technique. This detour came at a time when the sea was *dans la vague* ("in the wave," i.e., up to date) among the avant-garde in France, a trend that can be attributed in part to steamships, which made sea travel easier, and railroads, which made a coastal destination such as Dieppe a relatively easy journey from Paris. These technological advances led to the development of a seaside society with rituals that mirrored those of the capital, but now set against the freer, more democratic atmosphere of the coast. The sea, once feared as a destructive force against which man had no defense, was now tamed at its borders by architecture (bathing huts, clubhouses, jetties, piers) and shoreline businesses, including casinos. On the sea itself, lighthouses and steamships meant that one could control one's destination, if not one's destiny.[23]

The vogue for sea bathing found its way into novels such as Edmond and Jules de Goncourt's *Manette Salomon* (1867), part of which is set on the beach at Trouville. Another novel by these ultra-effete brothers, *Renée Mauperin* (1864), opens with the heroine swimming vigorously in the Seine with her boyfriend. As with Balzac's Etienne, Renée's personality is revealed through her relationship to water. But unlike Etienne, who is fatalistically wedded to this natural force, Renée represents the modern female—adventurous, athletic, and, like the sea, untethered by society's mores.[24]

For Baudelaire and others, the sea also functioned as a poetic trope suggesting a personal journey and escape from everyday life. Although Baudelaire cut short his own 1841

sea voyage to India due to discomfort and ennui, he relied extensively on imagery of voyages to exotic lands in *Fleurs du mal* [Flowers of Evil], first published in 1857. In the expanded edition published four years later, the sea is mentioned no less than thirty-nine times—from the most conventional imagery of oceans and voyaging to the most original and provocative metaphors.[25]

Baudelaire's marine allusions have little to do with actual shipboard life. Instead, the sea is seen as the artist's vessel or vehicle for self-expression. In "L'Homme et la mer," he likens the sea to his soul in all its complexity and depth; in "Le Voyage," it symbolizes man's insignificance in the universal plan. In the former poem, originally titled "L'Homme libre et la mer" [The Free Man and the Sea],[26] the sea is both positive and negative symbol for unrestrained freedom of the soul, alternately praised as ever changing, unfathomable, and rich or lamented as an empty void, a jealous guarder of secrets, and a voracious predator blindly driven to destroy.[27]

In other poems in the 1861 edition of *Fleurs du mal*—such as "Chevelure" [Tresses] and "Parfum exotique" [Exotic Fragrance], both sensuous odes to his mistress—Baudelaire uses the sea in a chain of associations to evoke images of distant paradises. Instead of serving as a means of escape to real faraway lands, the sea becomes a symbol for the idea of escape from the present. In "Chevelure," for example, the black tresses of the poet's lover become the rolling swell of a sea that carries him away, not from a particular place, but from the inherent and deadening ennui of modern existence.[28]

Baudelaire's sea imagery fluctuates between the Romantic and the modern. At times, like Balzac, he refers to its intimate kinship with human beings. In "Le Balcon" [The Balcony], Baudelaire evokes the sea as the antidote to the abyss or void.[29] If the abyss signifies forgetfulness, then immersion in the sea equals rejuvenation and rediscovered memories. In the final poem of the 1861 edition, "Le Voyage," he returns to the quintessentially Romantic notion of the *noir océan* [black ocean], a symbol of mystery and chaos, alluding to his own hopelessness and sense of impending death.[30]

Baudelaire and Manet are often discussed together as pioneers of modernity. In the final paragraph of his *Salon de 1845* the poet referred to the need for a true painter who would find an epic quality in contemporary life, a goal that Manet achieved in his art of the 1860s.[31] What escapes this generalization, however, are the departures that each took during the period between Manet's painting of *The Street Singer* in 1862 and *Steamboat Leaving Boulogne* (plate 13) in 1864. On the one hand, Baudelaire urged his painter friend to take on modern-life subjects and even wrote a quatrain for Manet's *Lola de Valence* of 1862 (Musée d'Orsay, Paris), an image of a wholly up-to-date Parisian type. On the other hand, the poet categorized his painter friend as a hopeless Romantic: "M. Manet whom one takes for crazy and mad is only a man very loyal, very honest, doing all he can to be even-handed, but unfortunately, since birth prone to Romanticism."[32]

For Baudelaire, to be modern was to be dispassionate, sophisticated, and detached—qualities embodied in the *flâneur*, or man about town, always observing, never participating. Baudelaire's comments on Manet, however, point to the contradiction between the poet's own temperament and his quest for style. This inner turmoil is apparent in *Fleurs du mal*, where the sea is used to evoke both a Romantic escape into the unknown and a detached, existential dilemma with the futility and chaotic nature of life. In that sense, Baudelaire and Manet shared both a Romantic temperament (particularly evident in Manet's anxiety about being ridiculed at the Salon, or in Baudelaire's infinitely varied references to his mistress, Jeanne) and a dispassionate skepticism associated with modernity. Both were bound to Romanticism not as a past but as a future, and both used Realist language or imagery to express Romantic and visionary (some would say Symbolist) ideas. (See, for example, Manet's *Escape of Rochefort* paintings, plates 69 and 71.)

Fig. 19. Théophile Chauvet, *The Phantom Ship*, c. 1870. Lithograph after a pastel by Charles Meryon, 1857, 13⅞ × 26⅜ inches (35.3 × 67 cm). Musée du Louvre, Paris

Baudelaire was a man of his time, loving both the high, ambitious art of Courbet and Wagner and the newly revived art of etching, which he singled out as the medium best suited for intimate and spontaneous expression. One of Baudelaire's favorite etchers was the difficult, disturbed, and highly Romantic Charles Meryon (1821–1868), whose moody etchings and drawings of boats with billowing sails (fig. 19), symbolizing leave-taking, adventure, and personal freedom, would have had special resonance for this splenetic poet. In 1855, Victor Hugo, in exile in Guernsey, created a pen and ink wash drawing of a similarly angled boat at sail on the horizon (fig. 20), one of several drawings by Hugo brought back to Paris by the artist Jules Laurens for the admiration of the Société des aquafortistes.[33]

Hugo, whose writings ranged from political and historical novels (most famously *Les Misérables*) to poetry expressing personal loss (especially after the drowning death of his daughter and son-in-law in 1843), was considered both a lion of Romanticism and a visionary.[34] Writing about Hugo in 1865, Baudelaire likened the author to Demosthenes as a speaker of the truth unparalleled in literature who, like the ancient orator, engaged the waves and wind and whose voice was as deep as the ocean:

> If he painted the sea, no marine painter could surpass it. The boats which glisten on the sea or which cross the frothing swells would have, more so than that by any other painter, this character of passionate combatants, this willfulness and animality, which mysteriously releases itself from a geometrical vessel of wood, iron, ropes and sails; a monstrous animal created by man, to which the wind and waves augment the beauty of its passage.[35]

Baudelaire here may be paying homage both to Hugo's writing and to his graphic work—especially the ink drawings and watercolors made between 1852 and 1864, which Hugo proposed using to illustrate his novel *Les Travailleurs de la mer* [Toilers of the Sea]. The sheer variety of Hugo's marine drawings—ranging from tranquil seascapes dotted with steamboats and sailboats to scenes of oceanic chaos, shipwreck, and devastation such as *Le Bateau vision* [The Ship-Vision] (fig. 21)—attests to his attraction to the sea as a laboratory for new expression. He was less interested in the details of the ocean than in its larger metaphoric resonance as an immense, unearthly power to which man compares

Fig. 20. Victor Hugo, *Ship*, 1855. Pen and ink wash on paper. Musée Duplessis, Carpentras

his own existence. Particularly telling in this regard is a pen and ink drawing of about 1867 (fig. 22), which depicts a fragment of a boat hovering at the crest of a wave, about to be engulfed by an even more gigantic wave.[36] Below, Hugo has written "Ma Destinée" [My Destiny], transforming the image from a particular incident at sea into a symbol for his own creative voyage and struggle.[37]

Hugo's great sea novel *Les Travailleurs de la mer*, first published in serial form in 1864, was an immediate sensation. Unlike *Les Misérables*, the politically motivated historical novel that immediately preceded it, *Les Travailleurs* presented a fresh setting and a new kind of

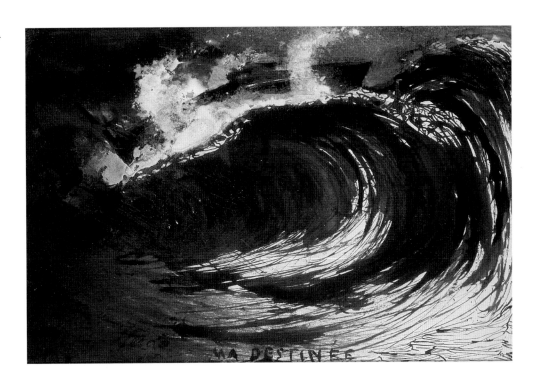

hero. Gilliat is "un homme de mer surprenant" [an amazing man of the sea], incarnating energy, determination, and resourcefulness. Against a background of highly specific descriptions of ship riggings and other nautical equipment, as well as the harsh realities of coastal life, Hugo explores the relationship between Gilliat and the sinister, stormy, and capricious ocean.[38]

Hugo not only humanizes the ocean, but also personifies its very contents. In elaborate word pictures, he describes the alternate universe of rocks and raging sea laden with mysterious and monstrous creatures against which Gilliat must prove himself. Gilliat himself is as deep and inscrutable as the sea that holds him. On the one hand, he is master of his environment, as he single-handedly recovers the engine from a shipwrecked steamer and defeats a terrifying octopus in a fight to the death. On the other hand, he is "a visionary" [un homme voyant] who can interpret dreams and penetrate "all of this mystery which we call a dream but which is nothing but an entry into an invisible world."[39] Gilliat thus functions as an alter ego for the author; his sea adventures lead to self-discovery, and his struggle with natural elements represents the process of self-examination.

Les Travailleurs was published in 1864, the same year Manet first ventured into marine painting. Although we do not know if Hugo's novel had any influence on this decision, mutual friendships and other connections suggest that the two men knew one another's current work. One link between them was Baudelaire, who was close to both men. In October 1865, for example, Manet congratulated the poet on having made himself indispensable to Hugo.[40] Did Manet and Baudelaire discuss Hugo's sea-based novel? Did Baudelaire discuss Manet's marine paintings with Hugo? Hugo clearly kept up with art, and he was delighted when Philippe Burty, editor of the *Gazette des beaux-arts*, sent him four sea engravings by the English artist Edwin Edwards as possible illustrations for *Les Travailleurs*.[41] Burty also collected Manet's prints and was close to the artist. It may have been through Burty that Manet met Edwards, whom he found "excellent" and "charming" when he visited the artist in London in 1868.[42] Moreover, Manet was part of the etching revival in which Hugo took a keen interest, and in 1862 Burty wrote a review of the album of Hugo's drawings published that year with a preface by Théophile Gautier.[43] Six years later, Burty asked both Hugo and Manet to contribute a special print to a deluxe album.[44]

Manet certainly would have known of the 1869 edition of Hugo's novel illustrated by François Chifflart (1825–1901), using Hugo's drawings as his guide. And it is possible that Manet had this edition in mind when he painted his own *Toilers of the Sea* (plate 64).[45] Hugo's sharp focus on Gilliat's relationship to the sea in the novel is analogous to Manet's radical point of view in that painting, as if he were on board the tilting craft. One of the fishermen returns the artist's (and the viewer's) gaze; like Gilliat, he controls the boat and, by extension, the fishermen's destiny. What is extraordinary about Manet's image is not the narrative, but rather the sensory experience resulting from the thick, agitated swaths of paint, with arabesques of white suggesting the sea hitting against the fishing boat. Manet's palpable treatment of the sea foam can be likened to Hugo's rhetorical excess, such as when he boasts of writing drenched in the "sea's saliva."[46]

Hugo's theme of man's quest for the infinite as revealed in the sea would be revisited in Jules Verne's futuristic sea novel *Vingt mille lieues sous les mers* [Twenty Thousand Leagues under the Sea], published serially in 1869 and 1870.[47] Like Hugo, Verne wrote about the sea as another universe—in this case, one inhabited by constantly regenerating creatures from different evolutionary stages, held in suspension by the transparent liquid. Verne's antihero, Captain Nemo—the genius whose experience in a penal colony causes him to reject society and begin anew under the sea—finds at the ocean bottom everything that appeals to his notions of humanity and personal freedom. When asked if he truly loves

the sea, Nemo replies: "Yes! I love it! The sea is everything! It covers seven-tenths of the world. . . . The sea is not just the setting for supernatural and extraordinary living things; she is continual movement and love; it's Infinity incarnate, as one of our poets has said."[48]

Nemo's "poet" could well have been Jules Michelet, the well-known philosopher-historian-poet-scientist whose 1861 book-length prose poem *La Mer* [The Sea] personified and gave anthropological, political, and psychological weight to the sea as metaphor.[49] It is difficult now to imagine the success Michelet had in his day. Hugo and Stéphane Mallarmé read him, and it is likely that Manet had Michelet on his shelf as well.[50] Michelet, who had already won academic fame with his many books on vast categories such as *L'Amour* [Love], *La Femme* [The Woman], and *Les Femmes de la Révolution française* [Women of the French Revolution], wrote *La Mer* during his self-imposed exile to French coastal towns beginning in 1852. His impressions of the sea are thus written from "the boundaries," looking away from Paris, where he had been relieved of his teaching duties at the Collège de France for refusing to endorse Louis Philippe's Second Empire.[51]

It is not surprising that for exiles like Michelet and Hugo—and for Verne, whose protagonist is an exile—the sea represented a brave new world. For Michelet the sea is the mysterious, viscous source of all life, a great "Mother" [*Mère*, homonym of *mer*] whose breasts, overflowing with sea milk, caress and shape the shores,[52] and whose inhabitants simply open their mouths and are fed.[53] Since it feeds all kinds of beings, from the tiniest, least-evolved life forms to whales, the sea can be seen as a metaphor for a freethinking society with unlimited resources. However, as Michelet makes clear (and Captain Nemo discovers), there is a downside to the sea's liberality. While open to all, it is unpredictable. Like the crowds (and here it should be remembered that Michelet wrote on the French Revolution and would say in the last pages of *La Mer* that he loved people but detested the "mob"), it is filled "with invisible currents" that are calm one moment and violent the next.[54]

At the time of Michelet's writing, of course, such crowds were beginning to flock to the sea. Michelet saw the building of sea resorts and bathing communities as a mixed blessing. Although he abhorred the "mobs" who "vulgarize the majesty of the sea" with their fashions and manners,[55] he advocated the necessity of sea resorts to restore a sick and weakened humanity and recommended building schools on the coasts to keep children from "murderous [urban] surroundings."[56]

Michelet, like Baudelaire, Hugo, and Verne, ventured into writing about the sea at a time when it served not only as a metaphor for self-awareness but as a symbol of freedom and a different world. Although unpredictable and always potentially harmful, the sea is (to use Nemo's motto) "mobilis in mobilis" [movement embodied], allowing for and even insisting upon metamorphosis and change. Writing with the hindsight of his own political struggles, Michelet credited the ocean with restorative and unifying powers. In it he saw many distinct communities coexisting in a way he longed to see emulated on land. Michelet likened the ocean's eternal flux to an evolutionary revaluation of life and, by extension, a new worldview. In his scientific symbolism, the sea and its shore were a laboratory for new observations and ideas. This theme would also find expression among the avant-garde painters of his day.

Taking the Plunge: The Sea and Modern Painting

By the 1860s the prevalence of the sea as an arena for literary experimentation pushed artists to take the plunge as well. Having already claimed the landscape as a new field for pictorial experimentation, they found an equally fertile motif in the watery deep. Just as Camille Pissarro (1830–1903), Paul Cézanne (1839–1906), Alfred Sisley (1839–1899), Claude Monet (1840–1926), and others associated with the Impressionist enterprise found

less rigid ways of structuring nature, as well as new ways of dabbing, stroking, and creating aerial perspective with paint, so they found in the constantly changing light and liquid of the seascape an opportunity and a challenge.[57]

For Manet, the idea of jumping into something new and unknowable, into the Hugolian and Baudelairian abyss, aptly described the creative process of the artist. As the Symbolist poet Stéphane Mallarmé (1842–1898), who visited Manet's studio frequently starting in 1873, reported: "Each time he begins a picture, says [Manet], he plunges headlong into it, and feels like a man who knows that his surest plan to learn to swim, is, dangerous as it may seem, to throw himself into the water."[58] Manet also insisted that one must forget what one knows and begin afresh with each canvas, an approach that recalls the Symbolist poet's personal aversion (and attraction) to the white page.[59]

Mallarmé's 1865 poem "Brise marine" [Sea Breeze] speaks to a similar need for new beginnings. Bored by what he knows ("The flesh is sad, alas! And I've read all the books"), he wants to "run away—to run away down there," although he realizes that with this decision there is an accompanying element of danger:

> And perhaps the masts will summon STORMS
> That BLAST the sails and WRECK the oars:
> Lost, without sails, without sails, or beating oars . . .
> But oh, my heart, listen to the song of SAILORS.[60]

For the artist, the danger is the risk of failure. Taking the swimming metaphor one step further, the trick is not to attack the water (the unknown challenge) but to experience it positively, calmly, and without fear—in other words, to let go.[61] While the poet realizes he may find himself adrift "without sails, or beating oars," he can't help himself, he must set off, as he hears the "song of sailors." Mallarmé's sailors' song is none other than the "chant profonde" [call of the deep] that Michelet claims has always attracted men to the sea.[62]

When Manet made his leap into the aqueous void, he was like a man poised on the shore, determined to learn to swim. For his initial subject, he chose a topical event—a Civil War naval battle—but his interest in the event gave way to his discovery of a new painterly approach, in which the very fluidity and changing quality of water, air, and light played a key role (see Leighton, pp. 201–25 below). The artist let go, purifying himself of what he already knew and finding confidence through the act of painting itself.

Manet's approach contrasts sharply with that of his contemporary Courbet, who, as we saw above, pitted himself defiantly against the sea. Having succeeded in establishing a reputation with landscapes of his native Ornans, Courbet began painting seascapes, which he termed "paysages de mer" [landscapes of the sea]. In the many marine pictures he exhibited at Alfred Cadart's gallery in 1866, and those shown at his private exhibition in 1867 (which closed three weeks before Manet's opened), Courbet has scraped, stabbed, scratched, and carved the rolling waves into submission, molding them to fit his vision of *paysage*. Treated as if they were landscape elements, the waves are fixed, frozen in time. The ebb and flow so central to Hugo's and Michelet's descriptions of the water are in Courbet's paintings permanently arrested.

Manet took on the sea within the same cultural context, but with different goals and means. Rather than trying to master the ocean's roiling energy, Manet took up the challenge posed by the young landscape painters of his time, that is, depicting static forms (in this case, boats) amid the ever-changing natural environment. Beginning with his 1864 seascapes, Manet devised for the sea a painter's "vocabulary" completely distinct from the thick concentric circles he used to shape the Christ figure in his Salon entry for that year.

Using wet-on-wet application for both water and sky, Manet instinctively adapted his brush to the liquidity of the subject, thus capturing its transient quality. Also new were an increased lack of finish, a higher horizon line, and greater compositional abstraction not found in his earlier pictures. With these and later seascapes from the 1870s, Manet succeeded in bringing to the canvas the sea as Michelet described it: formless, deep, and overwhelmingly abundant.

Certainly sea painting did not bring with it the dialogue with convention and need for verisimilitude necessitated by, say, portraiture and modern-life subjects. Yet it represented for painters, as for writers, a brave new world. However one plunged into sea painting— whether in the open air or in the studio—fixing the unfixed was an endeavor potentially more fraught with difficulty than capturing light and atmosphere in the landscape. Whistler, for example, felt the need early in his career to "kill" a wave in order to capture it, much like Courbet (see Dorment, pp. 187–93 below). Later, however, he developed the formula used in his *Nocturnes*, in which he sought a more timeless expression through washes of color that suggest atmospheric effects and momentary climatic conditions.

The expression of transience in paint has come to be one of the hallmarks of Impressionism and was recently the subject of an exhibition with the provocative title *Impression: Painting Quickly in France, 1860–1890*.[63] The linking of fluidity with modernity has also become commonplace in art and literature. Baudelaire used sea imagery in his earliest art criticism, in 1846 describing the pleasure of the *flâneur* at being among the crowd and his urge "to join the ebb and flow, the moving and the transitory, and the boundless."[64] Freeing oneself from convention meant embracing change and impermanence. Mallarmé's poems, for example, are in many ways as unfixed as Impressionist paintings. As Yves Peyré asserts regarding Mallarmé's tendency to continually rework his words, "At every moment the work of rebuilding is to begin over, that is to say the working part of meaning. . . . Mallarmé was an adventurer of thought and sentence. . . . In love with rupture and re-bounds, he detested everything fixed and frozen."[65]

Another characteristic of Manet's early sea paintings that came to be associated with both Impressionism and modernity in general was his use of a high horizon line. Writing in 1876, Mallarmé exclaimed: "Look at these sea pieces of Manet, where the water at the horizon rises to the height of the frame, which alone interrupts it. We feel the new delight at the recovery of a long obliterated truth."[66] The "truth" to which the poet refers is the deliberate adoption of the "natural" perspective of the East, which had been buried by science and civilization. By raising the horizon, the artist could increase the field of vision and foreground the sea as primary subject. The horizon, like the sea, thus acquired a new valence among artists of this period. Writing about Johann Barthold Jongkind (see Zarobell, pp. 173–75 below) in 1872, Zola characterized the high horizon line and the abstract application of paint as the true embodiments of "modern art."[67] It is likely Zola had in mind Manet's similar use of a high horizon when he proclaimed Manet's *Battle of the U.S.S. "Kearsarge" and the C.S.S. "Alabama"* one of the best paintings in the entire Salon.[68] Just as the sea offered a constantly shifting formal expanse and allowed for a reductivism and lack of finish that were synonymous with the new painting, it was inherently free of Western associations and compositional requirements.

The Romantic Journey Revisited

The slashing brushstrokes of Manet's last sea images—his two versions of *The Escape of Rochefort*, both painted in 1880–81 (plates 69, 71)—underscore how far he had traveled from the calm transparency of his *Steamboat Leaving Boulogne*. Already plagued with the illness (probably syphilis related) that would bring about his untimely death in 1883, Manet's vertical *Escape* paintings ostensibly portray the heroic return of a political figure,

but the theme also correlates with the artist's journey into the possibilities of abstraction. The paint takes on a life of its own in these compositions. When standing in front of the smaller of the two paintings (plate 69), one cannot help feeling that the artist was reaching far beyond the sea's surface to strive for a more profound meditation on the journey into the unknown. Despite its compositional and technical modernity—in this rendering of water's reflective quality, wet-on-wet takes on new meaning—it remains a Romantic image. In both versions, the boat, without masts or sails, drifts as if rocked by the tides of fate as the figure of Rochefort, the artist's stand-in, looks out in wonderment and foreboding.

Manet's *Escape* paintings are, at one level, about a physical journey to a real place; at another, they are about a subjective journey of the mind. Modern literature had been developing along a similar trajectory. The poet Arthur Rimbaud (1854–1891), for example, had extended the themes in Baudelaire's *Fleurs du mal* to suggest pure voyages of the mind, unfettered by earthly bounds. Inspired by the revival of sea imagery, and especially by Hugo's *Les Travailleurs de la mer*, Rimbaud's 1875 poem "Le Bateau ivre" [The Drunken Boat] links dreams and visionary thoughts to the mystery of the sea through sensations of the wind, waves, and spray. For Rimbaud, however, the physical boat is no longer necessary. The poet has lifted his mental anchor and embarked on a quest for an alternative, even utopian, universe. It's as if he, like Manet and his Impressionist colleagues, raised the horizon line on reality, shifting the position of author to subject so that the "craft" becomes the poet's mind. Using hallucinatory, figurative language (identifying himself as the boat, without sails, masts, or crew), he suggests a voyage of the mind that, though expressed in the language of the sailor, has nothing to do with the real sea. He describes the liberation of the boat and his reactions and feelings when he, "lighter than a cork," danced during ten nights on the waves. At sea he is confronted by wondrous and increasingly horrific sights, "what men imagine they have seen."[69]

Both Mallarmé and Rimbaud used mental landscapes to investigate the voyage into the unknown, the perils of the unconscious, and the search for the Absolute.[70] This is the voyage later evoked by the Symbolist artist Odilon Redon (1840–1916) in his pastels and paintings of mystical boats at sea (fig. 23). Like the poems, Redon's images have little to do with nautical experience. The title Redon originally gave to the work illustrated here, *Flower Clouds* (changed by the time he exhibited it in 1904 to the more straightforward *Boat*), was deeply personal. As Kevin Sharp pointed out in the catalogue for the 1994 exhibition *Odilon Redon: Prince of Dreams*: "Redon conflated the image of the cloud, an early symbol of the depression he associated with his *noirs* [charcoal drawings], with the flowers that represented his recent personal and artistic renaissance. . . . For his audience, the Boat was primarily a Fauvelike mass of expressive color; for Redon *Flower Clouds* represented his own long journey as an artist."[71] While stylistically very different, these writers and artists are modern in their break with conventional structure and form. And they share the inescapable metaphor of the sea as an open book for adventure and physical as well as spiritual journey.

Manet's canvases of *The Escape of Rochefort* represent his own membership in this Romantic modernist community. The discrepancy in size between the small craft in the foreground and the larger ship on the horizon emphasizes the precariousness of this voyage into the future, a theme with which Manet, weakened and already thinking about death, would have been preoccupied at this time. One wonders if a too-personal identification with these works prevented him from submitting the final versions to the Salon of 1881, where he instead showed his portrait of Rochefort. Or was there another reason? For in addition to their potential autobiographical content, these canvases represent a voyage

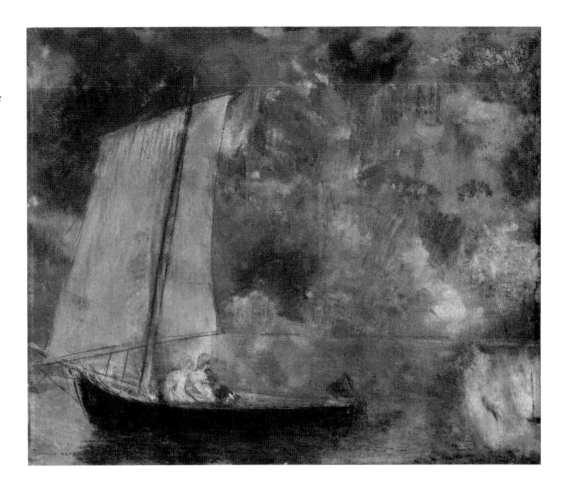

Fig. 23. Odilon Redon, *Flower Clouds,* also known as *Marine,* c. 1903. Pastel with touches of stumping, incising, and brushwork, on blue-gray wove paper, 17½ × 21⅜ inches (44.5 × 54.2 cm). The Art Institute of Chicago, through prior bequest of the Mr. and Mrs. Martin A. Ryerson Collection. 1990.165

into a new expressive timbre, achieved by means of a startling palette and bravura brushwork that seem to have been unleashed by the sea itself.

Mallarmé remembered that when he visited Manet's studio, the artist, after some chat, would talk about "what he means by painting; what new destinies are yet in store for it."[72] With these late seascapes, Manet concluded the conversation.

The author would like to thank Douglas Druick and Jane Roos for their contributions to this essay.

1. See Americo Bertuccioli, *Les Origines du roman maritime,* 2d ed. (Livorno: S. Belforte et Cie, 1937), p. 26; and Monique Brosse, "La Littérature de la mer en France, en Grande Bretagne et aux Etats-Unis (1829–1970)" (master's thesis, University of Paris, 1978), p. 111.

2. Both Bertuccioli (*Les Origines,* p. 31) and Eldon van Liere ("On the Brink," in *Poetics of the Elements in the Human Condition,* vol. 1, *The Sea: From Elemental Stirrings to Symbolic Inspiration, Language, and Life Significance in Literary Interpretation and Theory,* ed. Anna Teresa Tymieniecka [Dordrecht: Reidel, 1985], p. 273) cite Pierre de Saint Bernardin as the first Romantic marine author because of his eyewitness account of a sea storm in *Le Voyage en Ile de France,* 1773, which was followed by his account of the tempest and shipwreck in *Paul et Virginie,* "known by heart by every French and Italian schoolboy" (Bertuccioli, *Les Origines,* p. 31).

3. For Denis Diderot's enthusiastic response to Vernet's seascapes, see Brosse, "La Littérature de la mer en France," pp. 8, 26 n. 15. In the eighteenth-century Enlightenment, the sea served as a privileged site of violence, savagery, and Romantic

horror; see Etienne Taillemite, "La Mer au XVIII siècle," in *La Mer au siècle des encyclopédies*, ed. Jean Balcou (Paris: Champion; Geneva: Slatkine, 1987), pp. 17–20.

4. Pierre-Henri Valenciennes, *Elémens de perspective pratique à l'usage des artistes, suivis de réflexions et conseils à un élève sur la peinture et particulièrement sur le genre du paysage* (1800; reprint, Geneva: Minkoff, 1973), pp. 500–501.

5. Léon Gozlan, "De la littérature maritime," *Revue des deux mondes*, January 1, 1832, pp. 187 ff., cited in Bertuccioli, *Les Origines*, pp. 40–41 (my translation). Gozlan might also have pointed out that the forests, trees, mountains, and waterfalls had their champions, notably Jean-Jacques Rousseau.

6. This is not to exclude the importance of Lord Byron (*Pirate*, 1821) and Sir Walter Scott (*The Pilot*, 1821), but Cooper was recognized as setting new standards in sea novels. For an argument against Cooper's influence, see Brosse, "La Littérature de la mer en France," pp. 35–38, 45–48, 117 n. 7.

7. "Personne mieux que lui n'a compris l'Océan, ses murmures et ses teintes, son calme et ses tempêtes; personne n'a eu le sentiment aussi vif et aussi vrai d'un navire et de ses rapports sympathiques avec l'équipage. Il est inépuisable à rendre ces impressions vagues et profondes" (my translation). See Thomas Philbrick and Marion Philbrick, "Historical Introduction," in James Fenimore Cooper, *The Red Rover: A Tale* (Albany: State University of New York Press, 1990), p. xxvii.

8. In 1855 Manet, who considered Delacroix's *Dante and Virgil in Hell* "a real masterpiece in the Luxembourg," visited the artist to ask permission to copy it. See Juliet Wilson-Bareau, ed., *Manet by Himself: Correspondence and Conversations, Paintings, Pastels, Prints and Drawings* (London: Macdonald, 1991), p. 27.

9. Veracity was valued above all. See, for example, the preface to the first volume of *Le Navigateur*, founded in 1829 by former naval captain Jules Lecomte: "Les narrations qui doivent faire le sujet de ce Recueil ont été pour la plupart écrites par des marins qui ont joué un rôle dans les tristes drames." [The narratives which should comprise the theme of this collection have been written largely by seamen who have played a part in these sad tales.] Cited in Brosse, "La Littérature de la mer en France," p. 123 n. 102 (my translation). For a listing and brief description of these novels, see Bertuccioli, *Les Origines*, pp. 50–63 passim. For biographical information on each of these writers, see "Notices Littéraires" in Americo Bertuccioli, *La Grande Bleue: Pages de littérature maritime* (Milan: Garzanti, 1941), pp. 390 ff.

10. Gudin, for example, was friendly with both Eugène Sue and the poet Leconte de Lisle (1818–1894). For the crossover between sea painters and authors, see Brosse, "La Littérature de la mer en France," pp. 112–16.

11. Joseph Conrad, *Notes on Life and Letters* (London: J. M. Dent, 1921), p. 76.

12. Following Lamartine, whose poems manipulated nature as a medium for expressing his amorous, melancholic, and religious feelings, Hugo's *Les Odes et les ballades* [Odes and Ballads, 1822] was inspired by his travels and meditations on the sea.

13. "La mer boursouflait ses flots comme des morts dans le canal." Jacques Darras, *La Mer hors d'elle-même: L'Emotion de l'eau dans la littérature* (Paris: Hatier, 1991), p. 110 (my translation).

14. Delacroix returned to the storm-in-tempest theme in *Shipwreck of Don Juan* of 1840 (Musée du Louvre, Paris).

15. Translation by Katharine Prescott Wormeley, online at <http://digital.library.upenn.edu/webbin/gutbook/lookup?num=1427>, accessed January 27, 2003. This language seems to prefigure Whistler's dreamlike seascapes (see plates 84–89) as well as Boudin's pastels of sea studies (see fig. 58) that so enchanted Baudelaire at the Salon of 1859. See Charles Baudelaire, *Curiosités esthétiques*, ed. Jean Adhémar (Lausanne: Editions de l'Oeil, 1956), pp. 367–68.

16. "A force de chercher un autre lui-même auquel il pût confier ses pensées et dont la vie pût devenir la sienne, il finit par sympathiser avec l'Océan. La mer devient pour lui un être animé, pensant." Balzac, *L'Enfant maudit* (Paris: Editions Albin Michel, n.d.), p. 65 (my translation).

17. "Mais non! je devrais rentrer dans ma patrie pour y changer des misères, pour y être tout autre chose que ce que j'avais été. Cette mer, au giron de laquelle j'étais né, allait devenir le berceau de ma second vie; j'étais porté par elle, dans mon premier voyage, comme dans le sein de ma nourrice, dans les bras de la confidante de mes premiers pleurs et de mes premiers plaisirs. . . . Ici changent mes destinées: Encore à la mer! Again to Sea!" [But no! I should have returned to my native home to be miserable in a different manner—to become a completely different being than I am. The Sea, in whose bosom I was born, was to become the cradle of my second life; I was carried off by it, on my first trip as if on the breast of my wet nurse; in the arms of the nanny of my first tears and my first pleasures. . . . And so my destiny changed: Again to Sea!] Julien Gracq, ed., *Chateaubriand, mémoires d'outre tombe* (Paris: Le Livre de Poche, 1992), p. 181 (my translation). In the last sentence, Chateaubriand quotes Lord Byron's *Childe Harold*, book III, stanza 2.

18. See Emile Zola's Salon review of June 9, 1868, "Quelques bonnes toiles," in *Ecrits sur l'art*, ed. Jean-Pierre Ledu-Adine (Paris: Gallimard, 1991), p. 227.

19. Cited in van Liere, "On the Brink," p. 276.

20. Courbet may have been influenced by Gustave Le Gray's popular and esteemed marine photographs, in which, using separate negatives, he created stormy sky effects over an expanse of gently rolling sea. For Le Gray's significance to painting and possible overlapping currents between Le Gray and Courbet, see Margret Stuffman, "Between the Barbizon School

and the Beginnings of Impressionism: The Landscape Photography of Gustave Le Gray," in *Gustave Le Gray—Carleton E. Watkins (from the J. Paul Getty Collection)*, exh. cat. (Frankfurt am Main: Städtische Galerie im Städelschen Kunstinstitut, 1993), pp. 96–98.

21. Gustave Courbet, *Letters of Gustave Courbet*, ed. and trans. Petra ten-Doesschate Chu (Chicago: University of Chicago Press, 1992), pp. 248–49. *Les Châtiments* is a collection of politically motivated and satirical poems published by Hugo in 1853. Courbet's use of the term *abîme* [void] and his personification of the ocean as "laughing tiger" or crying crocodile is pure Hugolian terminology. For the psychological and literary significance of *abîme* in Hugo's work, see Roger Cardinal, "Victor Hugo: Somnambulist of the Sea," in *Artistic Relations: Literature and the Visual Arts in Nineteenth-Century France*, ed. Peter Collier and Robert Lethbridge (New Haven: Yale University Press, 1994), p. 211.

22. And vice versa: Baudelaire wrote a quatrain after Manet's 1862 painting *Lola de Valence* (Musée d'Orsay, Paris) that appeared on the frame of the painting in the Salon that year, thereby creating a huge scandal in which Manet was accused of illustrating banned literature. See Robert Lethbridge, "Manet's Textual Frames," in Collier and Lethbridge, eds., *Artistic Relations*, p. 144.

23. On lighthouses and special beacons (a rarity until the 1830s) and their impact on sea travel, see Jules Michelet, *The Sea* (New York: Rudd and Carleton, 1861), pp. 91 ff.

24. Jane Mayo Roos et al., *A Painter's Poet: Stéphane Mallarmé and His Impressionist Circle*, exh. cat. (New York: Bertha and Karl Leubsdorf Art Gallery, Hunter College of the City University of New York; Paris: Bibliothèque Littéraire Jacques Doucet, 1998), pp. 91–104.

25. For a brief overview of Baudelaire's sea experience and its relationship to his poetry, see Charles Baudelaire, *Selected Poems from "Les Fleurs du Mal": A Bilingual Edition*, trans. Norman R. Shapiro (Chicago: University of Chicago Press, 1998), pp. xv–xvi.

26. See Helen H. Aull, "Sea Imagery in *Les Fleurs du mal*: A Study of Its Nature and Function" (master's thesis, University of North Carolina, 1970), p. 8.

27. "Homme libre toujours tu chériras la mer!/La mer est ton miroir, tu contemples ton âme/Dans le déroulement infini de sa lame/Et ton esprit n'est pas un gouffre moins amer. . . . Vous êtes tous les deux ténébreux et discrets;/Homme, nul n'a sondé le fond de tes abîmes;/O mer, nul ne connaît tes richesses intimes,/Tant vous êtes jaloux de garder vos secrets!/Et cependant voilà des siècles innombrables/Que vous vous combattez sans pitié ni remords,/Tellement vous aimez le carnage et la mort,/O lutteurs éternels, O frères implacables!" [Free man, always will you cherish the sea!/The sea is your mirror; you contemplate your soul/In the *infinite unrolling of its swells,*/And your spirit is a *chasm* no less grievous. . . . You both are gloom and reserve:/Man, none have *sounded the bottom of your abysses;*/O sea, none are familiar with your intimate riches,/Jealous are you to guard your secrets!/And however many *innumerable centuries*/That you combat with neither pity nor remorse,/How much you love carnage and death,/O eternal *strugglers, o implacable brothers!*] Baudelaire, "L'Homme et la mer," in *Selected Poems from "Les Fleurs du Mal,"* p. 24 (translation by John Zarobell; my emphasis).

28. Aull, "Sea Imagery in *Les Fleurs du mal*," p. 20.

29. *Abîme* [abyss] was a favorite term of Hugo's and was, in fact, the first title he gave his 1864 *Travailleurs de la mer.* See Cardinal, "Victor Hugo," p. 211.

30. Aull, "Sea Imagery in *Les Fleurs du mal*," p. 31. The idea of the sea as void was explored by Percy Bysshe Shelley and other Romantic poets, in whose works it symbolizes the dark regions of the subconscious, "a submerged world that revealed itself only in the mirror of dreams." Corbin, *Lure of the Sea*, pp. 168–69 (paraphrasing Heinrich Heine).

31. Baudelaire, "Salon de 1845," in *Oeuvres complètes*, ed. Claude Pichois (Paris: Gallimard, 1976), vol. 2, p. 407. In 1863, the critic Charles Monselet described Manet as a student, not of Thomas Couture (his teacher), but of Goya and Baudelaire. See Alan Bowness, *Poetry and Painting: Baudelaire, Mallarmé, Apollinaire, and Their Painter Friends*, The Zaharoff Lecture, 1991–92 (Oxford: Clarendon Press, 1994), p. 8.

32. "M. Manet que l'on croit fou et enragé est simplement un homme très loyal, très simple, faisant tout ce qu'il peut pour être raisonnable, mais malheureusement marqué de romantisme depuis sa naissance." Letter from Baudelaire to Théophile Thoré, June 20, 1864, in Charles Baudelaire, *Correspondance*, ed. and annotated by Claude Pichois (Paris: Gallimard, 1973), p. 386 (translation by Wilson-Bareau, *Manet by Himself*, p. 55).

In the same letter, Baudelaire refers to Manet's early experiences as a sailor to refute Thoré's charge that Manet copied the Spanish masters, arguing that Manet could not have seen the paintings in Louis Philippe's Spanish galleries at the Louvre since the artist was then "a child and on board a ship." Ibid.

33. Laurens took the Hugo drawing back to Paris, where it was seen by the many artists, collectors, and writers with whom Hugo was in contact. Pierre Georgel, "Le Romantisme des années 1860," *Revue de l'art*, no. 20 (1973), p. 20. Georgel goes so far as to compare the impact of Hugo's painterly *bateau* on the Société des aquafortistes to that of Paul Sérusier's *Le Talisman* of 1888 (Musée d'Orsay, Paris) on the Nabis.

34. See Cardinal, "Victor Hugo," p. 214.

35. "S'il peint la mer, aucune marine n'égalera les siennes. Les navires qui en rayent la surface ou qui en traversent les bouillonnements auront, plus que tous ceux de tout autre peintre, cette physionomie de lutteurs passionnés, ce caractère de volonté et d'animalité qui se dégage mystérieusement d'un appareil géométrique la mécanique du bois, de fer,

des cordes et des toiles; animal monstreux créé par l'homme, auquel le vent et le flot ajoutent la beauté d'une démarche." Charles Baudelaire, "Réflexions sur quelques-uns de mes contemporains, I: Victor Hugo," in *Oeuvres complètes*, vol. 2, p. 135 (my translation).

36. *Ma Destinée* was recently re-dated from about 1857 to about 1867 on the basis of stylistic differences between this and Hugo's illustrations for *Les Travailleurs de la mer*. See Marie-Laure Prévost, *Victor Hugo, l'homme océan*, exh. cat. (Paris: Bibliothèque nationale de France, 2002), pp. 19–20, no. 7.

37. Hugo likened himself to the pantheon of other great men, including Michelangelo, Dante, and Shakespeare. His collective term for these men of genius was "les hommes océans," since looking at them is "like looking at souls or at the ocean." Cited in Cardinal, "Victor Hugo," p. 210.

38. See ibid., p. 229.

39. "Tout ce mystère que nous appelons le songe et qui n'est autre chose que l'approche d'une réalité invisible." Cited in ibid., p. 213 (my translation).

40. Letter from Manet to Baudelaire, c. October 25, 1865, in Wilson-Bareau, *Manet by Himself*, p. 37.

41. Letter from Hugo to Philippe Burty, May 16, 1866, in Georgel, "Le Romantisme des années 1860," p. 49.

42. Letter from Manet to Edgar Degas, July 29, 1868, in Wilson-Bareau, *Manet by Himself*, p. 47.

43. Georgel, "Le Romantisme des années 1860," pp. 14, 35 n. 42.

44. Wilson-Bareau, *Manet by Himself*, p. 314. For Manet's etching, see ibid., p. 46, no. 19.

45. See also Edgar Peters Bowron and Mary G. Morton, *Masterworks of European Painting in the Museum of Fine Arts, Houston* (Princeton: Princeton University Press, 2000), pp. 158–59, where no mention is made of a link between artist and author.

46. "There is always some trace of the cloud's shadow and the sea's saliva upon my verse or my page, my thoughts float and come and go, as if set loose by this whole gigantic oscillation of the Infinite." Translation by Cardinal, "Victor Hugo," p. 212.

47. The first French edition of the book, published in 1871 by J. Hetzel et Cie, was illustrated with wood engravings by Edouard Riou and the military artist Alphonse de Neuville. See the introduction to Jules Verne, *Twenty Thousand Leagues under the Sea*, trans. Walter James Miller and Frederick Paul Walter (Annapolis, Md.: Naval Institute Press, 1993), pp. xviii–xxix. As Miller and Walter make clear, Verne's title does not mean 20,000 leagues (43,200 miles) below the sea (impossible), but refers to the fact that his characters travel under all of the salt waters of the earth (ibid., p. xv).

48. "Oui je l'aime! La mer est tout! Elle couvre les sept dixièmes du globe terrestre. . . . La mer n'est que le véhicule d'une surnaturelle et prodigieuse existence; elle n'est que mouvement et amour; c'est l'infini vivant, comme l'a dit un de vos poètes." Jules Verne, *Vingt mille lieues sous les mers* (Paris: Editions Lidis, 1960; reprint, Paris: Librairie Hachette, 1964), p. 93 (my translation).

49. Although Michelet may not have used those exact words, *La Mer* does contain numerous allusions to the sea as an "infinity incarnate," especially in chapter I of the Second Book. For example, Michelet mentions the "infinite world of living atoms . . . that live and love, enjoy, struggle, suffer and die from the surface to the utmost depths of the sea" (Michelet, *The Sea*, p. 110). A few pages later, he writes: "Such is the Sea, such the great Female of the Globe, whose ceaseless yearning, whose permanent conception, whose production and reproduction, never end" (ibid., p. 113).

50. Dee Reynolds, *Symbolist Aesthetics and Early Abstract Art: Sites of Imaginary Space* (Cambridge: Cambridge University Press, 1995), p. 31. I am grateful to Vincent Lecourt and Pauline de Lannoy for sending me a list of Michelet works in Mallarmé's library, the remaining volumes of which are now housed at the Musée Départemental Stéphane Mallarmé, Vulaines-sur-Seine.

51. Paule Petitier, "Bords de mer: La Pensée de la marge chez Michelet," *Tangence* 57 (May 1998), p. 96.

52. "With her assiduous caresses she rounds or slopes the shore, and gives it those maternal outlines, and I had almost said the visible tenderness of that feminine bosom on which the pleased child finds so softly safe a shelter, such warmth, such saving warmth, and rest." Michelet, *The Sea*, p. 127.

53. Ibid., p. 64.

54. Petitier, "Bords de mer," p. 101. Michelet's words recall, for example, the *courants*, or crowd-as-waves, in the de Goncourts' imagery of Paris, as well as Zola's references to waves of people arriving at the Salon.

55. "I love the people but I hate a mob; especially a noisy mob of fast livers, who come to sadden the sea with their noise, their fashion and their absurdities. What! Is not the land large enough? Must such people come to the sea to martyrize the sick and to vulgarize the majesty of the Sea, that wild and true grandeur?" Michelet, *The Sea*, pp. 371–72.

56. Ibid., p. 394.

57. As long as they eliminated or subordinated the figure within the landscape and kept signs of modernity (industry) or too blatant rural life to a minimum, artists were free to experiment and abstract the formal language traditionally associated with the genre. For a concise discussion of the status of landscape artists' pictorial considerations in the 1860s and 1870s, see John House, "Framing the Landscape," in *Landscapes of France: Impressionism and Its Rivals*, exh. cat. (London: Hayward Gallery, The South Bank Centre, 1995), pp. 12–29.

58. Stéphane Mallarmé, "The Impressionists and Edouard Manet," *Art Monthly Review* 1 (September 30, 1876), cited in Jane Roos, "Learning to Swim: Manet and the Impressionist Moment," in *The Cambridge*

Companion to Manet, ed. Therese Dolan (Cambridge: Cambridge University Press, forthcoming).

59. "One of [Manet's] habitual aphorisms then is that no one should paint a landscape and a figure by the same process, with the same knowledge, or in the same fashion. . . . Each work should be a new creation of the mind. The hand, it is true, will conserve some of its acquired secrets of manipulation, but the eye should forget all else it has seen, and learn anew from the lesson before it." Ibid.

60. Translation by Jack Foley, "Three Translations," *Poetz.com* (June 2002), online at <http://www.poetz.com/fir/june02.htm#Jack%20Foley>.

61. On the symbolism of swimming and the "saut dans l'inconnu" [leap into the unknown], see Gaston Bachelard, *L'Eau et les rêves* (Paris: José Corti, 1942), pp. 223–25.

62. See ibid., p. 156.

63. The National Gallery, London, November 1, 2000–January 28, 2001; Van Gogh Museum, Amsterdam, March 2–May 20, 2001; and the Sterling and Francine Clark Art Institute, Williamstown, Massachusetts, June 16–September 9, 2001.

64. This quote is said to have inspired Manet's *Music in the Tuileries* of 1862 (National Gallery, London). See Françoise Cachin, *Manet, Painter of Modern Life* (London: Thames and Hudson, 1995), p. 35.

65. Yves Peyré, "Inscription of the Highest Dream," in Roos et al., *A Painter's Poet*, p. 29.

66. Mallarmé, "The Impressionists and Edouard Manet," cited in Roos et al., *A Painter's Poet*, p. 39.

67. Zola, "Lettres parisiennes," January 24, 1872, reprinted in *Ecrits sur l'art*, p. 254.

68. Zola, "Lettres parisiennes," May 12, 1872, reprinted in *Ecrits sur l'art*, p. 259.

69. See Alain Couperie, *Voyage et exotisme au XIX siècle* (Paris: Hatier, 1986), pp. 69 ff. Translation from Arthur Rimbaud, *Sui dore sen; Drunken Boat; Bateau Ivre* (Kyoto: Kyoto Shoin, 1988), pp. 9, 17.

70. See Hans Rudnick, "Medium for Artistic Experience," in *Poetics of the Elements in the Human Condition*, vol. 1, *The Sea: From Elemental Stirrings to Symbolic Inspiration, Language, and Life Significance in Literary Interpretation and Theory*, ed. Anna Teresa Tymieniecka (Dordrecht: Reidel, 1985), p. 196.

71. See Kevin Sharp, "Redon and the Marketplace after 1900," in Douglas W. Druick et al., *Odilon Redon: Prince of Dreams, 1849–1916*, exh. cat. (New York: Abrams, 1994), p. 226.

72. Mallarmé, "The Impressionists and Edouard Manet," cited in Roos et al., *A Painter's Poet*, p. 36.

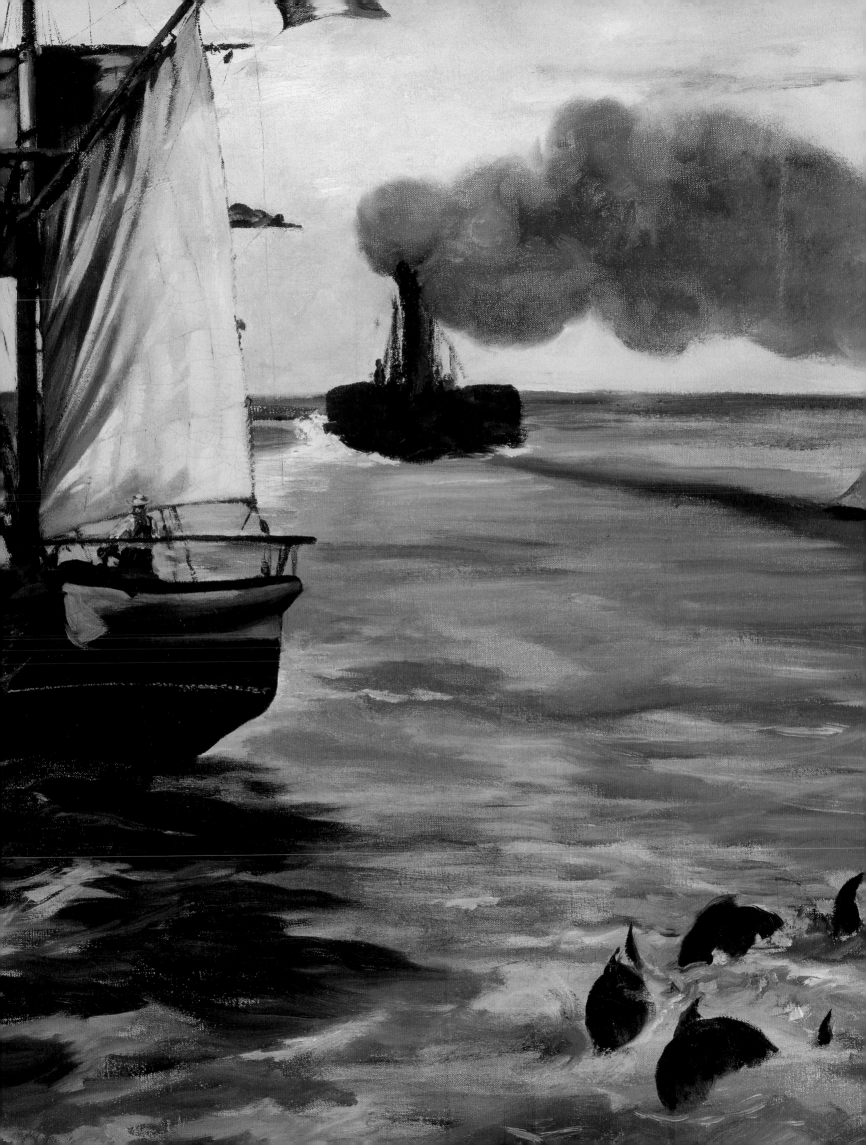

Manet and the Sea

JULIET WILSON-BAREAU AND DAVID DEGENER

Edouard Manet (1832–1883) had a unique relationship with the sea. As a teenager, he sailed from Le Havre to Rio de Janeiro and back and was deeply impressed by what he saw and experienced. Later, he turned his summer holidays with his family at Boulogne and Berck and his stay on the Atlantic coast of France in 1871 to good account, sketching on the spot and painting *in situ* or back in his Paris studio. Landscape hardly makes an appearance in his work, but representations of the sea play a substantial role in his artistic production. Of his total oeuvre of something over four hundred paintings, around forty can be classified as seascapes. The term *seascape* is taken here as including views of the sea through a window, the port at Bordeaux near the mouth of the Gironde River, and the canals of Venice but not river scenes, such as the ones he painted at Argenteuil in the company of Claude Monet and Pierre-Auguste Renoir. In addition to paintings on canvas or panel, Manet made a great many drawings and watercolors of ships and the sea in his sketchbooks.

Manet's early sailing experience gave him a hands-on familiarity with the workings of ships and their tackle and an interest in their structure. Sketches from early and late in his career, pentimenti in the paintings themselves, and his reported conversations show that he continued to be concerned with the difficulty of conveying the shape of a hull constructed from overlapping planks, whether it was that of a three-masted schooner, a rowboat, or a gondola. He could capture as few of his contemporaries could, and certainly better than most professional marine painters, the impression of a sailing ship skimming through the waves before a stiff breeze or the smoky progress of a packet boat chugging its way across the Channel.

Despite his direct experience, Manet's first and last seascapes were works of the imagination: the naval battle that took place off Cherbourg on the northern coast of France in 1864 (plate 10), which he did not witness, and the escape in March 1874 of the notorious journalist Henri Rochefort from the French prison colony on the island of New Caledonia, which Manet attempted to portray in his Paris studio seven years later (plates 69–71). In between come the pictures Manet made in response to his trips to coastal resorts— Boulogne and Berck in the north, Arcachon to the southwest—in which he responded to the lay of the land and qualities of light that distinguish the individual localities. Manet never wanted to repeat himself, and he always sought to intrigue and delight the viewer. The variety of his seascapes and the techniques that he developed to paint them give art lovers a rich sequence of motifs and pictorial strategies to examine, while his grasp of the shapes and types of ships and his evident delight in the complexities and atmosphere of harbor scenes will impress both amateur and professional sailors and those whose business is the sea.

In view of Manet's background, it seems safe to say that he knew the sea better than most Frenchmen of his time. His father Auguste, a bureaucrat in the Ministry of Justice until 1841, then a judge on a Paris trial court (*tribunal de première instance*), expected his oldest son

Opposite page: Edouard Manet,
The Steamboat, Seascape with Porpoises
(plate 16, detail)

Fig. 24. Muster roll recording Manet's presence on *Le Havre et Guadeloupe*, which set sail from Le Havre for Rio de Janeiro on December 9, 1848, and returned to Le Havre on June 13, 1849. Archives départementales de la Seine-Maritime, Rouen. 6P6/148

to follow in his footsteps.[1] However, in order to be received at the bar one had to study law, and Edouard was not a good student. He did fancy himself a good draftsman, and he was seconded in this opinion by his maternal uncle, Edouard Fournier, a colonel and aide-de-camp to the duke of Montpensier, Louis Philippe's fifth and youngest son.[2] Pressed on the one hand by his father and on the other by his own inability or disinclination to focus on the career that his father envisioned for him, Edouard Manet declared that he wanted to be a sailor. In July 1848 he took the entrance examination for the French naval officers' school but failed it. The examination was given once a year, and candidates had only one opportunity to take it. However, a law enacted on October 10, 1848, allowed Manet and others in his position to retake the exam if they had served on a French navy or merchant marine ship whose course took it across the equator.[3]

So it was that on December 9, 1848, the sixteen-year-old Edouard Manet boarded *Le Havre et Guadeloupe,* a small three-masted ship bound for Rio de Janeiro.[4] The ship had recently been refitted to house the forty-eight paying passengers recorded on its muster role (fig. 24) as "junior helmsmen" (*pilotins*) along with four instructors and a twenty-two-man crew. Manet's cruise to Rio has often been misinterpreted as training, and he has been described as an apprentice officer.[5] The cruise was in fact a kind of floating cram session, with the four instructors responsible for instilling the knowledge that candidates would need in order to pass the entrance examination. But Manet encountered distractions on the trip, not the least of which were the demands placed on his skills as a draftsman. In February 1849 he wrote to his mother: "I have to tell you that I developed a reputation during the crossing. All the ship's officers and all the instructors asked me to make caricatures of them. Even the captain asked for one, as his Christmas present." When the captain was unable to find a drawing instructor in Rio, he enlisted Manet to give lessons to his shipmates on the return voyage.[6] This must have been a validating experience for the aspiring artist, and it is not inconceivable that it played a role in Auguste Manet's change of heart concerning his son's career choice.

It is easy to romanticize the 113 days that Manet spent at sea on *Le Havre et Guadeloupe.* Manet himself reportedly told the painter Charles Toché in 1874: "I learned a lot on my voyage to Brazil. I spent countless nights watching the play of light and shadow in the ship's wake. During the day, I stood on the upper deck gazing at the horizon. That's how I learned to construct a sky."[7] However, the daily schedule that Manet outlined in a letter to his mother on December 21, 1848, left little time for musing on the horizon from the bridge, and he reports that he and the others had to be in their hammocks between decks at 9 P.M. Furthermore, Manet is not known to have been painting in 1848 or 1849. He may well have laid in a store of visual impressions during the cruise, but there is no evidence that he drew upon it until the mid-1860s.

Manet also experienced the sea in ways more typical of members of his social class. The elaboration of a railroad network in France during the middle decades of the century gradually made the seacoast available to Parisians and appreciably increased the number of vacation travelers making the once prohibitively long journey from the capital to France's coastal and port towns.[8] Manet is known to have visited Arcachon, Berck, Bordeaux, Le Havre, Nantes, Le Pouliguen, La Rochelle, Rochefort, Royan, and Saint-Nazaire. The bulk of his time during those visits was spent at the seaside resorts of Arcachon, Berck, and Boulogne.

While swimming in the sea may seem ordinary to modern Americans and Europeans, it was subject to cautions and strictures for citizens of nineteenth-century France. A number of resorts in France catered to the notion that mineral waters had therapeutic properties, but the idea that seawater and salt air could be beneficial was English in origin and slow to catch on in France.[9] The first beach club (*établissement de bains de mer*) in France opened in 1822 in Dieppe, and Boulogne opened the second in 1825. Particular localities were held to have benefits for particular complaints and illnesses. Medical professionals came to prescribe stays at the seaside for their clients, and practitioners in resort towns advised and monitored those who came for the cure. To a Belgian acquaintance who asked him in 1880 to compare the medical advantages of Boulogne and Berck, Manet wrote: "you will of course find what you need for hydrotherapy at both places—in Berck . . . you are sure of being well treated—in Boulogne, which has many resources and all kinds of things to do, you will find whatever you're looking for."[10] However, the three towns in which Manet spent the most time were not exclusively resorts: Boulogne was France's third most important port, oysters were raised commercially in Arcachon, and Berck had an active fishing community. As a result, Manet's visits afforded him an opportunity to observe and record a wide variety of commercial and social activities associated with the sea, and his seascapes accordingly reflect this diversity of experience.

The Battle of the U.S.S. "Kearsarge" and the C.S.S. "Alabama"

Manet's first seascape is an imaginative representation of a contemporary event that had been widely reported in French and English newspapers and illustrated journals: a naval duel between C.S.S. *Alabama* and U.S.S. *Kearsarge* that took place on Sunday, June 19, 1864, off the north coast of France. The U.S. Navy vessel sank the Confederate raider within earshot, if not eyesight, of Cherbourg and thus ended its career as a scourge of Union shipping.[11] By the third week of July 1864, Manet's *Battle of the U.S.S. "Kearsarge" and the C.S.S. "Alabama"* (plate 10) was exhibited in a window of Alfred Cadart's print shop and studio at 79 rue de Richelieu in Paris (fig. 25).[12] At more than four feet square, the picture would have been certain to attract attention even if its subject matter had not been topical. Given the date of the naval duel, Manet had to

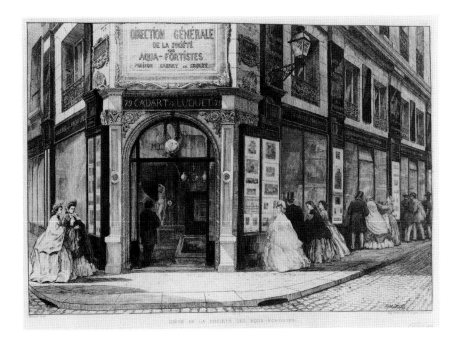

Fig. 25. Martial (Adolphe-Martial Potémont), *The Headquarters of the Société des aquafortistes* (Alfred Cadart's print shop and studio). From *Eaux-Fortes Modernes*, vol. 3, part 1, September 1, 1864, no. 124. Etching, 9⅞ × 14⅛ inches (25 × 36 cm). Bibliothèque nationale de France, Paris. Département des Estampes et de la Photographie. Ad97 Rés.

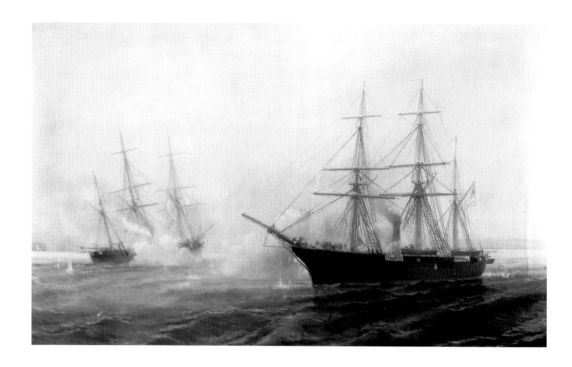

Fig. 26. Henri Durand-Brager, *Battle between the U.S.S. "Kearsarge" and the C.S.S. "Alabama,"* 1864. Oil on canvas, 40 × 64 inches (101.6 × 162.6 cm). Union League Club of New York

have executed the painting in very little time. Even so, he was not the first French artist of some renown to exhibit a *Kearsarge/Alabama* painting.[13] No later than July 3, the naval painter Henri Durand-Brager (1814–1879) had his *Battle between the U.S.S. "Kearsarge" and the C.S.S. "Alabama"* (fig. 26) on display at Goupil's fashionable gallery, whose 12 boulevard Montmartre address made what it showed somewhat more conspicuous than works hung in Cadart's windows. Durand-Brager, who began his professional life as a sailor before studying painting with Théodore Gudin and Louis-Gabriel-Eugène Isabey, was acquainted with many high-ranking officers in the French navy and had close associations with Cherbourg —the port from which *Alabama* had sailed and in which *Kearsarge* rested and repaired for fifteen days after its victory.[14] Newspapers that by their politics seem likely to have attracted Manet's attention took note of Durand-Brager's project, and at least four Paris newspapers publicized the completed work. It is possible that Durand-Brager's painting— and perhaps the publicity accorded it—moved Manet to undertake a *Kearsarge/Alabama* picture of his own.[15]

By their choice of subject matter, both artists placed themselves within the "noblest" tradition of marine painting, namely large pictures commemorating naval engagements. This tradition was launched in France when the government of Louis XVI, which had invested heavily in new ships, port facilities, and manpower, commissioned the former navy captain Auguste Louis de Rossel de Cercy (1736–1804) to paint sixteen canvases celebrating French naval victories. Louis Philippe's project of turning Louis XIV's largely vacant palace at Versailles into a *Galerie historique* had a substantial naval component, and he commissioned perhaps a dozen artists to cover a great many square feet of canvas with paint recording high points in France's history as a naval power (see Zarobell, pp. 20–23 above). Economic retrenchment and problems of governance distracted Louis Philippe from these activities well before his government collapsed in February 1848. However, French military successes in the Crimea in the mid-1850s and against Austrian forces in Italy in 1859 motivated Louis-Napoléon Bonaparte to renew this pictorial tradition.

While both Manet and Durand-Brager pay homage to the tradition of naval painting with their *Kearsarge/Alabama* pictures, they also depart from it in two important ways: The event that they commemorate was very recent, and the vessels that they depict are not French.[16] More important, Manet's painting also quite visibly—one might even say

aggressively—breaks with the traditions of naval painting by pushing the nominal object of interest far into the pictorial space and away from the visual center of the picture. The formal innovation constituted by Manet's representation of the duel has been recognized at least since 1872, when he exhibited the painting at the Paris Salon. Caricaturists gave comic expression to his departure from tradition, Stop and Bertall by showing what Stop described as a "cross section of the sea," at the bottom of which Bertall placed "M. Manet's faithful cat"—the animal that figured so provocatively in Manet's *Olympia* (Musée d'Orsay, Paris)—observing the progress of the battle alongside a fish (fig. 27).[17] The relatively few critics who discussed the work referred above all to its painterly qualities, but Jules Claretie also voiced complaints about its "Japanese" perspective.[18] Yet, in a long and enthusiastic text, the novelist Jules Barbey d'Aurevilly combined the two viewpoints. He described Manet's canvas as "first and foremost a magnificent piece of *marine* painting," in which the artist had exploited a direct and powerful rendering of the natural forces of wind and wave as a means of escape from the dead hand of tradition. But, by pushing his two vessels toward the far horizon, Manet had made the surging sea itself a symbol of their epic struggle.[19] Writing soon after the close of the Salon, Armand Silvestre judged the vigor and directness of Manet's depiction of the sea as comparable with Eugène Delacroix's handling of his seascapes.[20] Later critics tended to underline the influence of Japanese prints, although a high horizon is not a constant of *ukiyo-e* views of the sea, and Manet used the same device in several major paintings of the early 1860s that writers have not seen as "Japanese."[21]

Fig. 27. Bertall, *Naval Combat. From the bottom of the sea, its last resting place, M. Manet's faithful cat follows the details of the battle*. From *Le Grelot au Salon de 1872*, part 3, p. 20, no. 1059, 1872. Gillotage with stenciled color. Bibliothèque nationale de France, Paris. Département des Estampes et de la Photographie. Tf319, pet. fol.

X-radiography of Manet's painting (fig. 28) has confirmed what an examination of the canvas itself suggests: that the artist reshaped his composition extensively in the course of work. While the pilot boat heading into the picture on the left was in place from the start, there was a notable change at the right-hand edge in the middle third of the canvas, which at one time included the stern of a two- or three-masted sailing ship. The artist further increased the sense of empty expanses of water by replacing a rowboat originally positioned between the pilot boat and the ship that was painted out with a man clinging to a spar and what appears to be a drowned or drowning man. We cannot be sure that the surface we see today is what Parisians saw in 1864. Manet exhibited the canvas two more times during his lifetime—at his self-financed and self-organized retrospective exhibition in 1867 and at the Paris Salon of 1872—and it would be characteristic of him to have updated his canvas on one or both occasions. It was one of three seascapes in the 1867 show that G. Randon caricatured for the Paris weekly *Le Journal amusant*. While Randon's representation differs appreciably from the painting that we know today—for example, it suggests the possible presence of a small sailing ship in the lower right corner—we cannot be certain whether the differences were the result of careless observation, comic intent, or something else.[22]

We do not know exactly what motivated Manet to paint his *"Kearsarge" and "Alabama."* Until the 1950s, critical discussion of the painting was dominated by the idea that he had witnessed the event and that the painting was the record of direct observation.[23] A short but influential article published in 1962 helped to move investigation into formalist channels.[24] As mentioned, there is at least a possibility that Manet was inspired by the publicity surrounding Durand-Brager's painting. But in addition to or in place of artistic ambition, Manet might also have had political motivations. The politics of the sixteen-year-old sailor aboard *Le Havre et Guadeloupe* were anti-Bonapartist even before Louis-Napoléon was elected president of the Second Republic in 1848.[25] Manet was at least acquainted with Emile Ollivier, who until the end of the 1860s was a mainstay of the opposition, and in the same decade he associated with such opposition figures as Jules and Charles Ferry and Prosper-Olivier Lissagaray. The French press had relatively

Fig. 28. X-radiograph of *The Battle of the U.S.S. "Kearsarge" and
the C.S.S. "Alabama"* (plate 10). Conservation Department,
Philadelphia Museum of Art

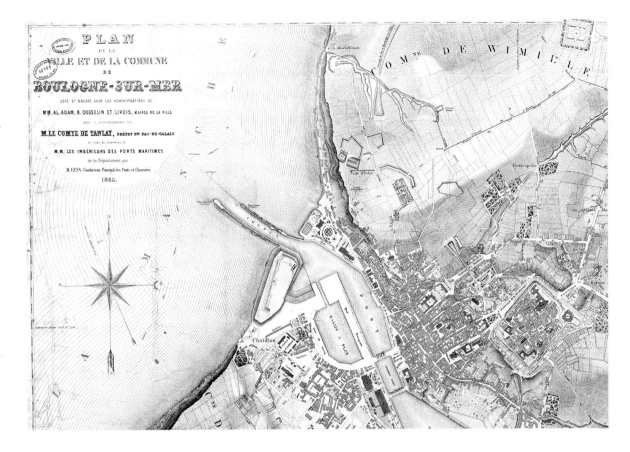

Fig. 29. Lens, Conducteur Principal des Ponts et Chaussées, *Map of the City and the Commune of Boulogne-sur-Mer* (detail), 1865. Lithograph, 31⅞ × 40⅛ inches (81 × 102 cm). Bibliothèque municipale, Boulogne-sur-Mer. Carte 1504

little to say about the American Civil War; most organs followed the French government's tacitly pro-Confederate line. But a few publications—among them the "moderate" dailies *Le Temps* and *Journal des Débats* and the openly anti-Bonapartist *L'Opinion nationale*—dared to buck the trend by raising such issues as slavery or French policy in Mexico, which a victory by the United States would have threatened. Anti-Bonapartists like Manet may well have viewed the sinking of *Alabama* as a defeat for the French emperor.[26]

Whatever Manet's particular reasons for undertaking his *"Kearsarge" and "Alabama"* painting, his hard-won solution to the formal challenges posed by his subject matter remained with him and served as a model for the paintings executed as a result of his visits to Boulogne in the 1860s. As we shall see, while Manet made many direct graphite sketches and watercolors of the sea and ships, virtually all his seascapes painted in oils during the 1860s appear to have been executed in his Paris studio. He therefore needed to rely on tried and tested methods, of which his battle picture was an exemplar.[27]

Boulogne

The Manet family was evidently accustomed to taking holidays in Boulogne (fig. 29). In a letter written in 1848, the sixteen-year-old Edouard reminds his mother of a kind of seagull that she "must sometimes have seen in Boulogne."[28] The letter does not allow us to date these visits, nor can we date what appears to be Manet's first known sketch of the sea (fig. 30).[29] He could have visited Boulogne in the summer of 1860, when he contributed a picture to an exhibition organized by the Société des amis des arts.[30] But the Manet family's two visits attested by documents, drawings, and paintings took place in 1864 and 1868.[31] The fact that family members and close friends appear in paintings from the later years (plates 45, 48) suggests that the Manets may have visited Boulogne again after 1870. More of Manet's seascapes are connected with Boulogne than with any other site, and his

Fig. 30. Edouard Manet, *Boy by the Sea,*
c. 1860–62. Page from a sketchbook
(watermark *Joynson 1855*). Graphite on
laid paper, 7⅛ × 4⅜ inches (18 × 11 cm).
Musée d'Orsay, Paris, held at the Musée
du Louvre, Département des Arts
graphiques, Paris. RF 30.439

constantly evolving response to familiar views of the port and its surroundings provides a
fascinating indication of the development of his style.

Located at the mouth of the Liane River on a stretch of France's Channel coast between
Cape Gris-Nez and the mouth of the Somme River, Boulogne was destined by its geog-
raphy to become a port. Settled first by Gauls, then by Romans, it fell under English con-
trol in the eleventh century and changed hands repeatedly until Louis XIV established a
semblance of centralized order. Napoléon Bonaparte gave its economy a boost when he
selected it as the logical staging point for his projected invasion of England. By the middle
of the nineteenth century, the town's population exceeded thirty thousand.[32] Described
in 1869 as France's third most important commercial port, it was second only to Calais for
traffic between France and the British Isles.[33]

Boulogne's first foray into the leisure industry dates from 1785, when Cléry de Bécourt
opened what he called an *établissement de bains de mer,* somewhat misleadingly since his cus-
tomers did their "sea bathing" indoors in tubs of heated saltwater. In 1824, reflecting the
success of the operation at Dieppe, Antoine-Auguste Versial constructed Boulogne's first
proper beach club.[34] Located northwest of the port at the mouth of the Liane, Versial's
one-story building consisted of men's and women's wings connected by a large central
room reserved for meetings, theatrical and musical performances, and dances. Versial's
operation foundered, and in 1833 the building and fifty-year lease on the beachfront
changed hands. By 1843, each wing had a second story, the central room had two addi-
tional stories and a rooftop observation deck, and a covered veranda ran the entire length
of the seafront façade.[35] This may have been the building that Manet visited as a boy,
before rail service was extended from Paris to Boulogne in 1848. Léon Asselineau's view
from Boulogne's eastern jetty (fig. 31) dates from 1860; the long, low beach club, at
the center, is overshadowed by tall buildings, the imposing Hôtel Impérial farther along
the beach to the left, and the town and port to the right. The bathing machine—at first
a cloth structure, later a wooden cabin on wheels pulled into the water by a horse—was
Boulogne's contribution to beach club culture.

The rail link made Boulogne much more accessible to travelers, but it also exposed
the town to competition from other localities.
By the early 1860s, rail service connected Paris
not only with other towns on France's north
Channel coast but also with resorts in Belgium
and Germany offering the more traditional hot
and cold springs and mineral waters. Taking
matters into its own hands, the city acquired the
beach club and the land on which it stood, tore
down Versial's building, and erected a new one
on the site. Dedicated on June 29, 1863, the new
beach club, a typically eclectic Second Empire
construction covering about sixteen thousand

Fig. 31. Léon Asselineau, *View of the Beach and Beach Club from
the East Jetty at Boulogne-sur-Mer.* From *La France de nos jours,*
no. 313, Paris: Sinnett / Becquet frères, 1860. Lithograph.
Bibliothèque nationale de France, Paris. Département des
Estampes et de la Photographie. Ve24b, pet. fol.

THE NEW BATHING ESTABLISHMENT AT BOULOGNE-SUR-MER.

square feet (fig. 32), moved a local chronicler to hail the day as the dawn of a new era of prosperity for Boulogne.[36]

This is the institution to which five members of the extended Manet family—the painter, his mother Eugénie, his wife Suzanne, his younger brother Gustave, and an unidentified Mme Leenhoff (possibly a sister-in-law)—took a one-month subscription on July 16, 1864. They gave 10 rue de l'Ancienne Comédie as their local address (fig. 33).[37] Presumably they rented all or part of this house, which was located on a small street near the center of town. Within two hundred yards or so of the Manets' temporary residence, one found three cafés, four restaurants, six bars, four bakeries, seven pastry shops, two printsellers, and six bookstores. Two of the bookstores—R. T. Seal's and H. M. Merridew's—specialized in *lecture de journaux,* meaning that for a fee one could read as many newspapers as one desired.[38] The restless painter could easily have kept abreast of developments in Paris when he was not sea bathing or ambling around town.

In the summer of 1868, Manet, his wife Suzanne, and her sixteen-year-old son Léon Leenhoff returned to Boulogne for about two months.[39] We do not know whether they took out a subscription to the beach club—its records for 1868 have not survived—but Manet's correspondence with friends in Paris informs us that, between July 15 and August 17, they occupied a rented apartment in the center of town at 2 bis rue Napoléon (now rue Victor Hugo). At the end of July or beginning of August, Manet took advantage of Boulogne's proximity to England to make a short trip to London. From August 18 on, the Manets lodged at 156 rue de Boston (now boulevard Sainte-Beuve), which extends north of town behind the beach club.[40] Manet would have had ample opportunity to focus on the beach and the sea from this location.

Apart from sea bathing and family obligations, Manet seems to have spent his time in Boulogne roaming the harbor, the jetties,[41] the beach and beach club, and perhaps even the cliffs behind them, with a sketchbook in hand on the lookout for motifs. The pencil and watercolor sketches he made became the raw material for his paintings, few if any of which from the 1860s seem to have been painted on the spot. Manet had been an

inveterate sketcher since his schoolboy days, and the testimony of people who knew him well indicates that the habit accompanied him to his dying day. Antonin Proust, who first met Manet at collège Rollin, studied with him in Thomas Couture's studio, and remained his friend for life, tells us about a seaside sketching expedition when Manet was twenty-one: "In fall 1853, we went on a walking tour to the Normandy coast [with Couture and other students]. Everyone had his own paintbox, and we all worked on studies after nature—Manet and I with great abandon."[42] Proust also recalled Manet's habit of entrusting the most fleeting visual impressions—"a profile, a hat"—to his sketchbook.[43]

The importance of Manet's drawings for an understanding not only of his art but of its chronology has been difficult to judge because most of the ten to fifteen or perhaps more identifiable sketchbooks were disbound after his death and their pages widely dispersed.[44] Only three bound notebooks are known to remain: A small, very early sketchbook; a small, oblong canvas-covered watercolor book that has recently come to light (plates 19–24); and a larger sketchbook from which many pages have been extracted (plate 31).[45] If we group the drawings by their technical characteristics—size and type of paper, watermarks, technique—we can reconstitute the sketchbooks and thereby gain insight into Manet's development as an artist.[46] We have already noted the earliest known sketch relevant to a study of Manet's seascapes, which depicts a young boy on a beach looking at the sea and a sailing ship (fig. 30). The paper on which the drawing was made is watermarked *Joynson 1855,* prompting us to ask whether Manet visited the coast between 1853 (if Proust's recollections can be trusted) and 1864—for example, as already suggested, in 1860, when his *Salamanca Students* was exhibited in Boulogne.

A second sketchbook, identified by the watermark *Joynson 1864,* is clearly connected with Manet's visit to Boulogne that year. Twenty pages from this Boulogne 1864 sketchbook have been identified, although none are related to the paintings traditionally associated with that visit (plates 12, 13). These drawings served instead for two paintings Manet began in 1864 but later cut down and reworked: a racetrack painting (The Art Institute of Chicago)[47] and *Departure of the Folkestone Boat—The Large Study* (plate 44), which

Fig. 34. Louis Caudevelle. *The Quai des Paquebots at Boulogne-sur-Mer*, c. 1860. Albumen print from a glass negative of an anonymous drawing showing the arrival of the Folkestone packet steamer, printed by Henri Caudevelle. Bibliothèque municipale, Boulogne-sur-Mer. Phot. 4

depicts the hubbub surrounding the arrival and departure of the steam packets (fig. 34). These paintings and the sketchbook drawings upon which they are based (for the Folkestone picture, see fig. 44) suggest that during his 1864 visit Manet's interest in ships and the sea was paralleled by an equally strong attraction to crowd scenes and popular entertainments, as exemplified by his painting *Music in the Tuileries* (fig. 59) and his lithograph *The Balloon*, both from 1862.

Not long after his arrival in Boulogne in 1864, Manet wrote to the painter Félix Bracquemond that he had already done some studies (*études*) of small boats on the open sea, but no such studies, on canvas or paper, have been identified.[48] Yet they must have provided the raw material for the two canvases painted in response to this seaside stay, *U.S.S. "Kearsarge" off Boulogne* (plate 12) and *Steamboat Leaving Boulogne* (plate 13). U.S.S. *Kearsarge* anchored off Boulogne twice in July 1864: in the early evening of Sunday, July 10, on which occasion it remained until Tuesday morning, and shortly after noon on Saturday, July 16, when it stayed only until 8:45 P.M. Sunday.[49] The Boulogne beach club subscribers list (fig. 33) indicates that the Manet family had settled in by July 16, so it seems most likely that the painter's firsthand encounter with *Kearsarge* took place the following day. He no doubt would have been interested in examining the ship that he had just imagined in his *Battle of the U.S.S. "Kearsarge" and the C.S.S. "Alabama"* (plate 10), and he told both Bracquemond and the critic Philippe Burty that he had "visited" the ship and would be bringing a study of it back to Paris.[50] Taken together, his remarks to

Bracquemond about studies of small boats and to Burty about a painting of *Kearsarge* "as she looks out at sea" suggest that he was referring not to the large oil painting (plate 12) but either to an oil sketch now lost or to the ink and watercolor brush drawing of *Kearsarge* (plate 11) from which the large canvas was no doubt painted in the artist's Paris studio.

Both the drawing and the oil painting of *Kearsarge* observe the conventions incumbent upon ship "portraits." Manet shows the vessel in profile, its masts and rigging silhouetted against a luminous bank of clouds. On July 16 and 17, the ship was anchored roughly a mile and a half northwest of the twin jetties. Manet might have examined *Kearsarge* with a telescope, or he might have approached it from the sea, as residents and visitors to Boulogne did in droves whenever it was anywhere near town.[51] The two white-sailed boats that head toward the American warship in the painting are typical of the small craft that were available for hire. While the drawing and the painting have the same high horizon line, the drawing has a more natural and spontaneous effect. Manet chose a much squarer format for the painting and filled its foreground with swirling foam-capped waves and a fishing boat bearing down on the viewer, its crew weighting the hull on the starboard side to counter the pull of the sails swollen by the stiff northwesterly wind that splays the *Kearsarge*'s flags against the sky. While the smaller ships in this carefully constructed composition are based on direct observation—there were many craft of all sorts at Boulogne, and the brown-sailed boat near the *Kearsarge*'s bow can be identified as a two-masted herring drifter—the two-masted fishing boat at the right is incorrectly rigged, neither a cutter nor a trawler, and too large to be a Boulogne fishing vessel. Artistic license in the studio, confirmed by an x-radiograph showing changes to the ship's hull, prevailed over the accurate detail reflected in sketches made on the spot. From his chance view of *Kearsarge* at anchor off Boulogne at the start of his summer holiday, Manet went on, probably back in Paris, to construct an impressive "portrait" of the victorious ship.

The other painting connected to Manet's 1864 trip, *Steamboat Leaving Boulogne* (plate 13), is one of his most abstract compositions. The calculated placement of ships against an almost unbroken turquoise-blue expanse of sea that rises to a high horizon has been likened to the decorative effect of such views in Japanese prints.[52] However purely "artistic" the composition may be, all the vessels in it can be identified with real-life models: the sidewheel packet steamer making its way from Boulogne to England; the single-masted, many-sailed trawler on the left trailing dinghies behind it; the two-masted herring drifter in the center. The white-sailed ship ahead of the steamer is probably a commercial brig plying Channel ports. Manet must have used sketches (now lost) of very particular types of ship to construct this swiftly brushed depiction of a steamboat making its way through the breeze-blown sailing ships on a calm sea off a busy port. When he showed the picture in 1867, he titled it *Le Steam-Boat (marine)*, leaving no doubt as to its focus.[53] On the same occasion, he chose to title the "portrait" of *Kearsarge* at Boulogne *Bateau de pêche arrivant vent arrière* (*Fishing Boat Coming in before the Wind*), the title under which G. Randon caricatured it (fig. 35).[54]

Manet's sketching activity is easier to follow in connection with his 1868 visit to Boulogne. Two sketchbooks have survived almost intact. The small, pocket-size Boulogne 1868 sketchbook was unknown and unpublished until very recently. The twenty-odd drawings that remain in it (a few have been removed) range from topographical sketches of the jetties as seen from the beach club or in striking bird's-eye perspective from the dune de Châtillon (plates 20, 24) to more purely pictorial renderings of sea and sky that streak whole pages with pure watercolor (plates 19, 22). The other, more important Boulogne 1868 sketchbook, whose pages are watermarked *J Whatman 1856*, is larger in format and has many more folios.[55] This Boulogne 1868 (Whatman) sketchbook survives in its original binding in the Louvre (plates 27, 31; fig. 36), but many of the most attractive pages, above

Fig. 35. G. Randon, caricature of *U.S.S. "Kearsarge" off Boulogne—Fishing Boat Coming in before the Wind* (plate 12), from *Le Journal amusant*, June 29, 1867

all those containing watercolored studies, were extracted from the sketchbook after the artist's death and are now found as single- or double-page sheets in a number of collections (plates 15, 17, 25, 33, 39, 40; fig. 37). Besides the album itself, the Louvre also owns a number of the extracted sheets.[56] Manet used most of the drawings still in the original binding for paintings of the eastern jetty (plates 29, 30) and the beach at Boulogne (plate 32).

These sketchbook studies and perhaps some small paintings made on the spot were followed up with a considerable body of works painted after Manet's return to Paris. One of the most impressive of these, *The Steamboat, Seascape with Porpoises* (plate 16), long thought to be related to his 1864 visit, can now be securely dated to 1868 through the preparatory study (plate 15) extracted from the Boulogne 1868 (Whatman) sketchbook.[57] This painting, which Manet may have envisioned as a pendant to *U.S.S. "Kearsarge" off Boulogne*, also includes a boldly painted schooner-brig, a sturdy commercial transport ship that contrasts with the fishing boat in the foreground of the earlier work. To these elements Manet added a school of porpoises, a motif found in many seascapes, including works by such acknowledged nineteenth-century French masters as Théodore Gudin and Louis Garneray, and a natural phenomenon Manet had observed from the deck of *Le Havre et Guadeloupe* in 1848.[58] A lively etching that remained unpublished in Manet's lifetime combines elements from both works, supporting the hypothesis that the canvases are related programmatically. It was probably made while Manet was working on the composition with porpoises and reflecting on its relationship with the earlier canvas.[59]

The 1868 visit inspired different kinds of painting, and the sketchbooks show the artist's varied responses to the many aspects of harbor, beach, and sea. The small Boulogne 1868 sketchbook, which includes watercolored drawings of identifiable sites (plates 20, 21, 24), did not serve for individual paintings. In contrast, the Boulogne 1868 (Whatman) sketchbook provided the basis for not only *The Steamboat, Seascape with Porpoises* but also *Study of Ships, Sunset* (plate 26), in which a foreground cutter with only its sails showing is flanked

Fig. 37. Edouard Manet, *Sailing Ships*, 1868. Page from the Boulogne 1868 (Whatman) sketchbook. Graphite on laid paper, 3⅝ × 5⅝ inches (9.2 × 14.3 cm). Musée d'Orsay, Paris, held at the Musée du Louvre, Département des Arts graphiques, Paris. RF 30.554

on the left by a commercial steamship and on the right by a transport schooner with just one topsail displayed—a motif that does not appear in the corresponding drawing (plate 25). This delicately brushed canvas suggests the influence of Japanese prints mediated through the vaporous seascapes of James McNeill Whistler (plates 84–89).[60]

The Boulogne 1868 (Whatman) sketchbook drawings that remain in the original binding are almost exclusively crayon or graphite studies (fig. 36), with the exception of the watercolor study across two facing pages that captures a waxing moon in a cloudy night sky (plate 27). The watercolor is no doubt related to other, lost studies for one of Manet's finest paintings, *Moonlight, Boulogne* (plate 28). The canvas depicts a full moon shining down on a harbor scene that includes women waiting for the return of the fishing fleet, the gleaming water and ships in the port, the burning chimneys in the industrial area of Capécure across the harbor from Boulogne, and the line of dunes lying between Capécure and the open sea.[61] Proust reports that Manet considered this work, which blends the realism of direct observation with a highly sophisticated composition and an exquisite balance of dark and silvery tones, to typify his straightforward, "honest" approach to painting.[62]

The crayon and graphite drawings from the Boulogne 1868 (Whatman) sketchbook are quick indications of figures on the beach or the jetties. Manet used the sketches on the early pages for *The Beach at Boulogne* (plate 32). Virtually every figure in this painting is based on a drawing in the sketchbook (plate 31; fig. 39). To compose this picture, whose perspectival relationships are impossible and whose construction seems almost naïve, Manet redraws men, women, children, and animals from the sketchbook on the canvas with barely a change and touches the resulting figures with color. The smartly dressed mothers and children, the man with a parasol, the bathing machine, and the donkey for hire suggest that we are in the vicinity of the beach club, perhaps on the terrace behind it, with the jetties and the entrance to the harbor just out of sight to the left. (A postcard from about 1900 [fig. 38] indicates that, however much the beach club building had changed, the scene on the beach had changed very little by the beginning of the next century.) The ships in the background of the painting are as varied as the figures on the strand: a two-masted vessel, perhaps a pilot boat, at anchor to the left; a yacht in the distance; a steamer on the horizon; a commercial clipper even farther out; and a brown-sailed fishing boat heading for home in the northeasterly wind that tugs at the figures' clothes.[63] The elongated rectangle of this canvas is a true "marine" format that is highly unusual for Manet and that suggests a connection with the elongated format of Japanese woodcut triptychs, which often feature beach scenes.[64]

Fig. 38. *Boulogne-sur-Mer: The Beach Club and the Beach*, c. 1900. Postcard. Bibliothèque municipale, Boulogne-sur-Mer

80 BOULOGNE-SUR-MER. — Le Casino et la Plage. — LL.

Fig. 39. Edouard Manet, *Young Woman with a Parasol*, 1868. Page in the Boulogne 1868 (Whatman) sketchbook. Graphite on laid paper, 5⅝ × 3¹¹⁄₁₆ inches (14.2 × 9.5 cm). Musée d'Orsay, Paris, held at the Musée du Louvre, Département des Arts graphiques, Paris. RF 11.169 (6r)

Turning his book around and working from the back, Manet sketched a girl with a parasol—her dress has a distinctly scalloped hem—and figures on the jetties, including a man with a telescope (figs. 39, 40). The artist used the girl twice: in *Jetty at Boulogne* (plate 30), where she stands with a young boy on the eastern jetty looking down at the sea in front of the beach club, and in *The Beach at Boulogne* (plate 32), where she stands with only slight modification beside the mother whose small child sits on the sand. The man with a telescope on the jetty is placed in the painting so that his outstretched arm and telescope parallel the line of a ship's boom at the left edge.

Near the middle of the bound book are several detailed drawings, one heightened with watercolor, that record the structure of the jetties and their cross-braced wood pilings (fig. 41). Manet used these studies for two paintings (plates 29, 30) that underline his ability to make an everyday scene or view into an intensely experienced slice of life and to project it as a masterly two-dimensional construction of line and color on canvas. The smaller of the two, *Jetty and Belvedere at Boulogne* (plate 29), offers the more complex and animated view: the end of a stone bastion and continuation of the wooden jetty, the restaurant with its rooftop deck and diners, and the cabin built over an oyster bed to the right. These features can all be seen in a photograph by Charles Grassin (fig. 42).[65] In *Jetty at Boulogne* (plate 30), the view of the piers that lie parallel to the picture plane is no doubt located farther along, between the restaurant and the end of the eastern jetty. In spite of the vivid realism of the drawings sketched from life, the painting is a fiction. While the group of figures looking down at the trawler moored beside the jetty is credible, the hull of the ship is too low and the mast is too high, which suggests that Manet altered them for aesthetic reasons. The view of the second jetty behind the first is impossible, but the horizontal and vertical elements, taken together, produce one of the most perfectly balanced compositions that Manet ever achieved. That he reworked his composition until he attained the balance he sought is seen from the almost obliterated trace of a tall ship whose mast and rigging rose to the very top of the canvas on the right.[66] In both paintings, ships of various types, based on drawings from his sketchbook (figs. 36, 37), float on the distant sea.

Fig. 40. Edouard Manet, *Five Figures on the Jetty*, 1868. Page in the Boulogne 1868 (Whatman) sketchbook. Graphite on laid paper, 3¹¹⁄₁₆ × 5⅝ inches (9.5 × 14.2 cm). Musée d'Orsay, Paris, held at the Musée du Louvre, Département des Arts graphiques, Paris. RF 11.169 (8r)

Fig. 41. Edouard Manet, *Study of the Jetty Piles*, 1868. Page in the Boulogne 1868 (Whatman) sketchbook. Graphite on laid paper, 5⅝ × 3¹¹⁄₁₆ inches (14.2 × 9.5 cm). Musée d'Orsay, Paris, held at the Musée du Louvre, Département des Arts graphiques, Paris. RF 11.169 (30v)

The atmosphere is limpid, the colors are clear and clean, and the darker tones of the sea are rich and translucent, an effect that Manet enlivens in *Jetty at Boulogne* (plate 30) by delicate scraping with the end of a brush. The artist's treatment of the figures on the piers may have been influenced by such Japanese prints as Hokusai's celebrated view of Mount Fuji from a temple terrace, but the clarity and sharp focus of Domenico Ghirlandaio's fresco *The Visitation* in Santa Maria Novella in Florence, which shows three people leaning over a wall, is a more plausible source of inspiration, since Manet copied the fresco on his visit to Italy in 1857.[67]

Bathers and Boats, Boulogne (plate 33), a double-page watercolored drawing from the Boulogne 1868 (Whatman) sketchbook, suggests that the oil painting *On the Beach at Boulogne* (plate 34) and the gouache and watercolor drawing *Seascape with Bather* (plate 35) should be related to Manet's 1868 visit to Boulogne.[68] In its fluid handling and fleshy treatment of the women's figures, *On the Beach at Boulogne* recalls both the image of Diogenes beside the sea in the background of Manet's 1860 lithograph of Emile Ollivier[69] and Japanese prints of *awabi* (abalone) divers,[70] while *Seascape with Bather* combines a figure from *Bathers and Boats, Boulogne* (plate 33) with the motif of a sailing ship in the small Boulogne 1868 sketchbook (plate 23). The ships crowding the horizon in *Bathers and Boats* also suggest a close connection with *Sailing Ships at Sea* (plate 38), the swiftly painted canvas of a fleet of fishing boats driven by a strong southwest wind toward the harbor entrance, their movement enhanced by the white-capped waves. The effect is so lively and present that one wonders whether the canvas was painted on the spot, perhaps from the vantage point of the dune de Châtillon. A smaller canvas, *Sailing Ships and Seagulls* (plate 37), and a signed watercolor, *Seascape with Sailing Ships* (plate 36), might also have been painted on the spot, but it seems more likely that they were made in the studio from informal sketches. Another seascape with a high horizon line and two sailing ships far out at sea is seen in a contact print from one of the glass negatives made by Fernand Lochard (fig. 43), whom Léon Leenhoff contracted to photograph the contents of Manet's studio after the artist's death in 1883.[71] Some additional works are probably related to this same summer in Boulogne. The precisely drawn *Ship's Deck* (plate 42) is not far removed in style from *Jetty at Boulogne*,[72] and the forest of masts and figures on the quay in *The Port at Calais* (plate 43), which was presumably based on sketches made during an excursion to that town, suggests the bustle of a busy harbor.

Fig. 42. Charles Grassin, *Steamers between the Jetties* (detail), c. 1880s. Albumen silver print. Château-musée de Boulogne-sur-Mer

Writing to the painter Henri Fantin-Latour from Boulogne on August 26, 1868, Manet told his friend that he had no intention of getting involved in large-scale works and that he simply wanted to make money.[73] Many of the seascapes that resulted from this protracted stay in Boulogne must have been painted with that end in mind. Seascapes were eminently salable. That the strategy was successful is suggested by the fact that five of the twenty-six paintings that Paul Durand-Ruel purchased from Manet in January 1872 (including *The Battle of the U.S.S. "Kearsarge" and the C.S.S. "Alabama"*) were seascapes, and in March 1873 the dealer purchased another four seascapes: *Jetty and Belvedere at Boulogne* (plate 29), *Jetty at Boulogne* (plate 30), *Departure of the Folkestone Boat* (plate 45), and *View in Holland* (plate 56).

There is no documentary evidence that Manet visited Boulogne after 1868, but the possibility arises with respect to three major paintings: *Departure of the Folkestone Boat—The Large Study* (plate 44), *Departure of the Folkestone Boat* (plate 45), and *Croquet at Boulogne* (plate 48). As we have noted, Manet began *The Large Study* in 1864, set it aside, and returned to it after reworking *Departure of the Folkestone Boat*, which seems to owe its origin to the 1868 visit. The many figures in *Departure of the Folkestone Boat* and *Croquet at Boulogne* are based on a series of succinct—even telegraphic—graphite drawings, some of which are enlivened with watercolor.[74] Summary outlines and quick, expressive scribbles capture figures in the crowd waiting for or hurrying to board the Folkestone packet, details of its stern and its helmsman, and the movements and postures of men and women playing croquet (plates 46, 47). Earlier and later sketches of figures on the quay clearly were made with *The Large Study* in mind.[75] Until the two *Departure* paintings can be fully examined, we can only speculate on their precise relationship. For the present, we suggest that Manet probably began work on the smaller *Departure* (plate 44) in 1868, with a view to reworking the larger, earlier picture. He may then have set aside both works until after the disruptions of 1870–71.

The bound Boulogne 1868 (Whatman) sketchbook in the Louvre (plate 31; fig. 36) includes many blank pages, so it seems unlikely that the small *Folkestone Boat* and *Croquet* sketches (plates 46, 47) were made at the same time. Moreover, the drawing styles are

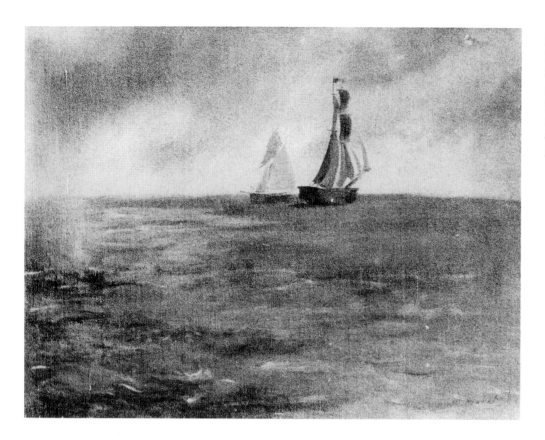

Fig. 43. Fernand Lochard, photograph taken in Manet's studio of the oil painting *Two Sailing Ships at Sea* (RW 200), 1883. From an unmounted albumen contact print, 3½ × 5⅛ inches (9 × 13 cm). Bibliothèque nationale de France, Paris. Département des Estampes et de la Photographie. S.N.R. Manet, boîte 6, micr. P190795

very different—still rather angular and sometimes deliberately awkward in the former, swift and fluent in the latter, which appear to be later in date. We know that Manet spent two months in Boulogne in the summer of 1868, but there is nothing to suggest that the family returned in 1869.[76] We discuss the family's travels in 1870–71 in the next section.[77] Manet visited Holland in June 1872, which would not preclude a later visit to Boulogne. Between 1873 and 1876, his summers are well documented. The sketches could have been made in the course of a brief visit to the coast, perhaps even a weekend excursion, since they include both friends and members of the artist's family.

Croquet at Boulogne appears to be all of a piece and has few visible alterations.[78] The ostensible subject is the fashionable game of croquet, newly imported from England.[79] Into this lively, witty composition, Manet has woven figures from rapid sketches that include studies of Léon Leenhoff, now a smart young man in a felt hat who stands at center foreground in the painting.[80] Immediately to his left, holding a croquet mallet behind her back, is Jeanne Gonzalès, the fashionably dressed sister of Manet's "pupil," the painter Eva Gonzalès (plate 47a).[81] Manet's friend Paul Roudier, with bowler hat and cane, turns his back on the croquet players and looks out at the viewer as two small dogs, one black, one white, gambol into the picture from the left. Gonzalès in profile and Leenhoff in three-quarter rear view direct our gaze toward two elegant sportswomen, one of whom raises her mallet to smack an unseen croquet ball. The women frame two more distant figures: a seated woman and a man who trains his telescope on the sailing ship that lies between the heads of Roudier and Gonzalès—a gesture that brings the viewer's eye full circle back to the foreground. The sea, which is dotted with lightly sketched ships, and the flagpoles that mark the unseen beach below are as important to the picture's effect as are the figures in its foreground. A strong southwesterly breeze flattens the stream of smoke from the distant steamer, tugs at Jeanne's skirts, whips through the flags, and compels the faceless woman across from Leenhoff to clutch at her toque—movements that invest the painting with a sense of cool salt air—while light floods the swiftly brushed

Fig. 44. Edouard Manet, *Study for the Captain of the Folkestone Boat*, 1864. Page from the Boulogne 1864 sketchbook (watermark *Joynson 1864*). Graphite on laid paper, 7¾ × 4⅞ inches (19.7 × 12.4 cm). Musée d'Orsay, Paris, held at the Musée du Louvre, Département des Arts graphiques, Paris. RF 30.537

sky from a point on the horizon just above the protagonists. The work can be viewed as a deceptively informal, highly sophisticated variant on Monet's *Garden at Sainte-Adresse* (plate 98). The composition combines depth and surface in its thinly applied parallel bands of local color—greens separated by the yellow stripe of the path, the blue of sea and sky—overlaid and enlivened by vivid, sketchy brushwork. The looser, freer style and the radiance and luminosity of the atmosphere in these paintings foreshadow Manet's version of Impressionism that flourished briefly in 1874.[82]

Departure of the Folkestone Boat—The Large Study (plate 44) was begun in 1864, cut down and extensively reworked, but never finished. While the artist left the sidewheel steamer relatively untouched (fig. 44), he adapted the scraped and repainted figures on the quay from figures in *Departure of the Folkestone Boat*, which are painted in a much looser, more Impressionistic style.

Departure of the Folkestone Boat (plate 45)—probably begun in 1868 and recognizably dependent on the structure of the steamer in *The Large Study* — shows clear signs, confirmed by its x-radiograph, that the sidewheel steamer and the crowd were extensively reworked.[83] The principal figures on the quay, freely brushed over areas of scraped or reworked canvas, were all based on Manet's little sketches (plate 46), which also include studies of the stern of the boat and the man at the wheel, features that do not appear in the large painting. The exact location of the scene is unclear. The coastline shown in the background, most notably the declivity between grass-topped dunes, does not appear to be the view from the quai des Paquebots in Boulogne, and Manet may have altered it for aesthetic reasons.[84]

These two paintings of an activity central to Boulogne's port, the arrival and departure of Channel packet steamers, span the period of Manet's known visits to Boulogne in the 1860s and perhaps extend beyond them into the 1870s. The fact that Manet sold *Departure of the Folkestone Boat* to Durand-Ruel in March 1873 suggests that it was still unfinished when he sold twenty-six pictures to the dealer in January 1872. Summer of 1872 therefore seems a likely period for Manet to have visited Boulogne to engage in the feverish sketching that enabled him to both rework and complete a picture probably started in 1868 and to undertake major revisions to an earlier work that for some reason were never completed. If this is the case, these paintings confirm the gradual development of Manet's seascapes from the solidly crafted studio compositions of 1864 to pictures that are just as tautly constructed but whose brushwork becomes increasingly loose. These lively, intimate canvases, which reflect the artist's own social scene, indicate the direction that his art was to take in the 1870s.

Manet's Travels in 1871

Throughout the 1860s, Manet worked primarily in his Paris studio on the rue Guyot, gaining increasing notoriety for his Salon paintings. In the summer of 1867, he challenged the public and critics alike by holding a large retrospective exhibition of his work in a temporary structure near the Exposition universelle, the world's fair that brought thousands of visitors to Paris. That summer also saw a major affront to the international prestige of Louis-Napoléon. In June, the Austrian archduke Maximilian, whom Louis-Napoléon had placed on the throne of Mexico at great cost to French army forces, was executed by a firing squad near Querétaro. As soon as the news reached Paris in July, Manet began the first of three large paintings of the execution.[85] This blow to the French emperor's foreign policy encouraged the republican opposition at home and France's enemies on

the Continent. France declared war on Prussia in July 1870, and by early September, after Louis-Napoléon and his forces surrendered at Sedan, the Prussian army was advancing on Paris. Manet's life was about to change profoundly.

As enemy troops surrounded the capital, the artist closed his studio, entrusted several of his finest works to his friend Théodore Duret, and sent his wife, his mother, and Léon Leenhoff to safety in southwestern France.[86] He and his brothers Eugène and Gustave joined the national guard and endured the rigors of a particularly cold winter, which were increased by the lack of fuel and food. On January 26, 1871, the provisional government signed an armistice with Prussian military authorities. Many of the middle-class and upper-middle-class men who had remained in Paris to defend it took advantage of the temporary lull to leave the city. Manet was one of them, but he took his time about it—perhaps because he wanted to vote in the February 8 elections to select a new National Assembly. In any case, by February 9 he had made up his mind to join Suzanne, Eugénie, and Léon at Oloron-Sainte-Marie.[87] It was the start of Manet's longest absence from the French capital, a period of some four months of traveling that also marks a decisive break with his artistic practice of the 1860s.

Manet left Paris for Oloron at some point after February 11.[88] According to a February 22 letter from Suzanne Manet to Eva Gonzalès, he reached that small town in the foothills of the Pyrenees—a distance of some five hundred miles from Paris—on or around February 15. Suzanne adds that she found him much changed after the ordeal of the siege but that he had begun to paint again to his great delight. In the same letter she tells Gonzalès that the family planned to leave Oloron for Arcachon, near Bordeaux, on March 1, so that her husband would be better able to keep up with things.[89] Manet addressed a letter to Duret from Arcachon on March 6 and letters to Félix Bracquemond and Duret on March 18.[90] He dwells chiefly on the art business—forthcoming shows or rumors of shows, the associated formalities, the pictures that he might send—but he also offers opinions on the very fluid political situation. For example, he informs Bracquemond that, on a visit to Bordeaux the previous week, he ran into Albert de Balleroy, with whom he had shared a studio in the early 1860s and whom voters in the Calvados department had elected to the National Assembly on February 8. Balleroy took him to the Assembly, which was temporarily seated in Bordeaux's Grand Théâtre. Manet was deeply disappointed: "I never imagined that France could be represented by such doddering old fools, not excepting that little twit Thiers who I hope will drop dead one day in the middle of a speech and rid us of his wizened little person."[91] On March 28 Suzanne informed Gonzalès that the family planned to leave Arcachon on April 1 for a two-week stay in Bordeaux.[92]

Léon records that from Bordeaux the family took the steam ferry to Royan, where they spent an unspecified number of days. Everyone but Edouard was seasick, so he alone visited "the tower" (most likely the Cordouan lighthouse). After that, the family headed up the coast, spending two days in Rochefort, one day in La Rochelle, and two days in Saint-Nazaire before stopping in Le Pouliguen for a month. After Le Pouliguen, they spent a week in Tours before returning to Paris, most likely during the first week of June.[93] The fact that Léon has nothing to say about their mode of transport after Royan probably means that they traveled by rail—especially since all the towns that they visited were stops on the Paris–Orléans line. Léon notes that Manet executed "three or four" paintings in Oloron and "two or three" paintings in Arcachon; in Bordeaux he "painted only the port." Of the other stops, Léon says only that Manet did not paint in Le Pouliguen.[94]

Bordeaux
Situated on a four-mile-long bend in the Garonne River, Bordeaux was as old as Boulogne but larger, more populous, and more prosperous than the Channel town.[95] An English guidebook published in 1870 praised the view from both ends of the long arc: "No city in Europe can display a more splendid water-front than this. The river abreast of the town, 2000 ft. wide, and 18 to 30 ft. deep, is filled with shipping up to the magnificent *Bridge*, the handsomest in France. . . . Nothing can be finer than the view of the long crescent quay of Bordeaux and the broad river crowded with shipping, many of them 3-masted vessels, as the steamer casts off from the quay opposite the rostral columns and skirts the Faubourg des Chartrons."[96] Separated from central Bordeaux by the place des Quinconces, the largest of its many public spaces, the Faubourg des Chartrons was the center of the wine trade. The English guidebook just mentioned juxtaposes its description of this neighborhood with "one of [Bordeaux's] most conspicuous, and at the same time handsomest buildings, the Grand Théâtre," the temporary home of the National Assembly.[97]

Manet is known to have completed only one painting during his stay, *The Port at Bordeaux* (plate 49), but it is a masterpiece and one of his most spectacular works.[98] In both subject matter and composition, it has links with the tradition of topographical painting launched in France in the eighteenth century with Joseph Vernet's series of ports (see fig. 9) and revived in the nineteenth century by such artists as Louis Garneray (1783–1857), Charles Mozin (1806–1862), and Jules Noël (1815–1881), whose *Port of Brest* (Musée de Brest) Manet may have seen at the 1864 Salon.[99] Although Manet employs some of the same strategies that Noël uses in his "explicitly nationalistic and imperialist . . . celebration of France's naval power"—including emblematic buildings and stretches of open water that lead the eye in a desired direction—*The Port at Bordeaux* belongs to a very different world.[100] His semiformal presentation in *U.S.S. "Kearsarge" off Boulogne* (plate 11) of 1864 was already couched in a new pictorial language. A "traditional" profile presentation of a naval vessel, it nevertheless lacked the fine detail normally associated with such depictions. Moreover, the artist relegated the vessel to the background, placing it against an unusually high horizon and a seascape in which the dramatic, head-on advance of a fishing boat in the foreground distracts the viewer's attention from the ostensible subject and concentrates it instead on the painterly qualities of a vast expanse of sea. *The Port at Bordeaux* recalls Manet's moonlit harbor with fisherwomen at Boulogne of 1868 (plate 28), the workaday *Port at Calais* (plate 43), and the livelier, more fashionable scene of *Departure of the Folkestone Boat* (plate 45), with its bales of merchandise stacked beside well-dressed tourists on the quay. Here, in this bright, daylight depiction of one of France's busiest ports, workmen roll barrels (most likely of wine) up and down the gangplank of a *gabare*—the small, flat-bottomed transport boat moored with dropped sail beside the quay. Below the boat, Manet has inscribed the name *Bordeaux*—a rare occurrence that seems intended to emphasize the specificity of his subject.

The picture is said to have been painted from the quai des Chartrons, but the precise viewpoint has been difficult to identify. The twin spires of Saint André Cathedral are unmistakable. However, the massive shape to its left—the true focus of the picture—has resisted identification. Painted in soft violet-blue, it appears to have a tower or multiple spires. If the viewpoint for the picture is taken to be a position on the quai des Chartrons somewhere near present-day cours du Médoc, the clearing on the quay in the foreground draws our eye across the water into an empty space between a boat and the red-painted smokestack of a tug, then up a vertical element that could be one of the two rostral columns on the river side of the place des Quinconces, over the site of the Grand Théâtre and on toward Tour Pey-Berland, the fifteenth-century bell tower behind Saint André Cathedral. The shape to which our attention is thus directed might be explained as a conflation of tower and theater in the hazy distance. A graphite and watercolor drawing that

Fig. 45. Edouard Manet, *The Port at Bordeaux*, 1871. Watercolor and graphite on wove paper, 7 1/16 × 9 7/16 inches (18 × 24 cm). Collection unknown. Reproduced from Kurt Martin, ed., *Edouard Manet: Aquarelle und Pastelle* (Stuttgart: Deutsche Verlags-Anstalt, 1958), plate 9

must have served as a study for the painting (fig. 45) shows the two buildings more clearly separated and suggests that, in the oil painting, Manet displaces the cathedral spires to the right and makes other modifications in the view. What significance might this particular view have had? As noted, Manet visited the Assembly in session and was not impressed. His own political sympathies at this juncture in French history are hard to read, but Proust records a discussion between Manet and the painter Alexis-Joseph Mazerolle in which Manet rejected the notion that the army was responsible for the nation's defeat. The soldiers were simply doing their duty, he argued.[101] Are the workers with whom Manet fills the foreground of his painting walk-ons or extras in this picture of a busy port? Or does Manet contrast their purposeful concentration on the tasks at hand with church and state as represented by the distant spires of the cathedral and the hazy form of the current, very temporary seat of France's government?

Arcachon

The Manet family arrived in Arcachon, a small town southwest of Bordeaux, on March 1, 1871. Located on the southern edge of the Bay of Arcachon, the town is sheltered from Atlantic storms by Cape Ferret, a long, low spit of sand dunes and pine trees whose lower end, about a mile west of the mainland, is marked by a tall lighthouse. The ocean floods

Fig. 46. Photographer unknown, *Arcachon—View from the Grand Hôtel,* 1870. Albumen silver print, 4¹⁵⁄₁₆ × 7¹⁄₁₆ inches (11 × 18 cm). Société scientifique d'Arcachon

and drains the bay through a channel full of sandbars. In the early 1860s, the water level in the bay changed by as much as fifteen feet every day. "At high tide, the surface of the bay is a huge sheet of green water that seems to dissolve into the marshy land around it. A single patch of dry land, which the eye has trouble separating from the long light and dark streaks reflected from the sky on the water as it moves to unseen currents, emerges from the waves: Bird Island [île aux Oiseaux]."[102]

Until the railroad line from Bordeaux to La Teste-de-Buch opened in 1841, Arcachon was frequented only by fishermen and *résiniers*—men who tapped and collected resin from pine trees.[103] The railroad brought families from Bordeaux to Arcachon's fine sand beaches. When the Bordeaux–La Teste line was extended to Arcachon in 1857, people started to build summerhouses for their own use and as investments. Arcachon's future as a resort community was secured when the Chemins de fer du Midi, headed by Emile and Isaac Pereire (natives of Bordeaux), acquired almost a thousand acres (400 hectares) of pine forest on the dunes south and west of the principal beach. Emile Pereire built himself a villa at the west end of the tract near the sea. By 1863 the forest at the water's edge had been replaced by exotic and fanciful structures reflecting a great variety of styles and surrounded by gardens. Beyond the gently sloping white sand beach, pleasure craft and fishermen's boats rode the waters of a deep channel. To the north, Bird Island and the coastal hamlets of Arès, Lanton, and Audenge would have been visible as gray streaks just above the surface of the bay, while the wooded spur of Cape Ferret to the west of Arcachon stretched in a north-south line between bay and sea, whose roar could almost always be heard in the distance.[104] A photograph from 1870 shows the seafront stretching east from the newly built Grand Hôtel (fig. 46).

The Manets rented a chalet from a Bordeaux doctor named Servantie on the avenue Sainte-Marie, at what was then the west end of town. The chalet, built between 1867 and 1869, occupied a small triangular plot next to a larger villa built in 1864.[105] Its modest size is confirmed by Manet's remark to Duret that they could put him up for a night if he brought no one with him but Manet's brother Eugène, and by a postcard view of the chalet some thirty years later (fig. 47).[106]

Fig. 47. *Arcachon—Les Villas de la Plage du Boulevard de l'Océan* (chalet Servantie is on the right), c. 1900. Detail from a postcard. Private collection

The chalet Servantie was the Manet family's home for the month of March 1871. It was here that the artist, looked after by his wife and mother, finally recovered from the privations of the siege of Paris. The closeness of this family group is reflected in the complex drawing, begun in pencil, then watercolored and completed in pen and ink on facing pages of a sketchbook (plate 51). Just visible in the original graphite sketch, Léon, wearing a hat, stands at the open French window of the chalet reading a letter; the chair to the right of the table was empty. To the left, the noticeably plump form of Suzanne Manet sits in an armchair facing away from us.[107] Pen in hand, ink bottle on the table beside her, she concentrates on her letter writing. When Manet decided to seat Léon in the empty chair, he drew the figure in

ink with pen and brush; the watercolored chair back is visible through his chest and on the hand that holds books or papers on his lap. Manet posed him with his right elbow resting on the table, hand holding an unknown object. Through the glazed doors that open onto the terrace, a little cabin, typical of Arcachon seafront villas, is visible on the left; a figure in graphite, half-erased, is now set behind ink-drawn iron railings; and a *pinasse*—the distinctive local flat-bottomed boat—lies partly under Léon's hand. Another *pinasse* on the bay, sailing toward the channel to the ocean, is the focal point. Behind it we see the dunes of Cape Ferret and the sandbanks that emerge when the tide falls. Of all Manet's preparatory drawings, this one is perhaps the most energetically worked up, its mix of techniques reflecting the radical changes that it underwent.[108] At some presumably later date, Manet transferred to canvas the design that finally emerged from this much revised and fully worked-out sketch. The painting (plate 52), which Manet may have left unfinished and which is unsigned, shows a somewhat different interior space.

The bay, glimpsed through the open window, would have been broadly visible from the terrace beyond, and Manet probably painted many of his Arcachon views in the immediate vicinity of the chalet, an area that was, in the early 1870s, still largely undeveloped.[109] Only three of Manet's views of the bay include architectural features. Of these, the one with a singular, tall element on the distant skyline to the left (plate 53) is the easiest to identify: Undescribed by Manet's several cataloguers, this structure is the lighthouse at the southern end of Cape Ferret. Manet reduces his composition to its simplest elements: land and sea, the distant lighthouse, a two-masted fishing boat out on the water just left of the picture's visual center, and four beached *pinasses* in the foreground. Light and color are as subdued as the forms: gray on gray with a slight rosy light suggesting the dying day over the dunes to the west, a background brushed with horizontal strokes over which Manet added the boats in fluid touches of deep black.

Boats are the subject of another of Manet's Arcachon canvases (plate 55). Here, they fill the middle ground of the composition. The vessels farthest back from us still seem to be afloat, but most appear to be beached at low tide, tilting at steep angles on the sand. From a low viewpoint, presumably on the beach, the artist focuses on the three *pinasses* in the foreground. Two are at rest and vacant. Two men are still busy with the third at the water's edge.[110] Sand, sea, and sky merge in the hazy light of this shallow, almost inland sea. The picture is structured only by the rhythms of hulls, masts, and rigging in a subtle patterning of reflected light and misty distance. This exquisite small picture and another (fig. 48) were acquired by Thomas Wiltberger Evans, dentist to the crowned heads of Europe but better known to Manet and Stéphane Mallarmé as their mutual friend Méry Laurent's well-heeled "protector." The intimacy, variety, and formal inventiveness of such works take them far beyond the category of dealer pictures and suggest that each work came into being as the artist's response to a particular visual stimulus.

While Manet may have observed the beached boats in the fishermen's district on the sheltered, eastern edge of Arcachon near La Teste-de-Buch, his best-known Arcachon view (plate 50) was no doubt painted in one of the gardens that ran down to the water's edge not far from the Manets' chalet. Framed by pruned and still leafless trees in the foreground, a variety of ships sail or ride at anchor in the bay—a small steamer to the left, a handsome schooner-brig in the center surrounded by sailing ships of different sizes. Behind them is the low, undulating outline of Cape Ferret. The picture is structured with sweeping brushstrokes in muted tones of brown and beige, green and blue. The thinly washed sky has a luminosity that conjures up the cool ocean breezes of early spring.

These pictures could have been and probably were painted largely on-site, perhaps Manet's first true series of *plein-air* pictures. He did not need to stray far to find his subjects, and small canvases like these would have been easy to transport. Two of the paintings

(plate 54; fig. 48) show a very similar view: a stretch of beach with buildings at the far end, near the right edge. Although they are not exactly the same size, they are still for all intents and purposes pendants offering the classic contrast of fair-weather and foul-weather scenes. The slightly larger work (fig. 48) shows blue-gray storm clouds rolling in from the Atlantic over the low-lying dunes of Cape Ferret.[111] Clouds swirl dramatically over the beach to the right to create the impression of a breaking or clearing storm. Two ships at anchor sway in the wind as fishermen hasten to secure their *pinasses* or head out, straining at the oars of a *grande pinasse de côte*.[112] A group of sketchily defined buildings suggests a two-story gabled villa and one of the masts used in French ports to signal the state of the tide.[113] Beyond or adjacent to these constructions stands what appears to be a rounded gray stone tower or buttressed terrace protected by planks or perhaps with wooden steps leading down to the beach. The coastline seems to turn away to the right, and it is possible that the view was taken some way down the coast from the chalet Servantie. The intensity of this picture indicates the speed with which the artist worked.

The fair-weather picture (plate 54) is as sunny and delightful as the foul-weather scene is dramatic. The tone is set by the red-hulled boat just left of center: Conjured up in three or four swift brushstrokes, it is accompanied by two white birds, one flying, the other on the water, its body a blob of yellow paint with head and long neck a thin filament of white. Again, we cannot be certain of the location, but the buildings to the right may represent a closer (and clearer) view of those shown in the foul-weather view. Dabs of yellowish pigment between the red-hulled boat and the vessel to its right indicate Bird Island. Manet "catalographer" Adolphe Tabarant characterized the constructions on the beach as walls, a semaphore tower, and a building with a pointed roof. Manet has obscured with swift brushstrokes the buildings at the extreme right edge, where only the red, white, and blue tricolor is clearly defined. The buildings themselves and the angled, probably wooden elements that seem to rise from the beach and sea on either side defy analysis at present. Two windswept figures and litter on the beach evoke the force of Atlantic winds, but until

the storm clouds roll in again the fine weather holds sway. Manet has captured the essence of the scene with an astonishing directness and economy of means, yet even in so swift and spontaneous a sketch as this there is some indication the painter made alterations in the foreground to enhance the composition. The brushstrokes, pure or with colors blended on the canvas, are dashed and dragged across the surface with consummate assurance, generating an invigorating effect of wind, waves, and fine weather.

Although Léon Leenhoff's notes on the Manet family's travels in 1871 credit Manet with no more than "two or three canvases" during his month-long stay in Arcachon, six paintings are known today. How could Léon have so underestimated Manet's production? Most seem to have been sold or given away during the artist's lifetime, so Léon would not have encountered them when he inventoried the contents of the artist's studio. Moreover, all the Arcachon paintings now known are small, not the kind of works that would have been in demand for exhibitions. Finally, the Bordeaux painting and most of the Arcachon works are still in the hands of private collectors or family foundations. Little known as they are, the Arcachon pictures prove to be a crucially important portion of Manet's artistic production, and we are fortunate to be able to present them here.

Holland

Manet is known to have visited Holland at least three times: in 1852, as an art student; in 1863, when he married Suzanne Leenhoff; and in 1872, when he and his brother-in-law, the sculptor Ferdinand Leenhoff, signed visitors' books at the Frans Hals Museum in Haarlem on June 26 and the Rijksmuseum at the Trippenhuis in Amsterdam the following day.[114] We do not know what prompted Manet's visit to Holland in 1872 or how long he stayed. The only anecdotal evidence is Proust's statement that Manet, on his return from Holland, reiterated his admiration for Johan Barthold Jongkind's studies (études) of the landscapes and seascapes of his native country.[115] Manet may have undertaken the trip as a result of contact with Claude Monet (fig. 49), who spent the summer and much of fall 1871 in Holland.[116] Monet stayed in Zaandam, near Amsterdam, painting views of wide expanses of water and the adjacent windmills. In May 1872 Durand-Ruel purchased a number of these pictures, including a *Windmill near Zaandam* (plate 104) that is very close to the prospect Manet would paint.

Manet's *View in Holland* (plate 56) is said to have been painted in Amsterdam, but no evidence has been offered to support the claim, and the picture itself belies it.[117] Manet supplies little topographical information that would help us—or a contemporary Dutch viewer—to identify the site. (Monet's views of the Zaan, in contrast, note such details as vegetation and mooring posts and give us an unmistakable sense that they were painted in a particular kind of light at a particular time of day.) The painting certainly does not depict an urban setting. Moreover, the sky is purely conventional—a "studio" sky that we find in many of

Fig. 49. Edouard Manet, *Portrait of Claude Monet,* 1880. Brush and India ink with white gouache on laid paper, 5½ × 4⅞ inches (14 × 12.5 cm). Private collection

Manet's paintings from 1864 onward. Finally, the water has none of the transparency or play of light that are such essential parts of Monet's paintings. However, what Manet's painting lacks in topographical or meteorological specificity, it gains in superb visual structure. The water line divides the picture plane into two equal horizontal halves. Diagonally across this otherwise peaceful surface Manet places two large sailing barges, one in the foreground, one in the middle ground. Their booms and sails slash dramatically across the canvas, carrying our eye to the windmill on the far shore and the striking Saint Andrew's cross formed by its blades. The craft in the background, including the small but conspicuous steamer between the two barges, complement the rhythms created by the larger vessels and carry the eye across the picture to the barely sketched windmills at the extreme right. Where Monet strives to capture the most fleeting effects of nature and leaves us sharing his admiration for the scene before him (even when it is clear that he has manipulated or "reconstructed" it), Manet takes raw materials noted in pencil or watercolors, or simply recorded in his remarkable visual memory, and constructs a painting that moves, delights, or intrigues us as the action of an artist's hand translating an idea from his mind's eye to the canvas.[118]

Berck

At least four members of the Manet family visited Berck in the summer of 1873: the painter, his wife Suzanne, his mother Eugénie, and his brother Eugène.[119] Located almost thirty miles south of Boulogne, just north of where the shallow Authie River empties into the Channel, Berck was a fishing community that had barely been touched by the rapid development that was transforming larger seaside resort towns. It had no structure approximating Boulogne's beach club until 1887, and in the 1870s Berck-Plage, as the beachfront community came to be called, had few shops and no organized social life. An advertisement from an 1860 Boulogne newspaper pinpoints Berck's selling points: it was cheap; it had peace and quiet (le calme et la solitude); and life was simple (sans façons).[120] These qualities also added to its attraction as a therapeutic center. As noted earlier, Manet recommended Berck to a fellow painter in 1880 as a place where "you are sure of being well treated."[121]

The area's unique topography is reflected in Manet's paintings, as it is in those of Boudin, Ludovic Lepic (1839–1889), and other artists who came to this coast. Berck was situated at the southern end of a wide, flat beach that ran uninterrupted for nine miles to Le Touquet at the mouth of the Canche River. Although its citizens had relied on the sea for their livelihood since the ninth century, the town had no port. The prevailing west winds that proved such a boon to Berck in the second half of the nineteenth century had dramatically changed its geography in the seventeenth and eighteenth centuries. The little Arche River silted up and disappeared, alluvial deposits drastically changed the course of the Authie River, and sand dunes accumulated along the coastline. By the end of the eighteenth century the church bell tower that had once served as a lookout and a signal for Berck's fishing fleet was a mile and a quarter inland.[122]

In the 1840s, Berck's fishermen began to find themselves sharing the beach during summer months with sea bathers, most of whom came from Boulogne and other points in the Pas-de-Calais. In 1858 Berck-Ville's pharmacist built the first hotel on Berck-Plage. It had a grand name—Hôtel de France et des Bains—but it was quite modest. By 1861 Berck also had a very modest beach club to serve visitors whom we now would call tourists.[123] Berck also attracted medical practitioners from the Paris city welfare system, who were on the lookout for healthful localities to which to send ill children from poor families. In 1861 a Dr. Perrochaud opened a beachfront hospital to serve underprivileged children suffering from scrofula and rickets.[124] The results were sufficiently impressive (or the bureaucratic apparatus was sufficiently relentless) that the Paris public welfare system constructed a much

Vue générale de l'hôpital Napoléon, à Berck-sur-Mer (Pas-de-Calais). — D'après un dessin de M. Rollion, architecte.

Fig. 50. *General View of the Hôpital Napoléon at Berck-sur-Mer*, c. 1869. Wood engraving. Bibliothèque nationale de France, Paris. Département des Estampes et de la Photographie. Va 62, vol. 2

more elaborate establishment, which Louis-Napoléon's wife Eugénie opened on July 18, 1869, as the Hôpital Napoléon (fig. 50).[125] The children's hospitals established Berck as a therapeutic center.

We do not know where the Manets stayed in Berck. Given their habits and social standing, they may have preferred to rent a house in Berck-Ville. The picture that Manet sent to the 1874 Salon as *Les Hirondelles* (*The Swallows*)—the admitting jury rejected it, and we know very little about its early history—was painted near Berck-Ville on the meadow known as La Mollière (fig. 51). The spire just right of center on the horizon is the bell tower of the church of Saint-Jean-Baptiste, which some centuries earlier had been much nearer the sea. This work offers considerably more topographical information than *View in Holland*, and its sky is observed, not conventional. Manet poses his mother (in black) and his wife (in gray) against the lush grass. The way in which the wide expanse of the meadow recedes into the distance and at the same time rises up the picture plane is reminiscent of Manet's seascapes of the previous decade.[126]

Another depiction of the family group shows Suzanne and Eugène lounging on the beach (plate 58). Léon Leenhoff, who was not a member of the party (he was doing his military service), reported years later that the question of Eugène's possible marriage to Berthe Morisot was first broached at Berck.[127] Suzanne, in a coat and fashionable summer hat, reads a small book, while Eugène reclines beside her on the sand in equally smart attire. The shadows cast by Eugène and by Suzanne's red and white espadrille suggest afternoon sun. Grains of sand in the paint indicate that the figures were swiftly sketched as Manet stood or sat beside his subjects on the beach. However, the dark ribbon of sea and ships that lies high on the horizon beyond the breaking waves may well have been added in the studio. The ships head south in a strong northwesterly breeze, their sails creating crisply angular accents that offset the softly rounded forms of the figures while echoing the disposition of their bodies and the black ribbons of Suzanne's bonnet.

The other pictures that Manet painted in Berck are almost exclusively concerned with fishermen and their boats. According to the 1872 census, 40 percent of Berck's citizens relied on the fishing industry for their livelihood,[128] and many more supported themselves by building, maintaining, and outfitting the fishing fleet. In 1873 Berck's fishermen manned somewhere between 120 and 170 boats of all types, open or decked.[129] The absence of a port dictated the shape of the boats used there: These broad, clinker-built vessels had flat-bottomed hulls so they would be easy to beach and would remain upright out of the

water.[130] The bowsprit mast and main lug-sail mast were placed very far forward; the small jigger-sail mast was aft and to port, just ahead of the distinctive, beamed structure that held the lowered mainmast when the boat was beached or was being rowed.

Another feature of Berck's geography determined not what Manet painted but how he painted it: Berck had no pier, no cliffs, and no cliff-top walks. Manet's paintings of Boulogne give us a sense of surveying the Channel and its traffic from some elevation, even if it was only from the beach club terrace. In Manet's beach paintings from Berck, we are down on the sand with the boats and the men who tend them. One canvas, *Fishing Boats, Berck* (plate 59), has such immediacy that it might have been sketched in half an hour. The tide foams around a boat beached in the shallows. In the foreground, a mariner, barefoot in summer gear and straw hat, is perched on a dinghy, while his companion busies himself beyond it. The roughly sketched anchor at the lower right corner of the canvas directs our attention toward the bare-legged figure at the center. It is curious that such a free and vigorous sketch became the property of that most circumspect of painters, Henri Fantin-Latour.

Beached boats are the subjects of two other canvases (plates 60, 63) in which Manet depicts the great expanse of sand that distinguishes this particular stretch of French coastline. Another canvas, one of the most effortless and luminous of all his seascapes, shows four boats beached on the sand (plate 62). We cannot tell whether they have just landed or are waiting to float on the tide. The three vessels tended by fishermen on the left, each with one or more of its sails unfurled, are balanced by the vessel on the right. The vessels face toward us, yet the horizon behind them both swells and curves as if we were looking not at the sea but at a gently rising coastline. The ambiguous shape at the extreme right edge of the canvas—windmill? tree? steamer?—is impossible to read. Perhaps in a tribute to Dutch masters, Manet has signed the painting on a piece of flotsam in the right foreground.

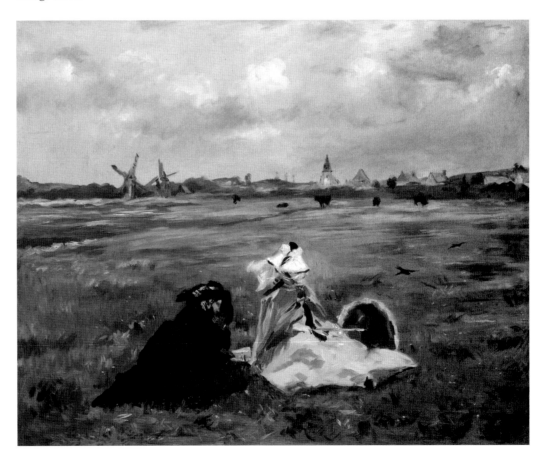

Fig. 51. Edouard Manet, *The Swallows— Suzanne Manet and Madame Manet mère at Berck*, 1873. Oil on canvas, 25⅝ × 31⅞ inches (65 × 81 cm). Fondation E. G. Bührle Collection, Zurich

A far more vigorously composed and brushed canvas focuses on the activity of tarring. Tar was used to keep the wooden hulls of Berck's fishing boats watertight. *Tarring the Boat* (plate 57) shows a medium-size boat keeled over to expose its port side to the torch as two men apply tar from a black cauldron on the sand. The vessel with sails set waiting for the tide at rear left is offset by a patch of empty sea just above and to the right of the workmen. The anchor in the left foreground counterbalances the aggressive tilt of boat and masts. The bold brushwork draws our attention away from the structural geometries of this dramatically composed canvas to its surface, where the artist's conspicuously applied pigment competes for our attention with the observed reality that such works conventionally represent.

A very different canvas, which Manet probably painted after his return to Paris, involves us directly in the harsh reality of the Berck fisherman's life. *Toilers of the Sea* (plate 64), titled after Victor Hugo's novel of 1866, is a studio picture par excellence and was probably intended for exhibition as well as for sale.[131] Manet's realism in this work is less anecdotal than experiential. The painter puts us on board the boat facing the two fishermen in sou'westers, the welter of ropes and sails, and the bare-legged lad handling a basket of fish. The foam and spray that splash up on either side suggest the vessel's plunging motion as the jib strains under the breeze.

Manet did not paint fishermen and boats because no other subjects were available. Boudin's depictions of Berck from 1873 show women and children at least as often as they show fishermen, so Manet's focus is clearly a matter of choice. At the same time, the interest that Manet takes in their activities has little if any ethnographic component. In other words, the fishermen and their boats are motifs—as bathers and croquet players and fishwives and tourists had been motifs in Boulogne. However, he observed and recorded these motifs with a keen eye, as attested by late-nineteenth-century photographs that match both the vessels in Manet's paintings and the activities that he depicts around them.[132] The most notable feature of Manet's Berck seascapes is their lack of a unified style. The painter was plainly curious about the life lived there. But he may also have felt somewhat out of his depth—a city man with little or no direct experience of its hardships and, more critically, no need to experience them himself. From the standpoint of practice, the Berck pictures experiment in a variety of ways, as, for example, in the rough and sketchy brushwork that both depicts and expresses tossing ships and foaming waves as experienced at the water's edge (plate 59) or in the distanced, exquisitely balanced presentation of motifs reduced to their essentials that transforms a beach scene with fishing boats into the visual equivalent of a haiku (plate 62). Although we now appreciate such works from the perspective of the modernist tradition, the Berck seascapes must have appeared distinctly "unpicturesque" in their day when compared with the Boulogne or Arcachon paintings. With the exception of the more colorful and immediately attractive *Swallows*, the Berck pictures of 1873 contrast strikingly with the works that Manet was to paint the following year on the Seine at Argenteuil and in Venice.

Venice

Manet did not go to the seaside in the summer of 1874.[133] Short of money, he ventured no farther than to Gennevilliers, where his family had long owned property, and to Argenteuil, across the Seine from Gennevilliers, where, thanks to Manet's intervention with a property-owning family friend, Monet, his wife Camille, and his son Jean had found lodgings.[134] Out of Manet's visits to this little town came *Argenteuil* (Musée des Beaux-Arts, Tournai), which the artist exhibited at the 1875 Salon, and *Boating* (The Metropolitan Museum of Art, New York), which he sent to the 1879 Salon. It was during this summer that Manet painted his studies of the river and of Monet and his wife and laid in the larger canvases,

which he no doubt finished in his Paris studio.[135] This was also the time when he came closest to adopting the *plein-air* tonality and manner espoused by the Impressionists. Prefigured by one or two of the small canvases painted at Arcachon in 1871 (plate 54) and by what was very probably the early 1870s reworking of the two *Folkestone Boat* pictures (plates 44, 45), Manet's Argenteuil pictures differ markedly from the seascapes painted the year before in Berck, and we encounter their high-keyed, Impressionistic manner again in the two works associated with his visit to Venice during the autumn of 1874.

Tradition hands us two very different accounts of the genesis of *Venice—The Grand Canal (Blue Venice)* (plate 66), the more complex of the two Venice paintings. After Louisine W. Havemeyer's husband Henry bought the picture for her from Durand-Ruel, Mrs. Havemeyer's artistic adviser Mary Cassatt told her that Manet had "been a long time in Venice . . . and he was thoroughly discouraged and depressed at his inability to paint anything to his satisfaction. He had just decided to give it up and return home to Paris. On his last afternoon in Venice, he took a fairly small canvas and went out on the Grand Canal just to make a sketch to recall his visit; he told me he was so pleased with the result . . . that he decided to remain over a day and finish it."[136] The owner of *Blue Venice* loved the story because it supported her notion that the greatest works are executed quickly after a long and painful process of maturation. As she puts it, "Through every hour of discouragement [the painting] was incubating in the cells of his brain, and being nourished by his heartbeats and by the echoes of his sighs."[137]

Charles Toché (1851–1916) tells a different story.[138] Manet allowed the young artist to follow him in a gondola of his own and watch him paint. This experience taught Toché that Manet worked hard to achieve his effortless effects: "To speak only of *Blue Venice*, I don't know how many times Manet started it over again. He spent an inconceivable amount of time on the gondola and the boatman. 'It is devilishly hard,' he said, 'to give a viewer the sense . . . that a boat is put together from planks cut and fitted according to the rules of geometry.'"[139] Examination of the work itself supports Toché's version. While the edges of the canvas are barely covered, particularly on the left, and the water is freely painted with parallel dabs of blue—elements that support Cassatt's contention that it was painted in two afternoons—the background only partly replicates the scene on the Grand Canal. The left half, behind the gondolier, either was left unfinished or was extensively reworked, since it shows buildings that do not correspond to known façades.[140] The most striking elements in this picture are the glossy black gondola, whose complex shape Manet has captured to perfection, and the practiced stance of the gondolier. In spite of the very different style of this picture, boat and boatman recall the vessels and fishermen at Berck (plate 57), as if the painter recognized the kinship between these exotic working boats and the equally idiosyncratic vessels at Berck.[141]

The other Venice picture, *View in Venice—The Grand Canal* (plate 65), appears to be a more direct, on-the-spot sketch, but it is clear that Manet reworked it too: He scraped out the dome of Santa Maria della Salute and repainted it slightly lower and to the left. In this more atmospheric, less finished work, signed by the artist on the foreground gondola, the sun casts the shadow of a mooring post onto the warm surface of an ancient wall.

The Sea Remembered, 1880–81

Manet's last representations of the sea, like his first, draw not on direct or recent observation but on imagination and remembrance. He is not known to have visited a coastal community in France after 1873, so he would have had to draw on his amazing visual memory for his seascapes of 1880 and 1881.

Edouard and Suzanne Manet spent five months, beginning June 1, in Bellevue in 1880. One of many communities to which smart Parisians retired in summer, Bellevue was a

locality (not a proper town) between Meudon, on the left bank of the Seine just down-stream from Paris, and the river. Easily accessible by the Paris–Versailles *rive gauche* train, Bellevue had a noted hydrotherapy clinic (*établissement hydrothérapeutique*), and Manet sub-mitted to treatments there. Much has been surmised about Manet's medical problems, but very little is known. Of his first three biographers, Duret gives the most coherent account and dates the first obvious symptoms to fall 1879.[142] All three memorialists agree that the problem affected Manet's gait and his endurance, but ataxia is only a symptom, not a diag-nosis. Manet treated the symptoms. In 1880, for a man of Manet's social standing, treating the symptoms meant submitting to the ministrations of the "water therapists."[143]

Manet no doubt intended to combine treatment in Bellevue with business, which in his case meant painting pictures, and his letters suggest that he preferred to work outside.[144] Both Bellevue and Meudon had splendid views of Paris,[145] and the dwelling in which the Manets lodged was adjacent to a sizable garden. But the weather that summer was often bad. To pass the time, Manet wrote a great many letters, some of them on paper he had decorated with watercolored motifs, and some to which he added watercolored illustrations as he wrote. The decorations—fruit and flowers, hats and flags, animals and insects—are brilliantly observed, exquisitely colored, and often breathtaking in their concision, while the drawings that illustrate letters can be quite droll. A gossipy and bantering letter to Eva Gonzalès's husband Henri Guérard, who was visiting Honfleur with his wife, is illustrated with sailboats, shrimp, the Manet family cat, a peach, and the bonneted or veiled heads of a young girl, Suzanne Manet, and Manet's mother.[146]

Although the painter's deep affection for his wife Suzanne cannot be questioned, Manet was very fond of pretty young women. They made good subjects for pictures that attracted the attention of collectors. Isabelle Lemonnier, sister-in-law of the publisher Georges Charpentier, was one of Manet's favorite models and the subject of a number of paintings.[147] In the summer of 1880 she was visiting Luc-sur-Mer with her older sister, and Manet sent her many letters from Bellevue.[148] His watercolor of Isabelle in a smart black bathing suit trimmed and belted with red (plate 68) most likely accompanied an undated note asking for news.[149] Manet depicts her in a slightly absurd three-quarter rear view, head down, arms extended, about to plunge into the choppy waters at her feet. Behind her, the sea rises close to the top of the page, where little blue boats tack to and fro. The large gray cloud may have less to do with Luc-sur-Mer than with Bellevue—the letter complains that the weather is almost always bad there.

The subject of the watercolor *Young Woman by the Sea* (plate 67) is another of Manet's favorite young women. Known to us only as Mademoiselle Marguerite, she was related to the Madame Jules Guillemet who posed for Manet's 1879 Salon picture *In the Conservatory* (Nationalgalerie, Staatliche Museen Preussicher Kulturbesitz, Berlin). Mademoiselle Mar-guerite visited Bellevue in the summer of 1880, and Manet painted her several times in a garden setting.[150] It must have been on one of these visits that he sketched her in graphite, seated and resting her chin on her hands.[151] Toward the end of July, Madame Guillemet went off to the seaside, taking Mademoiselle Marguerite with her. A wistful note from Manet urges them to enjoy themselves but not to forget the Bellevue hermits (*les solitaires de Bellevue*).[152] It was no doubt their absence that motivated the watercolor, in which Manet transposes the Marguerite whom he had sketched in the garden onto a beach beside a calm sea dotted with pleasure craft. While the drawing lacks the immediacy of the graph-ite sketch, the delicacy of the watercolor complements its rather pensive mood.[153]

Henri Rochefort's escape from the French penal colony on New Caledonia is the sub-ject of Manet's last seascapes, which, like his first, were thus history paintings. In contrast to *The Battle of the U.S.S. "Kearsarge" and the C.S.S. "Alabama"* (plate 10), we know a fair amount about the genesis of the two *Escape of Rochefort* pictures (plates 69, 71). In 1880, when

Manet began work on them, Henri Rochefort, born Victor-Henri, marquis de Rochefort-Luçay, in 1830, was an international celebrity—less for his writings than for his reputation. In the 1860s he coauthored plays and vaudevilles for the Paris stage and wrote for a number of Paris newspapers, most notably Hippolyte de Villemessant's *Figaro*. Rochefort was a skilled writer, especially when he was being critical, which was most of the time. He made his name—and, some claim, a great deal of money—as a polemicist. Polemicists need something to be against, and Rochefort never lacked for targets. He opposed the Second Empire in its waning days—first in Villemessant's publication, then in his own weekly *La Lanterne*, and later in his own daily *La Marseillaise*. Unable or unwilling to draw the line between polemic and provocation, Rochefort often found himself at odds with civil authorities. Convicted twice for contraventions of the press laws, he left France to publish from Switzerland.

After the collapse of the Second Empire, Rochefort served briefly as an officer of the government of national defense that replaced it, but he had no interest in administration or policymaking and resigned to start a new daily, *Le Mot d'ordre*. For what civil authorities believed to have been its role in encouraging the theft, vandalism, and murder that took place under the short-lived Commune, Rochefort was tried, convicted, and sentenced in September 1871 to exile for life in a fortified place.[154] The republican legislator Edmond Adam and other influential individuals with whom Rochefort had connections managed to keep him in France until 1873, but the balance of power within the nascent Third Republic changed when Adolphe Thiers was replaced on May 23 as head of government by Maurice de Mac-Mahon. Rochefort was finally shipped to the South Pacific in August, reaching New Caledonia on December 10. On March 20, 1874, he escaped with five other individuals, including Olivier Pain, Paschal Grousset, and François Jourde. They were met in Nouméa harbor by an Australian clipper ship whose captain had agreed to carry them to safety.[155] Rochefort and Pain returned to Europe via Australia, Hawaii, the United States, and London.[156] From Geneva, Rochefort revived *La Lanterne*, and in 1878 he revived *La Marseillaise*. His targets were now the leaders of the Third Republic, in particular his former friend Léon Gambetta, whom Rochefort pilloried as an "opportunist." On July 12, 1880, the National Assembly, in large part under pressure from Gambetta, amnestied those convicted for their activities in 1871. Rochefort returned to Paris the same day, and three days later he published the first issue of a new daily, *L'Intransigeant*, in which he continued to dog Gambetta and Gambetta's brand of republicanism, which Rochefort found too "centrist."

The idea for Manet's *Escape of Rochefort* paintings is said to date from November 1880 and to be connected with Manet's reading of Rochefort's novel *L'Evadé*, which Manet's friend Georges Charpentier had published in June.[157] Manet's intention was to produce a sensational picture *(tableau à sensation)* for the 1881 Salon.[158] He could have based his imagining of the event on Rochefort's nonfiction narrative of 1877 or on books published by four of the other five escapees.[159] Instead, he asked Marcellin Desboutin (the subject of his painting *The Artist* [Museu de Arte de São Paulo Assis Chateaubriand]) to put him in touch with Rochefort—a good indication that, despite Manet's connections with Edmond Bazire, who worked for Rochefort at *La Marseillaise* and *L'Intransigeant*, the artist did not know the journalist.[160] The reputation of Manet's first seascape, *The Battle of the U.S.S. "Kearsarge" and the C.S.S. "Alabama,"* seems to have persuaded the prickly celebrity to cooperate.[161] After learning from Rochefort or Pain that the boat in which the six escaped to the Australian clipper ship was a dark gray whaleboat *(baleinier)* with two oars,[162] Manet had a whaleboat brought to the courtyard of the complex at 77 rue d'Amsterdam where he then had a studio.[163] *The Rowboat—Study for The Escape of Rochefort* (plate 70) is roughed out on a bare, white, commercially primed canvas (which Manet's widow has "signed" *E. Manet* at lower

right). It concentrates on the shape of the boat and its overlapping planks and on the relationship between the man and the tiller. The man in the sketch looks to his left—not, as in the two *Escape* paintings, over his shoulder. Broad strokes of inflected blue indicate the waves.

The Escape of Rochefort: The Large Study (plate 71) is the same height as *"Kearsarge" and "Alabama"* but somewhat narrower. It focuses on the escapees in their boat, which occupies the exact center of the canvas. Below is nothing but sea. Propelled by oars that project into the water on either side, the boat and its passengers carry the viewer's eye up to a distant ship on the horizon, no doubt the Australian clipper that was the goal of the fleeing men. The figures are only sketched (*ébauchées*), but recent cleaning, which has spectacularly altered the effect of the canvas, has made the group much easier to decipher. Manet presumably based his depiction of Olivier Pain, who is shown in profile, on a study (private collection) that at one time belonged to Antonin Proust. Opposite Pain and dominating the figures is the man with his hand on the tiller—Rochefort—who turns not toward the waiting vessel but back, as if he fears pursuers.[164] Light touches the left edge and side of the boat, Pain's hair and back, and Rochefort's forehead and nose. The two rowers are seated in the bow, one straining with both hands raised to pull on his oar. Between him and Rochefort, a fifth figure is barely defined.[165] If the composition in its present form suggests a heroic, classically balanced triangle, that was not Manet's original concept. A dark underlying shape at upper right indicates that at one point the painting included a large ship whose mast and rigging rose to the top of the canvas above the figure of Rochefort. Vertical strokes in the sea below the boat suggest further alterations as the picture developed. Yet the sea in the foreground is a superbly rhythmic tangle of brushstrokes, viridian and turquoise green, dark and translucent or mixed with white, painted over areas of bare canvas in ways suggesting that Manet sketched it rapidly. Creamy, salmon-pink-tinged foam pulls our gaze into the lower portion of the picture and leads it to where the foam splashes against the boat. The perspective on the left, where the oar passes through the oarlock, is not entirely convincing. But the clear, clean sea, now flecked with white almost to the very high horizon, rises impressively up the canvas. *The Large Study* combines expressive brushwork with quasi-documentary content in ways that further study may help to elucidate.[166]

We do not know why Manet abandoned this already altered canvas and went on to develop the rather different "finished" *Escape of Rochefort* (plate 69), which is signed in a somewhat uncharacteristic hand in the lower right corner. Less than half the size of both *The Large Study* and *"Kearsarge" and "Alabama,"* it has two features in common with the latter: its almost square format and the resolve with which it embraces the sea as its subject matter. Indeed, the sea covers 95 percent of the picture's surface. The figures and the boat, which has no tiller, lack the bold brushwork that characterizes *The Large Study*, while the same invisible light source here falls directly on Rochefort's features and backlights the crown of Pain's head and outlines his back. The light is most vivid and the impasto touches are strongest at the points where the oars dig into the water and in the boat's wake. In *"Kearsarge" and "Alabama,"* the sea was dense, material, and shadowed, and Manet's contemporaries compared it to a wall. In *The Large Study*, the sea is a welter of brushstrokes, but their very virtuosity has an equally grounding effect. In the smaller *Escape*, the sea is a receding plane that stretches away into the distance. Brushstrokes in green and ultramarine lick across the surface, creating eddies rather than waves, and there are no white crests that rise up to emphasize the picture plane. The boat is lost in a limitless sea, and our eye is pulled toward a dark, unpromising horizon.

An explanation for the lights that zigzag around the whaleboat has been found in a sentence from Rochefort's novel.[167] But the novel is relevant to the painting in ways that

have less to do with particular details than with the emotions that seem to shape the picture. Rochefort's novel has not one but two escape attempts, and both are relevant. The first resembles history in that the would-be escapees use a whaleboat to rendezvous with a commercial trading vessel. They reach the meeting place without mishap, and everyone peers into the darkness—they deliberately choose a moonless night—for the white silhouette of *Surprise*. "But the harder they looked at the horizon, the less it told them."[168] Manet's smaller *Escape* projects an anxiety that seems less narrative than existential. In the novel, the second, successful attempt takes place five months later. Only the hero—a stand-in for the author—is saved. He is taken by New Caledonian natives to a beach where a European brig waits just offshore. As he climbs into the whaleboat that it sends, "he finally realized that he was breathing the air of freedom."[169] In the signed *Escape*, the artist deploys the sea as an almost limitless stretch of blues and greens and associates it with freedom—and its dangers.

We do not know why Manet did not send an *Escape of Rochefort* to the 1881 Salon. Instead he showed the portraits *M. Henri Rochefort* (Hamburger Kunsthalle) and *M. Pertuiset, the Lion Hunter* (Museu de Arte de São Paulo Assis Chateaubriand). The vigorous and unidealized portrait of Rochefort attracted a good deal of attention, not all of it favorable.[170] The portrait of Eugène Pertuiset was mocked for its blue and violet shadows and for the lion skin that Manet rather imprudently placed behind his subject, but it earned the painter a second-class medal, exactly twenty years after his *Spanish Singer* (The Metropolitan Museum of Art, New York) had earned him an honorable mention, which made him eligible for the Legion of Honor. During his seventy-four-day tenure as French arts minister, Antonin Proust made sure that Manet received one. The honors list of December 30, 1881, named Edouard Manet a knight (*chevalier*) of the Legion of Honor.[171]

Conclusion *The Battle of the U.S.S. "Kearsarge" and the C.S.S. "Alabama"* was painted in 1864 and perhaps reworked before it was shown at the 1872 Salon. *The Escape of Rochefort*, intended for the 1881 Salon, was realized in a large, unfinished version and a smaller, signed and finished one; the relationship between them remains obscure.[172] All the other seascapes known to us were painted in the intervening years, which cover virtually the whole of Manet's career as a mature artist. Stylistic development is easy to follow when we restrict our examination to a single genre because we compare works on a similar theme that have common visual elements. But it is also instructive to consider other works the artist painted during the same period as particular seascapes, especially when they have, or appear to have, very different characteristics.

At the 1864 Salon, which opened just six weeks before the event commemorated in *"Kearsarge" and "Alabama,"* Manet exhibited his startling *Dead Christ with Angels* (The Metropolitan Museum of Art, New York). In this painting, as in Manet's representation of the naval battle, the foreground is very present and immediate: Rocks, a serpent, and a thrusting foot lead the eye up and back along the planes of Christ's body to his head. The sweeping angels' wings suggest turbulence and drama in this otherwise static scene, which displays the body of Christ against the sculptural folds of his white shroud. In *"Kearsarge" and "Alabama,"* the dark, almost three-dimensional foreground waves suggest a moving, heaving sea in tune with the drama of the event and evoke the force of the wind that impels the sturdy pilot boat forward, leading the eye toward the distant drama of the sinking *Alabama*. A similar mode of presentation can be found in still-life compositions of these years: The eel and oysters of the early *Still Life with Fish* (plate 18) parallel the rocks and serpent in the *Dead Christ*, and the crisp folds of the linen tablecloth and thrusting form of a knife help to throw superbly painted objects on a buffet into relief.[173]

According to Léon Leenhoff, the two works that Manet contributed to the 1869 Salon—*The Luncheon* (Neue Pinakothek, Bayerische Staatsgemäldesammlungen, Munich) and *The Balcony* (Musée d'Orsay, Paris)—owed their genesis to the 1868 family holiday in Boulogne. The figures in these magisterial works are handled almost like still-life objects, and the painted porcelain *jardinières* are more defined than some of the faces. Both paintings are carefully constructed studio works whose distance from observed reality in Boulogne is considerable. This distance between observed reality and finished work supports the view that, while such paintings as *Moonlight, Boulogne* (plate 28) may have been sketched out on the spot but adjusted later in the studio, Manet's first *Departure of the Folkestone Boat* (plate 44), begun in 1864, was probably reworked after an attempt at a second version of this scene in Boulogne in 1868 (plate 45) and that the Impressionistic handling of the crowd in both paintings was the result of a still later campaign. The broken, sketchy handling of the figures in the second Folkestone picture—both on the quay and on the stern of the packet boat (but not the others)—is very close to that of the distant crowd in the racecourse scene that Manet completed for a private client in October 1872 (private collection).[174]

In the early 1870s, *plein-air* and studio painting played at being indistinguishable, and Manet often began painting works on the spot and completed them in the studio (a practice the Impressionists certainly did not abandon): *View in Holland* (plate 56), probably a studio work, and *On the Beach—Suzanne and Eugène Manet at Berck* (plate 58), largely painted *en plein air*, both adopt a carefully structured composition and a low-key palette, while the near-contemporary *Railroad* (National Gallery of Art, Washington, D.C.) brilliantly creates the illusion of *plein-air* painting in a work probably begun on the spot but continued in Manet's new studio on the rue de Saint-Pétersbourg, which is visible in the background.[175] It was not until 1874, painting with Monet at Argenteuil, that Manet adopted a form of broken, "Impressionist" brushstroke—particularly the horizontal dabs of varied greens and blues that render effects of water—and swiftly brushed cross-hatching that at once models form and suggests an enveloping atmosphere of light and air, as seen in *Monet in His Studio Boat* (Neue Pinakothek, Bayerische Staatsgemäldesammlungen, Munich) and *Argenteuil*. Only half-heartedly exploited in his Venice pictures (plates 65, 66), this Impressionist technique—and perhaps its shortcomings—led Manet to develop his own, inimitable style, which combines painting and drawing by means of vibrant, interwoven brushstrokes that enable light and air to surround and penetrate the sharply characterized forms of such figures as Marcellin Desboutin in *The Artist*, Ellen Andrée in *The Parisienne* (Nationalmuseum, Stockholm), Henriette Hauser in *The Skating Rink* (Fogg Art Museum, Cambridge, Massachusetts), and *Faure in the Role of Hamlet* (Hamburger Kunsthalle). As for the *plein-air* element, it is evident in all three paintings of the view of the rue Mosnier from Manet's studio windows.[176] Supreme examples of Manet's mature style are *Laundry* (Barnes Collection, Merion, Pennsylvania) and *A Bar at the Folies-Bergère* (Courtauld Galleries, London), Manet's final masterpiece, which was shown at the 1882 Salon. In view of the complexity and breathtaking accomplishment of this last picture, one wonders why he was unable to complete *The Escape of Rochefort* for the 1881 Salon. Perhaps the challenge of creating another "*Alabama*-like sea" proved too much for his waning forces. Or he may have found it impossible to accommodate the more traditional style of *The Large Study* to the almost abstract qualities of the smaller seascape, whose antiheroic qualities are underlined by Edmond Bazire's characterization: "The *Escape*, on the open sea, the boat tragically alone in its mysterious infinitude."[177]

Remembering that Manet's paintings are a distillation of his lived experience and that we cannot always link a particular work to a particular point in time, the survey of his oeuvre just sketched reveals the many layers of inspiration that lie behind the seascapes, which range from imaginative depictions of historical events, to sketches and small

paintings clearly done from nature, to works created in his studio from observations jotted down or applied with watercolor to paper in Boulogne and elsewhere. Whether working in the solid, painterly style that characterizes his very first works of 1864 (plates 10, 11) and such later paintings as *The Steamboat, Seascape with Porpoises* (plate 16) and *Moonlight, Boulogne* (plate 28); in the more luminous but precisely executed *Jetty* paintings (plates 29, 30); in the misleadingly naïve manner of *The Beach at Boulogne* (plate 32); or in the bustling activity around the Folkestone packet or the more circumspect movements of croquet players on a beach club lawn (plates 44–48), Manet seeks to involve viewers by pulling their gaze into the watery depths or toward a distant horizon. They experience the taste of salt spray, they are buffeted by sea breezes if not gales, and they are invited to consider the many types and shapes of vessels that Manet depicts and the varying viewpoints and terrains that the artist experienced on his seaside visits. He renders the stance and gesture of figures in his paintings with more fluency and conviction, and he uses varied approaches to portray the sea in all its many moods—sometimes adopting increased naturalness, other times deliberate artifice. In other words, in the seascapes as in the other genres of painting that he tackled, there is no "formula" to which Manet resorts in order to express himself on canvas, whether he undertakes a large work for the Salon or a smaller picture painted for his own pleasure or to sell. Stéphane Mallarmé, a friend and sometime collaborator in the last decade of Manet's life, put his friend's view of painting into words whose 1876 English translation (the French original has yet to be located) still conveys the essence of Manet's art:

> Each time he begins a picture, says he, he plunges headlong into it, and feels like a man who knows that his surest plan to learn to swim safely, is, dangerous as it may seem, to throw himself into the water. . . . Each work should be a new creation of the mind. . . . The hand . . . will conserve some of its acquired secrets of manipulation, but the eye should forget all else it has seen, and learn anew from the lesson before it. It should . . . [see] only that which it looks upon, and that as for the first time; and the hand should become an impersonal abstraction guided only by the will, oblivious of all previous cunning.[178]

This willingness to immerse himself in each painting and to allow the work to dictate its treatment explains the remarkable variety of styles in Manet's oeuvre and the unmistakable individuality of each work, whether it was painted early or late in his career and whether it is a figure painting, a still life, or one of the seascapes that deploy his talent in such brilliant and varied ways.

1. For Auguste Manet's career, see Nancy Locke, *Manet and the Family Romance* (Princeton: Princeton University Press, 2001), pp. 44–48.

2. Antonin Proust, "L'Art d'Edouard Manet," *The Studio*, January 15, 1901 (supp. no. 28), p. 87. Colonel Fournier financed Manet's attendance at an elective drawing class while he was a student at Rollin.

3. For the entrance examination and the 1848 legislation, see Juliet Wilson-Bareau and David C. Degener, *Manet and the American Civil War: The Battle of U.S.S. "Kearsarge" and C.S.S. "Alabama"* (New York: The Metropolitan Museum of Art, 2003), p. 12.

4. Manet's first biographer, Edmond Bazire, tries to explain the cruise as the result of a clash of wills

between Edouard and his father. In this account, when Auguste Manet refused to allow his firstborn son to study painting, Edouard announced that he would be a sailor. Edmond Bazire, *Manet* (Paris: A. Quantin, 1884), p. 2. Bazire's account seems problematic. There were no sailors in the immediate Manet family tree, and the notion of *relation* was so well entrenched in the nineteenth-century French mind that sons, especially upper-middle-class sons, did not normally envision careers for which the family did not have connections of one sort or another.

5. The confusion seems to have arisen from a sentence in Bazire's account: "Il fut présenté à un capitaine marchand, M. Besson, et rejoignit son poste modeste à bord de la *Guadeloupe*, transport qui faisait voile sur Rio-de-Janeiro." [He was introduced to Mr. Besson, captain in the merchant marine, and took his place on *Guadeloupe*, a cargo headed for Rio de Janeiro.] Ibid., p. 2. Twentieth-century writers interpreted the word *poste* as meaning that Manet held some kind of office on board *Le Havre et Guadeloupe*. It is clear from letters Manet wrote during the cruise that he understood *poste* to mean simply the place on board ship where certain specific activities take place: *poste de commande*, *poste de tir*, *poste d'observation*. Bazire's *son poste* refers to the place where Manet stowed his belongings and slept.

6. "Il faut te dire que pendant la traversée je m'étais fait une reputation, que tous les officiers et les professeurs m'ont demandé leur caricature et que le Commandant même m'a demandé la sienne pour ses étrennes." Letter from Edouard Manet to Eugénie Manet, Sunday, February 25, or Monday, February 26, 1849, Edouard Manet, *Lettres de jeunesse 1848–1849: Voyage à Rio* (Paris: Louis Rouart et fils, 1928), p. 55. A drawing (now lost) of Porto Santo, one of the Madeira Islands, accompanied one of Manet's letters home. For the cruise and its implications for Manet's career, see Wilson-Bareau and Degener, *Manet and the American Civil War*, pp. 14–15.

7. "Mais j'appris beaucoup durant mon voyage au Brésil. Combien de nuits j'ai passées à regarder, dans le sillage du navire, les jeux d'ombre et de lumière! Pendant le jour, du pont supérieur, je ne quittais pas des yeux la ligne d'horizon. Voilà qui m'a révélé la façon d'établir un ciel." Ambroise Vollard, *Souvenirs d'un marchand de tableaux*, rev. ed. (Paris: Editions Albin Michel, 1948), p. 177. (The first edition was published in 1937, two years before Vollard's death.) Vollard quotes Toché (whom he met at an unspecified date in the Louvre) quoting Manet. Toché made Manet's acquaintance in Venice in 1874.

8. The practice of sea bathing spread from the top down. Prior to the construction of the railroads, travel required considerable amounts of uncommitted time and disposable income, so beach clubs were essentially a luxury operation. An 1843 article on summer travel published in the weekly *L'Illustration* is accompanied by a pair of wood engravings contrasting the *Départ de la petite propriété pour la campagne* with the *Départ de la haute et moyenne classe*. The former, the

petit bourgeoisie or lower-middle class, left their homes in the city on foot, trailed by horse carts or handcarts containing their considerable baggage. Under these conditions, they did not travel far. The upper and upper-middle classes left town in carriages or coaches drawn by teams of horses; they traveled farther—perhaps even to the coast. "L'Eté du Parisien," *L'Illustration*, July 1, 1843, pp. 275–77. Roy Parker, "Les Anglais et les loisirs," in *L'Avènement des loisirs 1850–1960*, ed. Alain Corbin (Paris: Aubier, 1995), pp. 21–54, has described the railroads as the single most powerful instrument of social change in the nineteenth century.

9. A few French authorities actually advocated ingesting seawater, but the bulk of them modeled their advice on that of their English counterparts, who recommended immersing oneself in the sea. Parker, "Les Anglais et les loisirs"; Alain Corbin, *Le Territoire du vide: L'Occident et le désir du rivage (1750–1840)* (Paris: Aubier, 1988); Louis Brunet, *Villégiature et tourisme sur les côtes de France* (Paris: Librairie Hachette, 1963).

10. "Vous trouverez évidemment en ces deux endroits à faire votre hydrotherapie—à Berck . . . vous êtes sûr d'être bien traité—à Boulogne ville de ressources et de distractions vous trouverez tout ce que vous voudrez." Letter from Edouard Manet to Eugène-Henri Maus, after August 2, 1880. See David Degener and Juliet Wilson-Bareau, "Bellevue, Brussels, Ghent: Two Unpublished Letters from Edouard Manet to Eugène Maus," *Burlington Magazine* 142 (September 2000), p. 567.

11. Wilson-Bareau and Degener, *Manet and the American Civil War*, pp. 19–39.

12. Jacques Hillairet's account in his *Dictionnaire historique des rues de Paris* (Paris: Editions de Minuit, 1963), vol. 2, pp. 345–46, suggests that the building housing Cadart's shop was razed to make way for what is now known as rue du Quatre-Septembre. We do not know exactly when Manet's picture was placed on exhibition. Philippe Burty records its presence in Cadart's windows in the July 18, 1864, issue of the Paris daily *La Presse* (p. 3). Monday issues of *La Presse* were printed and distributed on Sunday evening. Under these circumstances, Manet's painting cannot have been hung in Cadart's window later than the morning of Saturday, July 16. (We stated in error in *Manet and the American Civil War* that the Monday issues were printed and distributed on Saturday.)

13. Manet was just beginning to impress himself on public consciousness in the early 1860s. His *Spanish Singer* of 1860 (The Metropolitan Museum of Art, New York) attracted some favorable attention and won him an honorable mention at the 1861 Salon. In 1863 a large group of paintings shown in Louis Martinet's galleries on the boulevard des Italiens and the three works shown at the Salon des refusés provoked strong critical reactions.

14. The September 24, 1863, issue of *Phare de la Manche* (one of Cherbourg's two local newspapers) announced that the French navy secretary had

ordered Durand-Brager to make himself available to Vice-Admiral Charles Penaud, who commanded an experimental squadron of ironclads. In the January 2, 1864, issue of the weekly *Le Monde illustré*, Durand-Brager commemorated the drowning near Cherbourg of several men from the ironclad *La Couronne*.

15. "Notre excellent peintre de marine, M. Durand-Brager, était à Cherbourg ces jours derniers. Il a été visiter le lieu du combat des deux navires américains. Bientôt sans doute, nous aurons à admirer une nouvelle composition du grand artiste." [Our fine naval painter Mr. Durand-Brager was in Cherbourg recently. He visited the site of the duel between the two American vessels. We will no doubt soon have another composition by this great artist to admire.] "Chronique locale," *Vigie de Cherbourg*, June 26, 1864, p. 3. The Paris daily *La Presse*—a paper that we know Manet read—reprinted this short text in its June 28 issue ("Nouvelles du jour," p. 2). Charles-Olivier Merson—the painter Luc-Olivier Merson's father—hailed Durand-Brager's painting in *L'Opinion nationale*, July 3, 1864, p. 2. *L'Opinion nationale* was resolutely pro–United States for the duration of the American Civil War. Mac-Sheehy, "Chronique et faits," *L'Union*, July 4, 1864, p. 3; L.L., "Faits divers," *Le Pays*, July 5, 1864, p. 2; and Marquis de la Tour-d'Arlendes, "La Vie à Paris," *Le Sport*, July 6, 1864, p. 3, discuss the painting in their own terms. All four Paris writers note that John Ancrum Winslow, captain of U.S.S. *Kearsarge*, had seen the painting and deemed the representation credible.

16. French marine painters were in the habit of depicting events that they had not observed. Théodore Gudin exhibited nine paintings at the 1839 Salon depicting historical events of 1690, 1702, 1703, 1705, 1706, 1707, 1778, and 1838. Durand-Brager's first Salon submission, in 1840, depicted a French attack on Algiers in 1683.

17. Stop in *Le Journal amusant*, May 25, 1872; Bertall in *Le Grelot au Salon de 1872*, part 3, p. 20.

18. George Heard Hamilton, *Manet and His Critics* (New Haven: Yale University Press, 1986), pp. 155–62.

19. Jules Barbey d'Aurevilly, in *Le Gaulois*, July 4, 1872; reprinted in Pierre Courthion, ed., *Manet raconté par lui-même et par ses amis* (Geneva: Pierre Cailler, 1953), vol. 2, pp. 85–89.

20. Armand Silvestre, "L'Ecole de peinture contemporaine," *La Renaissance littéraire et artistique* 1 (September 28, 1872), p. 179; reprinted as the preface to *Galerie Durand-Ruel: Recueil d'estampes gravées à l'eau-forte* (Paris: Durand-Ruel, 1873).

21. Anne Coffin Hanson, "A Group of Marine Paintings by Manet," *Art Bulletin* 44 (December 1962), pp. 332–36; Wilson-Bareau and Degener, *Manet and the American Civil War*, p. 73.

22. The caricature of the framed painting misrepresents its format and relative size. See Wilson-Bareau and Degener, *Manet and the American Civil War*, p. 65, fig. 45.

23. In *Manet and the American Civil War* we examine a number of wood engravings published in the immediate aftermath to which Manet may have been reacting; pp. 42–44 and figs. 4, 23–26.

24. Hanson, "A Group of Marine Paintings by Manet."

25. Manet expressed his opinions in letters sent from shipboard; Manet, *Lettres de jeunesse*, pp. 22–23, 41, 60, 64, 67.

26. See Wilson-Bareau and Degener, *Manet and the American Civil War*, pp. 31–36.

27. The painting remained in Manet's studio until after he had sold it, together with twenty-five other major pictures, to the dealer Paul Durand-Ruel in January 1872.

28. "Une mauve, espèce de gros oiseau blanc que tu as dû voir quelquefois à Boulogne." Manet, *Lettres de jeunesse*, p. 22.

29. The sheet (RWD 268) was detached from a sketchbook that contained many studies for the 1862 painting *Music in the Tuileries* (fig. 59).

30. Manet's *Salamanca Students* (RW 28, present location unknown) was included in the twelfth exhibition organized by the Société des amis des arts de Boulogne-sur-Mer. The exhibition opened on Sunday, July 15 (or Friday, July 13—perhaps the private view—if the issue of *L'Impartial de Boulogne-sur-Mer* of the same date is to be believed), and closed September 15; *Almanach de Boulogne-sur-Mer pour 1861 (24me année)* (Boulogne: C. Watel, 1861), p. 56. Manet's painting is no. 261 in the exhibition catalogue, *Société des amis des arts de Boulogne-sur-Mer: Explication des tableaux dessins et gravures exposés dans les galeries du musée de Boulogne en 1860* (Boulogne: Charles Aigre, 1860), p. 33. Boulogne was only four hours from Paris by rail, and the twenty-eight-year-old artist might well have wanted to attend the opening of this exhibition—the first in which he is known to have participated.

31. Auguste Manet died in September 1862. Since 1860, Edouard Manet and Suzanne Leenhoff had been living together with Léon, Suzanne's son, who was always presented as her younger brother. Following their marriage in October 1863, the couple formed, with Manet's widowed mother, a close family unit that included Edouard's younger brothers Eugène and Gustave; Suzanne's two brothers, the sculptor Ferdinand and the painter Rudolph Leenhoff; and her sister Marthe, who was married to the painter Jules Vibert. Léon Leenhoff's manuscript notes on Manet's travels, made years later, mention only two visits to Boulogne: the first in 1864, the second in 1868. See Léon Leenhoff, untitled text, pp. 69–70 in *Copie faite pour Moreau-Nélaton vers 1900* (an unknown hand has corrected 1900 to 1910), Bibliothèque nationale de France, Département des Estampes et de la Photographie, Rés. Yb-3-2401, 8°. This document will be referred to hereafter as Cahier Léon Leenhoff I.

32. Pierre Heliot, "Essai sur le développement urbain de Boulogne," *Bulletin de la société académique de l'arrondissement de Boulogne-sur-Mer* 12 (1929–33), pp. 281–311.

33. Adolphe Joanne, *Dictionnaire géographique, administratif, postal, statistique, archéologique, etc., de la France, de l'Algérie et des colonies*, 2d ed. (Paris: L. Hachette et Cie, 1869), p. 324.

34. Ernest Deseille, *L'Ancien etablissement des bains de mer de Boulogne 1824–1863: Notes historiques et statistiques* (Boulogne: Charles Aigre, 1866).

35. See the anonymous wood engraving *Les Bains de Boulogne-sur-Mer*, in *L'Illustration*, July 1, 1843, p. 277.

36. Frédéric Debussche, "L'Architecture du XIXe siècle à Boulogne-sur-Mer. II. La Station balnéaire: Etablissements de bains de mer et hôtels," *Histoire et archéologie du Pas-de-Calais: Bulletin de la commission départementale d'histoire et d'archéologie du Pas-de-Calais* 16 (1998), pp. 211–46; Louis Bénard, "Revue de l'année du mois d'Octobre 1862 au mois d'Octobre 1863," in *Almanach de Boulogne-sur-Mer pour 1864 (27me année)* (Boulogne: C. Watel, 1864), p. 70.

37. Henri Florent, "Manet et Boulogne. 2e article. Etude sur le milieu Boulonnais en 1864. Trois faits nouveaux," *Les Cahiers du Vieux Boulogne*, no. 21 (n.d.), pp. 7–11. If the rates set in 1863 still prevailed, the group subscription would have cost them 70 francs. The twelve-year-old Léon's name does not appear in the register.

38. *Almanach de Boulogne-sur-Mer pour 1864*, pp. 179, 180, 189–90, 196, 203, 215–16.

39. Cahier Léon Leenhoff I, p. 70.

40. Henri Florent, "Manet et les hommes du 6 Août 1940 [*sic*]," *Les Cahiers du Vieux Boulogne*, no. 23 (n.d.), pp. 9–14.

41. The terms *pier* and *jetty* are more or less interchangeable: *Pier* suggests both an open construction, in this case made of wooden piles, and a promenade on which restaurants or places of entertainment can be found. *Jetty* usually applies to a solid, probably stone structure that forms a harbor or protects the entrance to a port. In the case of Boulogne, the double jetties served both purposes.

42. "Nous avions tous fait un voyage à pied sur les côtes de Normandie. Chacun de nous, muni de sa boîte de couleurs, travaillait—Manet et moi avec furie—à des études après nature." Antonin Proust, *Edouard Manet: Souvenirs* (Paris: Librairie Renouard, 1913), p. 27. In the first redaction of his recollections—Antonin Proust, "Edouard Manet (souvenirs)," *La Revue blanche* 12 (1897), p. 130—Proust claims that they had arranged to meet Alexandre Dumas *fils* in Sainte-Adresse, but Dumas is not in the 1913 version. Proust's memory for dates is shaky; where there are differences, the 1913 version is to be preferred. Manet visited Venice in September 1853 and Florence in the second week of October, which suggests that a fall walking tour in 1853 would have had to take place in the second half of October.

43. Proust, "Edouard Manet (souvenirs)," p. 132.

44. Denis Rouart and Daniel Wildenstein, *Edouard Manet: Catalogue raisonné*, vol. 2 (Lausanne: Bibliothèque des arts, 1975), list close to seven hundred sheets. On Manet's death in 1883, his sketchbooks devolved to his widow Suzanne. Probably intact until that time, they were broken up and dispersed in the years that followed. Suzanne gave some away—Rouart-Wildenstein list many drawings as "formerly Rouart collection," and the diary kept by Berthe Morisot and Eugène Manet's daughter Julie records that her aunt gave her Manet drawings (Julie Manet, *Journal [1893–1899]* [Paris: Librairie C. Klincksieck, 1979], p. 50). But a great many more were sold. An account book belonging to Suzanne Manet and letters to her from Antonin Proust (unpublished documents in the Tabarant archive, Pierpont Morgan Library, New York) show that she was selling drawings to the art dealer Ambroise Vollard in 1894 and that by 1897 Proust was making arrangements to sell albums filled with drawings to the industrialist Auguste Pellerin (1852–1929). Drawings that Proust acquired from Vollard or extracted from sketchbooks that Suzanne had deposited with him were mounted singly or in groups and bound in five red leather albums with little regard for their original source and no regard for sequence. The albums were sold to Pellerin, and on his death they passed to his children. In 1954 the Louvre acquired all five. Now in its Cabinet des dessins, they are part of the collections (*fonds*) of the Musée d'Orsay. Cf. Françoise Cachin, Charles S. Moffett, and Juliet Wilson-Bareau, *Manet 1832–1883*, exh. cat. (New York: The Metropolitan Museum of Art, 1983), p. 266, no. 100, "Provenance."

45. The early notebook is now part of the Tabarant archive in the Pierpont Morgan Library, New York. See Rouart and Wildenstein, *Catalogue raisonné*, RWD 678 and 679 (listing pages from the single binding).

46. Peter Meller, "Manet in Italy: Some Newly Identified Sources for His Early Sketchbooks," *Burlington Magazine* 144 (February 2002), pp. 68–110.

47. RW 98. See Jean C. Harris, "Manet's Race-Track Paintings," *Art Bulletin* 48 (March 1966), pp. 78–82; Cachin, Moffett, and Wilson-Bareau, *Manet*, no. 99. Boulogne had a racetrack, located a mile or so north of town.

48. Letter from Edouard Manet to Félix Bracquemond, undated (written in Boulogne after July 16, 1864), Juliet Wilson-Bareau, ed., *Manet by Himself: Correspondence and Conversation, Paintings, Pastels, Prints and Drawings* (London: Macdonald, 1991), p. 31.

49. U.S.S. *Kearsarge* logbook, National Archives, Washington, D.C. See Wilson-Bareau and Degener, *Manet and the American Civil War*, p. 54, fig. 34.

50. Letter from Manet to Bracquemond, Wilson-Bareau, *Manet by Himself*, p. 31. To Burty, he wrote: "The *Kearsarge* was anchored off Boulogne last Sunday and I went to see her; I had formed a pretty

accurate view of her, and in fact have now painted her as she looks out at sea." Letter from Edouard Manet to Philippe Burty, undated (written in Boulogne after July 16, 1864), ibid.

51. Wilson-Bareau and Degener, *Manet and the American Civil War*, pp. 51–55.

52. Cachin, in Cachin, Moffett, and Wilson-Bareau, *Manet*, p. 224. See the discussion in Wilson-Bareau and Degener, *Manet and the American Civil War*, pp. 73–75, fig. 54.

53. *Catalogue des tableaux de M. Edouard Manet exposés avenue de l'Alma en 1867* (Paris: Poupart-Davyl, 1867), no. 34.

54. Ibid., no. 45. Manet chose not to identify *Kearsarge* but to center attention on the "local" fishing theme, perhaps because he also showed *The Battle of the U.S.S. "Kearsarge" and the C.S.S. "Alabama"* in 1867, under the title *Le Combat des navires américains "Kerseage" et "Alabama"* (no. 22).

55. The Boulogne 1868 (Whatman) sketchbook originally contained at least 110 folios of thin but strong laid paper. About 90 folios, many of them unused, are still in the dark red leather binding, which has a pencil holder attached to the front cover and an elastic tie and small pocket (for loose sheets?) incorporated into the back cover. Marbled endpapers complete the slim, supple notebook, whose front and back pages are filled with handwritten notes. Manet used the sketchbook from both ends (and the folios have since been numbered in reverse, with a detached group, folios 71–76, placed out of sequence). The *Whatman* watermark, which consists of the name, date, and a crowned shield, breaks across individual folios, making it possible to place extracted pages in sequence. We may never know whether Manet had owned but not used the sketchbook for many years or whether he purchased it in 1868, perhaps at one of Boulogne's print sellers or bookstores. No drawings from the sketchbook appear to predate the 1868 visit.

56. To date, six drawings in the Pellerin albums have been identified as coming from the 1868 Boulogne (Whatman) sketchbook: RWD 253, 296, 297, 299, 300, and 659 (RF 30.550, 553, 554, 556, 557, 562). Many of the sheets removed from the Pellerin albums are now known to have drawings on both sides.

57. This identification was made in Wilson-Bareau and Degener, *Manet and the American Civil War*, p. 69.

58. In 1850 the French government bought a scene of porpoise fishing from Gudin, and Garneray painted a similar scene (undated; Musée Thomas Henry, Cherbourg); Laurent Manoeuvre, *Louis Garneray, 1783–1857: Peintre, écrivain, aventurier* (Arcueil: Anthèse, 1997), p. 205, no. 45. Manet wrote to his mother that on December 28 the ship encountered a group of *marsouins* (porpoises): "They are huge creatures, schools of 10 or 12 swim around the ship, especially the bows; they swim like lightning and are a very difficult target." Wilson-Bareau, *Manet by Himself*, p. 20.

59. Wilson-Bareau and Degener, *Manet and the American Civil War*, pp. 69–71.

60. The "cut" canvas that lacks the hull of the boat has always been said to indicate a Japanizing tendency in Manet's painting at this relatively early date; Cachin, Moffett, and Wilson-Bareau, *Manet*, pp. 313–14, no. 120. However, until the edges of the canvas can be examined—they are not accessible in its present condition—it is impossible to determine whether the alleged cutoff was a deliberate act on the artist's part.

61. Women acted as porters for the fishermen, just as they did for the travelers and tourists on the packet boats; *Merridew's Visitor's Guide to Boulogne-sur-Mer and Its Environs . . .* (London: Simpkin, Marshall, and Co., n.d. [1864]), pp. 24–25. Capécure had cement factories and iron foundries, as well as a church that may be visible on the left of the painting. Adolphe Tabarant, *Manet: Histoire catalographique* (Paris: Editions Montaigne, 1931), p. 196, claimed that *Moonlight, Boulogne* was painted from a window in the Hôtel Folkestone. There was indeed a Hôtel Folkestone in Boulogne—at 22 quai des Paquebots (1860–67) or 20 quai des Paquebots (1869–73). But Tabarant does not repeat the claim in *Manet et ses oeuvres* (Paris: Gallimard, 1947), p. 165. If the painting was indeed sketched out in Boulogne, alterations revealed by x-radiograph suggest that it was completed in Manet's Paris studio, where he added the dark foreground boats on the right; Cachin, Moffett, and Wilson-Bareau, *Manet*, pp. 311–12, no. 118. The artist sent the canvas to the Brussels Salon in July 1869 together with *The Balcony* (Musée d'Orsay, Paris) and *The Luncheon* (Neue Pinakothek, Bayerische Staatsgemäldesammlungen, Munich) after showing them in the Paris Salon.

62. "I interpret what I see as straightforwardly as possible. *Olympia* is a case in point, what could be more naïve? . . . And the *Women on the Jetty at Boulogne [Moonlight, Boulogne]*, I can't think of a less conventional, more honest, more directly observed work than that." Wilson-Bareau, *Manet by Himself*, p. 179.

63. A "ghost" ship that appears near the horizon to the right, apparently overpainted, and varying thicknesses and colors on the sand suggest that Manet's composition was carefully worked out as he transferred figures from the sketchbook. This hypothesis is supported by x-radiograph, which shows that the bathing machine was painted over a much larger form (not necessarily of the same motif) and suggests alterations that resist analysis at present. See Ronald Pickvance, *Manet*, exh. cat. (Martigny: Fondation Pierre Gianadda, 1996), p. 223, no. 25. We are grateful to Malcolm Cormack for making the x-radiograph available.

64. If in its original state, the canvas is somewhat narrower than a standard 15 Marine, 25⁹⁄₁₆ × 18⅛ inches (65 × 46 cm), and measures 25⁹⁄₁₆ × 12⁹⁄₁₆ inches (65 × 32 cm)—a double square, as Pickvance has noted (see ibid.). A triptych by Hiroshige, *View of the Bay of Futami, a Famous Place in the Province of Ise* (included in Monet's collection of Japanese prints), offers a compelling comparison with Manet's beach scene, down to the cutoff horse at the right edge; Geneviève Aitken and Marianne Delafond, *La Collection d'estampes japonaises de Claude Monet à Giverny* (Paris: Bibliothèque des arts, 1983), p. 119, no. 130.

65. The Boulogne 1868 (Whatman) sketchbook includes a drawing of a man reading in what appears to be a brasserie or restaurant, possibly the one located on the eastern jetty (RWD 181).

66. Louis van Tilborgh, "Catalogue of Acquisitions: Paintings and Drawings, August 2001–July 2002," *Van Gogh Museum Journal*, 2002, pp. 151–54. X-radiograph examination has shown that the present painting is set at right angles to an initial, underlying composition of which only a few elements can be made out; its lower edge after cutting forms the left edge of the present painting.

67. Hokusai's color woodcut, possibly owned by Manet, was part of Monet's print collection; Aitken and Delafond, *La Collection d'estampes japonaises de Claude Monet à Giverny*, p. 70, no. 59. The three figures by Ghirlandaio are included in Manet's copy of part of the fresco in the Large Italian Notebook (RWD 41; Musée d'Orsay, Paris, held at the Musée du Louvre, Département des Arts graphiques, RF 30.342).

68. Both works had been arbitrarily ascribed to the artist's 1873 visit to Berck.

69. Manet's first lithograph, a caricature of the politician and family friend Emile Ollivier as Diogenes that was reproduced in the journal *Diogène*, no. 6 (April 14, 1860), included what must be one of Manet's first depictions of the sea; Jean C. Harris, *Edouard Manet: The Graphic Work* (San Francisco: Alan Wofsy Fine Arts, 1990), no. 1. Manet's lithograph was perhaps based on Delacroix's painting of the same subject; Lee Johnson, *The Paintings of Eugène Delacroix: A Critical Catalogue* (Oxford: Clarendon Press, 1986), no. 347.

70. Claude Monet owned one such print, Utagawa Kunisada's *Awabi Fishers*. Aitken and Delafond, *La Collection d'estampes japonaises de Claude Monet à Giverny*, p. 98, no. 97.

71. The painting (RW 200), formerly in the Matsukata collection in Tokyo, is not available for study. Lochard's photographs were taken to accompany Léon Leenhoff's manuscript register of Manet's works preserved in the Département des Estampes of the Bibliothèque nationale de France (Yb3 4649 Rés.). The print annotated by Leenhoff is in the Tabarant archive, Pierpont Morgan Library, New York, Leenhoff album II, p. 80.

72. The date traditionally given to this unfinished picture, which was signed by a hand other than the artist's, is 1860, but Wilson-Bareau proposed a

date of about 1868 in *Manet by Himself*, p. 19, fig. 1. See also *European Masterpieces: Six Centuries of Paintings from the National Gallery of Victoria, Australia*, exh. cat. (Melbourne: National Gallery of Victoria, 2000), pp. 150–51, no. 65.

73. Wilson-Bareau, *Manet by Himself*, p. 49.

74. Manet made these sketches on roughly fifty sheets of laid paper that either were never bound or were trimmed after being removed from a book (no binding holes can be seen). That he often used both sides of the same sheet underlines the speed and fluency with which he worked.

75. In 1864, in addition to studies for the captain (fig. 44) and a mariner on the steamboat (RWD 294), Manet also made many drawings for the crowd on the quay: RWD 229 (unpublished verso), 333 (recto and unpublished verso), 334, 335, 340, 341 (recto and unpublished verso), 342 (recto and unpublished verso), and 537.

76. Adolphe Tabarant mistakenly dates Manet's longest Boulogne visit to 1869, an error that has been widely repeated. There is no record of the family's whereabouts in summer 1869, but it seems unlikely that the *Folkestone Boat* and *Croquet* sketches could have followed so soon after those in the 1868 sketchbook.

77. The Manets could have visited Boulogne at some point after June 1871, but such a trip seems unlikely after their long and doubtless expensive trip up France's Atlantic coast. Manet's letter of August 22, 1871, to Théodore Duret shows both that he was in Paris on that date and that he was having money problems. Wilson-Bareau, *Manet by Himself*, p. 162.

78. As in *The Beach at Boulogne* (plate 32), Manet used what appears to be a true marine-format canvas for the *Croquet* picture—in this case close to a 20 Marine size, 19¾ × 28¾ inches (50 × 73 cm).

79. The 1874 edition of *Merridew's Guide to Boulogne-sur-Mer and Its Environs* (London: Simpkin, Marshall) advises readers: "On the terrace next to the sea will be found spacious lawns, on which the game of croquet is played" (p. 71). An advertisement at the front of the guide notes that croquet equipment can be obtained at Merridew's bookstore. One of Manet's sketches (RWD 281, unpublished verso) shows the layout of the croquet game with hoops and posts in their correct positions. When Leenhoff drew up his manuscript register of Manet's studio after the artist's death (see note 71), he described another painting on the same theme but set in a Paris garden (RW 211, Städelsches Kunstinstitut, Frankfurt-am-Main), adding that the idea for the picture had come from the croquet games played in the beach club garden at Boulogne. Paris, Bibliothèque nationale de France, Département des Estampes et de la Photographie (Yb3 4649 Rés., no. 16).

80. The sketch for this figure is on the unpublished verso of a sheet with another croquet player (RWD 559).

81. Manet showed his formal portrait of Eva Gonzalès (RW 154, National Gallery, London) at the 1870 Salon.

82. This painting was purchased directly from Manet in 1879 by his wealthy young friend, the artist and collector Gustave Caillebotte, for his outstanding collection of Impressionist pictures; Anne Distel, "Essai de récapitulation de la collection de Gustave Caillebotte," in *Gustave Caillebotte, 1848–1894*, exh. cat. (Paris: Réunion des musées nationaux, 1994), pp. 42–43.

83. The x-radiograph reveals areas of strong scraping with chipping or flaking of old, dry paint under the steam escape beside the smokestack and under the furled sail along the mast and yardarm.

84. When Manet sold the picture to Durand-Ruel in March 1873, he listed it as *Départ du bateau à vapeur* (*Departure of the Steamer*), and the dealer entered it in his stock book as *Départ d'un steamer*. However, when Durand-Ruel sent it to London in October of that year for an exhibition, he gave it the English title *Visitors at Boulogne*.

85. For Manet's involvement in the Mexican drama, see Juliet Wilson-Bareau with John House and Douglas Johnson, *Manet: The Execution of Maximilian: Painting, Politics and Censorship* (London: National Gallery, 1992).

86. For Manet's letter to Duret (Tabarant archive, Pierpont Morgan Library, New York), which includes provisions in the event of the artist's death, see Wilson-Bareau, *Manet by Himself*, p. 56. Manet's letter of Sunday, September 10, 1870, to Eva Gonzalès records that Suzanne, Eugénie, and Léon left Paris on September 8; ibid., p. 55.

87. Manet (Paris) to Emile Zola (Bordeaux), February 9, 1871, Cachin, Moffett, and Wilson-Bareau, *Manet*, p. 523, no. 18.

88. There are two sources for details about Manet's trip west in spring 1871: Léon Leenhoff's unpublished notes (Cahier Léon Leenhoff I, pp. 68–69) and the published and unpublished correspondence of Edouard and Suzanne Manet. Because Léon's notes were set down at some undetermined point between 1890 and 1910, we prefer the evidence of the letters when the two sources disagree.

89. Suzanne Manet (Oloron) to Eva Gonzalès (Dieppe), February 22, 1871, partially published in Hôtel Drouot, *Lettres et manuscrits autographes: Musique et spectacle—beaux-arts—littérature*, expert Thierry Bodin, March 27, 2003, lot 112. Manet's only canvas that certainly depicts Oloron is a view of Léon on the balcony of their temporary home (RW 163, Fondation E. G. Bührle Collection, Zurich). Arcachon was some 146 miles north of Oloron and about 37 miles southwest of Bordeaux.

90. Manet (Arcachon) to Duret (Paris), March 6 and March 18, 1870, Wilson-Bareau, *Manet by Himself*, p. 160; Manet (Arcachon) to Bracquemond (Paris), March 18, 1870, ibid.

91. Ibid. Adolphe Thiers (1797–1877), politician and historian, a veteran of the July Monarchy, Second Republic, and Second Empire, refused a role in the government of national defense but was nonetheless its delegate in Tours and Bordeaux. Twenty-six departments elected him as their representative on February 8, and on February 17 the new National Assembly named him head of the executive branch.

92. Léon's notes have the family going from Oloron to Bordeaux, staying in Bordeaux a week, then spending a month in Arcachon.

93. Proust, *Edouard Manet: Souvenirs*, pp. 64–65, and Théodore Duret, *Histoire de Edouard Manet et de son oeuvre avec un catalogue des peintures et des pastels*, new ed. (Paris: Bernheim-Jeune, 1919), p. 95, state that the Manets returned to Paris before troops representing the national government had routed the communards.

94. Le Pouligen, twelve miles west of Saint-Nazaire, had a nice beach, a picturesque setting, and sea-bathing facilities; Joanne, *Dictionnaire géographique*, p. 1828.

95. Ibid., p. 305.

96. *A Handbook for Travellers in France: Being a Guide to Normandy, Brittany; the Rivers Seine, Loire, Rhône, and Garonne; the French Alps, Dauphiné, the Pyrenees, Provence, and Nice, &c, &c. &c.; the Railways and Principal Roads*, 11th ed. (London: John Murray, 1870), pp. 285, 295.

97. Ibid., p. 285.

98. Recent cleaning removed the coat of yellowed varnish that long covered its fresh, cool tones.

99. Noël, a native of Quimper who trained in Brest, had also shown depictions of that seaport at the 1844, 1846, and 1849 Salons.

100. John House, *Landscapes of France: Impressionism and Its Rivals*, exh. cat. (London: Hayward Gallery; Boston: Museum of Fine Arts, 1995), p. 78, no. 7.

101. Proust, "Edouard Manet (souvenirs)," p. 175. Proust and Léon Gambetta were present. When Mazerolle made apparently slighting comments on Manet's art, Gambetta intervened to restore peace.

102. Elisée Reclus, "Le Littoral de la France. III. Les Plages et le bassin d'Arcachon," *Revue des deux mondes*, November 15, 1863, p. 462. Reclus sketches a compelling verbal picture of Arcachon in its early days.

103. A bit less than two miles from Arcachon, La Teste-de-Buch was much older than Arcachon, which separated from it administratively in 1857.

104. Reclus, "Le Littoral," p. 469. Bernard Marrey, "Arcachon ou le levier de l'idée," pp. 31–56 in *La Ville d'hiver d'Arcachon*, exh. cat. (Paris: Institut Français d'Architecture, 1983), is a lucid and well-illustrated discussion of Arcachon's development.

105. The chalet is not to be seen on a map dated 1867, but an almanac from 1869 records its existence. The 1864 villa is shown on *Compagnie des Chemins de Fer du Midi. Domaine d'Arcachon. Plan général*, drawn by P. Régnauld, lithographed by H. Franc and J. Ménard, 1865 (reproduced in Institut Français d'Architecture, *Arcachon*, pp. 130–31), and on *Arcachon* (Chemins, 1867), a hand-drawn map in the Archives départementales de la Gironde (Bordeaux), which

shows the larger villa next to the small triangular plot on which the chalet Servantie would be constructed abutting the rue de Joigny.

106. Letter from Edouard Manet to Théodore Duret, March 2, 1871, Musée du Louvre, Département des Arts graphiques, Album, feuillet 8.

107. Berthe Morisot's sharp-tongued mother referred to the shock that Manet must have felt at the sight of the "bucolically blooming" Suzanne after her Pyrenean retreat; Denis Rouart, ed., The Correspondence of Berthe Morisot, trans. Betty W. Hubbard (London: Camden Press, 1986), p. 82.

108. Perhaps as a result of the difficult times, Manet drew on pages from a notebook of relatively poor quality graph paper, which he may have used from the start of his travels in the southwest or even during the siege in Paris (some pages appear to show sketches of soldiers). For drawings that probably formed part of the Arcachon section of the sketchbook, see RWD 216, 235, 236, 238, 239, 240, 316.

109. François Cottin and Françoise Cottin, Le Bassin d'Arcachon à l'age d'or des villas et des voiliers (Bordeaux: L'Horizon chimérique, forthcoming). We are much indebted to M. and Mme Cottin and to M. Aubertin for information about Arcachon and its region.

110. For characteristic shapes of pinasses and their rigging, see François Cottin and Françoise Cottin, Le bassin d'Arcachon au temps des pinasses, de l'huître et de la résine (Bordeaux: L'Horizon chimérique, 2000), pp. 55, 57.

111. This painting, on deposit in the Kunstmuseum, Basel, was not available for reproduction as a color plate. See Hartwig Fischer, Orte des Impressionismus: Gemälde und Fotografien, exh. cat. (Basel: Kunstmuseum Basel, 2003), pp. 84 (color plate), 96, no. 16. Both scenes were reproduced in black and white in Etienne Moreau-Nélaton, Manet raconté par lui-même (Paris: Henri Laurens, 1926), vol. 1, figs. 147, 148.

112. For the action of the fishermen pulling on their oars together, see Cottin and Cottin, Le bassin d'Arcachon au temps des pinasses, p. 280.

113. "In August 1855, the French Minister of Commerce and Public Works issued a new system of Tidal Signals . . . these are now used at most of the French ports. . . . [Tidal signals] are made at most French ports by flags and balls hoisted on a mast, on which a yard is crossed. The balls are black. One ball hoisted at the intersection of the mast and yard, denotes a depth of 10 feet in the channel between the jetties. Each ball hoisted on the mast under the first denotes an extra depth of 3¼ feet. Each ball hoisted above the first denotes an extra depth of 6½ feet." Sailing Directions for the English Channel Compiled from the Most Recent Surveys Made by Order of the British and French Governments (London: James Imray and Son, 1859), p. 85.

114. Petra ten-Doesschate Chu, "Nineteenth-Century Visitors to the Frans Hals Museum," in Gabriel P. Weisberg, Laurinda S. Dixon, and Antje Bultmann Lemke, eds., The Documented Image: Visions in Art History (Syracuse: Syracuse University Press, 1987),

p. 134; J. Verbeek, "Bezoekers van het Rijksmuseum in het Trippenhuis 1844–1885," in 1808–1958 Het Rijksmuseum: Gedenkboek Uitgegeven ter Gelegenheid van het Honderdvijftigjarig Bestaan, special double issue of Bulletin van het Rijksmuseum 6, nos. 3–4 (1958), p. 64. Duncan Bull of the Rijksmuseum kindly translated the relevant paragraph for us.

115. Proust, "Edouard Manet (souvenirs)," p. 178. Recounting a conversation with Manet that took place in 1850, 1852, or 1853, Proust has Manet describe Jongkind as "le plus fort de tous nos paysagistes," superior to Corot and Daubigny; ibid., p. 133. (The 1913 text [p. 31] has "le plus fort des paysagistes" and does nothing to clarify the date.)

116. He is not known to have returned to Paris until November; Daniel Wildenstein, Monet or the Triumph of Impressionism (Cologne: Taschen/Wildenstein Institute, 1996), vol. 1, pp. 88, 91.

117. Tabarant, Manet: Histoire catalographique, p. 228; Tabarant, Manet et ses oeuvres, p. 201.

118. "Il y a des choses qui me restent gravées dans la cervelle." [Certain things stick in my mind.] Proust, "Edouard Manet (souvenirs)," p. 311.

119. An undated note from Manet to Emile Zola has been interpreted as dating the start of the trip to early July; Cachin, Moffett, and Wilson-Bareau, Manet, p. 525.

120. Advertisement in La Saison des Bains de Boulogne-sur-Mer, July 5, 1860, p. 4.

121. Manet to Eugène Maus, August 2, 1880, Degener and Wilson-Bareau, "Bellevue, Brussels, Ghent," p. 567.

122. Alain Cardon, "Berck-sur-Mer: Etude urbaine," Hommes et terres du nord, 2e semestre 1968, pp. 19–38, and 1er semestre 1969, pp. 37–58.

123. Paul Billaudaz, Berck à travers les siècles, vol. 2, De 1789 à 1978 (Berck: n.p., 1978), esp. pp. 21–33.

124. H. Castlemans, "Hôpital d'enfants à Berck-sur-Mer," L'Illustration, August 17, 1861, pp. 111–12. The accompanying wood engraving (p. 112), which depicts the new hospital and a couple of other buildings made of planks, successfully conveys the rather rough-and-ready aspect of seaside life in Berck at this early stage of its development.

125. The new hospital was very badly sited—threatened both by sea and by sand. Because it represented a sizable investment, the Third Republic spent large sums to protect it. These measures undoubtedly had benefits for Berck-Plage.

126 . The picture, lent by Albert Hecht, was listed as Les Hirondelles in the 1884 Ecole des Beaux-Arts exhibition (no. 63). Writers have echoed Tabarant in stating that Hecht acquired the work directly from Manet in 1873, but no documentary evidence for the sale has been produced.

127. Cahier Léon Leenhoff I, p. 70.

128. 1872 census records, Berck Hôtel de ville (city hall).

129. Christian Gonsseaume, "La flotille berckoise dans la seconde moitié du XIXème siècle d'après les Archives Maritimes de Cherbourg," *Sucellus: Dossiers archéologiques, historiques et culturels du Nord-Pas de-Calais,* no. 47 (1998), pp. 35–36.

130. François Beaudouin, *Le bateau de Berck,* Mémoires 5 (Paris: Institut d'Ethnologie, Université de Paris, 1970), pp. 27–29, 39–46.

131. The picture was one of five canvases purchased by the baritone Jean-Baptiste Faure directly from the artist's studio on November 18, 1873 (Cahier Léon Leenhoff I, p. 75).

132. Georges Dilly and Michel Troublé, *Mémoire d'entre Canche et Authie,* vol. 1, *Le Berck des pêcheurs en cartes postales anciennes* (Berck-sur-Mer: Amis du Musée du Passé et de la Bibliothèque de Berck-sur-Mer et Environs, 1985).

133. Manet's mother and brother Eugène went to Fécamp in Normandy, where the Morisots were staying and where Eugène courted and won Berthe Morisot as they painted side by side.

134. Wildenstein, *Monet,* vol. 1, p. 58.

135. Zola to Antoine Guillemet, July 23, 1874, in Emile Zola, *Correspondance,* vol. 2: *1868–mai 1877,* ed. B. H. Bakker (Montreal: Les presses de l'université de Montréal; Paris: Editions du Centre National de la Recherche Scientifique, 1980), p. 362.

136. Louisine W. Havemeyer, *Sixteen to Sixty: Memoirs of a Collector* (New York: The Metropolitan Museum of Art, 1961), p. 226.

137. Ibid. Mrs. Havemeyer imagines Manet in conversation with Paul Véronèse on his last afternoon in Venice.

138. Vollard, *Souvenirs,* p. 182.

139. "Pour ne parler que des *Pieux du Grand Canal,* Manet recommença sa toile, je ne sais combien de fois. La gondole et son batelier l'arrêtèrent un temps inimaginable. 'C'est le diable, disait-il, pour arriver à donner la sensation . . . qu'un bateau a été construit avec des bois coupés et ajustés suivant des règles géométriques!'" Ibid., p. 178.

140. Cachin, Moffet, and Wilson-Bareau, *Manet,* pp. 375–77, no. 148.

141. Before the discovery and publication of Léon Leenhoff's transcription of an unknown page from Manet's account book, the Venice pictures were dated to 1875. But Léon's transcription reveals that Manet sold a *Vue de Venise* to Jean-Baptiste Faure in January 1875 and another work listed as *Venise* to the painter James Tissot on May 24, 1875; Juliet Wilson-Bareau, "L'Année impressionniste de Manet: Argenteuil et Venise en 1874," *Revue de l'art,* no. 86 (1989), pp. 28–34, fig. 9. Leenhoff's transcription is on the first page of a notebook (referred to hereafter as Cahier Leenhoff II) that remained in the Pierre-Prins family collection and was unknown to Tabarant and Moreau-Nélaton. Toché does not note when he first ran into Manet in Venice, but he puts the end of Manet's visit at some point in September. Documentary evidence shows that Manet was back in Paris by October 8 and that he was still there on October 10, 16, and 24. We also know that he was in Paris in the second half of December, because he signed the wedding register when his brother Eugène married Berthe Morisot on December 22. Havemeyer, *Sixteen to Sixty,* p. 226, reports Mary Cassatt's assertion that Manet told her "that he had been a long time in Venice. I believe he spent the winter there." If Cassatt is correct, Manet's trip to Venice took place in November to early December 1874.

142. Duret, *Histoire,* p. 196.

143. In 1880 hydrotherapy was at once "advanced," fashionable, and costly. One writer lists the *personnages illustres* whom one is apt to encounter in the rue de Miromesnil waiting room of Dr. Joseph-Marie-Alfred Béni-Barde, the most prominent proponent of hydrotherapy in 1880: "le prince Napoléon et Coquelin aîné, la reine d'Espagne et Coquelin cadet, Manet et le duc de Chartres." Un Monsieur de l'orchestre, "Paris l'Eté: Auteuil," *Le Figaro,* August 10, 1880, p. 3.

144. "Everything is more expensive here than in Paris and there is no reduced rate for the water treatment. I'm waiting impatiently for fine weather so that I can start work." Letter from Edouard Manet to Mme Méry Laurent, undated [June? 1880], Wilson-Bareau, *Manet by Himself,* p. 247.

145. "It wouldn't be so bad if I could see the rue de Rome from my window but no, it's always that wretched Panthéon—what a thing to have to look at." Letter from Edouard Manet to Méry Laurent, undated [September? 1880], Wilson-Bareau, *Manet by Himself,* p. 256. Méry Laurent lived on the rue de Rome.

146. Letter from Edouard Manet to Henri Guérard, undated (RWD 599, Fondation Custodia, Paris), reproduced in Wilson-Bareau, *Manet by Himself,* p. 255, fig. 198, and p. 275, fig. 214; text on p. 255. The letter was written on or after August 30; Degener and Wilson-Bareau, "Bellevue, Brussels, Ghent," p. 567.

147. For example, RW 299–302, 304. Many of Manet's paintings of Isabelle are unfinished because she was an irregular sitter.

148. The article on Luc-sur-Mer in Joanne, *Dictionnaire geographique,* p. 1270, identifies it as a commune of 1,563 inhabitants in the Calvados department. Its *bains de mer* were at a locality rather unhappily known as Petit Enfer, that is, "Little Hell."

149. Letter from Edouard Manet to Isabelle Lemonnier, undated [August 1880], Wilson-Bareau, *Manet by Himself,* p. 254.

150. RW 343, 344, 347.

151. Until recently, this drawing (RWD 413, private collection) was known only from its reproduction in Bazire's 1883 biography of Manet; Bazire, *Manet,* p. 75.

152. Letter from Edouard Manet to Mme Jules Guillemet, Sunday [July 25, 1880], Wilson-Bareau, *Manet by Himself*, p. 254.

153. In 1881 Manet executed several images of young women by the sea (RWD 435–38) for a projected edition of Stéphane Mallarmé's translation of Edgar Allan Poe's poem "Annabel Lee"; Juliet Wilson-Bareau and Breon Mitchell, "Tales of a Raven: The Origins and Fate of *Le Corbeau* by Mallarmé and Manet," *Print Quarterly* 6 (1989), pp. 295–301, fig. 140; Wilson-Bareau, *Manet by Himself*, p. 262, fig. 203.

154. The government's case against Rochefort is set forth in *Le dossier de la commune devant les conseils de guerre* (Paris: Librairie des bibliophiles, 1871), pp. 188–206. Like the hero of his novel *L'Evadé*, Rochefort was prosecuted as one of the Commune's covert leaders (*chefs occultes*). The terms in which Rochefort ridicules the charge in the novel suggest that he viewed his writing not as politics or even journalism but as a literary exercise. He was elected to the French Assembly twice, but on both occasions he resigned his seat after a few weeks.

155. For the government's case against Grousset, see *Le dossier de la commune*, pp. 59–66, 127–30; for Jourde, see pp. 92–98, 138–42. The Second Empire jailed Pain for contraventions of the press laws. He, with a number of other prisoners, was freed after September 4, and during the Commune he wrote for Rochefort's *Le Mot d'ordre*.

156. He was a celebrity in every town that he set foot in. He eluded reporters in San Francisco, Salt Lake City, and Omaha, but in Chicago he yielded to a representative of the *New York Herald*, which devoted two whole pages (pp. 5, 12) of its May 31, 1874, issue to his story and views.

157. Leenhoff Register, no. 21, *L'Evasion—La Grande toile*. Henri Rochefort, *L'Evadé: Roman canaque* (Paris: G. Charpentier, libraire-éditeur, 1880). The June 5 issue of the *Bibliographie de la France* (p. 311) records the first and second printings of Rochefort's novel, and the July 31 (p. 432) issue records the third printing.

158. "J'ai vu Manet assez bien portant, très occupé d'un projet de tableau à sensation pour le Salon: l'evasion de Rochefort dans un canot en pleine mer." [I saw Manet. He's in fairly good health, very busy with a sensational picture for the Salon: Rochefort's escape in a small boat on the open sea.] Letter from Claude Monet to Théodore Duret, December 9, 1880, Wildenstein, *Monet*, vol. 1, p. 441.

159. The last chapter of Rochefort's heavily illustrated *De Nouméa en Europe: Retour de la Nouvelle-Calédonie* (Paris: F. Jeanmaire, 1877) recounts the escape from New Caledonia. Achille Ballière (*Un Voyage de circumnavigation: Histoire de la déportation par un des évadés de Nouméa* [London, 1875]), Paschal Grousset and François Jourde (*Les Condamnés politiques en Nouvelle-Calédonie: Récit de deux évadés* [Geneva, 1876]), and Olivier Pain (*Henri Rochefort: Paris-Nouméa-Genève* [Paris, 1879]) published accounts of their own.

160. "Vous aurez à votre disposition, quand vous voudrez, non seulement Robinson Rochefort, mais aussi Olivier P[a]in — vendredi ! Lancez donc avec assurance votre missive — demande, les voies sont larges ouvertes à votre nom et à votre talent." [Not only Robinson Rochefort but also Olivier Pain— Friday—are at your disposal whenever you like. So dispatch your letter—ask what you will, the doors have been opened to your name and talent.] Letter from Marcellin Desboutin to Edouard Manet, "Monday" (perhaps November 22 or 29, 1880), Cahier Leon Leenhoff II, pp. 98–99. Desboutin's "Robinson" confirms that the lowercased *vendredi* is Daniel Defoe's Friday, not the day of the week.

161. "La perspective d'une mer à l'Alabama a tout emporté!!" [The prospect of an *Alabama*-like sea carried the day!] Ibid. "Il n'attendait que l'autorisation de ce dernier pour se mettre à l'oeuvre." [The only thing that (Manet) was waiting for was the go-ahead from (Rochefort).] Monet to Duret, December 9, 1880. Ibid.

162. Letter from Edouard Manet to Stéphane Mallarmé, Saturday (December 4, 1880, postmark), Wilson-Bareau, *Manet by Himself*, p. 259.

163. Leenhoff Register, no. 21, *L'Evasion—La Grande toile*.

164. In fact it was Achille Ballière who manned the rudder; Eric Vatré, *Henri Rochefort ou la comédie politique au XIX^e siècle* (Paris: J. C. Lattès, 1984), p. 170 n. 1.

165. Rochefort had five companions on his successful escape. We cannot explain why Manet shows only five figures here and in the other *Escape*.

166. One striking result of the cleaning carried out by Paul Pfister was the discovery of an "authentication" by Suzanne Manet in the lower right corner: *Certifié d'Ed. Manet/[M^me V^ve] Manet*.

167. "Les gouttes d'eau qui commençaient à tomber larges et pesantes rejaillissaient sur la mer magnétique et transparente, pareilles à des fusées qui s'éteignent." [The large, heavy drops that started to fall (from the oars) bounced off the magnetic, transparent sea like sputtering rockets.] Rochefort, *L'Evadé*, p. 146.

168. "Tous se soulevèrent sur leur banc et lancèrent la pointe de leurs regards dans la direction indiquée, s'efforçant de distinguer dans le noir de la nuit la silhouette blanche de la *Surprise*. Mais plus ils interrogeait l'horizon, moins l'horizon leur répondait." Ibid., p. 147. In the novel, six men are party to the escape plans, but one man becomes ill, so only five men take to the sea. However, in contrast to history the captain of *Surprise* does not meet them— he has been captured and killed by native New Caledonians—and four of the five, including the hero, are recaptured. (The fifth falls prey to a shark.)

169. "Le condamné eut pour la première fois ce sentiment délicieux que l'air qu'il respirait état celui de la liberté." Ibid., p. 377.

170. The artist tried to give the picture to the subject, but he declined it.

171. The certificate is illustrated on p. 9 of the March 10, 1907, issue of *Le Journal des curieux*. Anyone who had won two medals or honorable mentions at the Salon was eligible for the Legion of Honor decoration, and a great many nonentities Manet's age, as well as a fair number of his friends and acquaintances, had so been honored. When *"Kearsarge" and "Alabama"* was shown at the 1872 Salon, Edmond Duranty remarked in print on "the curious fact . . . that decorations have been given to young men, like M. Carolus Duran, M. Mercié, and M. Leenhoff, the brother-in-law of M. Manet" (*Paris-Journal*, July 3, 1872, p. 1). People who had won two medals were also exempt. That is, they did not have to submit their pictures to the Salon jury.

172. Recent examination has confirmed that the smaller picture was not a modello for the larger canvas, which is complete in its present, original format.

173. RW 121, National Gallery of Art, Washington, D.C.; RW 140, The Shelburne Museum, Shelburne, Vermont.

174. The rather striking contrast between the carefully drawn and painted racehorses, possibly based on a racing scene by Théodore Géricault acquired by the Louvre in 1866, and the very Impressionistic treatment of the crowds in the background (Cachin, Moffett, and Wilson-Bareau, *Manet*, no. 132) is paralleled in the contrast between the carefully detailed treatment of the smokestacks and sidewheel casings of both *Folkestone Boat* pictures and the vibrant, summary treatment of the crowds, which were clearly brushed over scraped and reworked areas of canvas. This evocation of crowds in motion, particularly the indistinguishable melee of figures at the stern of the second packet steamer, found its earliest expression in Manet's depiction of the sun-drenched crowds at the bullfight that he attended in Spain in 1865; Gary Tinterow et al., *Manet/Velázquez: The French Taste for Spanish Painting*, exh. cat. (New York: The Metropolitan Museum of Art, 2003), p. 232, nos. 147, 148.

175. Juliet Wilson-Bareau, *Manet, Monet, and the Gare Saint-Lazare*, exh. cat. (Washington, D.C.: National Gallery of Art, 1998), pp. 41–63.

176. RW 270, J. Paul Getty Museum, Los Angeles; RW 271, Fondation E. G. Bührle Collection, Zurich; RW 272, private collection.

177. *"L'Evasion, en pleine mer, avec la barque tragiquement seule dans l'immensité mystérieuse"*; Bazire, *Manet*, p. 132. The writer saw the finished painting displayed in Manet's studio after the artist's death.

178. Stéphane Mallarmé, "The Impressionists and Edouard Manet," *Art Monthly Review* 1 (September 30, 1876), p. 118.

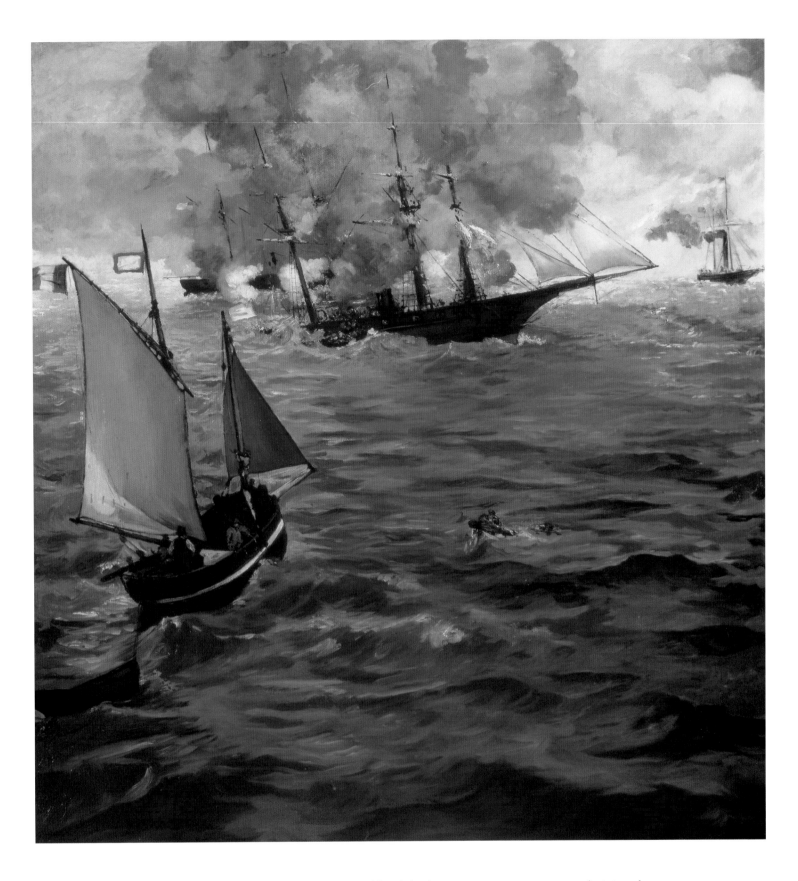

PLATE 10
Edouard Manet
The Battle of the U.S.S. "Kearsarge" and the C.S.S. "Alabama"
1864
Oil on canvas
52¾ × 50 inches (134 × 127 cm)
Philadelphia Museum of Art. The John G. Johnson Collection.
Cat. no. 1027

Manet's first known seascape is an imaginative depiction of a
June 19, 1864, American Civil War naval battle off the coast of
France near Cherbourg. A pilot boat advances across a heaving
sea to throw a line to sailors stranded on a spar. In the distance,
C.S.S. *Alabama* sinks by her stern, clouds of smoke rising from
a direct hit to her engines by U.S.S. *Kearsarge*, lying half-hidden
in the background. On the horizon, an English steam yacht waits
to pick up survivors.

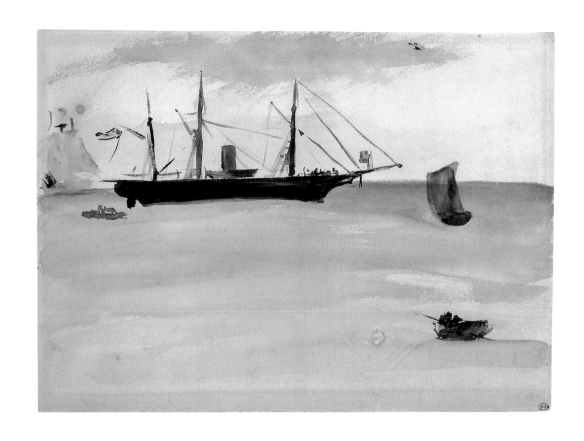

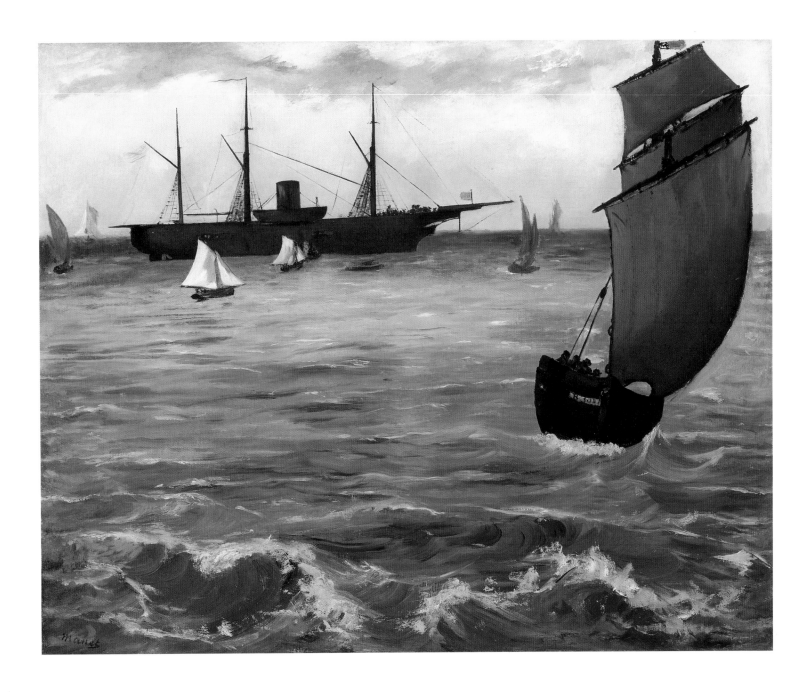

PLATE 12
Edouard Manet
U.S.S. "Kearsarge" off Boulogne—Fishing Boat Coming in before the Wind
1864
Oil on canvas
32⅛ × 39⅜ inches (81.6 × 100 cm)
The Metropolitan Museum of Art, New York. Partial and Promised Gift of Peter H. B. Frelinghuysen, and Purchase, Mr. and Mrs. Richard J. Bernhard Gift, by exchange, Gifts of Mr. and Mrs. Richard Rodgers and Joanne Toor Cummings, by exchange, and Drue Heinz Trust, The Dillon Fund, The Vincent Astor Foundation, Mr. and Mrs. Henry R. Kravis, The Charles Engelhard Foundation, and Florence and Herbert Irving Gifts, 1999. 99.442

The victorious *Kearsarge* appeared off Boulogne on July 17, 1864, just as Manet arrived there for a family holiday. He captured the image of the vessel lying at anchor, surrounded by sailing boats, in a wash and watercolor drawing (plate 11) and later painted this canvas, into which he introduced a large fishing boat as a foreground motif. The fishing boat reappears, reversed, in a later etching (plate 14).

PLATE 13
Edouard Manet
Steamboat Leaving Boulogne
1864
Oil on canvas
29 × 36½ inches (73.6 × 92.6 cm)
The Art Institute of Chicago. Potter Palmer Collection. 1922.425

PLATE 14
Edouard Manet
Seascape
c. 1868
Etching, aquatint, roulette, and plate tone in brown
on verdârte laid paper
5½ × 7⅞ inches (14 × 20 cm): plate
The Art Institute of Chicago. Kate S. Buckingham Fund
and restricted gift of Edward McCormick Blair. 1984.1115

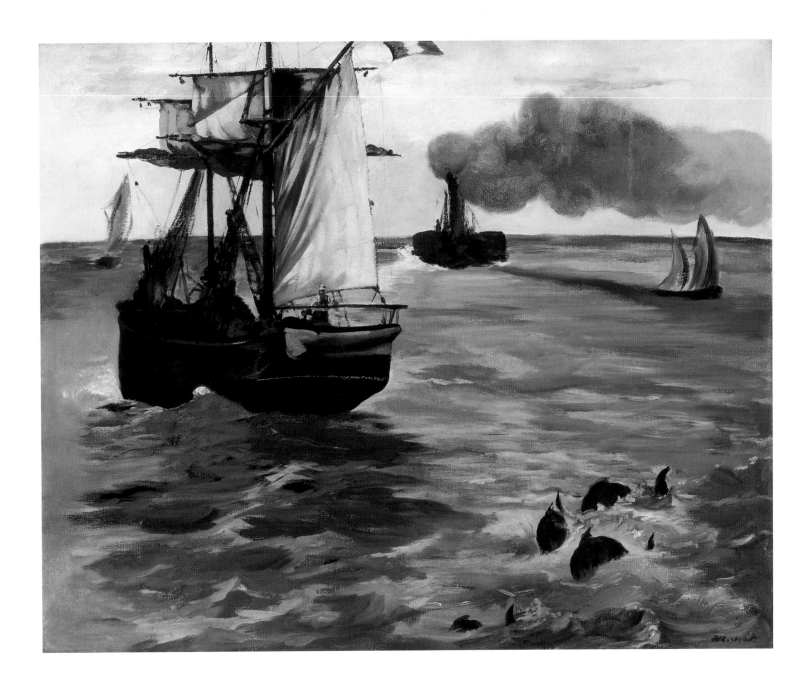

PLATE 16
Edouard Manet
The Steamboat, Seascape with Porpoises
1868
Oil on canvas
31⅞ × 39⅜ inches (81 × 100 cm)
Philadelphia Museum of Art. Bequest of Anne Thomson
in memory of her father, Frank Thomson, and her mother,
Mary Elizabeth Clarke Thomson. 1954-66-3

This broadly brushed canvas, possibly made as a pendant to
U.S.S. "Kearsarge" off Boulogne (plate 12), was previously dated to
1864. However, a watercolor from the 1868 (Whatman) sketch-
book (plate 15) connects this work with Manet's 1868 visit to
Boulogne. In the painting, Manet has added a large sailing ship
and a school of porpoises to enliven the expanse of sea.

PLATE 17

Edouard Manet

Fishermen with a Beached Sailboat

Trimmed page from the Boulogne 1868 (Whatman) sketchbook

Oil over brush and wash on laid paper

5⁵⁄₁₆ × 3⅛ inches (13.5 × 8.1 cm)

Bibliothèque nationale de France, Paris.

Département des Estampes et de la Photographie.

Rés. DC300d (drawing no. 19)*

PLATE 18
Edouard Manet
Still Life with Fish
1864 or 1868
Oil on canvas
28⅞ × 35⅞ inches (73.4 × 91.2 cm)
The Art Institute of Chicago. Mr. and Mrs. Lewis
Larned Coburn Memorial Collection. 1942.311

Fish, oysters, and an eel lie beside a large copper fish kettle.
Their arbitrary placement on a crisp white cloth suggests a studio
arrangement in Paris rather than a real life "kitchen scene" in
Boulogne. Yet the freshness of the boldly brushed fish evokes the
sea and fishing boats such as the one Manet sketched in oils on a
page of his 1868 notebook (plate 17).

Six pages from a pocket-size sketchbook, whose existence remained unknown until recently, convey the range of Manet's interest in what he could see around him in Boulogne: from washes of color that record the skies to topographical notations of the jetties and harbor, and from many types of sailing boats to the characteristic shape of the side-wheel steamers that regularly crossed the Channel, sailing to Folkestone or directly up the Thames to London.

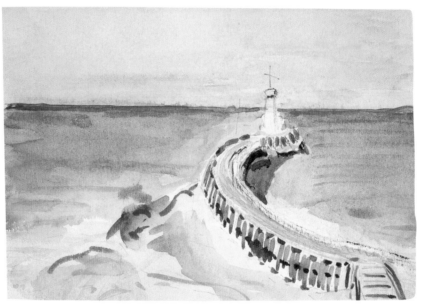

PLATES 19–21
Edouard Manet
Pages from the Boulogne 1868 sketchbook:
Evening Sky and Sea (top), *The West Jetty from the Dune de Châtillon* (center), *Steamboat in Port, beside a Crane* (bottom)
Watercolor and graphite on wove paper
3½ × 5⅜ inches (9 × 13.8 cm) each page
Private collection

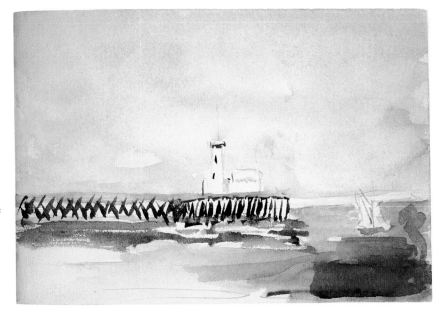

PLATES 22–24
Edouard Manet
Pages from the Boulogne 1868 sketchbook:
Sunset Sky and Sea (top), *Herring Boat in Full
Sail* (center), *The West Jetty Seen from the End
of the East Jetty* (bottom)
Watercolor and graphite on wove paper
3½ × 5⅜ inches (9 × 13.8 cm) each page
Private collection

PLATE 25
Edouard Manet
Study of Ships at Sunset
Double page from the Boulogne 1868 (Whatman) sketchbook
Watercolor and graphite on laid paper
7⅜ × 5⅝ inches (18.8 × 14.3 cm)
Collection R. Pauls, Basel

For this horizontal motif, Manet drew in his sketchbook held
vertically, extending the sea over the lower page, on which he
also sketched a detail of the stern of the steamboat. When he
transferred the composition to canvas (plate 26), he truncated
the sails abruptly where they should meet the hull of the fishing
boat in the foreground, giving the scene—whether by accident
or design—a very Japanese effect.

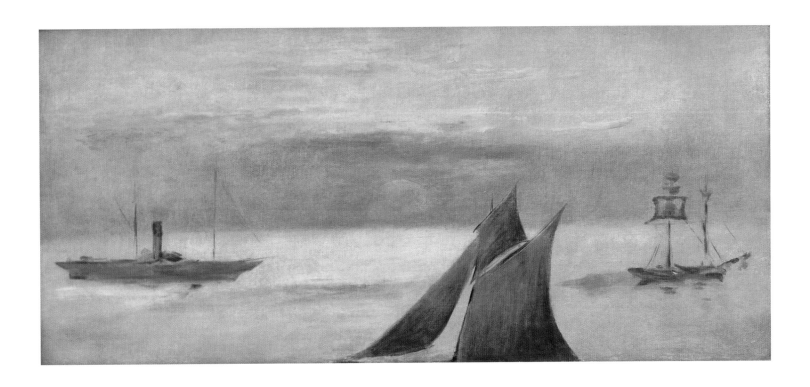

PLATE 26

Edouard Manet

Study of Ships, Sunset

1868

Oil on canvas

16½ × 37 inches (42 × 94 cm)

Musée Malraux, Le Havre. Dépot des musées nationaux. MNR 873*

PLATE 27
Edouard Manet
Study of a Night Sky
Double page in the Boulogne 1868 (Whatman) sketchbook
Watercolor on laid paper
5⅝ × 7½ inches (14.2 × 19 cm)
Musée d'Orsay, Paris, held at the Musée du Louvre, Département
des Arts graphiques, Paris. RF 11.169*

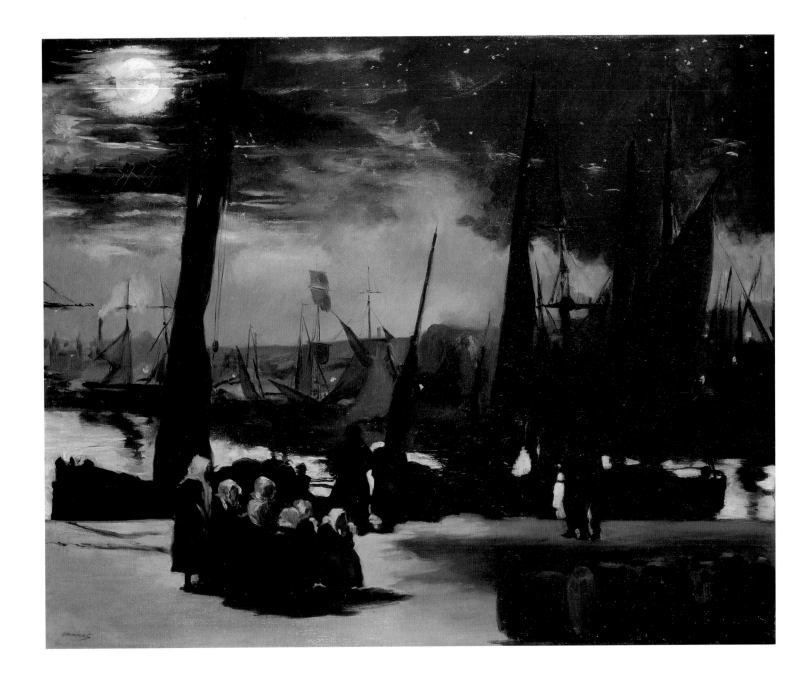

PLATE 28

Edouard Manet

Moonlight, Boulogne

1868

Oil on canvas

32¼ × 39¾ inches (82 × 101 cm)

Musée d'Orsay, Paris. Bequest of Comte Isaac de Camondo,
1911. RF 1993

Manet regarded this magical night scene of the harbor at
Boulogne as one of his finest, most direct and "honest" paintings.
Was this picture, at least, done from life, on the spot? Or did
Manet rely on drawings in his sketchbook, such as the view of
a night sky with crescent moon that he brushed swiftly across
a double page (plate 27)?

PLATE 29
Edouard Manet
Jetty and Belvedere at Boulogne
1868
Oil on canvas
13 × 17⅝ inches (33 × 45 cm)
Private collection

In two views of Boulogne's parallel jetties, Manet captures, with
a mixture of topographical accuracy and perspectival trickery, the
structure of the wooden piers and such details as the restaurant
capped by a shaded belvedere and the adjacent cabin, an oyster
bar. In both pictures, sailing boats and a steamer float on the open
sea beyond the jetties. Manet signed the larger canvas (plate 30)
on the floating buoy in the foreground.

PLATE 30
Edouard Manet
Jetty at Boulogne
1868
Oil on canvas
23⅜ × 28⅞ inches (59.5 × 73.3 cm)
Van Gogh Museum, Amsterdam. s 507 S/2002

PLATE 31
Edouard Manet
Sketches for *The Beach at Boulogne*
The Boulogne 1868 (Whatman) sketchbook
Graphite on laid paper
5⅝ × 3¾ inches (14.3 × 9.5 cm) each upright page
Musée d'Orsay, Paris, held at the Musée du Louvre, Département
des Arts graphiques, Paris. RF 11.169*

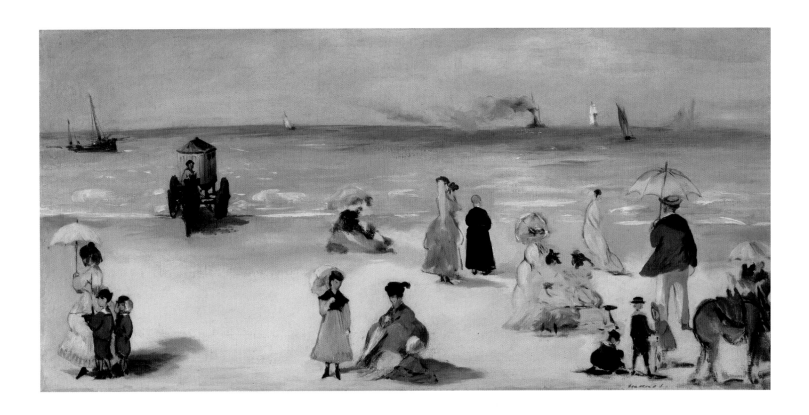

PLATE 32
Edouard Manet
The Beach at Boulogne
1868
Oil on canvas
12⅝ × 25⅝ inches (32 × 65 cm)
Virginia Museum of Fine Arts, Richmond.
Collection of Mr. and Mrs. Paul Mellon. 85.498
PMA, VGM

In this fresh, deliberately naïve composition, every figure or group
of figures, including the bathing cabin, is drawn from the pages
of Manet's sketchbook (plate 31). Traces of extensive repainting,
confirmed by an x-radiograph, indicate the great care that went
into this apparently random depiction of Boulogne's elegant beach
club subscribers and their children.

PLATE 33
Edouard Manet
Bathers and Boats, Boulogne
Double page from the Boulogne 1868 (Whatman) sketchbook
Watercolor and graphite on laid paper
5⅝ × 7⁵⁄₁₆ inches (14.3 × 18.6 cm)
Öffentliche Kunstsammlung Basel, Kupferstichkabinett. Bequest
of Dr. Gotthelf Kuhn. 1975.114
AIC, PMA

PLATE 34
Edouard Manet
On the Beach at Boulogne
c. 1868
Oil on canvas
15 × 17⅜ inches (38 × 44 cm)
The Detroit Institute of Arts. Bequest of Robert H. Tannahill.
70.173

Previously dated to the 1870s, this painting appears related to a
double-page watercolor from the 1868 (Whatman) sketchbook
(plate 33). Unusual in Manet's oeuvre, it is signed and was appar-
ently given to Henri Guérard, Eva Gonzalès's husband, after
Manet's death.

PLATE 35
Edouard Manet
Seascape with Bather
c. 1868
Watercolor and gouache on wove paper
8⅛ × 9½ inches (20.5 × 24 cm)
Private collection*

A bather similar to those in the 1868 (Whatman) sketchbook
(plate 33) and a sailing boat based on a watercolor in the pocket-
size sketchbook of the same date (plate 23) are features of this
gouache and watercolor drawing. An eminently marketable work,
it bears the stamp of the distinguished collector Alfred Beurdeley.

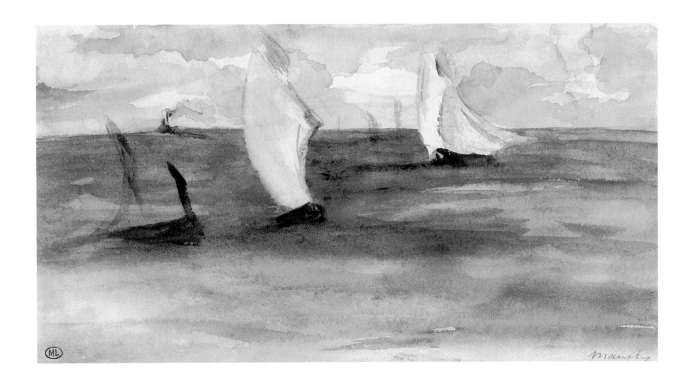

PLATE 36
Edouard Manet
Seascape with Sailing Ships
c. 1868
Watercolor on wove paper
4⅜ × 8¼ inches (11 × 21 cm)
Musée d'Orsay, Paris, held at the Musée du Louvre, Département
des Arts graphiques, Paris. Gift of Mme. J. Pillaut, 1961. RF 31.283
AIC

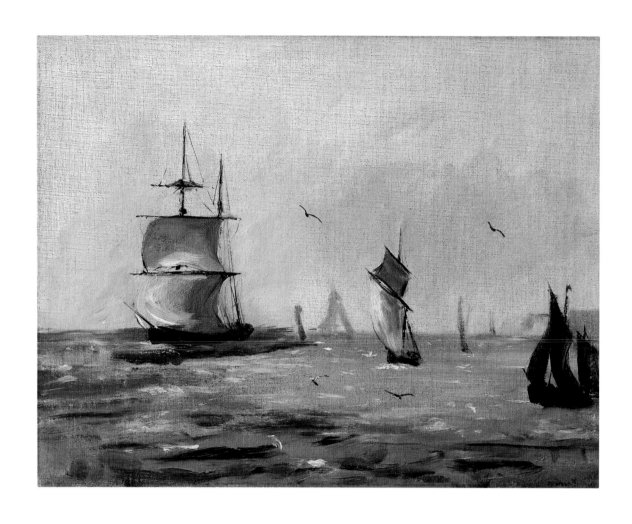

PLATE 37

Edouard Manet

Sailing Ships and Seagulls

c. 1864–68

Oil on canvas

8¼ × 10¼ inches (21 × 26 cm)

Fondation Aetas Aurea

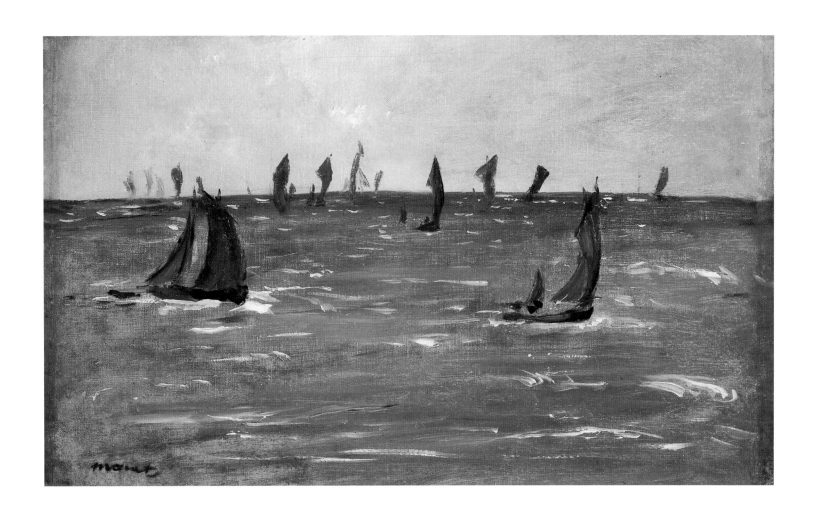

PLATE 38
Edouard Manet
Sailing Ships at Sea
c. 1864–68
Oil on canvas
13⅜ × 22 inches (34 × 55.8 cm)
The Cleveland Museum of Art. Purchase from
the J. H. Wade Fund. 1940.534

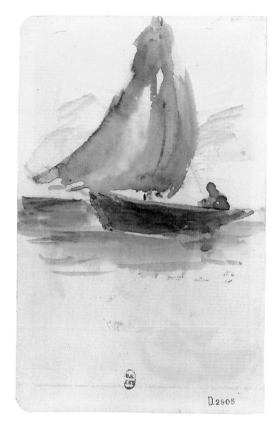

D.2905

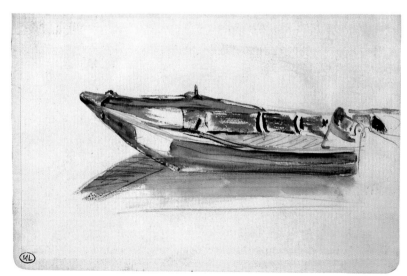

PLATE 39
Edouard Manet
Sailing Boat on the Sea
Trimmed page from the Boulogne 1868
(Whatman) sketchbook
Watercolor on laid paper
5⅝ × 3⅝ inches (14.3 × 9.3 cm)
Bibliothèque nationale de France, Paris.
Département des Estampes et de la
Photographie. Manet no. 17*

PLATE 40
Edouard Manet
Rowboat
Page from the Boulogne 1868
(Whatman) sketchbook
Graphite and watercolor on laid paper
3⅝ × 5⅝ inches (9.3 × 14.3 cm)
Musée d'Orsay, Paris, held at the Musée
du Louvre, Département des Arts
graphiques, Paris. RF 30.550
AIC, PMA

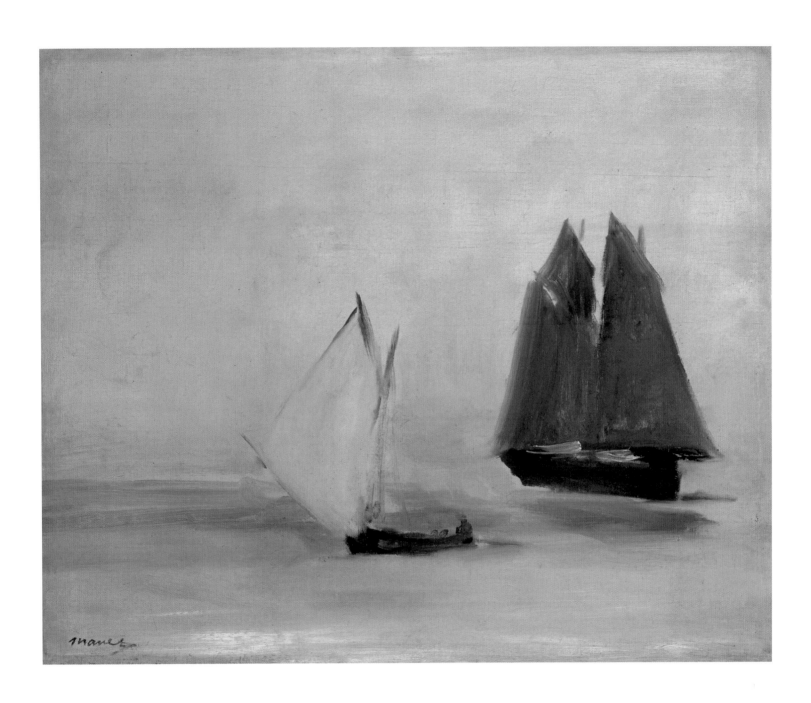

PLATE 41
Edouard Manet
Two Fishing Boats
c. 1868
Oil on canvas
15⅛ × 18½ inches (38.5 × 47 cm)
Private collection*

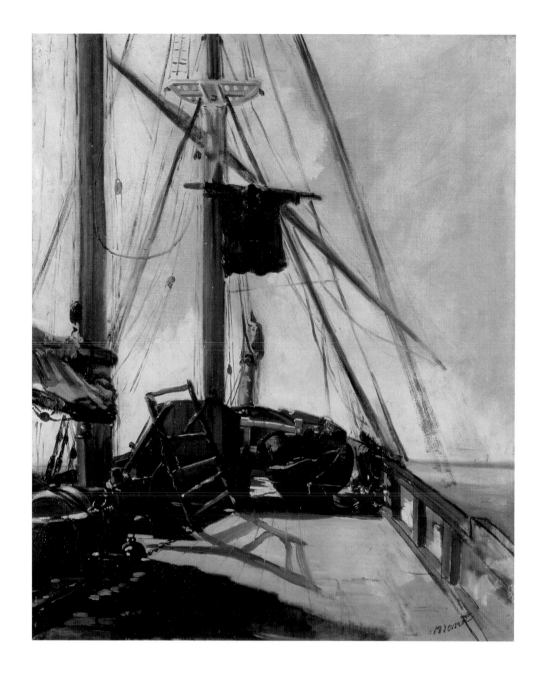

PLATE 42

Edouard Manet

Ship's Deck

c. 1868

Oil on canvas

22¼ × 18½ inches (56.4 × 47 cm)

National Gallery of Victoria, Melbourne, Australia.

Felton Bequest. 1926

Various dates, including a very early one (c. 1860), have been
proposed for this partly unfinished painting, which was apparently
"signed" after the artist's death. The crisp, dabbed quality of some
of the brushwork suggests a date of about 1868 at the earliest.

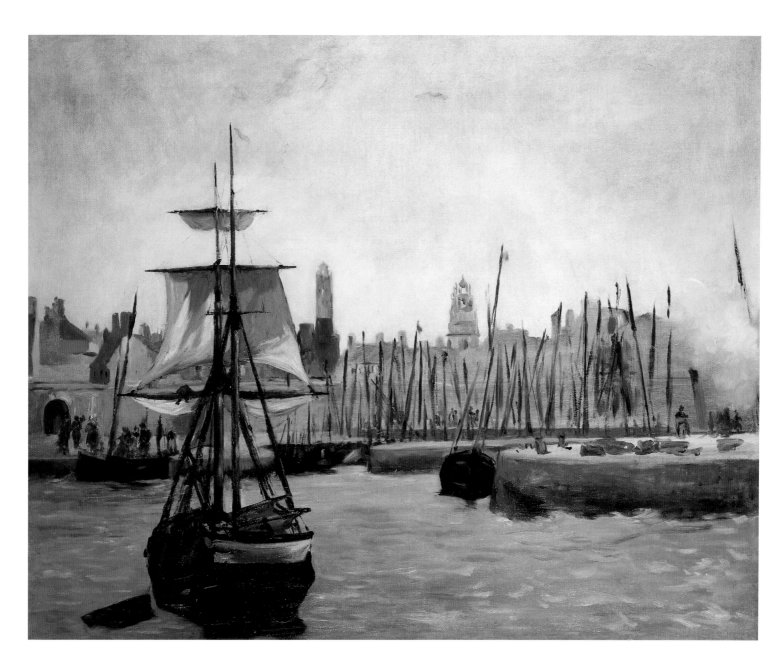

PLATE 43
Edouard Manet
The Port at Calais
c. 1868
Oil on canvas
32⅛ × 39⅝ inches (81.5 × 100.7 cm)
Private collection

No documentary evidence records Manet's visit to Calais, to which this canvas bears witness with its identifiable view of the town and the inscription *Edouard Manet / Calais* painted on the stern of the schooner-brig to the left. Listed in the artist's inventory of his studio in 1871–72, it was purchased by the baritone Jean-Baptiste Faure in 1882.

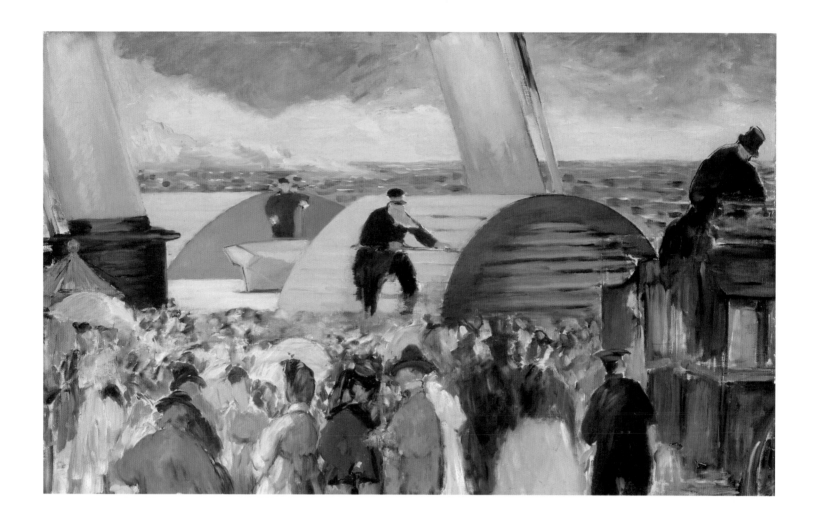

PLATE 44
Edouard Manet
Departure of the Folkestone Boat—The Large Study
c. 1864
Oil on canvas
24⁷⁄₁₆ × 40⅜ inches (62 × 100.5 cm)
Collection Oskar Reinhart "Am Römerholz,"
Winterthur. 1923.17*

This painting of the Folkestone boat, a steam packet that ferried
passengers to and from England, is cut from a larger canvas. Based
on sketches made by Manet in 1864 (fig. 43), it was probably
laid aside until the artist reinterpreted the theme on a second,
smaller canvas in 1868 (plate 45). The "Impressionistic" figures
on the quay, most likely added some years later, present a striking
contrast in styles.

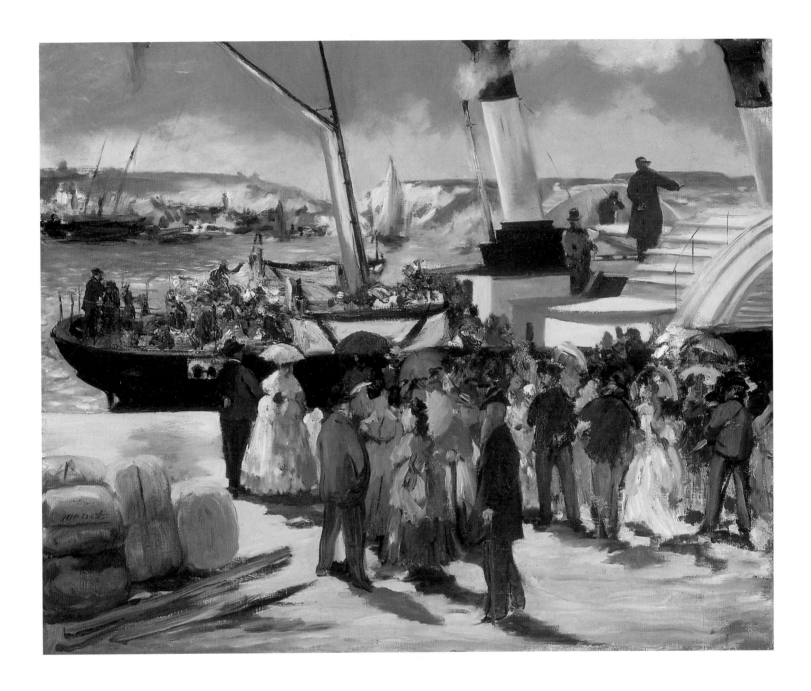

PLATE 45

Edouard Manet

Departure of the Folkestone Boat

c. 1868–72

Oil on canvas

23⅝ × 28¹⁵⁄₁₆ inches (60 × 73.5 cm)

Philadelphia Museum of Art. The Mr. and Mrs. Carroll S.
Tyson, Jr. Collection. 1963-116-10

PMA

The second Folkestone boat painting, with its visible stern, may provide a clue to the original composition of the earlier, cut canvas (plate 44). The apparently random distribution of the crowd, whose figures are sketched over scraped or reworked areas of paint, is brilliantly orchestrated with the shadows on the quay and the timbers and bales to the left to create a sense of the bustle and excitement attending the arrival and departure of the packet boats.

PLATES 46a,b
Edouard Manet
Sketches for *Departure of the Folkestone Boat:*
(a) *Couple on the Quay* (left) and (b) *Man with a Blond Baby* (right)
c. 1872
Graphite on laid paper
4 × 2½ inches (10 × 6.4 cm) each sheet
Musée d'Orsay, Paris, held at the Musée du Louvre, Département des Arts graphiques, Paris. RF 30.485, 30.484
AIC, PMA

PLATES 47a,b
Edouard Manet
Sketches for *Croquet at Boulogne:* (a) *Jeanne Gonzalès with a Mallet* (left) and (b) *Two Croquet Players* (right)
c. 1872
Graphite (left) and watercolor and graphite (right) on laid paper
4 × 2½ inches (10 × 6.4 cm) each sheet
Musée d'Orsay, Paris, held at the Musée du Louvre, Département des Arts graphiques, Paris. RF 30.410, 30.549
AIC, PMA

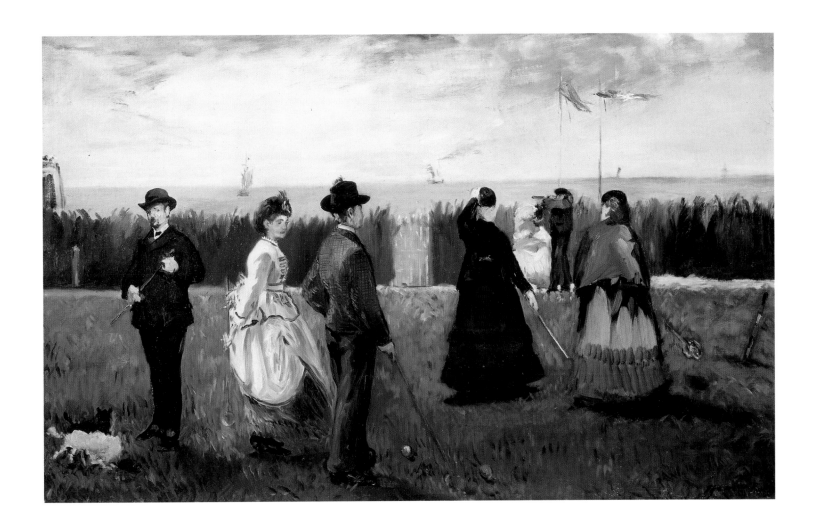

PLATE 48

Edouard Manet

Croquet at Boulogne

c. 1872

Oil on canvas

18½ × 28¾ inches (47 × 73 cm)

Private collection*

Croquet was imported from England as a pastime suitable for
both sexes. Here, Manet's son-in-law Léon Leenhoff appears to
concentrate on the action before him, but the proximity of the
fashionably attired Jeanne González, Eva's younger sister, suggests
that croquet is not the only game in play. Based on the same set
of sketches he made for the *Departure of the Folkestone Boat* (plates 46,
47), Manet's canvas is a brilliant comedy of manners set on the
croquet lawn overlooking the sea at Boulogne.

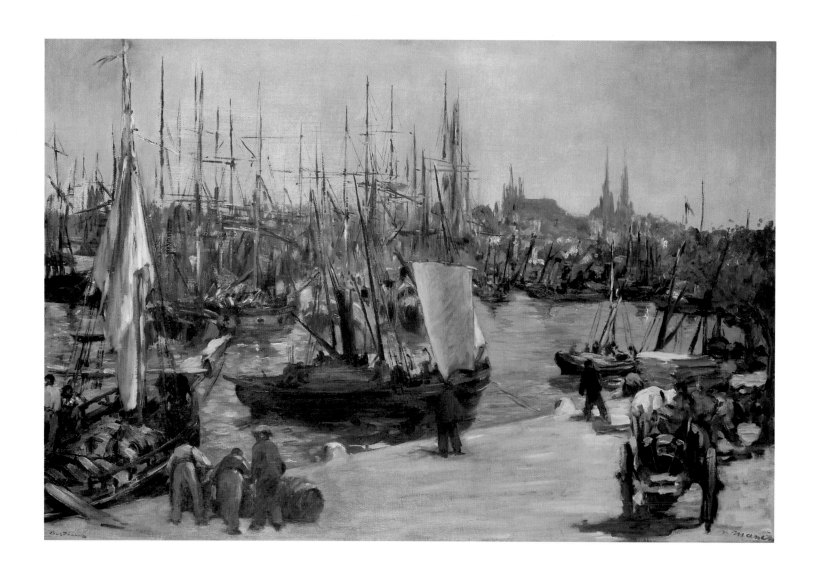

PLATE 49
Edouard Manet
The Port at Bordeaux
1871
Oil on canvas
25⅝ × 39⅜ inches (65 × 100 cm)
Private collection*

PLATE 50
Edouard Manet
The Bay of Arcachon
1871
Oil on canvas
13¾ × 21⅝ inches (35 × 55 cm)
Fondation E. G. Bührle Collection, Zurich
VGM

By 1871, Arcachon and its bay had become a resort for vacation-
ers from Bordeaux and elsewhere. Manet depicts the inland sea
and, in the background, the long, low spit of wooded sand dunes
that separated and protected it from the ocean. A variety of ships
suggests the fishing and leisure activities of this site, where Manet
rested for a month during his travels following the upheaval of the
Franco-Prussian War.

PLATE 51
Edouard Manet
Study for *Interior at Arcachon*
1871
Watercolor, pen and iron gall ink with brush and wash, and
graphite on graph paper; double page from a sketchbook
7¼ × 9¼ inches (18.5 × 23.5 cm)
Fogg Art Museum, Harvard University Art Museums, Cambridge,
Massachusetts. Bequest of Willima G. Russell Allen. 1957.59
AIC, PMA

Manet drew and colored in a sketchbook this domestic scene,
which served as the basis for a painting (plate 52). His wife
Suzanne has her feet up as she pens a letter while her son Léon,
originally positioned in front of the window, occupies a chair at
the table. Outside the villa a *pinasse*—the local type of boat—sails
by, parallel with the distant spit of land that leads to the mouth
of the bay.

PLATE 52

Edouard Manet

Interior at Arcachon

1871

Oil on canvas

15½ × 21⅛ inches (39.4 × 53.7 cm)

Sterling and Francine Clark Art Institute, Williamstown,

Massachusetts. 1955.552

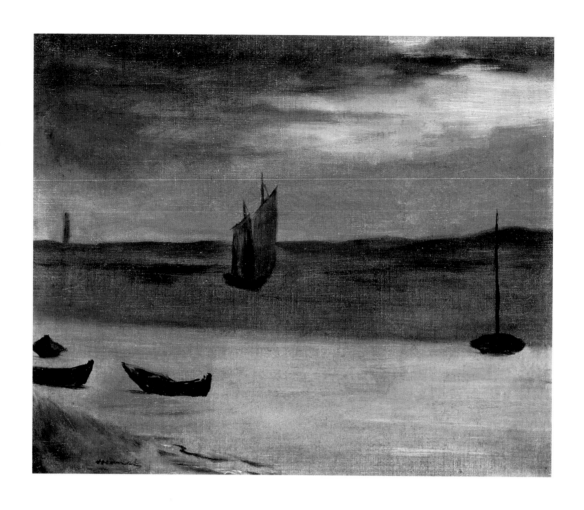

PLATE 53
Edouard Manet
The Bay of Arcachon and Lighthouse on Cape Ferret
1871
Oil on canvas
9 × 11¾ inches (25 × 30 cm)
Collection Rudolf Staechelin

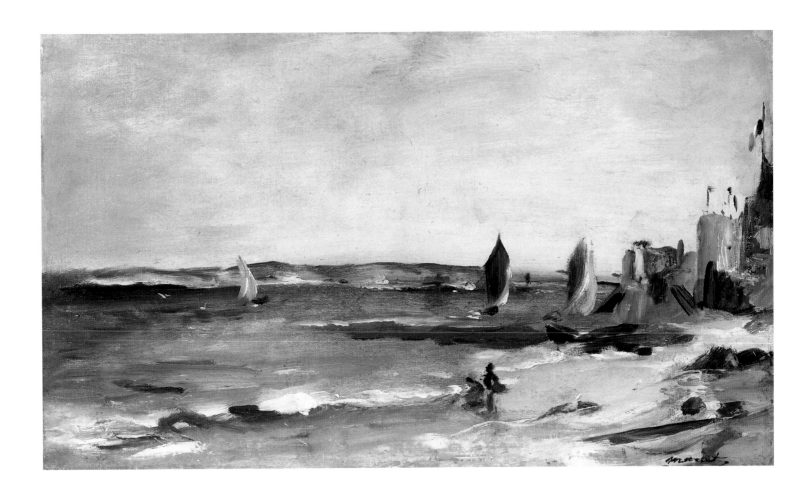

PLATE 54

Edouard Manet

Fine Weather at Arcachon

1871

Oil on canvas

9 × 16½ inches (25 × 42 cm)

Private collection

Ships scudding over the bay and windswept figures on the beach
suggest the force of the Atlantic weather just beyond Cape Ferret.
Arcachon was unprotected against often violent storms, depicted
in another canvas (fig. 48). Here, buildings and swiftly sketched
timbers down the beach may indicate the construction of coastal
defenses.

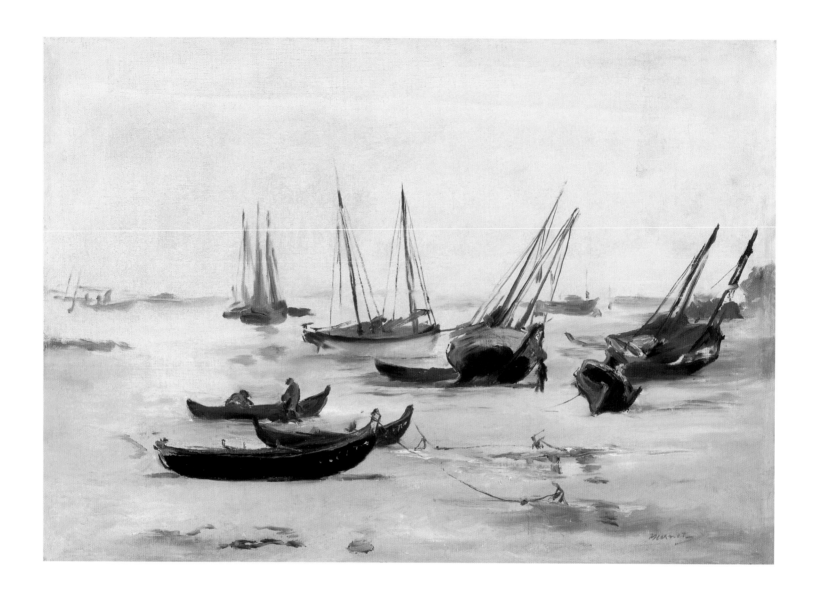

PLATE 55
Edouard Manet
Boats at Low Tide on the Bay of Arcachon
1871
Oil on canvas
14⅜ × 20⅛ inches (37 × 51 cm)
Private collection
AIC, PMA

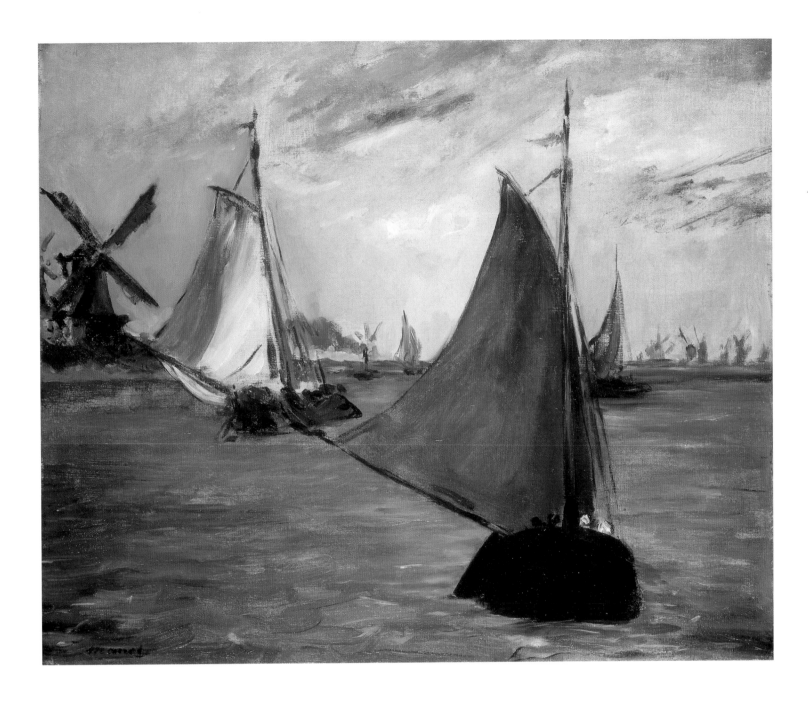

PLATE 56
Edouard Manet
View in Holland
1872
Oil on canvas
19¾ × 23¾ inches (50.2 × 60.3 cm)
Philadelphia Museum of Art. W. P. Wilstach Collection.
W1921-1-4

In contrast to the soft luminosity of southwestern France, the
more bracing northern atmosphere of Holland is evident in the
single painting that records Manet's visit to his wife's homeland
in 1872. With swift strokes dragged across the canvas, he captured
or constructed a seemingly instantaneous image, in which dis-
parate elements in an otherwise banal perspective view converge
in an absolute perfection of line and tone on the picture plane.

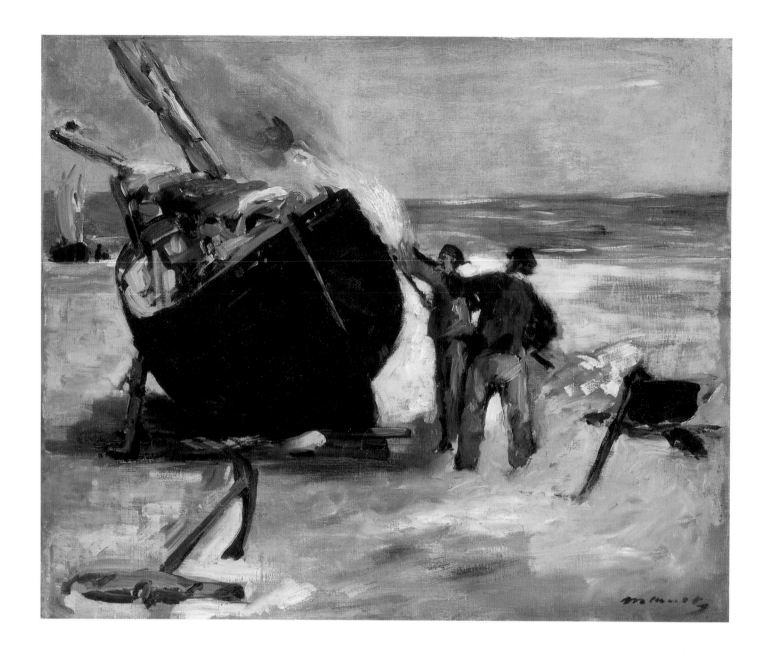

PLATE 57
Edouard Manet
Tarring the Boat, Berck
1873
Oil on canvas
23¼ × 23⅝ inches (59 × 60 cm)
The Barnes Foundation, Merion, Pennsylvania. BF 166*

In 1873 the Manet family vacationed at Berck, where the artist
responded to the very different character of this seacoast with its
great expanses of flat beach. In the absence of a harbor, the sturdy
fishing boats were hauled up on the sand (plate 60). Manet ob-
served the shapes of these boats and the actions of the men who
tended them as closely as he did the familiar figures of his wife
and brother Eugène relaxing on the beach (plate 58), or those of
his mother and his wife in a meadow near the village (fig. 51).

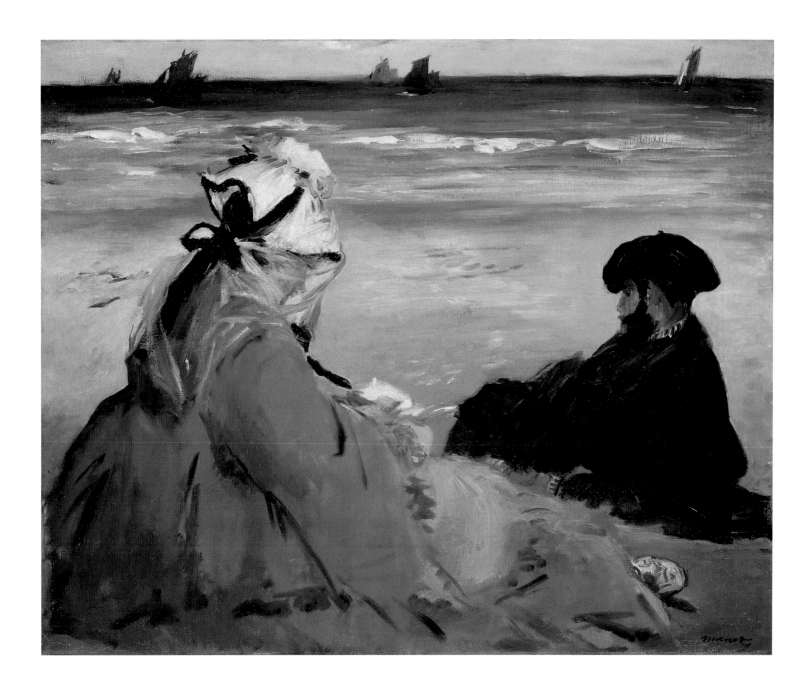

PLATE 58
Edouard Manet
On the Beach—Suzanne and Eugène Manet at Berck
1873
Oil on canvas
23½ × 28⅞ inches (59.6 × 73.2 cm)
Musée d'Orsay, Paris. Life interest gift of
Jean-Edouard Dubrujeaud. RF 1953.24

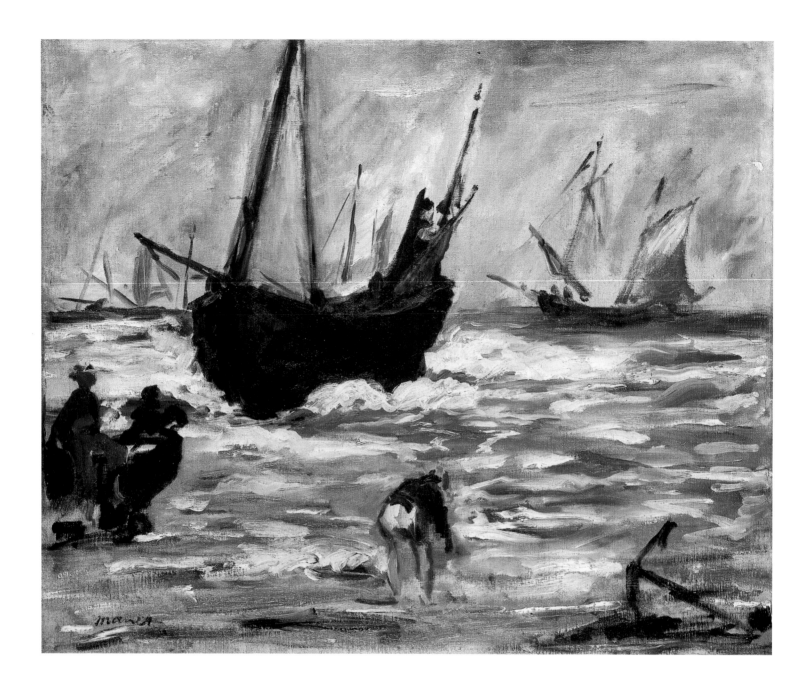

PLATE 59
Edouard Manet
Fishing Boats, Berck
1873
Oil on canvas
19⅝ × 24¼ inches (50 × 61.5 cm)
Private collection
AIC, PMA

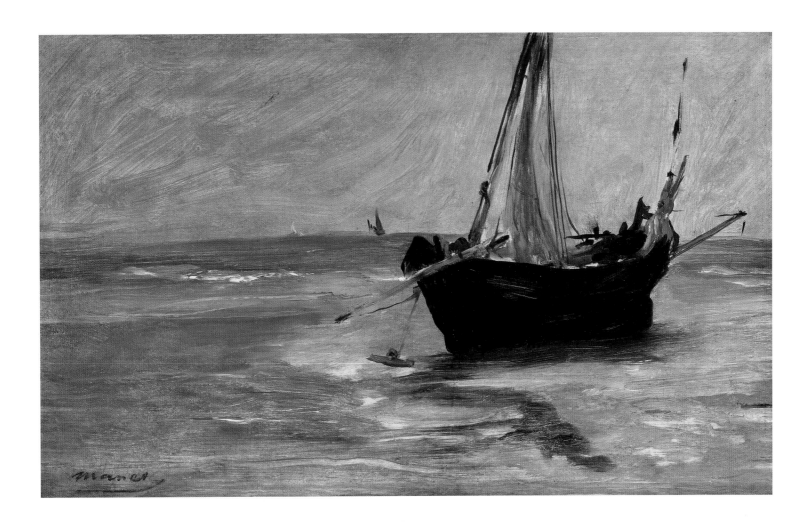

PLATE 60
Edouard Manet
Fishing Boat on the Beach at Berck
1873
Oil on panel
7⅞ × 13 inches (20 × 33 cm)
Wallraf-Richartz-Museum – Fondation Corboud, Cologne. FC 777

Direct contact with the elements in the rustic fishing village of Berck
led Manet to experiment with a more rugged handling and subdued
use of color. In this picture, Manet streaked and washed paint over
a small wood panel. In another (plate 59), he scrubbed and dashed
paint over the bare, primed canvas.

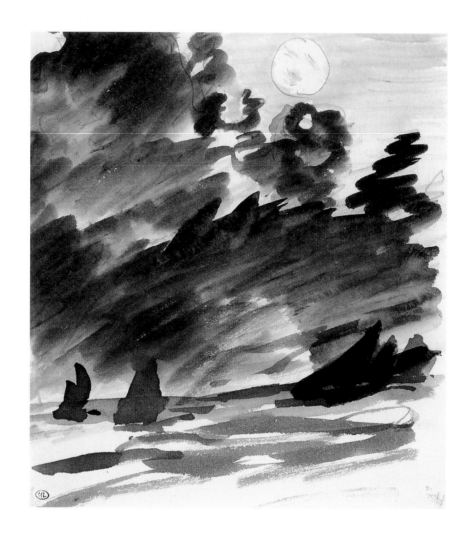

PLATE 61
Edouard Manet
Seascape by Moonlight
c. 1873–76
Brush and ink wash on wove paper
7¾ × 7⅟₁₆ inches (19.7 × 17.9 cm)
Musée d'Orsay, Paris, held at the Musée du Louvre, Département
des Arts graphiques, Paris. RF 30.504
AIC, PMA

PLATE 62
Edouard Manet
Low Tide at Berck
1873
Oil on canvas
22 × 28¾ inches (56 × 73 cm)
Wadsworth Atheneum Museum of Art, Hartford, Connecticut.
The Ella Gallup Sumner and Mary Catlin Sumner Collection
Fund. 1967.1

The speed of Manet's hand is seen in a wash drawing (plate 61)
and in this painting, in which touches of grey and black conjure a
group of fishing boats beneath ragged clouds that race above the
limitless but ambiguous horizon. Manet signed this deceptively
simple masterpiece on a piece of driftwood in the foreground.

PLATE 63

Edouard Manet

Rising Tide

1873

Oil on canvas

18½ × 22⅞ inches (47 × 58 cm)

Private collection

PLATE 64
Edouard Manet
Toilers of the Sea
1873
Oil on canvas
24¾ × 31¼ inches (63 × 79.3 cm)
Museum of Fine Arts, Houston.
Gift of Audrey Jones Beck. 92.171*

The harsh simplicity of the Berck sailors' lives touched Manet
deeply. In a painting he titled after a saga by Victor Hugo, Manet
places the viewer on board a fishing vessel as it plunges through
the waves. The frankly heroic nature of this composition was
accentuated by lowering the horizon line: traces of overpainted
green show that the sea once rose above the head of the central
sailor who sits confronting the viewer, a pipe clenched between
his teeth and his hand on the lowered sail.

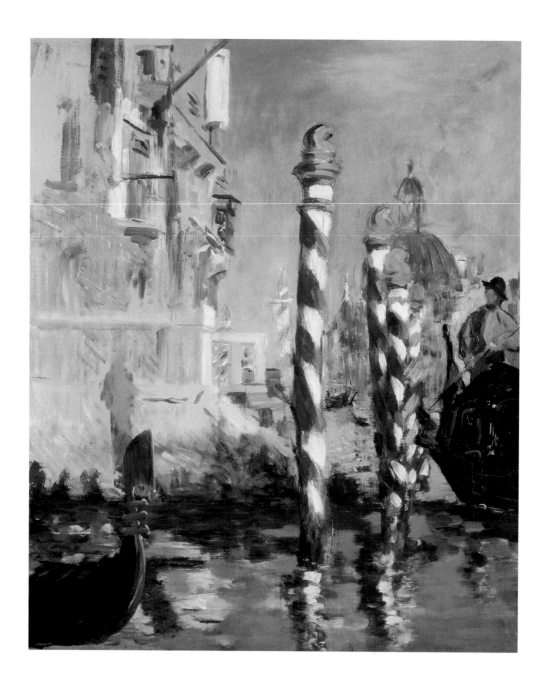

Manet completed only two paintings as a result of his visit to Venice in 1874. This canvas, the smaller of the two, is dominated by the azure splendor of the sky, the dome of the Salute, and the twisted capping on the famous "barber's poles" to which gondolas are moored. Colors on the palace façade draw the eye upward, away from the waters of the canal. In the larger Venice painting (plate 66) our gaze is concentrated on the gondola and the blue-and-white poles emerging from dappled reflections on the canal.

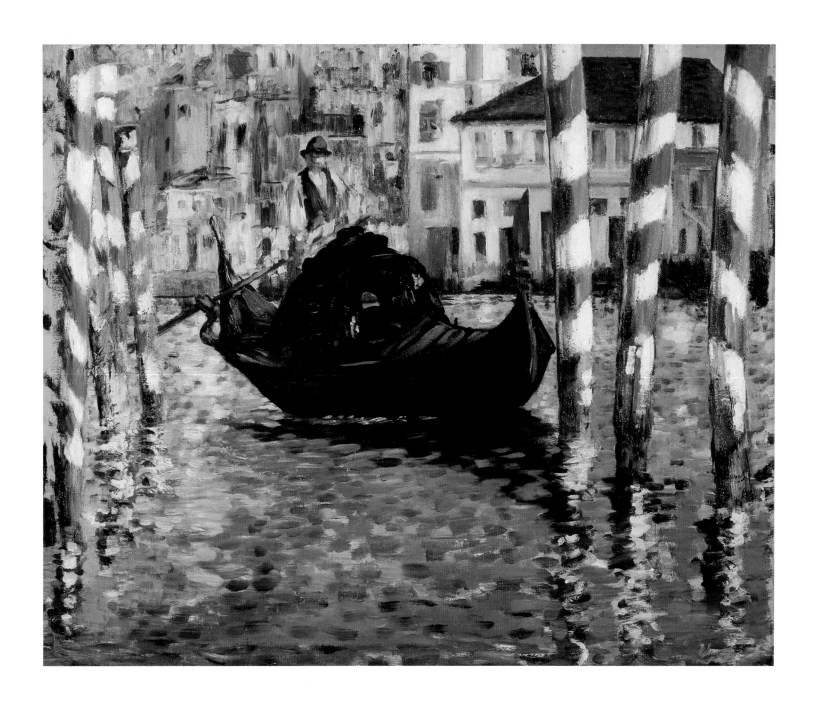

PLATE 66
Edouard Manet
Venice—The Grand Canal (Blue Venice)
1874
Oil on canvas
23⅛ × 28⅛ inches (58.7 × 71.4 cm)
Collections of the Shelburne Museum,
Shelburne, Vermont. 1972-69.15
AIC, PMA

153 ~ *Manet and the Sea: Venice*

PLATE 67
Edouard Manet
Young Woman by the Sea
1880
Graphite and watercolor on wove paper
6¾ × 5 inches (17.2 × 12.7 cm)
Collection André Bromberg
AIC, PMA

PLATE 68
Edouard Manet
Isabelle Diving
1880
Watercolor on wove paper
7⅞ × 4⅞ inches (20 × 12.3 cm)
Musée d'Orsay, Paris, held at the Musée du Louvre, Département
des Arts graphiques, Paris. RF 11.175*

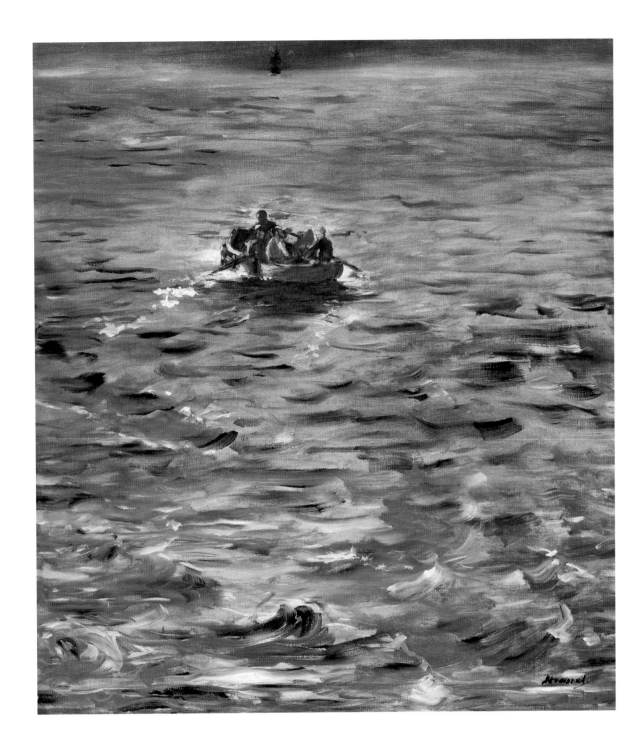

PLATE 69

Edouard Manet

The Escape of Rochefort

1880–81

Oil on canvas

31½ × 29½ inches (80 × 75 cm)

Musée d'Orsay, Paris. Acquired through payment in kind, 1984.

RF 1984.158

Of his two depictions of the escape of Henri Rochefort and his companions from a prison colony on New Caledonia, this smaller canvas is in theory the more finished one, since it is signed. The fragile bark with five men on board is set in a vast expanse of sea, propelled by two oars toward the distant ship that awaits them on the horizon.

PLATE 70
Edouard Manet
The Rowboat—Study for *The Escape of Rochefort*
1880
Oil on canvas
19⅝ × 18⅞ inches (50 × 48 cm)
Private collection*

PLATE 71
Edouard Manet
The Escape of Rochefort—The Large Study
1880–81
Oil on canvas
56¼ × 44⅞ inches (143 × 114 cm)
Kunsthaus Zürich. Vereinigung Zürcher Kunstfreunde. 1955.9
AIC, PMA

This large canvas was probably the work Manet originally intended for the Salon of 1881. It is based on direct study of a gray whaling boat (plate 70), which Manet had brought to the courtyard of his Paris studio, and on an oil sketch of Olivier Pain, Rochefort's principal companion. Impressive even in its apparently unfinished state, the painting is dominated by the central boat and the figure of Rochefort, who guides it toward the waiting schooner over heaving, iridescent waves.

Gustave Courbet

JOSEPH J. RISHEL

At the 1870 Salon in Paris, Gustave Courbet (1819–1877) exhibited two seascapes—or "landscapes of the sea," as he preferred to call them—*Cliff at Etretat* (fig. 52) and *Stormy Sea* (fig. 53). In a decision calculated to attract attention by concentration, Courbet had entered only two paintings that year. Many critics hailed these works as the apogee of his long career.[1] The man who for twenty years had done more than any other French artist to upset and redirect the course of picture-making, primarily through his figurative works, had reinvented himself as a seascape painter. Ironically, these works—seemingly his least-loaded images politically and socially—would become, because of their independence and neutrality, one of his most prophetic, "modernist" legacies.

Courbet adored the sea. As one critic noted, "it was said that the sea gave him the same emotion as love."[2] Born in the mountainous Jura district in the east of France, he had to wait until he was twenty-one for his first direct experience of the ocean, and it took. As he wrote his parents in 1841 from Normandy, where he had made the brief trip from Paris with his childhood friend and fellow art student Urbain Cuenot: "I am delighted with this trip, which has quite developed my ideas about different things I need for my art. We finally saw the sea, the horizonless sea—how odd for a mountain dweller. We saw the beautiful boats that sail on it. It is too inviting, one feels carried away, one would leave to see the whole world."[3] In 1865, while staying at Trouville, he bragged that he had swum in the sea some eighty times, most recently six days before posting his letter—which is to say, on November 11![4] Paul Collin, the doctor who attended a weak and disconsolate Courbet at the end of his life, when he was forced into exile on Lake Geneva in Switzerland for his role in the Paris Commune, reported that the artist would emerge from his lethargy "only to speak to me of his love of water and for the lake. 'Ah!' he said to me, 'if only I could stretch myself out in the water of the lake, I should be cured. I am like a fish in the water.'"[5]

Although Courbet saw the sea as central to his physical well-being, it took some time for him to interject himself into the long history of French marine painting. Quick sketches in a notebook he took with him on the 1841 trip down the Seine to the harbor of Le Havre and beyond,[6] as well as a charming if slightly naïve oil painting of the estuary of the Seine (Musée des Beaux-Arts, Lille),[7] are the only indication that he reacted immediately to this new subject. It was not until thirteen years later, while visiting his principal early patron, Alfred Bruyas, in Montpellier, that Courbet took up marine painting in earnest. It must have been an altogether exhilarating visit, from which came Bruyas's enlightened commission for Courbet to produce a joint portrait of the artist and patron meeting in the broad Languedoc landscape, a work best known by its anecdotal title of *Bonjour, M. Courbet* (Musée Fabre, Montpellier). Courbet also made for his friend a portrait of himself saluting the Mediterranean from the beach at Palavas-les-Flots just east of Montpellier (plate 72). In this, his first mature marine painting, he established himself straightaway as an artist at one with the sea. Some nine other seascapes are associated with the 1854 visit

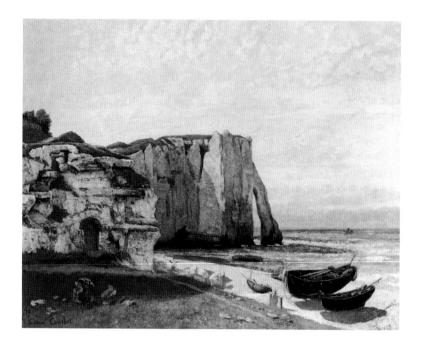

Fig. 52. Gustave Courbet, *Cliff at Etretat*, 1870. Oil on canvas, 52⅜ × 63¾ inches (133 × 162 cm). Musée d'Orsay, Paris. MNR 561

to Montpellier or with another trip south in 1857, when he again worked at Palavas as well as a nearby cove called Les Cabanes.[8] All of these works show a vast and completely serene sea that reaches an intense, dark azure blue just at the horizon line. In sharp contrast, the skies are limpid and pale with long, broad scuffs of clouds. Working with both a brush and a palette knife, Courbet has given the surfaces a notably even application of long horizontal gestures layered up the canvas. These works laid much of the foundation for what the younger artists James McNeill Whistler and Claude Monet would take from Courbet as a marine painter when they encountered him on the Normandy coast in 1865 (see, respectively, plates 86 and 91 below).

More than a decade separated Courbet's Mediterranean views and his critical stays in Normandy starting in 1865, when he commenced his second, far more vigorous, exploration of the sea as a subject (plates 73, 74). The two "campaigns"—if one can call visits to the seashore over a two- or three-year period something so concise—could not have been more different in their results. The fresh exhilaration of Courbet's Montpellier visits is replaced by a much more energetic, darker (often verging on manic) approach to his

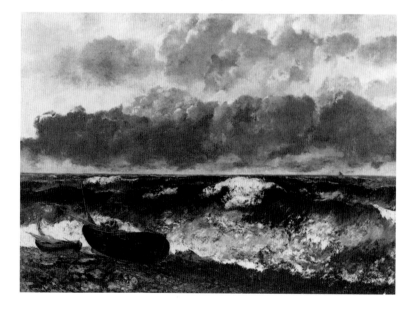

Fig. 53. Gustave Courbet, *Stormy Sea*, 1870. Oil on canvas, 46⅟₁₆ × 63 inches (117 × 160 cm). Musée d'Orsay, Paris. RF 213

subject. Even the subject itself is markedly different. With the exception of a group of beach views at low tide, the sea is rarely calm in these pictures. The skies are turgid and heaving. Near the end of the decade, great crashing waves became a dominant motif in these progressively dramatic works from which figures are banned, fishing boats dragged well up the shingle serving as the only reflection of humanity. The number of works Courbet produced during this period is astounding, as is the pure energy of their creation. He claimed to have executed thirty-five paintings during his stay in Trouville in the autumn of 1865, although in addition to "pure" marine paintings, this figure also includes fashionable portraits and a joyously bizarre painting of a girl rowing a new catamaran-like canoe called a "podoscaphe."[9]

The following year the Count de Choiseul lent Courbet his house at Trouville on the Normandy coast where he was often in the company of Eugène Boudin and Monet. Some ten marines have been dated to this period, including the strangely lyrical *Waterspout* (plate 75). The reductive quality of these works has frequently been noted. They are all presented on a frontal plane, with the long, now progressively more matte and built-up layers of dragged paint taking on an encaustic-like luminosity and density. These marines of 1866 mark a period of concentrated aesthetic exploration preceding the titanic explosion that occurred two years later.

Courbet was at Etretat for about two months, starting on August 10, 1869. Some fifty paintings have been attributed to this period,[10] although some no doubt were produced upon his return to his Paris studio or (sometimes with assistance) during his long Swiss exile after 1873. Many are variations on the theme of a central wave churning near the center of the canvas, just below the horizon (plates 76, 78). Some, like the two large canvases shown in the Salon of 1870 (figs. 52, 53), are pitched on a steep beach. Manet once called Courbet "that bull of a man," and the artist's huge personality and high-pitched engagement with his subject are at the very center of these works. Michael Fried reminds us of Joan Miró's remark after encountering Courbet's *Stormy Sea* in the Louvre: "One feels physically drawn to it, as by an undertow. It is fatal. Even if this painting had been behind our backs, we would have felt it."[11]

By the mid-1860s, marine painting played a central role in Courbet's critical reception, and he manipulated this attention with great energy. That Courbet discovered this passion —and critical strategy—late in his career is demonstrated by the complete absence of marine paintings among the forty canvases he hung in his independent Realism pavilion adjoining the fairgrounds of the 1855 Exposition universelle. By the 1867 Exposition this had changed dramatically: he showed twenty-three "landscapes of the sea" (twenty of them from his 1865 Trouville visit) among some 135 works he included in his independent show. The numerous waves and repetitions of earlier marine subjects after 1870, when Courbet was desperate for money, only underscore the marketability of these (by then often formulaic) easel paintings. They continued to hold the critics' attention: Paul Mantz in 1878, a year after Courbet's death, specifically admired *Stormy Sea* as a veritable "synthesis of the wave" and said that Courbet has "consumed the concrete phenomena into the abstract" while "underscoring the fatality of the ideal."[12]

As noted earlier, Courbet did more than any other painter to change the course of painting in France in the mid-nineteenth century, and his exploration of the marine genre influenced many other artists. The cross-fertilization and interplay among Courbet, Whistler, and Monet—and, by extension, Renoir in his wave paintings—offer a clear picture of artistic interaction. But what of Manet? To address the question broadly, Manet is inconceivable without Courbet.[13] Coming only half a generation ahead of Manet (Courbet was born in 1819, Manet in 1832), Courbet's enormous energy, faith in realism, and unceasing and intensely public promotion of his radically independent views established

Fig. 54. Caricature of Courbet and Manet from *L'Illustration*, June 3, 1865: "Picture by M. Manet for next year (painting of the future)—M. Courbet meets M. Manet in the Elysian fields of realism. They are going to visit the sewers of Paris, the final refuge of today's truth."

Fig. 55. Edouard Manet, *Portrait of Courbet*, 1878. Pen and ink on paper, 9½ × 7⅛ inches (24 × 18 cm). Illustrated in Denis Rouart and Daniel Wildenstein, *Edouard Manet: Catalogue raisonné* (Lausanne: Bibliothèque des arts, 1975), vol. 2, p. 173.

a platform on which Manet could only build. Courbet was to Manet as Manet would be to Cézanne: an astutely admired figure from whom he could learn greatly and progress, though in a completely different direction.

Manet's admiration for Courbet is amply documented, although it is always tempered with qualification. The artist's friend and biographer Antonin Proust, for example, recalled that the young Manet said of Courbet's *Burial at Ornans* of 1849 (Musée d'Orsay, Paris), which he saw at the Salon of 1851: "Yes, the *Burial* is very good. It can't be said often enough that it is very good, because it is better than anything else. But between ourselves, it doesn't go far enough. It is too dark."[14]

While it seems improbable that the two never met, given the fluidity of the Paris artistic world in the nineteenth century, we cannot know for sure. As Reff notes, on at least two occasions they were linked in the public's mind through caricatures (fig. 54).[15] They had numerous friends in common, most notably Champfleury (1828–1889), Emile Zola (1840–1902), and especially Charles Baudelaire (1821–1867), although all three of these critics diverted their interests from Courbet to Manet by the late 1860s.[16] In 1871, Manet sent a very sharp and dismissive note to his great supporter Théodore Duret: "You mentioned Courbet. He behaved like a coward at his court-martial and doesn't deserve any further attention."[17] This brutal tone, all too illustrative of the great social and class distinctions between the two artists, is to some degree mitigated by Manet's agreement to provide a portrait of Courbet for the memorial volume published one year after his death in 1878 (fig. 55).[18]

Manet certainly knew, through the Salons and especially through Courbet's Realism pavilion of 1855, nearly all the important, large figurative works. With regard to the seascapes, the connections are less easily traced. The relatively small group of seascapes that formed Courbet's first substantial contribution in this genre—the Mediterranean views from 1854 and 1857—seems to have had no public life, although arguably Whistler knew the celebrated Palavas beach painting (plate 72) by 1865, when he (in the company of Courbet) did his own homage to this image, *Harmony in Blue and Silver: Trouville* (plate 84). Manet's coming of age

as a marine painter in the summer of 1864 in Boulogne preceded by a full year Courbet's return to marines farther down the coast in Trouville and Deauville.

A central feature of Manet's sea paintings was, of course, the high horizon line. This raising of the pictorial plane toward the horizon is prefigured in Courbet's evolution over the preceding fifteen years, though Manet's use of this element is more radical. In the end, however, despite their mutual love of the sea and the liberating pleasure taken in depicting it, they simply are too different in temperament and taste to force a simple comparison.

Manet's engagement with the business of the sea, that is, the nautical comings and goings of sailboats and steamships, has only a casual (although sometimes quite literal) parallel in Courbet's seascapes—for example, in Manet's *Sailing Ships at Sea* (plate 38), where, as in Courbet's *Waterspout* (plate 75), the sails position the depth of the view toward the horizon like staffage figures, with little commentary on their purpose. Channel packets, war vessels, and aspects of harbors and passage that so engaged Manet do not seem to have been of interest to Courbet.

Courbet's marine paintings were shaped by his own corporeal encounters with the sea, and from his start in 1855 he often put himself into his seascapes in a literal and grandly dramatic fashion. As Courbet's pace of painting his seascapes quickened in the 1860s, so did his energy in making them. From Manet's perspective, Courbet's imposition of his own will and desire to expose himself in these paintings may well have seemed a vulgar show of egoism.

Perhaps it is best to leave the last word to Manet. Antonin Proust recorded Manet's views on Monet, as told to Jean Béraud during the 1870s:

> And when it comes to water—he's the Raphael of water. He knows all its movements, whether deep or shallow, at every time of day. I emphasize that last phrase, because of Courbet's magnificent remark to Daubigny who had complimented him on a seascape: "It's not a seascape, it's a time of day." That's what people don't fully understand yet, that one doesn't paint a landscape, a seascape, a figure; one paints the effect of a time of day on a landscape, a seascape, or a figure.[19]

Assuming that Proust's recollection is accurate,[20] few statements more clearly demonstrate Manet's admiration for Courbet as a great independent, progressive figure. Manet here refers to Courbet, his predecessor, in relation to Monet, one of the essential tenants of the new painting of the 1870s—which, in turn, looked so needfully to Manet.

1. See Marie-Antoinette Tippetts, *Les Marines des peintres: Vues par les littérateurs de Diderot aux Goncourt* (Paris: A. G. Nizet, 1966), pp. 172–89.

2. Georges Riat, *Gustave Courbet: Peintre*, Maîtres de l'art moderne (Paris: H. Floury, 1906), p. 120; cited in Tippetts, *Les Marines*, p. 172.

3. Letter from Gustave Courbet to his family, spring/summer 1841, in *Letters of Gustave Courbet*, ed. and trans. Petra ten-Doesschate Chu (Chicago: University of Chicago Press, 1992), p. 38.

4. Letter from Courbet to his family, November 17, 1865, in ibid., pp. 268–69.

5. Quoted in *Gustave Courbet, 1819–1877*, exh. cat. (Philadelphia: Philadelphia Museum of Art; Boston: Museum of Fine Arts, 1959), n.p.

6. Chu, ed., *Letters of Gustave Courbet*, p. 39 n.1.

7. *Gustave Courbet*, exh. cat. (Paris: Editions des Musées Nationaux/Grand Palais, 1977), no. 2.

8. See Philippe Bordes, *Courbet à Montpellier* (Montpellier: Musée Fabre, 1985); Sarah Faunce and Linda Nochlin, *Courbet Reconsidered* (New York: Brooklyn Museum, 1988), pp. 122–23; and Robert Fernier, *La Vie et l'oeuvre de Gustave Courbet: Catalogue raisonné*, vol. 1, *1819–1865* (Lausanne: Bibliothèque des arts; Paris: Fondation Wildenstein, 1977), nos. 150–55, 218–20, 238.

9. *The Woman in a Podoscaphe*, 1865 (Murauchi Art Museum, Tokyo). This painting is evidence that for Courbet, as well as many other artists during the Second Empire (e.g., Alexandre Cabanel and Pierre-Auguste Renoir), the sea, waves, and eroticism were inextricably linked.

10. Fernier, *La Vie et l'oeuvre de Gustave Courbet*, nos. 678–727.

11. Michael Fried, *Courbet's Realism* (Chicago: University of Chicago Press, 1992), p. 215.

12. Tippetts, *Les Marines*, p. 183 (my translation).

13. See Fried, *Courbet's Realism*, pp. 200–201.

14. Juliet Wilson-Bareau, ed., *Manet by Himself: Correspondence and Conversation, Paintings, Pastels, Prints and Drawings* (London: Macdonald, 1991), p. 27.

15. Theodore Reff, "Courbet and Manet," *Arts Magazine*, March 1980, pp. 98–99.

16. A sad note survives in which Manet told Baudelaire, who was stranded in Brussels and badly in need of money, that he could not accept the offer to buy Courbet's portrait of the poet, though he did suggest another buyer. Letter from Manet to Baudelaire, September 14, 1865, in Wilson-Bareau, ed., *Manet by Himself*, p. 36.

17. Letter from Manet to Théodore Duret, August 22, 1871, in Wilson-Bareau, ed., *Manet by Himself*, p. 162.

18. Henri de Ideville, *Gustave Courbet: Notes et documents sur sa vie et son oeuvre avec huit eaux-fortes* (Paris: Alcan-Lévy, 1878).

19. Quoted in Wilson-Bareau, ed., *Manet by Himself*, p. 169.

20. Proust's recollections, published at the end of the century, are notorious for their relaxed treatment and interpretation of material, which often seems almost too prescient of the events that followed.

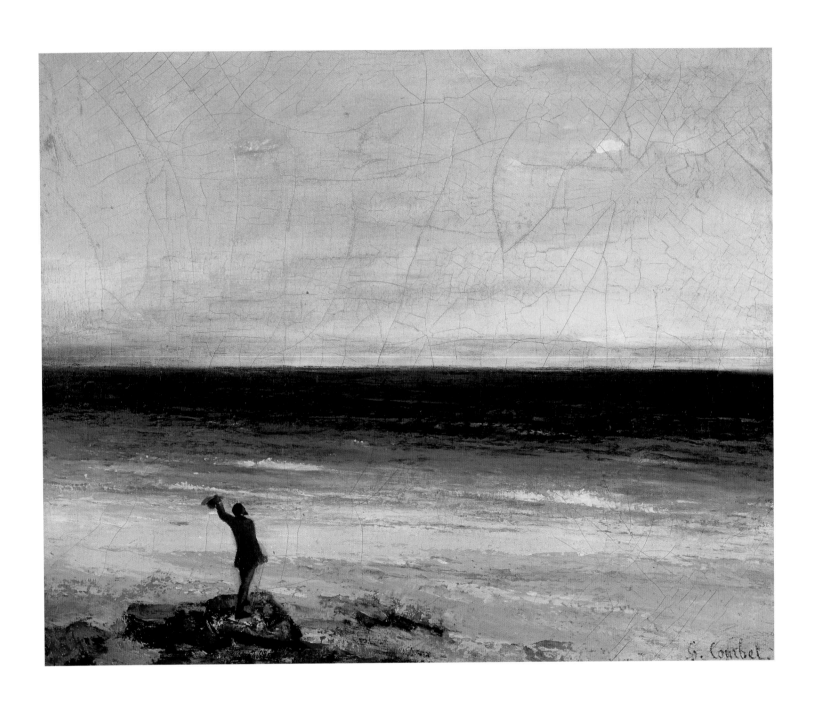

PLATE 72
Gustave Courbet
Seacoast at Palavas
1854
Oil on canvas
10⅝ × 18⅛ inches (27 × 46 cm)
Musée Fabre, Montpellier*

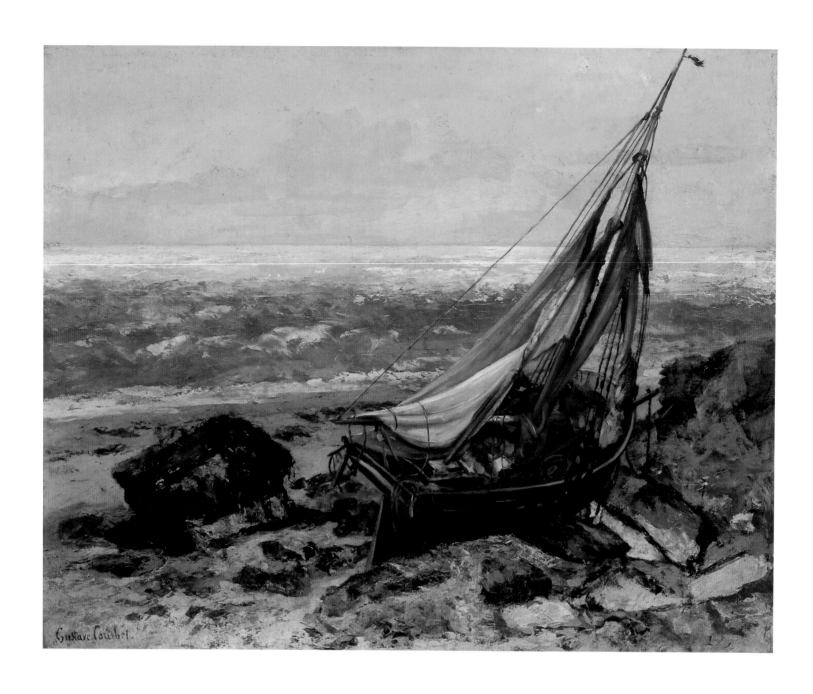

PLATE 73
Gustave Courbet
The Fishing Boat
1865
Oil on canvas
25½ × 32 inches (64.8 × 81.3 cm)
The Metropolitan Museum of Art, New York.
Gift of Mary Goldenberg. 1899.11.3

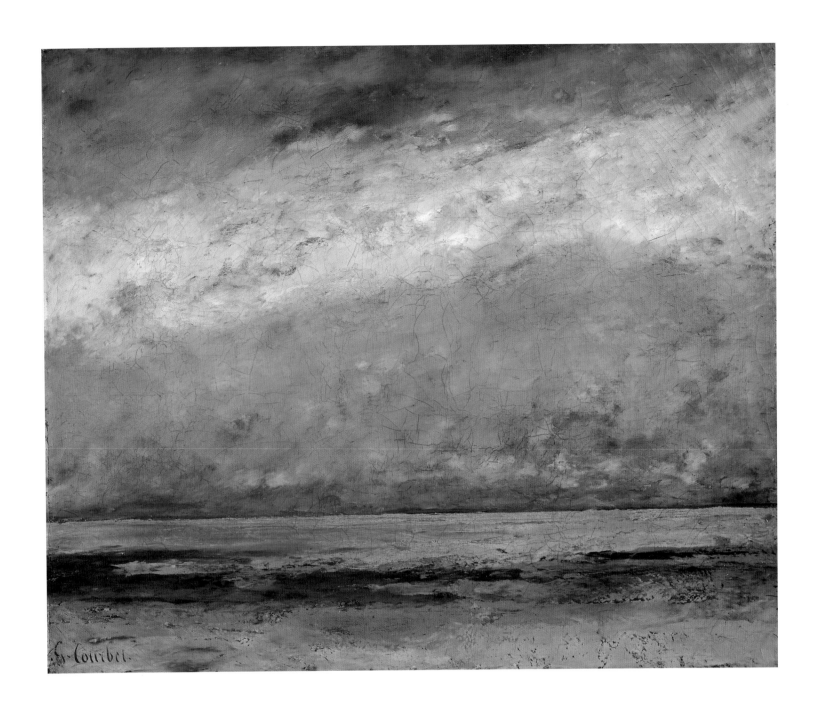

PLATE 74
Gustave Courbet
Seascape
1865
Oil on canvas
21 × 25³⁄₁₆ inches (53.5 × 64 cm)
Wallraf-Richartz-Museum – Fondation
Corboud, Cologne. WRM 2095
AIC, PMA

167 ~ *Gustave Courbet*

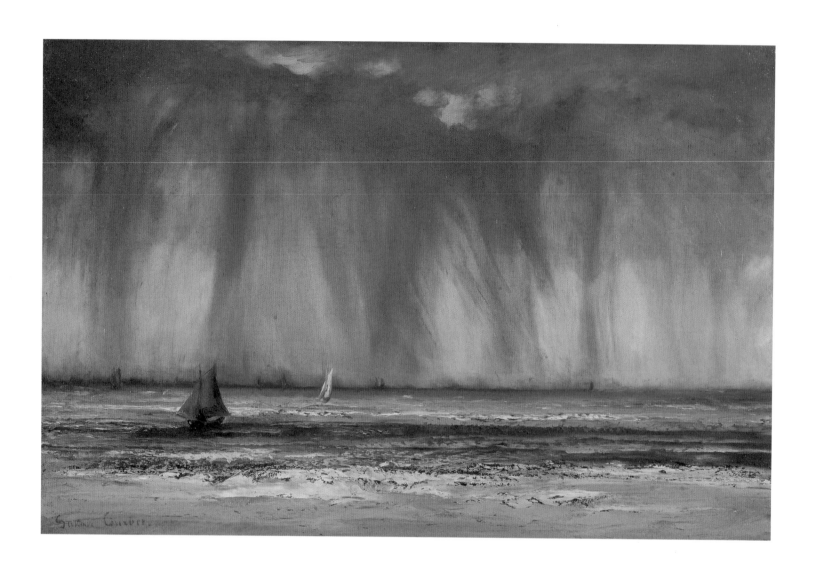

PLATE 75
Gustave Courbet
The Waterspout
1866
Oil on canvas on gypsum board
17 × 25⅞ inches (43.2 × 65.7 cm)
Philadelphia Museum of Art.
The John G. Johnson Collection. Cat. no. 948

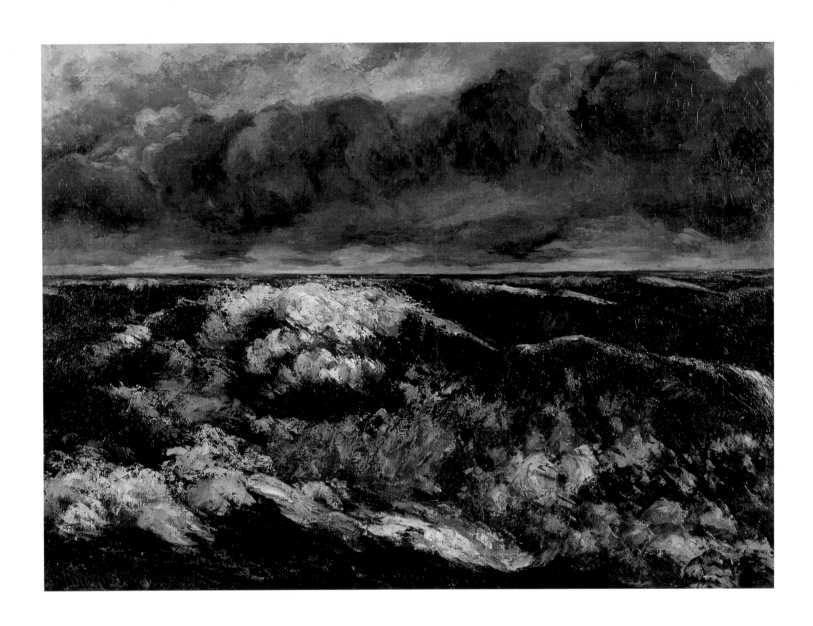

PLATE 76
Gustave Courbet
The Wave
1869
Oil on canvas
25¾ × 35⅜ inches (65.5 × 90 cm)
Musée des Beaux-Arts, Lyon. B295
AIC, PMA

PLATE 77
Gustave Courbet
Waves
1869
Oil on canvas
29⅞ × 59⅝ inches (75.9 × 151.4 cm)
Philadelphia Museum of Art. Gift of John G.
Johnson for the W. P. Wilstach Collection.
W1905-1-1

PLATE 78
Gustave Courbet
The Wave
c. 1871
Oil on canvas
18⅛ × 21¹¹⁄₁₆ inches (46 × 55 cm)
National Gallery of Scotland, Edinburgh. NG-2233

Johan Barthold Jongkind

JOHN ZAROBELL

Johan Barthold Jongkind (1819–1891) was the first artist to exhibit a modern style in his representation of the sea. Like his mentor Louis-Gabriel-Eugène Isabey, this Dutch émigré was not a painter of the open sea but of harbor and beach scenes, and it was these works that pointed the way for the Impressionists, especially the young Claude Monet. When considered alongside Impressionist seascapes, Jongkind's works seem prescient because they capture moments of light that translate both sea and sky in a loose and evocative manner.

Like many progressive artists of the period, Jongkind was a committed *plein-air* painter. His marines of the early 1860s, such as *Port of Honfleur at Evening* of 1863 (plate 80), draw equally from Dutch predecessors and the Barbizon artists who emulated them. Many of the Barbizon artists, including Constant Troyon, Jules Dupré, and Narcisse Diaz de la Peña, befriended Jongkind during his youth, and it was in this milieu that he first found his artistic footing. Yet Jongkind's use of light and color departs from the sentimental view of nature embraced by the Barbizon school and begins a more rigorous visual examination of the natural world that was continued by the Impressionists. In Jongkind's hands, a sunset is not merely a liminal moment full of expressive tones, but a chance to experiment with an array of colors reflected in complex patterns on the water in a harbor. As Monet—who for years painted motifs alongside Jongkind—would later write, "Jongkind, along with Corot, is at the origin of what one called Impressionism."[1]

While Jongkind had direct connections with both Barbizon artists and Impressionists, his links to Edouard Manet are more elusive. Manet is said to have held Jongkind in high regard. In *Edouard Manet: Souvenirs*, published in 1913, Antonin Proust states that "even more than Corot and Daubigny, Jongkind was in [Manet's] opinion the strongest of the landscapists."[2] These figures circulated among the same group of artists and writers and, as founding members of the Société des aquafortistes (1862), certainly knew one another before Manet began painting marines in 1864. Jongkind, who was thirteen years older than Manet, first exhibited at the Paris Salon in 1848, when Manet was only sixteen.[3] While Jongkind's early Salon appearances were favored by a string of official successes (state purchases in 1851 and 1853 and a medal in 1852),[4] by 1863 his Salon entries were rejected and, along with the works of Manet, Whistler, Monet, and others, found their way into the Salon des refusés. The careers of Jongkind and Manet would have been closest at this time. As members of the small circle of independent artists active in Paris, they would have shared exhibition venues, dealers, and, to a certain extent, audiences.[5] Both artists remained steadfastly original, but, unlike some of their contemporaries, neither sought to band together with other independents in opposition to the art establishment. Instead, they continued to exhibit whatever works they could at the official Salon and declined to take part in the numerous Impressionist exhibitions beginning in 1874. Both journeyed to the sea in the summers and made marine paintings resulting from these voyages. Both artists also knew and admired Baudelaire.

Opposite page: Johan Barthold Jongkind, *Port of Honfleur at Evening* (plate 80, detail)

173

It was Baudelaire who placed the two artists in the closest proximity when he wrote, in 1862: "If men with mature and profound talent (M. Legros, M. Manet, M. Yonkind [*sic*], for example), give the public confidence in their studies and their engraved sketches, they have the right to do so. But the crowd of imitators can become too numerous, and one must fear exciting the disdain, truly legitimate, of the public for such a charming genre, that is already wrong for being beyond its reach."[6] Aside from the potential for arousing the disdain of the public, the grounds on which Baudelaire compares the etchings of Jongkind, Manet, and Legros are in their use of unconventional techniques to renew this long-neglected art form. All three artists, Baudelaire suggests, value the possibility of innovation over the weight of tradition and approach their medium with an immediacy that captures the distinct characteristics of their studies. As Baudelaire's comment indicates, it is perhaps in the formal qualities of their works, rather than their shared historical and social milieu, that one finds the strongest connections between Jongkind and Manet.

On September 17, 1862, Jongkind wrote to his friend and fellow marine painter Eugène Boudin that he had arrived in Le Havre and had since been working on studies at Sainte-Adresse.[7] *Seacoast at Sainte-Adresse* (plate 79) was the result of one of these excursions. This picture evokes a palpable sense of the artist's observation of the natural world and demonstrates his rigorous experimentation with *plein-air* painting, with the artist employing a thick impasto and a rich palette. This scene is full of light, with a sky of luminescent yellow. The sea is composed of browns and blues, but the rocky seaside is made up of rich umbers overlaid with gray, beige, and black overtones. *Seacoast at Sainte-Adresse* is rugged, immediate, and not concerned with pictorial diversions. For example, the worker and his two horses in the lower right corner do not function as subjects in themselves but form a part of the natural appearance of the scene. Further, this group is composed of the same tones found in the rocks and the sea. Without any clear pictorial motifs, Jongkind focused instead on light, matter, and atmosphere and sought a visual harmony based on color, tone, and facture. Such a work could well have served as an example for the marine painting of Manet. In fact, one of Manet's small studies of 1871, *Fine Weather at Arcachon* (plate 54), is similar both in its composition and in its use of an overall tonality to create a sense of atmosphere.

Port of Honfleur at Evening (plate 80) is the largest of a group of small paintings Jongkind made of Honfleur in late summer of 1863. In this work, his experimentation with *plein-air* painting yields even more spectacular results than his seaside images of the previous year. The artist's evocation of sunset and its pastel hues reflects a peaceful and beautiful moment without a hint of melodrama. A careful examination of this canvas reveals Jongkind's experimentation with overpainting, and it is clear that he developed the work over the course of several sessions, a technique Monet would later perfect in his Rouen Cathedral series. The technique allows Jongkind to fragment the surface of the water and reproduce the visual sensation of dying light on rippling water. The immediacy of this sensation is palpable here, as are the artist's interests in representing a specific time of day and experimenting with chromatic contrast achieved by juxtaposing patches of pigment.

While *Port of Honfleur at Evening* forecasts the painterly developments of Impressionism, it also underlines a connection between the artistic interests of

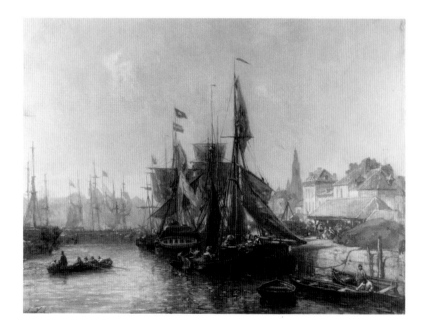

Fig. 56. Johan Barthold Jongkind, *The Port of Anvers,* 1855. Oil on canvas, 34¼ × 42⅛ inches (87 × 107 cm). Musée des Beaux-Arts, Rennes. D 1952.3.1

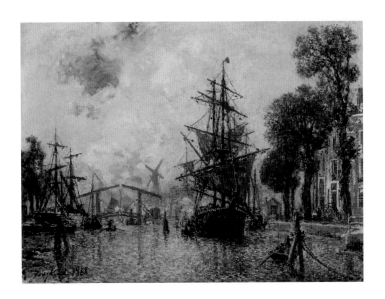

Fig. 57. Johan Barthold Jongkind, *The Port, Evening Effect*, 1868. Oil on canvas, 16½ × 22 inches (41.9 × 55.9 cm). Museum of Fine Arts, Boston. Gift of Count Cecil Pecci-Blunt. 61.1242

Jongkind and those of Manet. Jongkind specialized in port scenes, and his earliest Salon successes were achieved with pictures such as *Port of Anvers* of 1855 (fig. 56). This composition, which features numerous boats nestled together in the port with buildings and dock workers in the background, is typical of the kind of picture that made a name for Jongkind in France. Manet's harbor scenes, *Moonlight, Boulogne* of 1868 (plate 28) and *The Port at Bordeaux* of 1871 (plate 49), unlike most of his marines, are large paintings that probably were originally conceived as potential Salon works. Like Jongkind, Manet would have looked to Dutch marine precedents (see DeWitt, pp. 1–15 above), and he would also have seen Jongkind's port and harbor scenes at the annual Salons. The painting of Bordeaux, for example, is reminiscent of Jongkind's palette, though finally richer in tonality.

Jongkind has been credited with reintroducing nocturnes in marine painting, beginning as early as 1853 with *Boats at the Quai, Evening Effect* (private collection). Manet also produced evening harbor scenes, and a comparison of two nocturnes from the same period underlines both the similarities and the differences between the works of Manet and Jongkind. Manet's *Moonlight, Boulogne* features several shadowy figures in the foreground with only a thin sliver of glistening water behind dark boats. Jongkind's *The Port, Evening Effect* (fig. 57) focuses instead on the light of the setting sun falling on the water, and there are no figures visible on the quay in the background. While the mood of these two nocturnes is similar, Manet's application of pigment is slick and refined while Jongkind's is fine and choppy. Both artists sought to communicate a palpable sense of the harbor in the evening hours, but Manet achieved this through subtle tonal gradations that provide for a certain pictorial obscurity, whereas Jongkind focused on the light scintillating on the water and providing a spectacular contrast. Although these artists emerged from the same milieu and pursued shared interests, their resulting seascapes produce very different effects upon the viewer. Manet's work concentrates on the figures and their nocturnal domain, while Jongkind is taken with the play of light in the transitory hour between day and night. Whereas Manet's picture of the return of the fishermen is consistent with other views of obliquely observed figures by the seaside made in Boulogne during or after his second trip in 1868, Jongkind's interest in light and its visual effects clearly presages Monet's impression pictures of the next decade.

1. Unpublished letter from Monet to Gustave Geffroy, May 8, 1920, Documentation, Musée d'Orsay, Paris.

2. Antonin Proust, *Edouard Manet: Souvenirs* (Paris: Librarie Renouard, 1913), pp. 30–31 (my translation).

3. Victorine Hefting, *Jongkind: Sa vie, son oeuvre, son époque* (Paris: Arts et Métiers Graphiques, n.d. [1974]), p. 24.

4. Charles C. Cunningham, *Jongkind and the Pre-Impressionists: Painters of the Ecole Saint-Siméon* (Williamstown, Mass.: Sterling and Francine Clark Art Institute, 1977), p. 26.

5. One important connection in the context of this exhibition is the fact that Alfred Cadart, who exhibited Manet's *Battle of the U.S.S. "Kearsarge" and the C.S.S. "Alabama"* (plate 10) in his shop window in 1864, was responsible for publishing Jongkind's portfolio of etchings titled *Views of Holland* in 1862.

6. Charles Baudelaire, "Peintres et aqua-fortistes," in *Oeuvres complètes*, ed. Y.-G. Le Dantec, rev. Claude Pichois (Paris: Gallimard, 1961), p. 1147 (my translation). Originally published in *Le Boulevard*, September 14, 1862.

7. Victorine Hefting, *Jongkind d'après sa correspondance* (Utrecht: Haentjens Dekker and Gumbert, 1969), p. 131.

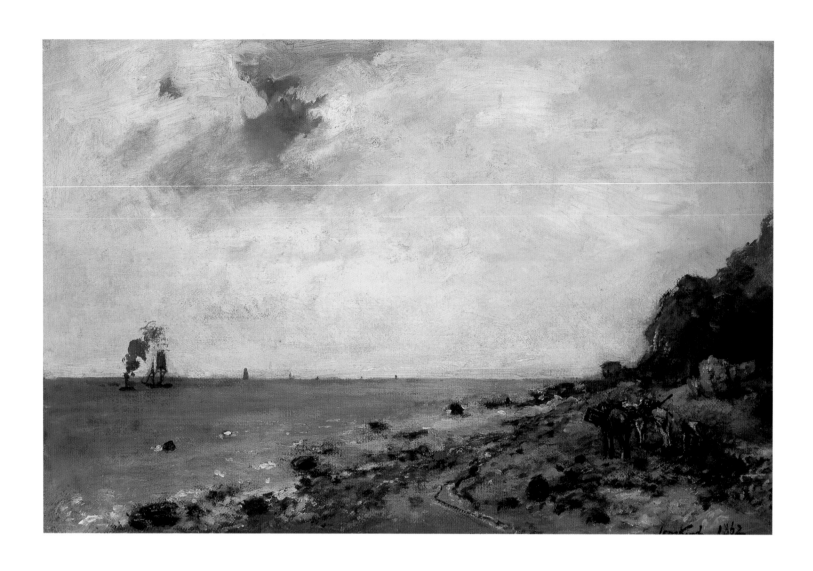

PLATE 79

Johan Barthold Jongkind

Seacoast at Sainte-Adresse

1862

Oil on canvas

10⅝ × 16 inches (27 × 40.5 cm)

Private collection, courtesy Galerie Brame &
Lorenceau, Paris

AIC, PMA

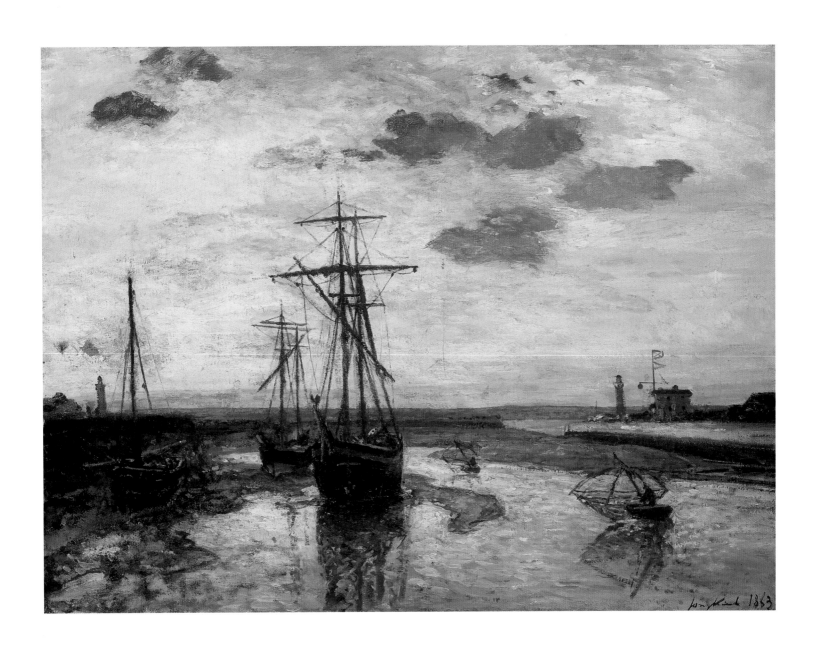

PLATE 80
Johan Barthold Jongkind
Port of Honfleur at Evening
1863
Oil on canvas
16½ × 22¼ inches (41.9 × 56.5 cm)
Philadelphia Museum of Art.
The William L. Elkins Collection. E1924-3-76

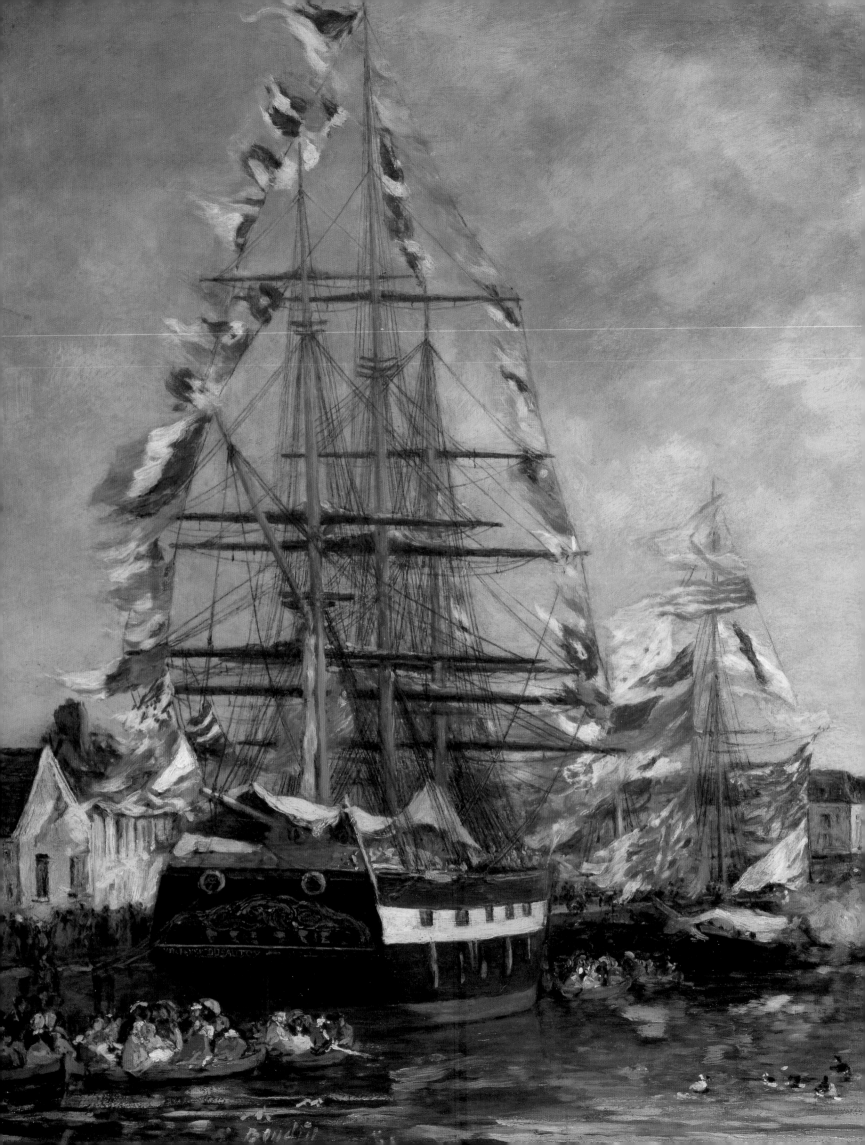

Eugène Boudin

JOHN ZAROBELL

Eugène Boudin (1824–1898) was one of the most prominent sea painters of Manet's generation. Although we do not know of any direct relations between Boudin and Manet, the artistic connections between the two are clear. Both painters engaged the panorama of modern social life, and Boudin was the first artist to capture the social world of the beach vacation. Furthermore, both artists employed a modern approach to their subjects, using a loose handling of their materials to register the fleeting impressions of crowded outdoor scenes bustling with activity.

Born in Honfleur and raised in Le Havre, Boudin had grown up with the sea. The son of a sea captain, his knowledge of marine subjects was intimate and personal. He studied in Paris between 1851 and 1853, but much of his education came from his interactions with Louis-Gabriel-Eugène Isabey and the other artists who visited Honfleur. He worked as an assistant to Constant Troyon in 1861–62 and became a pivotal figure among the painters—including Camille Corot, Charles Daubigny, Gustave Courbet, and Claude Monet—who came annually to the artist's colony at Honfleur, the Auberge Saint-Siméon.[1]

Fig. 58. Eugène Boudin, *Blue Sky, White Clouds*, c. 1854. Pastel on blue-gray paper, 6⅜ × 8¼ inches (16.2 × 21 cm). Musée Eugène Boudin, Honfleur. Inv. 899.1.32

Opposite page: Eugène Boudin, *Festival in the Harbor of Honfleur* (plate 82, detail)

It was from Barbizon artists such as Corot, Daubigny, and Troyon that Boudin learned the importance of light and atmosphere, and this first generation of French landscape painters to devote themselves to working *en plein air* had a profound impact on his development.

As Boudin matured artistically, his choice of subjects and his style emerged as decisively modern. An intimate of Courbet and Monet, Boudin developed his reputation as a painter of the social world of the coast, representing the bourgeois patrons of beach resorts as well as the festivals that drew crowds from the city to seaside towns such as Honfleur. Unlike Manet, he participated in the first Impressionist exhibition in 1874. Even before his interaction with such well-known modern masters, however, Boudin was recognized as an artist with a serious interest in the effects of light and a penchant for technical innovation.

In Charles Baudelaire's review of the Salon of 1859, he devoted a long description to the pastel cloud sketches (fig. 58) of a then unknown artist named Boudin. Boudin had previously shown his works in provincial exhibitions, but this was his Salon debut. Although Boudin's entry was *The Pardon of Saint Anne-La-Paulud* (Musée André Malraux, Le Havre), a rustic genre scene representing a folk custom of Brittany, Baudelaire used the occasion as an opportunity to praise the cloud pastels he had seen in Boudin's studio in Honfleur that summer. Baudelaire notes that Boudin had produced "hundreds" of these sketches, and that, like the earlier cloud studies by the British painter John Constable (1776–1837), each was inscribed with the date, time of day, and wind direction.

179

Although Baudelaire was careful to point out that Boudin saw these drawings, not as finished works, but as studies intended to serve only the artist and his peers privately, he nevertheless waxed lyrical about their beauties: "In the end, all of these clouds, with their fantastic and luminous forms; these ferments of gloom; these immensities of green and pink, suspended and added one upon the other; these gaping furnaces; these firmaments of black or purple satin, crumpled, rolled, or torn . . . in short, all these depths and all these splendors rose to my brain like a heady drink or like the eloquence of opium."[2] Such a review would have catapulted Boudin from utter obscurity to notoriety in the minds of the Parisian avant-garde who read and admired Baudelaire, Manet first among them.

Boudin's *Coastal Scene with Fishing Boats in Normandy* of about 1853–57 (plate 81) was produced during the same period in which he was making his pastel cloud studies. Since it did not enter the collection of the poet Gustave Mathieu until 1861, it is quite possible that Baudelaire would have seen this work in Boudin's studio in 1859. Although this work is signed, it should not be considered a finished work, but rather an *étude*, that is, a study from nature that might be transformed into a more complete composition. This small, moody, and intimate picture of peasants working by the sea at daybreak reflects Boudin's study of Dutch masters at the Louvre during his years in Paris as well as his knowledge of the seascapes of Isabey. Boudin's interest in atmospheric phenomena governs the work as a whole, as the illumination emerging at the horizon produces a half-light that sets the mood. The dark browns in the foreground and the light gray of the surface of the water imbue the picture with a rustic charm while reflecting a consistent dispersal of light. This view stands as a romantic evocation of peasant labor, demonstrating a harmony between the natural world and human work, and one can perceive a nascent Impressionist style in the representation of clouds.

Boudin soon shifted his attention from such rustic scenes to more modern subjects, especially the manifestations of tourism on the Normandy coast. In 1858, for example, he turned to a subject that would become a favorite Impressionist motif, the regatta. *Festival in the Harbor of Honfleur* (plate 82) does not picture the boat race itself but rather the harbor decked out in festival splendor. Such festivals, which first came to Honfleur in September 1854, were designed to lure tourists from the cities to the newly accessible countryside.[3] This image of the Normandy coast, distinct indeed from depictions of fishing peasants, is much closer in subject to pictures of Paris that Manet and the Impressionists began executing in the 1860s. On the left, groups of society ladies, decked out in gowns and carrying parasols, watch the event from small boats. The ships in the harbor, a traditional caravel and a modern steamship, are festooned with colorful flags that flutter in the strong breeze. While the rigging of the tall sailing ship is rendered with precision, the water and the sky, as well as the flags and the buildings in the background, are executed with a freer hand. The artist's technique captures the flurry and excitement of a sporting competition witnessed by a large crowd. In this sense, it is the first marine to marry the nature of the event to the technique for rendering it. Boudin has here employed the sense of immediacy—of freezing a transient moment—he learned from his cloud studies in the execution of a more finished picture intended for display and sale. Although he would eventually be surpassed in experimentation by his Impressionist cohorts, the central concern of Impressionist art—representing modern subjects in an unprecedented manner—is evident in this and other works produced by Boudin in the late 1850s and early 1860s.

Beach at Trouville of 1863 (plate 83) represents another of Boudin's innovations in marine painting. While Isabey had occasionally painted vacationers at the beach,[4] it was Boudin who eventually made his career painting *le beau monde* at the new seaside resorts. He made the first of such canvases in 1860, and by 1863 he was already exhibiting them publicly in Bordeaux. In 1866 and at the 1867 Exposition universelle in Paris, Boudin's beach scenes

Fig. 59. Edouard Manet, *Music in the Tuileries*, 1862. Oil on canvas, 29⅞ × 46⅞ inches (76 × 119 cm). National Gallery, London. 3260

adorned the walls of the Salon. These pictures, of which *Beach at Trouville* is representative, repeated a standard formula: a frieze of fashionably dressed vacationers stretches across a horizontal beach. The leisure-seekers appear to block out any sense of the place in these paintings, literally eclipsing the natural beauty of the sea. Such a perspective was perhaps personal for Boudin, who grew up in a sleepy seaside town that was transformed into a tourist trap during his early adult life. Nonetheless, the most remarkable aspect of this beach painting is the relentless horizontality that seems to force the figures into a flat space.

The work brings to mind Manet's representations of social life in Paris around the same time, such as *Music in the Tuileries* of 1862 (fig. 59). It is not surprising, therefore, that when Manet took up the subject of tourists at the seaside after his voyage to Boulogne in 1868, he painted subjects similar to those represented by Boudin, such as tourists on the jetty (plate 30) and pleasure-seekers on the beach (plate 32). Manet seems to avoid the congestion of figures typical of Boudin's compositions, however, and instead distributes small figure groups across his similarly horizontal composition. Manet's beach scene appears almost like a theatrical set, with distinct figure groups placed upon a pitched stage. Boudin's representation of social life on the beach is more naturalistic, with a low horizon line, a clear sky, and a mass of vacationers huddled together.

Fig. 60. Eugène Boudin, *Luncheon on the Grass*, 1866. Oil on panel, 6⅞ × 9⅞ inches (17.5 × 25 cm). Musée d'Orsay, Paris. RF 1988-55

Although we do not know if the two artists ever met in person, we do know that Boudin was acquainted with Manet's family and was also an advocate of Manet's art. For example, there is a unique picture by Boudin dedicated to "Mme Eug. Manet" and dated October 10, 1866.[5] *Luncheon on the Grass* of 1866 (fig. 60) was dedicated to Manet's sister-in-law, Mme Eugène Manet (Berthe Morisot),[6] and it clearly carries over some of the features of Manet's 1863 painting of the same title,

now in the Louvre. Furthermore, we know that in 1868 Boudin influenced the jury in favor of Manet at the first International Maritime Exhibition at Le Havre, at which Manet was awarded a medal for his *Dead Toreador* of 1864 (National Gallery, Washington, D.C.).[7]

Considering the thematic, technical, and even social connections between Boudin and Manet, we might expect to find more evidence of a personal relationship between these artists. However, they lived in very different worlds. Boudin never liked Paris, and Manet hated to be away from it. Their similarity rests upon certain shared ideas about painting as a means to represent the emerging social panorama of nineteenth-century France.

1. On Boudin, see *Eugène Boudin en Normandie* (Honfleur: Musée Eugène Boudin, 1998); and Robert Schmit, *Eugène Boudin, 1824–1898*, 3 vols. (Paris: Robert Schmit, 1973). The classic work on Boudin is Gustave Cahen, *Eugène Boudin: Sa vie et son oeuvre* (Paris: H. Floury, 1900). On the Auberge Saint-Siméon, see Anne-Marie Bergeret-Gourbin, "Honfleur, cité des artistes au 19e siècle," in *Boudin et les peintres à Honfleur* (Tokyo: Musée des Beaux-Arts Bunkamara, 1996), pp. 22–28.

2. Charles Baudelaire, "Salon of 1859," in *Art in Paris, 1845–1862: Salons and Other Exhibitions Reviewed by Charles Baudelaire*, trans. and ed. Jonathan Mayne (London: Phaidon, 1965), pp. 199–200.

3. Theodore Reff, *Manet and Modern Paris* (Washington, D.C.: National Gallery of Art, 1982), p. 254. In fact, the rail line to Honfleur was not completed until 1862, but Parisians could take the train as far as Le Havre, the adjacent city. See Bergeret-Gourbin, "Honfleur," p. 22.

4. See Pierre Miquel, *Eugène Isabey (1803–1886): La Marine au XIXe siècle*, 2 vols. (Maurs-la-Jolie: Editions de la Martinelle, 1980).

5. *Boudin en Normandie*, p. 159.

6. Berthe Morisot was not married to Eugène Manet until December 1874, but Boudin apparently was in the habit of inscribing paintings years after actually executing them. See ibid.

7. Isolde Pludermache, "L'Exposition Maritime Internationale de 1868 au Havre," in *Boudin en Normandie*, pp. 175–78.

PLATE 81
Eugène Boudin
A Coastal Scene with Fishing Boats in Normandy
c. 1853–57
Oil on canvas
8½ × 10½ inches (21.6 × 26.7 cm)
Bob P. Haboldt, Paris and New York
AIC, PMA

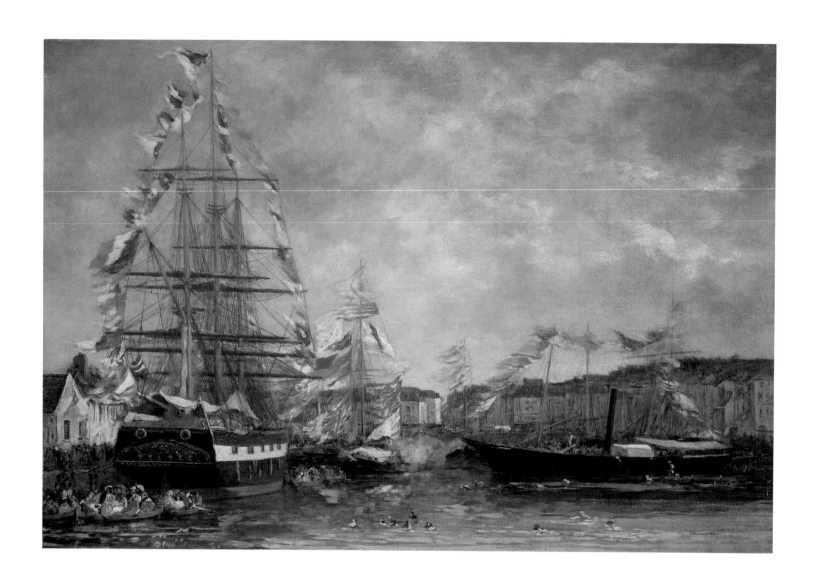

PLATE 82

Eugène Boudin

Festival in the Harbor of Honfleur

1858

Oil on panel

16⅛ × 23⅜ inches (41 × 59.3 cm)

National Gallery of Art, Washington, D.C.

Collection of Mr. and Mrs. Paul Mellon.

1983.1.10

AIC, PMA

PLATE 83

Eugène Boudin

Beach at Trouville

1863

Oil on panel

13¾ × 22½ inches (34.9 × 57.8 cm)

National Gallery of Art, Washington, D.C.

Collection of Mr. and Mrs. Paul Mellon.

1983.1.14

AIC, PMA

James McNeill Whistler

RICHARD DORMENT

"How did he do it? It's as good as Manet."[1] James McNeill Whistler's celebrated comment in front of William Powell Frith's *Derby Day* of 1858 (Manchester City Art Gallery) represents a rare recorded instance in which he praised one of his contemporaries—not the English artist Frith, as is sometimes said, but the French one, Edouard Manet. For Whistler's compliment to Frith was at best backhanded. The anecdote would have no real point were it not implicitly understood that Whistler despised Frith's narrative paintings and yet could still compare passages in his work with an artist whom he had held in the highest esteem since their first meeting in the early 1860s.

We do not know precisely when the American-born painter James NcNeill Whistler (1834–1903) met Manet, but by March 1863 the two men knew each other well enough for Whistler to provide the poet Algernon Charles Swinburne with a letter of introduction to the French painter, and in May of the same year Whistler and Manet showed together at the Salon des refusés. There is no surviving early correspondence between the two artists, no suggestion of an intimate friendship such as Whistler had with Henri Fantin-Latour in the 1860s—nor, for that matter, of any later estrangement.[2] And yet, a comparison between individual works by both suggests that they were engaged in an artistic dialogue—or, perhaps more accurately, a fruitful creative rivalry—that lasted more than two decades. Neither had a relationship quite like this with any other artist, something contemporary critics in London and Paris acknowledged by regularly linking their names together. An examination of Whistler's and Manet's seascapes of the 1860s throws light on the nature of that exchange, demonstrating how one artist picked up and explored ideas first developed by the other—sometimes after an interval of years.

In September and October of 1862 at Guéthary, Basses-Pyrénées, Whistler painted his first true seascape, *Blue and Silver: The Blue Wave, Biarritz* (fig. 61). In his head-on view of waves breaking on a rocky shore as seen from eye level, the young American was working in the naturalistic style he associated with the contemporary who most impressed him in his early years, Gustave Courbet. To paint it—and all his early works—Whistler used the technique he had been taught as a student in the atelier of the academician Charles Gleyre. This involved the controlled application of opaque pigments over a dark ground, the "bonne peinture" that Courbet practiced and against which Whistler was later to rebel.[3]

Whistler painted *The Blue Wave* outdoors, directly from nature. While at work on it, he wrote to Fantin-Latour complaining about the limitations imposed by this slow working method: "I do not work fast enough! I seem to learn so little! Moreover these paintings from nature done outside can only be large sketches, It does not work! [or, There is nothing!] An end of a floating drape, a wave, a cloud, it is there one minute and then gone forever. You put down the tone true and pure, you catch it in flight as you kill a bird in the air—and then the public asks you for something finished."[4]

Fig. 61. James McNeill Whistler, *Blue and Silver: The Blue Wave, Biarritz*, 1862. Oil on canvas, 25¾ × 35 inches (65.4 × 88.9 cm). The Alfred Atmore Pope Collection, Hill-Stead Museum, Farmington, Connecticut. 46-1-20

The depth of his frustration can be gauged by the length of time that elapsed before Whistler returned to *plein-air* painting. This happened three years later, during a stay in Trouville in October–November 1865 in the company of Courbet.[5] Whistler painted at least five seascapes there, all of which show empty expanses of sea and sky—some including the beach, others sailboats scudding across the surf. Each canvas is different, suggesting that Whistler was experimenting with diverse compositions and painting techniques in order to find a way to depict the look and feel of the moving sea.

In the finest of these, *The Sea* (plate 86), the slow painting technique about which he had complained to Fantin-Latour has clearly given way to a swifter, looser way of painting, which he uses to capture fleeting effects of light and movement. Pigment of medium consistency is applied with a large square brush, following the curves of the waves without losing contact with the canvas. Keeping his horizon line fairly low, Whistler creates the illusion of deep recession into space through atmospheric perspective and by the inclusion of a sail in the distance.

In *Harmony in Blue and Silver: Trouville* (plate 84) Whistler has once again swept his thin, pale pigments across the canvas, using a brush, palette knife, and probably his fingers. He now stands back from the shoreline and paints from a slightly elevated position (possibly the esplanade). He also raises the horizon almost to the top of the picture, flattening the picture plane. Although the composition still has a foreground, middle ground, and distance, it can be read as a series of horizontal bands of color, against which the thinly painted figure of Courbet stands on the shore looking out to sea. The influence of Japanese art is evident in Whistler's restricted palette, reduced detail, and treatment of pictorial space as a flattened field on which to arrange forms.

The Sea and *Harmony in Blue and Silver*, painted at virtually the same time, demonstrate that by the mid-1860s Whistler was alternating between the naturalism of Courbet, which entailed painting directly from nature, and the high artifice of Japan. *Trouville* (plate 87), also painted that autumn, stands midway between these two extremes. In this painting the sea rises up to fill three-quarters of the canvas. While this minimizes the recession into depth by blurring transitions between foreground and middle ground, it does not wholly flatten the picture plane, so that the four sailboats appear to be caught in a casual snapshot, not placed in an exquisite decorative arrangement like the figure in *Harmony in Blue and Silver*. *Trouville* is unique among the marines Whistler finished that autumn in the somewhat thick consistency of the paint, the unnaturally straight horizon line, and the schematic treatment of the sea and sky—all of which raise doubt that it was painted directly from nature. And yet, precisely for this reason, of all the Trouville seascapes, it is the one most closely related to a series of pictures painted by Manet a year earlier.

Manet is not known to have painted a seascape before 1864. But on June 19 of that year, as the American Civil War neared its end, the Union corvette *Kearsarge* sank the Confederate

vessel *Alabama* in a naval battle off Cherbourg. The engagement, so close to the coast of France, received extensive publicity in journals on both sides of the Channel. On the day of the skirmish, spectators went to vantage points in and around Cherbourg in an attempt to witness the battle, though Manet was not among them. He worked in his Paris studio from written descriptions, sketches, and possibly photographs of the event. A few weeks after the battle, Manet went to Boulogne-sur-Mer on holiday with his family, and by chance the *Kearsarge* turned up there, anchored off the shore. Using the studies he made then, he painted *U.S.S. "Kearsarge" off Boulogne*, also known as *Fishing Boat Coming in before the Wind* (plate 12). Another marine executed that summer was *Steamboat Leaving Boulogne* (plate 13). On July 15 or 16, 1864, *The Battle of the U.S.S. "Kearsarge" and the C.S.S. "Alabama"* (plate 10) was exhibited in the large display window of Alfred Cadart's shop at 79 rue de Richelieu, on the corner of the rue Menars.[6]

Were it not for Whistler's *Trouville*, we would have no evidence that the artist saw any of Manet's three 1864 seascapes. But the high point of view, the seemingly casual disposition of the sailboats, and, in fact, the very presence of the sailboats as subject in this painting combine to make a convincing visual argument that Whistler was aware of Manet's *Steamboat Leaving Boulogne* when he painted it. And if he knew that picture, he could only have seen it in Paris, and so certainly would have seen *"Kearsarge" and "Alabama."*

The importance of Manet's *"Kearsarge" and "Alabama"* for Whistler goes far beyond any stylistic or compositional affinities it might or might not have with the Trouville seascapes. What impressed Whistler about the picture was its exploration of a genre wholly new to him: painting as journalism. The relatively short amount of time that elapsed between the battle and the exhibition of the picture in Cadart's window emphasizes the speed with which Manet painted it. It was, so to speak, Manet's report from the front line.

Everything about the painting is urgent and specific. Purporting as it does to chronicle a highly topical event and exhibited in a shop front, it was literally intended to catch the attention of the man on the street. It prefigures Manet's best-known excursion into the genre of reportage, his "eyewitness" description, *Execution of the Emperor Maximilian* of 1867 (Kunsthalle, Mannheim), another crowd-pulling, up-to-the-minute illustration of a news story then engrossing all of France.[7]

In *"Kearsarge" and "Alabama,"* Manet establishes a high horizon that tilts the picture plane upward. Although some scholars have argued that he borrowed this compositional device from Japanese art (as Whistler certainly did in *Harmony in Blue and Silver*), the depiction of spatial depth is more naturalistic and less stylized than anything found, for example, in the prints of Hokusai. What is more, the simplicity of design and economy of expression that Whistler assimilated from the Japanese masters in *Harmony in Blue and Silver* are not, as far as I can see, features of Manet's *"Kearsarge" and "Alabama."* Instead, I suggest that Manet chose this point of view simply because it allowed him to convey the excitement and immediacy of the battle by plunging us into the middle of the action. Manet surrounds the viewer with the disturbed sea, rendered with an almost syncopated rhythm of repeated strokes of black and aquamarine pigment, brushed onto the canvas upward and sideways with a loose, "wristy" action. By omitting a foreground through which to enter the picture, he conveys the sensation that we are looking down at the scene as though from a high vantage point.

Already destabilized by our headlong entry into the fray, we at first have difficulty making sense of the scene in front of us. Which ship is the *Kearsarge*? Which the *Alabama*? We eventually realize that clouds of smoke have obscured the Union ship at the very moment when the three-masted *Alabama*'s stern is sinking into the sea. In the foreground, the dramatic tension is further enhanced by the sailboat flying the French tricolor that races to rescue survivors of the *Alabama*. Small details such as the rescue dinghy towed by

the French sailboat or the American flag flying from the *Kearsarge* help us to piece together the unfolding story. The precision of these observations says to the viewer, "I was there. I saw this."

It is in the light of Manet as both reporter and history painter, and specifically as the author of *The Battle of the U.S.S. "Kearsarge" and the C.S.S. "Alabama,"* that we should now look at Whistler's impetuous flight to Valparaiso in 1866 to assist the Chileans in their war with Spain. Every commentator on this incident agrees that the journey represented a personal as well as an artistic crisis in the artist's life. Certainly Whistler felt a growing awareness of the inadequacy of his technical training after he failed to complete a ten-foot-high canvas in which Fantin-Latour and Albert Moore were shown with the artist in his Chelsea studio surrounded by models dressed in white. It has also been suggested that Whistler embarked on his foreign adventure because mounting debts and his deteriorating relationship with his partner Jo Hiffernan made his departure from London expedient. Then, too, though he was proud of his West Point education, his failure to fight for the Southern cause in the American Civil War may have added a psychological impetus to his determination to visit a war zone, particularly after his younger brother William, a surgeon in the Confederate army, arrived in London in June 1865.

I want to propose here a further motivating factor: that the journey represents Whistler's delayed response to Manet's depiction of modern warfare. Having missed the American Civil War, Whistler may have been doubly struck by the sheer originality Manet demonstrated when he seized the opportunity to record one of its battles. It is my contention that Whistler traveled halfway around the world to witness a similar conflict, and that three of his Valparaiso pictures represent his only foray into the genre of history painting.

The Valparaiso episode is now reasonably well documented.[8] In 1864 the Spanish Pacific fleet had appeared off the west coast of Peru to "investigate" claims of debt owed to Spaniards by the Peruvian government. When the fleet occupied the Chincha Islands, Chile joined Peru, Bolivia, and Ecuador in an alliance to fight a war against Spain. On February 2, 1866, Whistler sailed from London to Valparaiso to deliver torpedoes intended to destroy the Spanish fleet. He had been commissioned for this task by a certain Captain H. H. Doty, a shady character who claimed to have been a captain in the Confederate army and was then employed by the Chilean navy. Doty was in London as a contractor with a Chilean agent on a mission to return to Chile with a consignment of explosive charges to be used as underwater mines. For his part in the adventure, Whistler was to be paid £30 per month, plus the guarantee of a much larger sum for every Spanish ship destroyed by the mines.

Arriving on March 12, Whistler found a squadron of six Spanish ships (including the ironclad flagship *Numancia* and several wooden frigates) blockading independent Chile's principal harbor, Valparaiso, a town of 80,000 inhabitants. The British, American, and French governments had sent fleets to protect their property and to act as a neutral force between the combatants. On March 27 the Spanish announced their intention to bombard the defenseless city in order to "destroy every palace, house, or hut within reach of [their] guns."[9]

International opinion was outraged, but because no state of war existed between Spain and the United States, France, or England, their fleets were obliged to withdraw during the attack. On the evening of March 30 the withdrawal began, starting with the French fleet. Many years later, Whistler described what happened next: "There was the beautiful bay with its curving shores, the town of Valparaiso on one side, on the other the long line of hills. And there, just at the entrance of the bay, was the Spanish fleet, and, in between, the English fleet and the French fleet and the American fleet and the Russian fleet. . . . And when the morning came, with great circles and sweeps, they sailed out into the open

sea, until the Spanish fleet alone remained."[10] When the noncombatants were about three miles from the port, the Spanish expedition came into position to "pour in a raking fire of shot, shell and all manner of projectiles into the defenseless buildings and houses."[11]

The whole bombardment lasted only two hours, but its effect on the city was devastating. The guns of the *Numancia* destroyed the fortifications and port installations and reduced parts of the city to ruins. During the shelling, we know exactly where Whistler was: "I and the officials rode to the opposite hills where we could look on."[12] He therefore witnessed the two-and-a-half-hour conflict from a safe distance. But it is also clear that he was in Valparaiso while the harbor was bristling with warships, and in the days before and after the bombardment.

Crepuscule in Flesh Color and Green: Valparaiso (plate 88) may not, therefore, be the peaceful scene of a sleepy harbor it at first seems to be. At the very least, the ships in it must include some from the international fleet of warships stationed there before and after the hostilities. In the distance, to the left of center, are two squat, rectangular ironclad ships, similar in design to the *Kearsarge*. All the ships in the center of the picture have swung around toward the open sea; some have unfurled their sails, two have not. Since the one flag clearly visible is the French tricolor, I suggest that the picture evokes the initial withdrawal of the French fleet on the evening of March 30.

This interpretation gains credibility when we turn to the two other Valparaiso views. We know that Whistler stayed at the Naval Circle (the naval club) overlooking the port and harbor. According to one source, he painted *Valparaiso Harbor* (plate 89) from the club's windows. In both *Valparaiso Harbor* and *The Morning after the Revolution, Valparaiso* (fig. 62), Whistler looks down on the long wharf or jetty known as Muelle Prat, which, according to one historian, "in those days projected itself challengingly into the sea."[13]

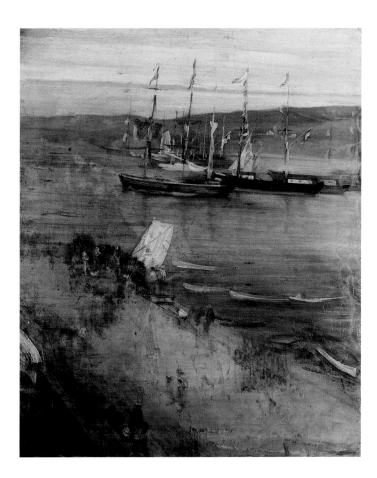

Fig. 62. James McNeill Whistler, *The Morning after the Revolution, Valparaiso*, 1866. Oil on canvas, 29⅞ × 25 inches (76 × 63.5 cm). Hunterian Art Gallery, Glasgow. Bequest of Miss R. Birnie Philip

In both of these paintings, Whistler evokes the confusion and drama surrounding historical events. To do this, he uses the same compositional device Manet employed in *"Kearsarge" and "Alabama"*: tilting the broad wharf upward toward the horizon and omitting a foreground element through which to enter the picture. As in Manet's painting, the effect is to create an initial moment of confusion. What is happening in *The Morning after the Revolution?* We can just make out that several of the indistinct figures on the wharf are wearing sombreros and ponchos. The red, white, and blue flags and bunting identify the ships as American, British, and French. Though the title is certainly Whistler's, it is not necessarily descriptive. Given his somewhat cavalier attitude toward titles, it may well be a fanciful name attached to the painting at a later date.[14] What the picture may actually record, in fact, is a celebration, perhaps to mark the end of hostilities between Chile and Spain after the Spanish fleet was defeated in a battle at Callao, Peru, on May 2. Spain withdrew its forces on May 9, and Whistler was in Valparaiso at least until July, awaiting the arrival of Captain Doty and payment for his services as a gunrunner. In *Valparaiso Harbor*, the dark, indistinct figures that seem to be running up and down the wharf initially appear to be in turmoil, but on second glance the rocket or fireworks in the distance suggest that they too are celebrants.

If, as I have proposed, these Valparaiso pictures represent Whistler's response to Manet's *Battle of the U.S.S. "Kearsarge" and the C.S.S. "Alabama,"* then it would appear that here, at least, Manet is the originator, Whistler the imitator. But this is not the whole story of the sea paintings of the 1860s. Manet certainly saw *Crepuscule in Flesh Color and Green: Valparaiso* when it was exhibited at the International Exposition in 1867. One year later he painted *Moonlight, Boulogne* (plate 28), a view seemingly from nature and painted from an elevated viewpoint, possibly a hotel window, looking down over the quay. Here, Manet attempted to capture the dark, romantically lit harbor scene in a canvas, apparently painted rapidly and on the spot, working with opaque pigments, possibly from an upstairs window, just as Whistler did in his Thames and Valparaiso views. If we also compare Manet's *Jetty and Belvedere at Boulogne* of 1868 (plate 29) with Whistler's *Brown and Silver: Old Battersea Bridge* of 1865 (Addison Gallery, Boca Raton, Florida), which was also exhibited at the Exposition universelle of 1867, it feels as though it is Manet who has studied Whistler's working technique and set out to capture those moments Whistler described to Fantin-Latour, when a motif is "there one minute and then gone forever."[15]

The author is grateful to Margaret MacDonald and Juliet Wilson-Bareau for reading an earlier draft of this essay. M. Hulse and Martin Hopkinson shared both their knowledge of Whistler and their valuable time with me online.

1. Elizabeth Robins Pennell and Joseph Pennell, *The Whistler Journal* (Philadelphia: J. B. Lippincott, 1921), p. 78. The date of Whistler's comment to Joseph Pennell is not recorded.

2. Manet mentions Whistler in a letter to Fantin-Latour, August 10(?), 1868: "Wisthler [sic] wasn't in London, so I couldn't see him, I was very dis-appointed about it, he was on an excursion on a yacht." Juliet Wilson-Bareau, ed., *Manet by Himself: Correspondence and Conversation, Paintings, Pastels, Prints and Drawings* (London: Macdonald, 1991), p. 47. The one surviving letter from Manet to Whistler, dated November 22, 1880, is an introduction to the critic Théodore Duret. See Margaret F. MacDonald, Patricia de Montfort, and Nigel Thorp, eds., *The Correspondence of James McNeill Whistler, 1855–1903* (Glasgow: Centre for Whistler Studies, University of Glasgow, online centenary edition forthcoming at www.whistler.arts.gla.ac.uk), no. 03985.

3. Though this technique could be employed in paintings executed in the studio, it was slow and unwieldy to use outdoors. Virtually all of Whistler's Thames views of 1862–64 are painted from a high point of view, looking down on the river traffic, suggesting that he worked indoors, from an upstairs window overlooking the river, or from the balcony of his house in Chelsea. This solution enabled him to retain his painting technique while working sur le motif, the two linchpins of his training in Paris.

4. Whistler to Fantin-Latour, October 14/21, 1862, Library of Congress, Manuscripts Division, Pennell-Whistler Collection, PWC 1/33/6. See MacDonald, de Montfort, and Thorp, eds., Correspondence of Whistler, no. 08028.

5. See my discussion of the Trouville seascapes in Richard Dorment and Margaret F. MacDonald, James McNeill Whistler, exh. cat. (London: Tate Gallery, 1994), p. 111, nos. 40–42.

6. Cadart was the publisher of Whistler's prints, as well as Manet's.

7. As the newly elected president of the International Society of Sculptors, Painters and Gravers, Whistler organized its first exhibition in London in 1898. The picture by Manet, lent by Paul Durand-Ruel, was a history painting, Execution of the Emperor Maximilian (Kunsthalle, Mannheim). See International Society of Sculptors, Painters and Gravers: Exhibition of International Art, exh. cat. (London, 1898), no. 16.

8. See my discussion of the Valparaiso pictures in Dorment and MacDonald, Whistler, pp. 115–16, nos. 43–45. See also Whistler Papers, Burlington Fine Arts Club, Victoria and Albert Museum, London. Whistler letter to Captain Hunter Davidson, January 19, 1868 (MSL/1952/1353/4/4/2), cited in Richard Dorment, "Contretemps at Prince's Gate," New York Review of Books 46, no. 10 (June 10, 1999), pp. 12–13.

9. Times (London), May 14–15, 1866.

10. Pennell and Pennell, Whistler Journal, p. 42.

11. Times (London), May 15, 1866. See also William Columbus Davis, The Last Conquistadores: The Spanish Intervention in Peru and Chile, 1863–1866 (Athens: University of Georgia Press, 1950), p. 302.

12. Pennell and Pennell, Whistler Journal, p. 42.

13. Alfonso Calderon, ed., Memorial de Valparaíso: En los 450 años de su Descubrimiento (Valparaiso: Ediciones Universitarias de Valparaiso, 1986), p. 354.

14. Whistler bequeathed the picture to his executrix, his sister-in-law Miss R. Birnie Philip, who in turn bequeathed it to the Hunterian Art Gallery, University of Glasgow, with the title Morning after the Revolution. Miss Philip was a fierce defender of Whistler's reputation, and we can be certain that the titles she attached to the pictures are his. Whistler sometimes changed his titles from exhibition to exhibition and certainly chose them for their poetic resonance as much as for any descriptive function they might have.

15. Whistler to Fantin-Latour, October 14/21, 1862.

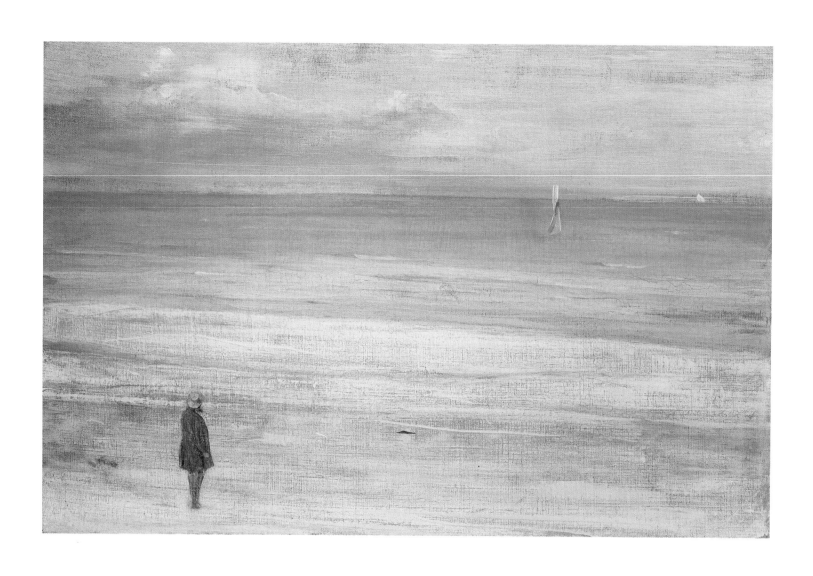

PLATE 84
James McNeill Whistler
Harmony in Blue and Silver: Trouville
1865
Oil on canvas
19½ × 20¾ inches (49.5 × 75.5 cm)
Isabella Stuart Gardner Museum, Boston. P1e6*

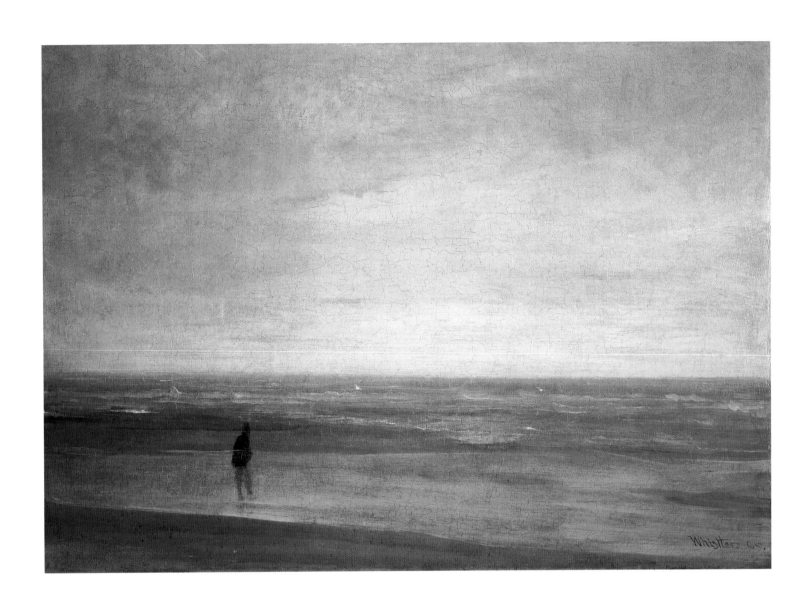

PLATE 85
James McNeill Whistler
Sea and Rain: Variations in Violet and Green
1865
Oil on canvas
20⅛ × 28⅞ inches (51 × 73.4 cm)
University of Michigan Museum of Art, Ann Arbor.
Bequest of Margaret Watson Parker. 1955/1.89
AIC, PMA

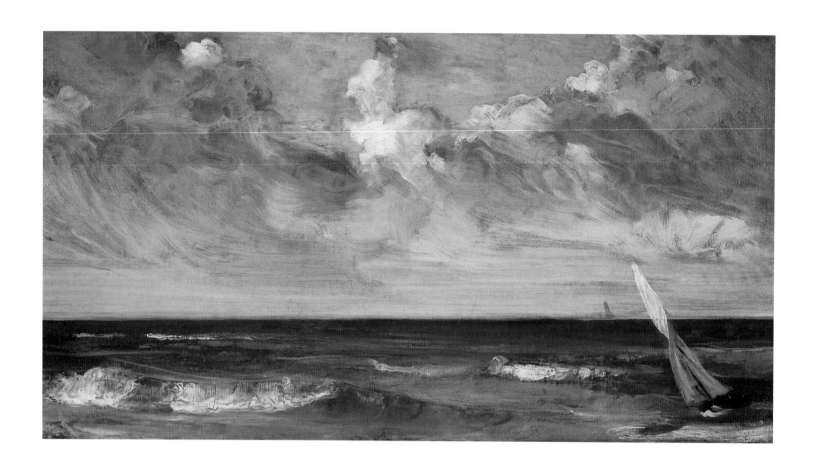

PLATE 86
James McNeill Whistler
The Sea
1865
Oil on canvas
20¾ × 37¾ inches (52.7 × 95.9 cm)
Montclair Art Museum, Montclair, New Jersey.
Museum purchase; Acquisition Fund. 1960.82

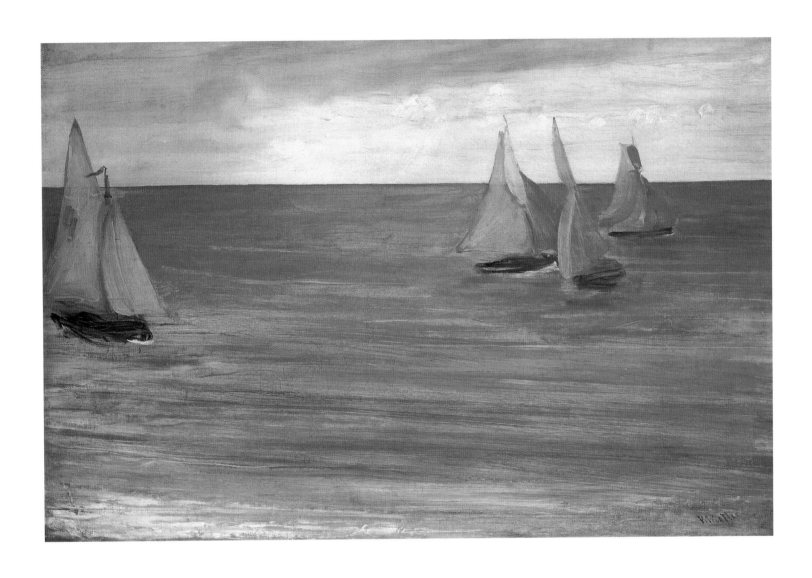

PLATE 87
James McNeill Whistler
Trouville (Gray and Green, the Silver Sea)
1865
Oil on canvas
20¼ × 30⅜ inches (51.5 × 76.9 cm)
The Art Institute of Chicago. Potter Palmer
Collection. 1922.448

PLATE 88
James McNeill Whistler
Crepuscule in Flesh Color and Green: Valparaiso
1866
Oil on canvas
23 × 29¾ inches (58.4 × 75.5 cm)
Tate, London. Presented by
W. Graham Robertson, 1940. N05065

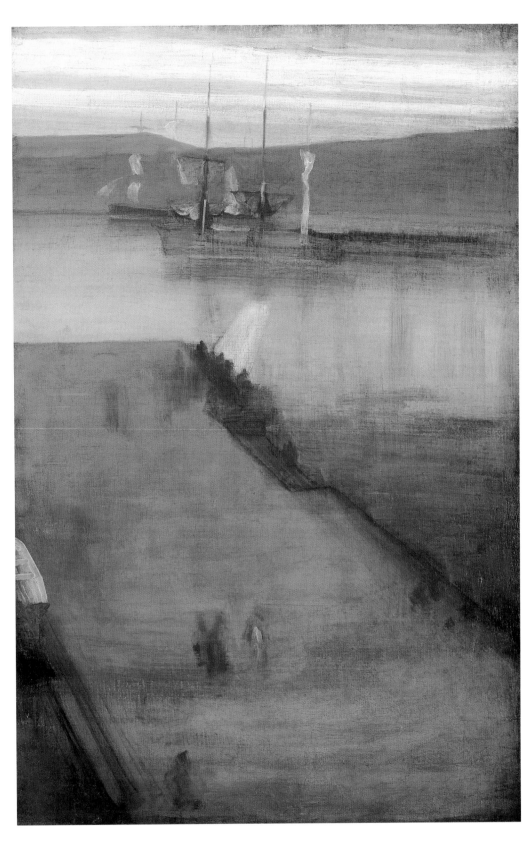

PLATE 89
James McNeill Whistler
Valparaiso Harbor
1866
Oil on canvas
30¼ × 20 inches (76.9 × 50.8 cm)
Smithsonian American Art Museum,
Washington, D.C. Gift of John Gellatly. 1929.6.159

Claude Monet

JOHN LEIGHTON

In 1917 the elderly Claude Monet (1840–1926) made a brief trip to the Normandy coast. He went not to paint but simply to revisit familiar sites and to gaze at the sea. Back home in Giverny, he wrote: "I saw and dreamed about so many memories, so much toil. Honfleur, Le Havre, Etretat, Yport, Pourville, and Dieppe—it's done me good and I'll get back to work with renewed zeal."[1]

These nostalgic recollections were typical of the aging artist, who liked to stress his lifelong passion for the sea. Although he was born in Paris, Monet was raised in Le Havre and, as he told an interviewer in 1889, "remained faithful to that sea in front of which I grew up."[2] From early in his career, commentators noted his familiarity with the coastline where, as a child, he had escaped from school to play on the beaches. Later, his efforts to capture the dramatic confrontation between land and sea in all weathers would generate colorful accounts of his bravura in the face of nature. Clambering over wet cliffs, lashing down his easel against the wind, and, on one occasion, nearly drowning in the surf, Monet's seaside exploits became part of his artistic persona. Fond of conveying his heroic struggle to render the elemental power of nature, Monet spoke of his relationship with the sea as both a love affair and a madness and even declared a wish to be buried at sea in a buoy.[3]

Monet's close identification with the sea as subject and as source of inspiration seems in stark contrast to Edouard Manet's sporadic forays into marine painting. Whereas Monet could draw on personal associations and local knowledge, Manet's seaside pictures evoke the outsider's view, or, more accurately, the curious gaze of the city dweller on vacation. In Manet's work, an expanse of saltwater often remains something of a backdrop for an essentially human theater. Even in marine paintings by Manet that are devoid of figures, the ships and boats seem to take on the elegance, manners, and movements of human actors. For Monet, however, the sea itself, with all its fickle moods and changing appearances, could be the main spectacle and attraction.

Nevertheless, in spite of such readily apparent contrasts, the sea paintings of these two artists also reveal common interests and concerns. The example of Manet was crucial to Monet's development at the outset of his career in the 1860s, both in terms of general ambition and specific issues of style and subject matter. This is most obvious in Monet's larger figure paintings, but it also extends to his sea paintings, a genre in which he invested great hopes for early public recognition. In turn, Manet, at first apparently "tormented" by and jealous of his near namesake, was gradually won over by Monet's achievements.[4] Manet's own interest in the sea as a subject in the late 1860s and early 1870s was perhaps partly inspired by the example of the younger painter. Colored by rivalry and friendship, the artistic interchange between Manet and Monet was a tangled web of overlapping and divergent interests that has never been easy to define. The present exhibition offers an opportunity to review one of the more intriguing aspects of this interchange and to compare the work of two artists who, in different ways, did so much to transform and

Opposite page: Claude Monet, *The Green Wave* (plate 94, detail)

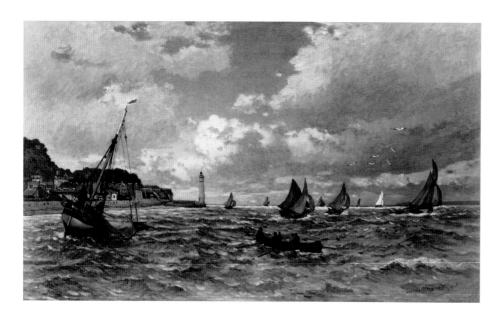

Fig. 63. Claude Monet, *Mouth of the Seine at Honfleur*, 1865. Oil on canvas, 35¼ × 59¼ inches (89.6 × 150.5 cm). Norton Simon Museum, Pasadena. F.1973.33.2.P

modernize the tradition of marine painting in France.

In 1864, when Manet was painting his first major seascapes, Monet was preparing his own public debut as a painter of marines. At the Paris Salon the following year Monet showed two imposing pieces, *Mouth of the Seine at Honfleur* (fig. 63) and *The Pointe de la Hève at Low Tide* (plate 91). These large, ambitious paintings were designed to attract attention, and, to some extent, they succeeded, impressing a few of the more liberal critics with their "audacious manner" and "startling appearance."[5]

Although they were constructed in the studio, Monet's Salon pieces were based on studies made on location the previous summer. In letters written from Honfleur to his friend and fellow painter Frédéric Bazille (1841–1870) during those months, he conveyed his visual excitement when painting in front of nature and his desire "to do everything" and "to note it all down."[6] His pictures reflect this effort to describe and document the fullest range of natural textures and materials and reveal his sensitivity to the vaporous atmosphere of the Channel coast with its rapidly changing moods. In *The Lighthouse at Honfleur* (plate 90), a strip of dark coastline is the visual anchor between a vast, moisture-laden sky and a turbid, dun-colored sea, swollen with sand. In *The Pointe de la Hève*, we are drawn in behind the procession of a cart, horses, and a walking figure as they make their way along the shoreline. Varying his handling of paint from the smoother yet still gestural rendering of the sky to the granular, loaded brushstrokes of the beach, Monet is able to convey an impressive variety of forms and effects. Like beachcombers, we are invited to scan the shoreline, taking in details like the delicate, transparent foam; the dark, wet sand; or the waterlogged and rotting breakwaters.

Since the late 1850s Monet had been in close contact with Eugène Boudin (see Zarobell, pp. 179–85 above), who had encouraged his ambitions as a *plein-air* landscapist. But his greatest debt in these early marines was to the Dutch painter Johan Barthold Jongkind (see Zarobell, pp. 173–7 above), described earlier by Monet as "our only decent painter of seascapes."[7] The view adopted by Monet in *The Pointe de la Hève* appears in works by Jongkind, who often used a similar type of composition, dividing the canvas with a dramatic diagonal and, at the same time, drawing the eye of the spectator into the canvas with the strong perspective effect of the receding coastline.

Monet was generally disparaging about contemporary marine painting in France. As early as 1859 he noted the absence of good seascapes at the Salon, and he seems to have focused on this genre in the 1860s as one in which he might quickly become prominent.[8] After his modest successes in 1865, he presented a succession of large scenes of harbors, ports, and shipping to the Salon. Two of these works are now lost, but those that remain, together with many studies and smaller pictures, provide eloquent testimony to Monet's ambitions as a painter of the sea.[9]

In 1866 and again in 1867 Monet was back on the north coast. His studies and informal paintings from those trips show him grappling with influences more challenging and diverse than his own local tradition centered on Boudin and Jongkind. In his *Seascape* of 1866 (plate 93), for example, Monet pared down his composition to the confrontation of sky and water. Four tiny sails on the horizon enhance the immensity of the livid sky and the

open sea. In its directness and simplicity, this is one of the most radical seascapes by any artist of the period. *Seascape: Storm* of 1867 (plate 96) is equally poetic in its solitude, with a single fishing boat racing away from a threatening bank of clouds. Most adventurous of all, *The Green Wave* of about 1866–67 (plate 94) places us in the trough of a wave looking up toward a sailing boat that is keeling over as it speeds through the swell. Monet's abbreviated style brilliantly evokes the giddy sensation of movement, and few pictures have better captured the disorienting effect of a rolling, heavy sea and its rapidly changing horizon of peaks and furrows.

The directness of these works recalls the coastal studies of Gustave Courbet (see Rishel, pp. 159–71 above), who seems to have taken a paternal interest in Monet's emerging talent during this period. The two artists had been in contact in 1866 in Trouville, the site where Courbet had earlier made his most spectacular "landscapes of the sea" (as he called them), and it seems safe to assume that Monet was familiar with at least some of these works. According to one account, while staying at Ville d'Avray in 1866, Monet dashed off some sea paintings using a palette knife, a tool that was inextricably linked with the no-nonsense manner of Courbet.[10] *The Green Wave* may be one of the works in question, since its thick, troweled surface was achieved at least in part with the use of a palette knife.

There seems to be more than the influence of Courbet at play in Monet's seascapes of 1866 and 1867. For example, the unusual composition and flattened forms of *The Green Wave* have been linked to the Japanese woodblock prints that Monet was probably already collecting at the time. However, the most intriguing and elusive inspiration for these works appears to have been Manet. The bravura application of paint and the concise rendering of form are certainly reminiscent of the older artist. More specifically, the combination of intense greens with grays and blacks creates a striking parallel with the distinctive color schemes of Manet's marine paintings. Above all, the sheer vitality of the image makes us think of Manet. The economy of *The Green Wave* is far removed from the cumulative, descriptive style of Monet's earlier works, and it seems hard to believe that he could have painted it without the stimulus of Manet's seascapes.

It seems only natural that Monet would have sought to measure up to Manet as a sea painter, especially as this was an area in which the younger artist was looking to establish his reputation. However, we do not know whether Monet had actually seen any of Manet's marine paintings before 1867, let alone what he thought of them. Monet first encountered Manet's work in the early 1860s, but he probably was not in Paris when *The Battle of the U.S.S. "Kearsarge" and the C.S.S. "Alabama"* (plate 10) was first shown there in 1864. After their first meeting, most likely in 1866, it seems to have taken some time for their friendship to develop. When Manet's one-man show opened in Paris in 1867, Monet was cool in his admiration, noting grudgingly to Bazille that there were "some good things" to be seen.[11]

There can be little doubt, however, that the example of Manet encouraged Monet to experiment further with novel subjects and techniques. In his marine paintings, this seems evident in a more questioning approach to his subject matter as well as a more aggressively modern style in many of his works from about 1867 on. Not long after he saw Manet's show in the early summer of 1867, Monet was back at Sainte-Adresse on the Normandy coast, and over the course of that summer he produced a remarkable sequence of beach scenes and seascapes. In his earlier views of this coastline, he had been content to record the traditional indigenous activities of the shore, giving his works a sense of undisturbed tranquility and timelessness. Now he confronted his sites in a much more self-conscious way, documenting the infiltration of urban vacationers, juxtaposing pleasure craft with local fishing vessels, and setting Parisian holidaymakers among native residents. Boudin, of course, had been recording the fashionable clientele of the Normandy resorts for several years. But in a work like *The Beach at Sainte-Adresse* (plate 97), the juxtaposition of different

social groups, coupled with a curious dislocation of scale, seems closer in spirit to Manet's paintings than to the cheerful commotion of Boudin's seaside promenades.

The most ambitious of Monet's compositions of the summer of 1867 is *Garden at Sainte-Adresse* (plate 98). Although we have no reason to believe that Monet intended to submit it to the Salon, at more than four feet across this is a sizable painting clearly designed to make a statement. It shows members of the artist's family relaxing in a well-tended garden with a view across the sea toward Honfleur. With its striking composition, divided into bands of color, this work is usually associated with Monet's interest in Japanese woodblock prints. Monet himself referred to this work as his "Chinese painting with flags" (in France the terms "Chinese" and "Japanese" were more or less interchangeable at this time).[12] But it is also tempting to see this picture as Monet's coastal counterpart to Manet's paintings of contemporary life in Paris. It is among the younger artist's most insistently modern pictures of the 1860s. With its glaring sun, scented flowers, and seaside breeze, it is an utterly convincing rendering of the sensations of an outdoor scene. Yet, the rigorous observation is coupled with a frank display of the painter's artifice. The near and the distant are compressed into a decorative surface. The dabs and strokes of paint call attention to the artist's skill with the brush, while the sea is simplified into a flat, blue band animated with calligraphic strokes. In this combination of the natural and the artificial, the sensual and the remote, Monet seems to be responding to the provocative example of Manet's art.

Not all of Monet's studies of the coast in the late 1860s were as overtly modern as *Garden at Sainte-Adresse.* His marine painting of this period is characterized by variety and experimentation and could range from storm effects rendered in a fierce, gestural technique to surprisingly detailed studies of quiet ports and harbors. At Sainte-Adresse in 1868 he painted a ferociously energetic view of what was by then a familiar stretch of coast near Le Havre (plate 99). Here the power of the sea, whose white, foaming surf seems to flood toward the edge of the canvas, finds its direct equivalent in Monet's forceful brushwork. In *Rough Sea at Etretat* (fig. 64), painted later that winter, the niceties of style are further reduced in a stark rendering of the storm-lashed cliff. By contrast, in a group of paintings made at Fécamp during the summer of 1868, he returned to the less emotionally charged examples of Boudin and Jongkind, recording with some precision the individual character of traditional boats laid up in the old-fashioned, picturesque harbor.

Monet's attempts to translate these efforts into public recognition at the Salon met with little success. Only one of the two marine paintings he submitted in 1868 was accepted, and in 1869 his *Fishing Boats at Sea* (fig. 65) was also rejected. Nonetheless, by now Monet had established himself, in Emile Zola's words, as a "first-class painter of seascapes."[13] Describing the two paintings submitted to the Salon in 1868, Zola contrasted Monet's "frankness" with the "sugar-coated" works of academic sea painters. The qualities that Zola praised—the "harshness of touch" and striking immediacy—were the same ones that provoked opposition and, to many critics, served to link Monet's work with that of the notorious *bête noire* of the Salon, Edouard Manet. The connection was expressed caustically in the caption to a caricature by André Gill of Monet's *Boats Coming out from the Port of Le Havre:* "Manet's Marine

Fig. 64. Claude Monet, *Rough Sea at Etretat*, 1868–69. Oil on canvas, 26 × 51⅝ inches (66 × 131 cm). Musée d'Orsay, Paris. RF 1678

Fig. 65. Claude Monet, *Fishing Boats at Sea*, 1869. Oil on canvas, 37¾ × 51⅛ inches (96 × 130 cm). Hill-Stead Museum, Farmington, Connecticut

painting by Monet. How long will M. Monet walk in the sabots of M. Manet?" The lack of refinement and simplifications in Monet's style attracted the same type of criticism and scorn that had greeted Manet's work. What the artist himself aspired to as directness and sincerity in his approach were twisted by the critics into irony. Another caption for a caricature of the same picture read: "Here finally is art that is naïve and sincere. Monet was four and a half years old when he did this painting."[14]

Far from shying away from this association with Manet, the younger artist seems to have accentuated it. For one of his Salon submissions the following year, Monet chose a work that virtually pays homage to Manet. *Fishing Boats at Sea* is a large canvas that aims for the same visual impact that characterizes Manet's earlier seascapes. The dramatic silhouettes of two tar-black boats fill the canvas. A third, more distant vessel disappears into a bank of mist. A stretch of blue-green sea with gently lapping waves is evoked with the same deceptively simple and economical style of Manet's marines. Only the number on the sail nearest to us gives any clue as to a specific place or moment. In a work that is modern in style but timeless in effect, Monet comes as close as he ever would to the elusive art of his older rival.

Fishing Boats at Sea was Monet's final attempt to achieve recognition at the Salon with a large marine painting. His honeymoon at Trouville the following summer also marked a turning point, as this was the last significant campaign of sea painting in his early career. He painted different aspects of the resort, including a more traditional view of the harbor as well as several paintings of the seafront with its row of elegant hotels. He also produced a group of smaller studies of his wife and other figures on the beach. Far from being intimate snapshots of a shared holiday, they are astonishingly rapid studies of light and atmosphere. It is possible that they were made as studies for a more ambitious composition, but if so, nothing came of them. Nevertheless, these modest pictures stand poised between the more ambitious figure pieces that Monet produced in the 1860s and the more informal compositions that would dominate his work over the following decade. For Monet the study of transitory effects of light, weather, and atmosphere was beginning to take precedence over traditional subject matter, becoming a subject in its own right.

The sea and coastline are largely absent from Monet's work of the 1870s. After the disruption of the Franco-Prussian War and a brief period of exile in England followed by an extended stay in Holland, he settled in Argenteuil, choosing proximity to Paris rather than the Channel coast. Water and sky still predominate in his work of this period, but in the more sedate form of rivers and inland waterways, sources of pleasure and relaxation rather than elements against which man fights for survival and sustenance.

In some ways, it was Manet, not Monet, who went further in his exploration of the beach and the sea as subjects in the early 1870s. Moreover, Manet's growing friendship with the younger artist may have stimulated his interest in these subjects. In his paintings of Boulogne and, later, of other holiday locations, notably Arcachon and Berck, Manet tackled subjects, ranging from crowded jetties to lonely beaches, that had already become part of Monet's standard repertoire. If there is often a resemblance between the marine

pictures of the two painters, this might reflect their common interests, including their admiration for the work of Boudin and Jongkind. But there are paintings in which the resemblance is strong enough to suggest that Manet studied the work of his young friend.

When we look at Manet's 1873 painting *On the Beach—Suzanne and Eugène Manet at Berck* (plate 58), it is difficult to believe that the similarities with Monet's 1870 studies from Trouville are completely coincidental. The composition of Manet's picture is very close to that of Monet's *The Beach at Trouville* (plate 100), with the figures pressed right up to the picture plane and set to either side of the view through to a bright patch of beach beyond. The grains of sand embedded in the surface of both works bring them into a sort of gritty complicity and underline the fact that Manet too could become absorbed in the open-air painting activities associated with Impressionism.

These paintings also point to essential differences in approach between the two artists. Monet's little picture is characterized by a certain emotional blankness. Drained of personality, his figures become merely a vehicle for his study of outdoor effects. At the center of his picture is quite literally a void, an empty patch of unpainted canvas. In contrast, Manet clearly enjoyed painting fabric in the wind and the play of light on his sitters. But his picture remains focused on his sitters as subject rather than on their environment. The portrayal of human character and mood remains important to Manet, and in this painting the somewhat pensive and somber attitude of his figures seems strangely at odds with the seaside subject.

Manet's relationship with Impressionism in the 1870s was complex. His artistic innovations had played a major role in the development of Impressionist techniques, and his own work was in turn nourished and enriched through contact with the ideas and methods of a younger generation. While he distanced himself from the artistic politics and exhibition strategies of the Impressionists, he provided support behind the scenes, in particular to Monet, who was by now a firm friend. On several occasions, he gave Monet financial help, sometimes anonymously. Their portraits of one another document a friendship that was further cemented by exchanging their work.

Given his own interests, Manet must have had a genuine admiration for Monet as a painter of seascapes. He reportedly described the younger artist as the "Raphael of water"— a strange comparison perhaps, but intended as high praise.[15] He even owned one of Monet's early marine paintings, *Boats Lying at Low Tide, Fécamp* of 1868 (private collection). However, Manet did not live long enough to witness the full culmination of Monet's career as a sea painter. In 1880 Monet returned to the Channel coast to paint, and over the following seven years he undertook extensive painting campaigns at the familiar sites of his youth. He broadened his range with stays in Brittany and with travels farther afield, notably to the Mediterranean. Paintings of the sea again began to predominate in his work and played a major part in establishing his success in the 1880s.

In sequences of pictures, Monet again tackled the full range of effects of weather and the corresponding moods of the sea as the barometer climbed or fell. Sometimes he added figures or sails to his compositions, but often they are devoid of any human point of reference. In two 1881 paintings, *Waves Breaking* (plate 105) and *A Stormy Sea* (plate 107), for example, he returns to the simple combination of sea and sky as a subject. In contrast to the complex, highly wrought surfaces found in many of his paintings of this period, these works retain the freshness and vigor of rapid outdoor studies. We can easily follow the movement of the artist's hand and wrist as he attempted to find a painterly equivalent for the tumult and movement of the waves. The subject, it seems, has become entirely absorbed into its manner of representation.

Now a mature artist, Monet could draw on a long experience of observing the sea. In addition to his lifelong involvement with the subject, he could look back on an apprentice-

ship with Boudin, the example of Courbet, and, of course, the inspiration of Manet. The style and the manner have changed and the reliance on color and its expressive power is much stronger, but the forceful, visual impact of these paintings of the 1880s links them to the sea pictures that Monet made at the outset of his career. Deceptively simple in their making, convincing in their rendering of nature yet boldly declaring their artifice, these later works are worthy successors to the innovations in marine painting that were set in motion, first by Manet and then by Monet himself when he set up his easel on the Normandy coast.

1. Letter from Claude Monet to J. Durand-Ruel, October 29, 1917, in Daniel Wildenstein, *Claude Monet: Biographie et catalogue raisonné*, vol. 4, *1899–1926* (Lausanne: Bibliothèque des arts, 1985), letter 2247, p. 398; cited in John House, *Monet: Nature into Art* (New Haven and London: Yale University Press, 1986), p. 26.

2. Hugues Le Roux, "Silhouettes parisiennes: L' Exposition de Claude Monet," *Gil Blas*, March 3, 1889; cited in Steven Z. Levine, "Seascapes of the Sublime: Vernet, Monet, and the Oceanic Feeling," *New Literary History* 16 (1985), p. 398. For Monet and the Channel coast, see Robert L. Herbert, *Monet on the Normandy Coast: Tourism and Painting, 1867–1886* (New Haven and London: Yale University Press, 1994).

3. Grand Palais, Paris, *Hommage à Claude Monet*, exh. cat. (Paris: Grand Palais, 1980), p. 16.

4. "[Manet est] très tourmenté par son concurrent Monet" [(Manet is) really tormented by his rival Monet]. Letter from Edmond Duranty to Alphonse Legros, October 1866, cited in Grand Palais, Paris, *Manet 1882–1883* (Paris: Grand Palais; New York: The Metropolitan Museum of Art, 1983), p. 509. The names of the two artists were frequently confused by critics and reviewers, most famously, and much to Manet's irritation, at Monet's Salon debut in 1865.

5. Paul Mantz, "The Salon of 1865," *Gazette des Beaux-Arts* 19 (1865), p. 26. See also Steven Z. Levine, *Monet and His Critics* (New York and London: Garland Publishing, 1976), p. 6.

6. Letter from Monet to Bazille, c. July 15, 1864, in Daniel Wildenstein, *Claude Monet: Biographie et catalogue raisonné*, vol. 1, *1840–1881* (Lausanne: Bibliothèque des arts, 1974), letter 8, p. 420.

7. Letter from Monet to Boudin, February 20, 1860, in ibid., letter 3, p. 420.

8. Letter from Monet to Boudin, June 3, 1859, in ibid., letter 2, p. 419.

9. The two lost paintings are *Port of Honfleur*, rejected from the Salon of 1867, and *Boats Coming out from the Port of Le Havre*, which was shown at the Salon of 1868. Monet's *The Jetty at Le Havre* (private collection) was rejected from the Salon of 1868, and his *Fishing Boats at Sea* (Hill-Stead Museum, Farmington, Connecticut) seems to have been rejected from the Salon of 1869.

10. See House, *Monet: Nature into Art*, pp. 75, 147. See also Gary Tinterow and Henri Loyrette, *Origins of Impressionism*, exh. cat. (Paris: Grand Palais; New York: The Metropolitan Museum of Art, 1994–95), pp. 240, 426 f., for excellent descriptions of several of Monet's seascapes and their relationship to Manet's work.

11. Letter from Monet to Bazille, c. June 25, 1867, in Wildenstein, *Claude Monet*, vol. 1, *1840–1881*, letter 33, p. 424. For Monet's first meeting with Manet, see Grand Palais, Paris, *Hommage à Claude Monet*, p. 54 n. 2. See also Marc Elder, *A Giverny, chez Claude Monet* (Paris: Bernheim-Jeune, 1924), pp. 37–38; Etienne Moreau-Nélaton, *Manet: Raconté par lui-même* (Paris: Henri Laurens, 1926), vol. 1, p. 91; Wildenstein, *Claude Monet*, vol. 1, *1840–1881*, pp. 29, 32.

12. Letter from Monet to Bazille, December 1868 or January 1869, in Wildenstein, *Claude Monet*, vol. 1, *1840–1881*, letter 45, p. 426. See also Tinterow and Loyrette, *Origins of Impressionism*, p. 433; and Virginia Spate, *The Colour of Time: Claude Monet* (London: Thames and Hudson, 1992), pp. 48–49.

13. Emile Zola, *Mon Salon: Les Actualistes* (Paris, 1868); reprinted in Emile Zola, *Ecrits sur l'art*, ed. Jean-Pierre Leduc-Adine (Paris: Gallimard, 1991), pp. 206 ff.

14. See Jane Mayo Roos, *Early Impressionism and the French State, 1866–1874* (Cambridge and New York: Cambridge University Press, 1996), p. 118. Monet's painting is lost and is known only through caricatures and reviews of the Salon. See also Wildenstein, *Claude Monet*, vol. 1, *1840–1881*, pp. 39, 161.

15. Recorded by Antonin Proust; see Juliet Wilson Bareau, ed., *Manet by Himself: Paintings, Pastels, Prints and Drawings* (London: Macdonald, 1991), p. 169.

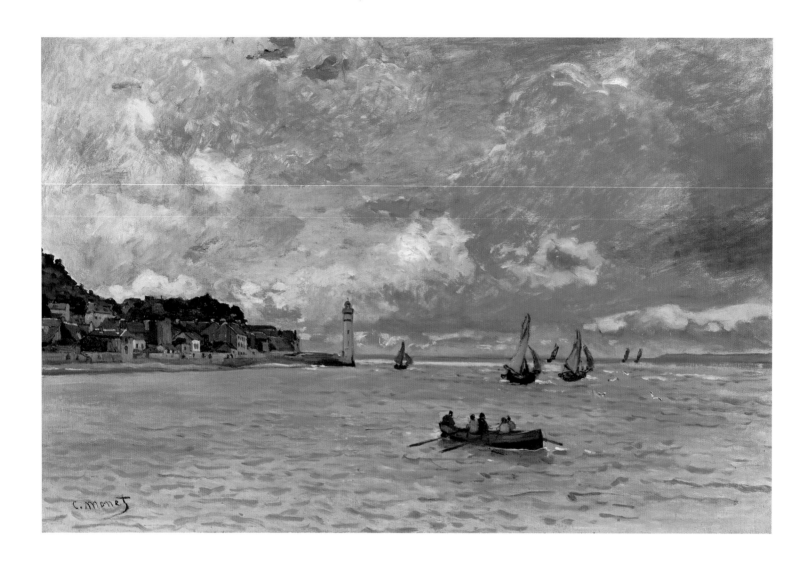

PLATE 90
Claude Monet
The Lighthouse at Honfleur
1864
Oil on canvas
21¼ × 31⅞ inches (54 × 81 cm)
Kunsthaus Zürich. Gift of the Heirs of Dr. Adolf Jöhr. 1968/4
AIC, PMA

This study was painted during Monet's stay at Honfleur in the
summer or autumn of 1864. Although it was probably painted
outdoors, it is more than a rapid sketch and shows Monet's careful
attention to the differing effects of light, weather, and atmosphere
on the Channel coast. This composition was developed in a larger
painting, now in the Norton Simon Museum, that Monet showed
at the Salon of 1865.

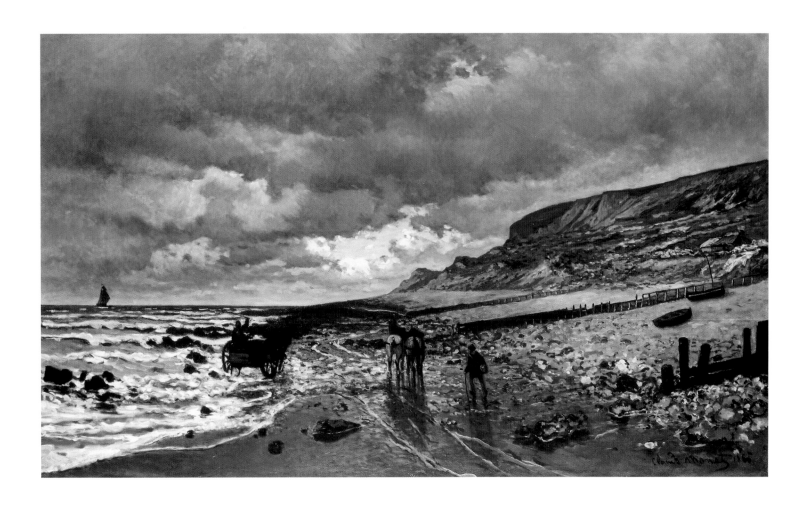

PLATE 91

Claude Monet

The Pointe de la Hève at Low Tide

1865

Oil on canvas

35½ × 59¼ inches (90.2 × 150.5 cm)

Kimbell Art Museum, Fort Worth, Texas. AP 68.7

Based on studies that Monet painted during his stay on the
Normandy coast in 1864, this is one of two large marines that he
showed at the Salon of 1865. The view looking along the beach
at Sainte-Adresse is similar to earlier works by Jongkind, but the
influence of other artists, including Boudin and Daubigny, is also
evident. The painting was noticed by a handful of critics at the
Salon, who praised its vigorous style and honest naturalism.

PLATE 92
Claude Monet
Seascape, Shipping by Moonlight
1866
Oil on canvas
23⅝ × 29 inches (59.5 × 72.5 cm)
National Gallery of Scotland, Edinburgh. NG 2399

This work is loosely related to a large painting (*Boats Coming out of the Port of Le Havre*) that Monet showed at the Salon of 1868 and then later destroyed. However, the broad handling of paint and the unusual nighttime subject suggest that this was a one-off experiment, perhaps inspired by the nocturnes of his artistic mentor Jongkind.

PLATE 93
Claude Monet
Seascape
1866
Oil on canvas
16⅝ × 23½ inches (42 × 59.5 cm)
Ordrupgaard, Copenhagen. 264WH*

In 1866 and 1867, Monet painted a group of seascapes in which
he experimented with dramatic effects of light and almost sche-
matic compositions. Here he reduces his picture to the basic
elements of sea and sky, concentrating on the contrast between
the smooth bank of cloud and the silvery reflections on the water.

PLATE 94
Claude Monet
The Green Wave
c. 1866–67
Oil on canvas
19⅛ × 25½ inches (48.6 × 64.8 cm)
The Metropolitan Museum of Art, New York. H. O. Havemeyer
Collection, Bequest of Mrs. H. O. Havemeyer. 1929.100.111

The bold style suggests the influence of Courbet and the simple
composition hints strongly at Monet's interest in Japanese wood-
block prints, but it is Manet who seems the foremost inspiration
for this startling picture. The fluid handling and the distinctive
color combinations of green and black are especially reminiscent
of Manet's earliest marines.

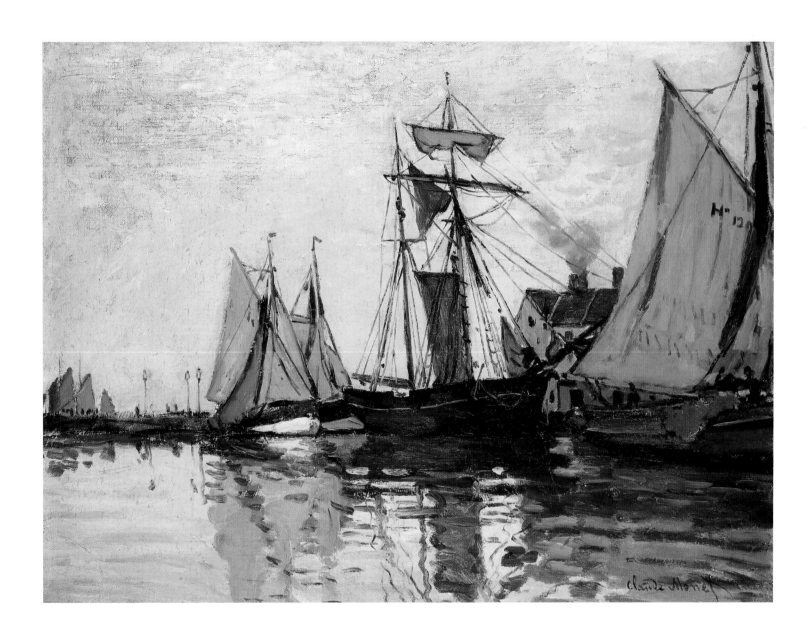

PLATE 95
Claude Monet
Boats in the Port of Honfleur
1866–67
Oil on canvas
19¼ × 25⅝ inches (48.8 × 65.1 cm)
Private collection

This is one of several studies painted at Honfleur during the
winter of 1866–67. Monet was then working on a monumental
picture, *Port of Honfleur,* that was subsequently rejected from the
Salon of 1867 and is now lost. The flat, simplified forms of the
boats and the caricatural rendering of figures such as the sailors
clambering up the masts in this study were probably carried over
into the final painting, rendering it unacceptable to the Salon jury.

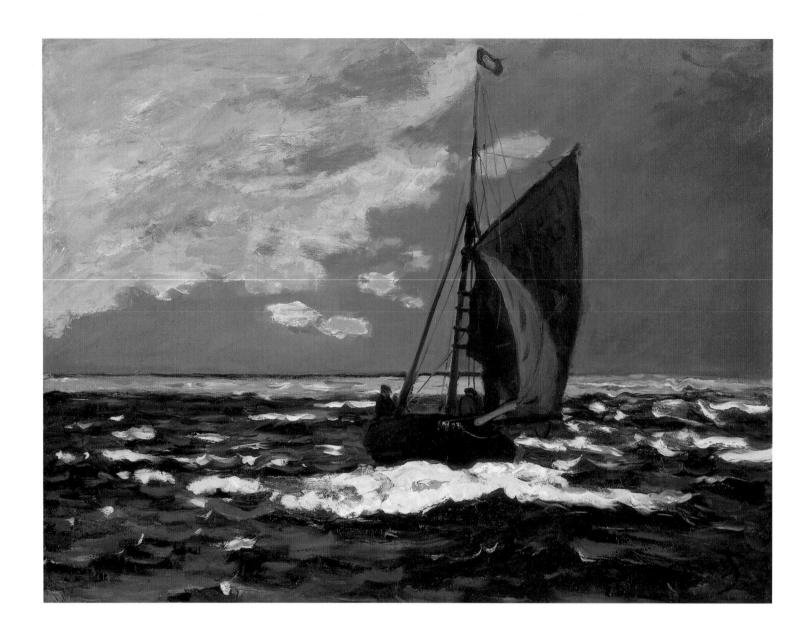

PLATE 96

Claude Monet

Seascape: Storm

1867

Oil on canvas

19⅛ × 25½ inches (48.7 × 64.7 cm)

Sterling and Francine Clark Art Institute, Williamstown,
Massachusetts. 1955.561

Together with *Seascape, Shipping by Moonlight* (plate 92),
this study is loosely related to *Boats Coming out of the Port of
Le Havre*, which Monet showed at the Salon of 1868 and
later destroyed.

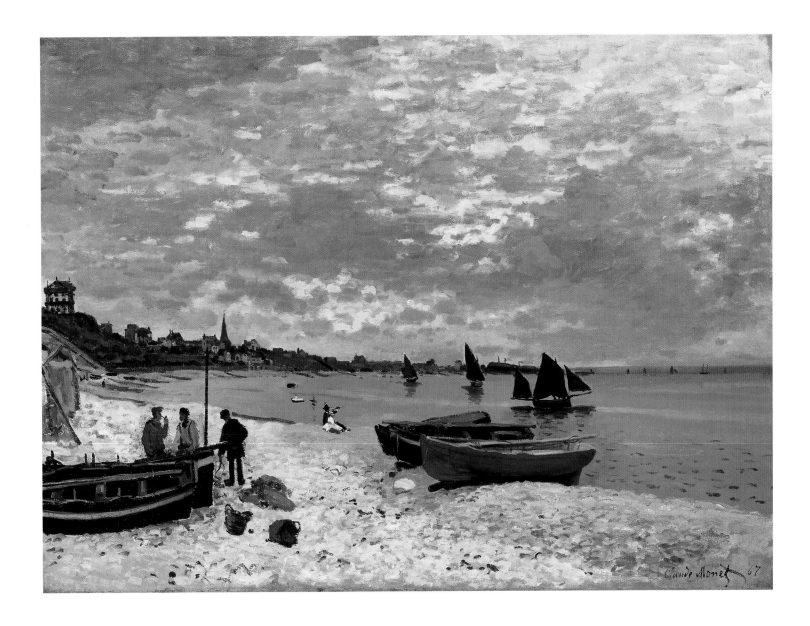

PLATE 97
Claude Monet
The Beach at Sainte-Adresse
1867
Oil on canvas
29½ × 40¾ inches (75 × 102 cm)
The Art Institute of Chicago. Mr. and Mrs. Lewis Larned Coburn
Memorial Collection. 1933.439

Monet spent the summer of 1867 at Sainte-Adresse near Le Havre.
His persistence in painting outdoors in the full glare of sunlight
led to problems with eyestrain, but he was able to complete a
group of studies of the beach. In this view, taken at low tide, the
focus is on the fishermen standing idly by their boats. In a similar
composition, *Regatta at Sainte-Adresse* (The Metropolitan Museum of
Art, New York), Monet shows the same scene but at high tide and
peopled with fashionable vacationers.

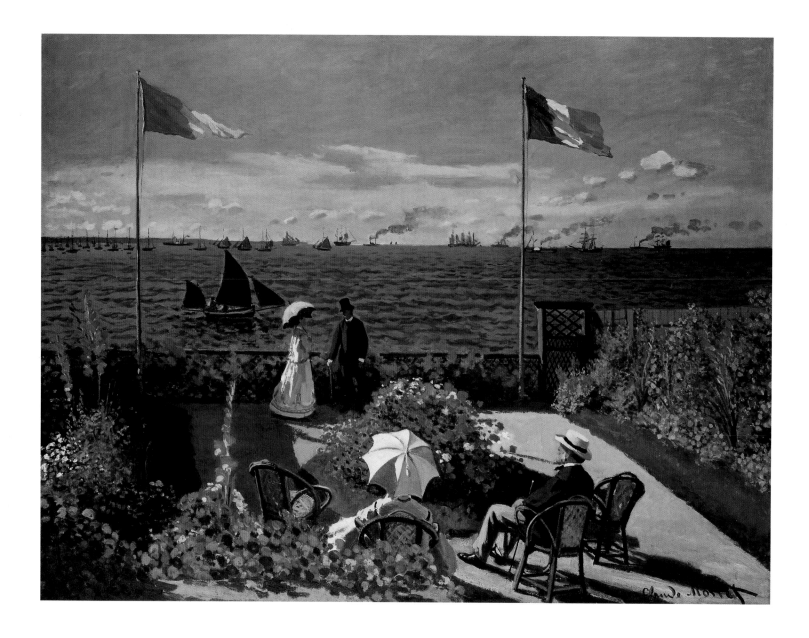

PLATE 98
Claude Monet
Garden at Sainte-Adresse
1867
Oil on canvas
38⅝ × 51⅛ inches (98.1 × 129.9 cm)
The Metropolitan Museum of Art, New York. Purchase, special
contributions and funds given or bequeathed by friends of
the Museum. 1967.241

During the summer of 1867 Monet stayed at the villa of his aunt,
Sophie Lecadre, at Sainte-Adresse. This is presumably the location
depicted here, and the people have been identified as members of
the artist's family, including his father, seated in the foreground.
The sophistication of Monet's rendering of bright outdoor light is
matched by the daring of his technique, with bold colors applied
in flat planes. While the direct style and startling design relate
to Monet's interest in Japanese woodblock prints, the example
of Manet probably encouraged his innovative approach.

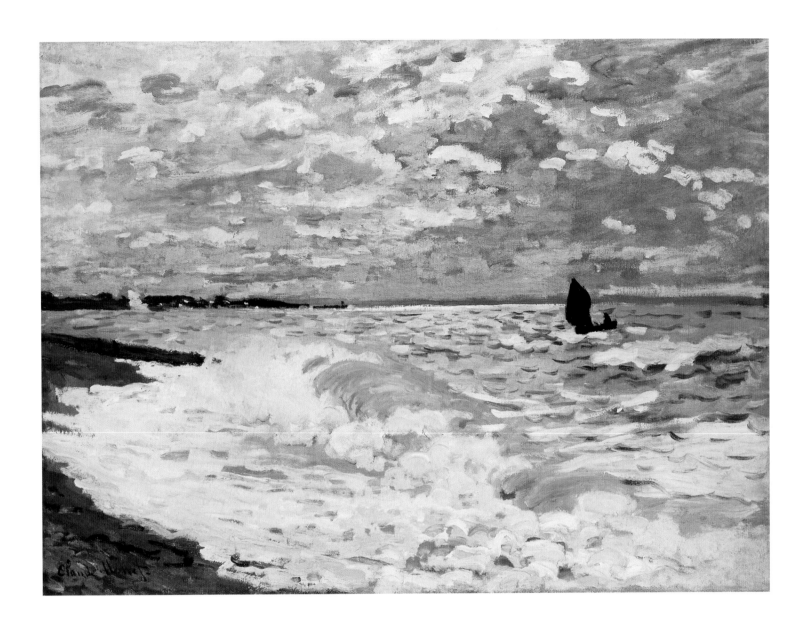

PLATE 99
Claude Monet
The Sea at Sainte-Adresse
1868
Oil on canvas
23⅝ × 32⅛ inches (60 × 81.6 cm)
Carnegie Museum of Art, Pittsburgh; purchase. 1953.22

For this view at Sainte-Adresse looking toward Le Havre, Monet turned away from the beach and its human activity and focused instead on the raw power of the incoming sea. The forcefully painted waves are matched by a dramatic cloud formation in the sky, and only a solitary boat at sea gives any sense of scale and distance. The treatment and the composition may have been inspired by the seascapes of Courbet, who in turn took a close interest in the work of his younger friend.

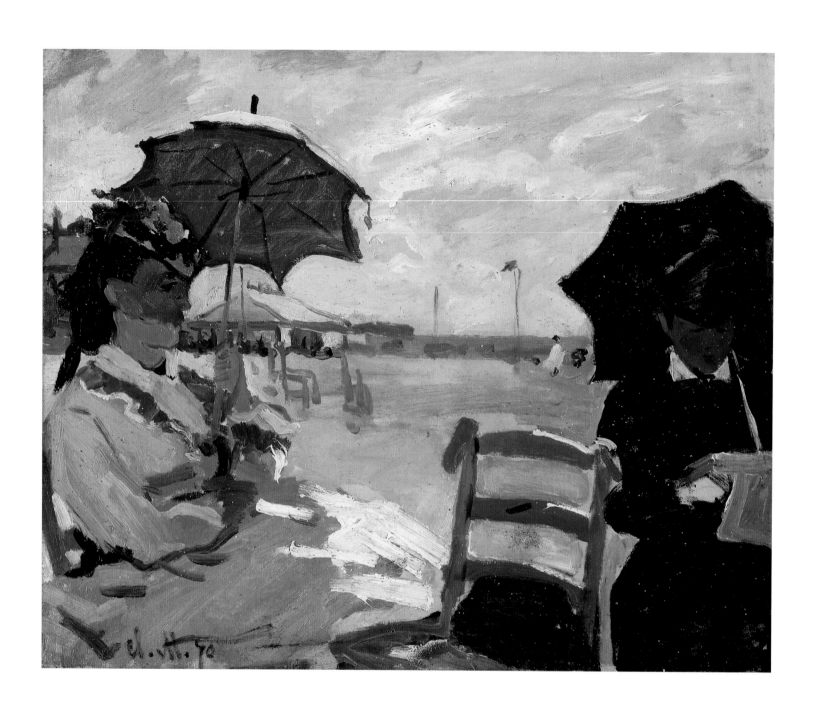

PLATE 100
Claude Monet
The Beach at Trouville
1870
Oil on canvas
15 × 18⅛ inches (38 × 46 cm)
The National Gallery, London. 3951
AIC, PMA

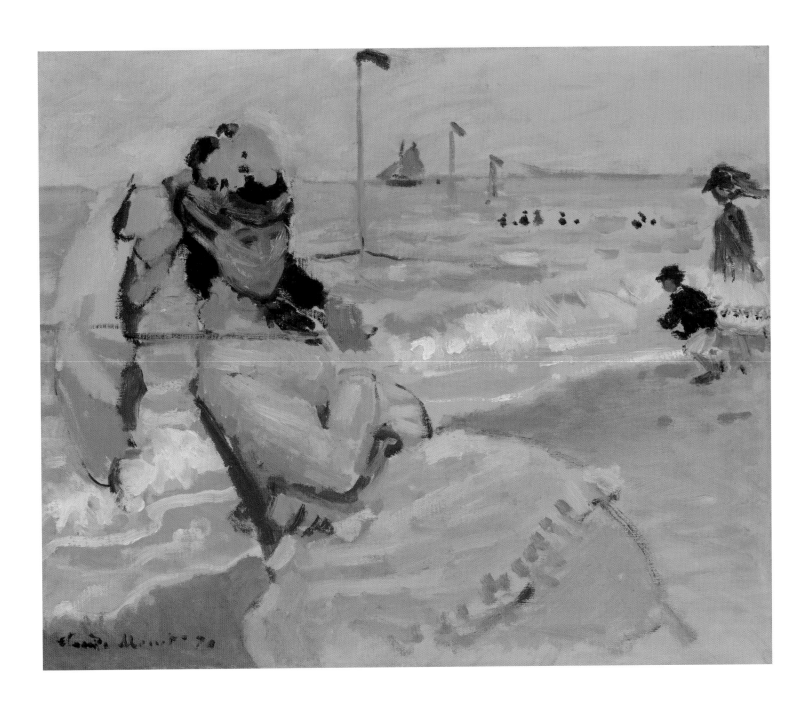

PLATE 101
Claude Monet
Camille on the Beach at Trouville
1870–71
Oil on canvas
15 × 18½ inches (38 × 47 cm)
Yale University Art Gallery, New Haven.
Collection of Mr. and Mrs. John Hay Whitney. 1998.46.1*

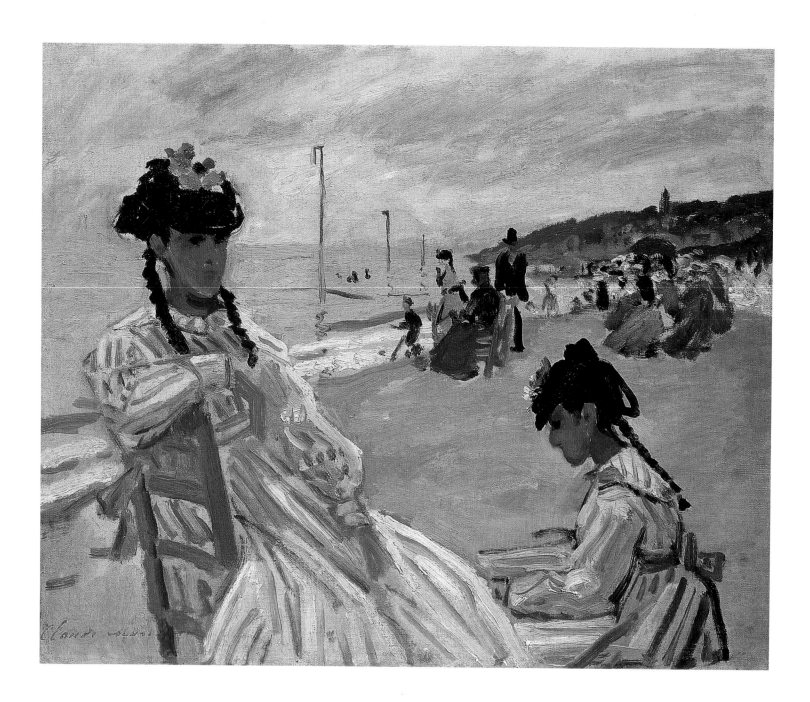

PLATE 102
Claude Monet
On the Beach at Trouville
1870
Oil on canvas
15 × 18⅛ inches (38 × 46 cm)
Musée Marmottan Monet, Paris. 5016
AIC

Shortly after Monet married his first wife, Camille, on June 28,
1870, he took his bride and their three-year-old son to Trouville
on the Normandy coast. This is one of five small studies that
depict Camille and other figures on the beach. The picture shows
all the signs of a hastily made sketch, with its broad handling,
shorthand rendering of forms, and open style that allows the
tint of the ground to show through as a color in its own right.

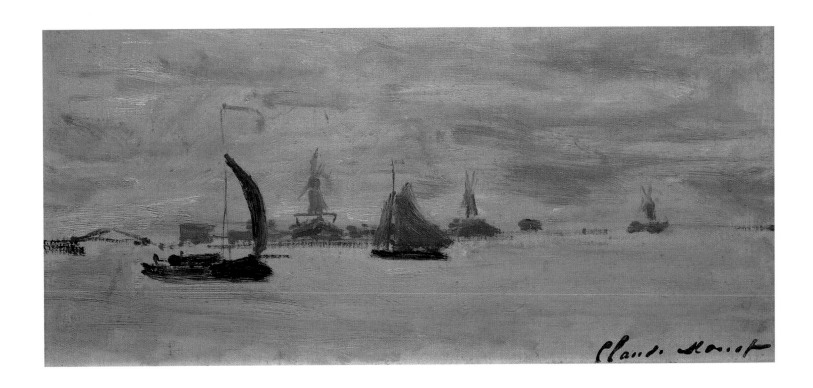

PLATE 103

Claude Monet

View of the Voorzaan

1871

Oil on canvas

7¹⁄₁₆ × 15 inches (18 × 38 cm)

Musée Marmottan Monet, Paris. 5239

AIC, PMA

Monet was in Zaandam from June to October 1871. He had come
to Holland from London, where he had been in self-imposed exile
to escape conscription during the Franco-Prussian War. The motif
here is a stretch of the Zaan River, where it broadens and flows
into the expanse of open water called the IJ. The swift notational
style recalls the river pictures that Whistler made in the 1860s.

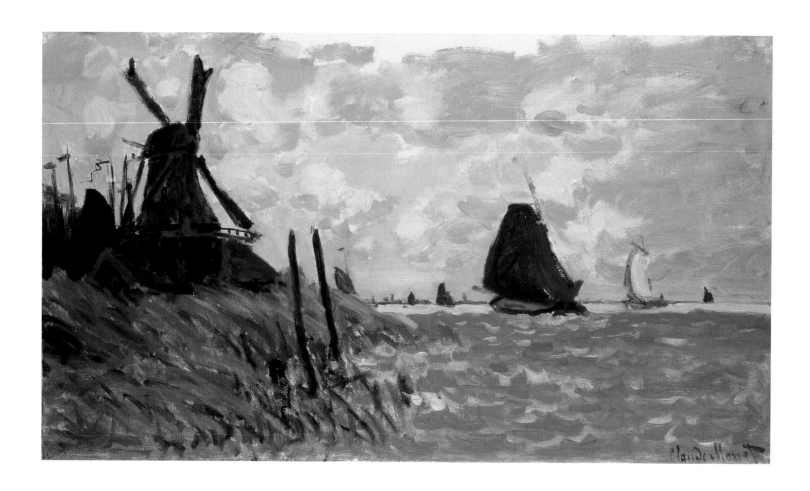

PLATE 104
Claude Monet
Windmill near Zaandam
1871
Oil on canvas
16⅛ × 28½ inches (41 × 72.5 cm)
Ashmolean Museum, Oxford. Accepted by H.M. Government
in lieu of Capital Transfer Tax and allocated to the Ashmolean
Museum according to the wishes of Dr. and Mrs. Richard Walzer.
WA 1980.81; A1115
AIC, PMA

Monet explored differing aspects of Zaandam and its surround-
ings, from close-up views of the harbor to panoramic views of the
Zaan River and the IJ. In this view of a windmill on the banks of
the IJ, his gestural touch and wet-on-wet handling evoke the tenu-
ous balance between reclaimed land and the surrounding water.

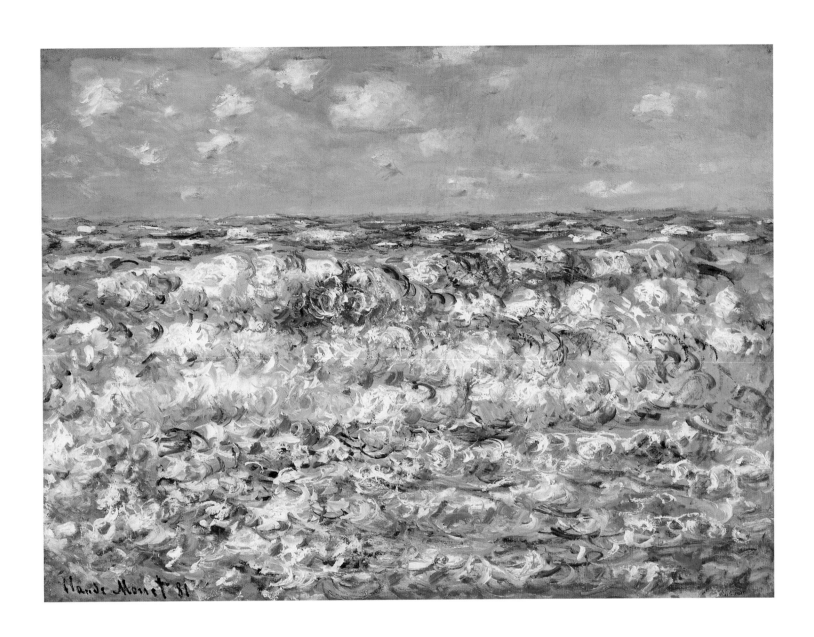

PLATE 105
Claude Monet
Waves Breaking
1881
Oil on canvas
23⅝ × 31⅞ inches (60 × 81 cm)
Fine Arts Museums of San Francisco,
California Palace of the Legion of Honor. 1970.10
PMA, VGM

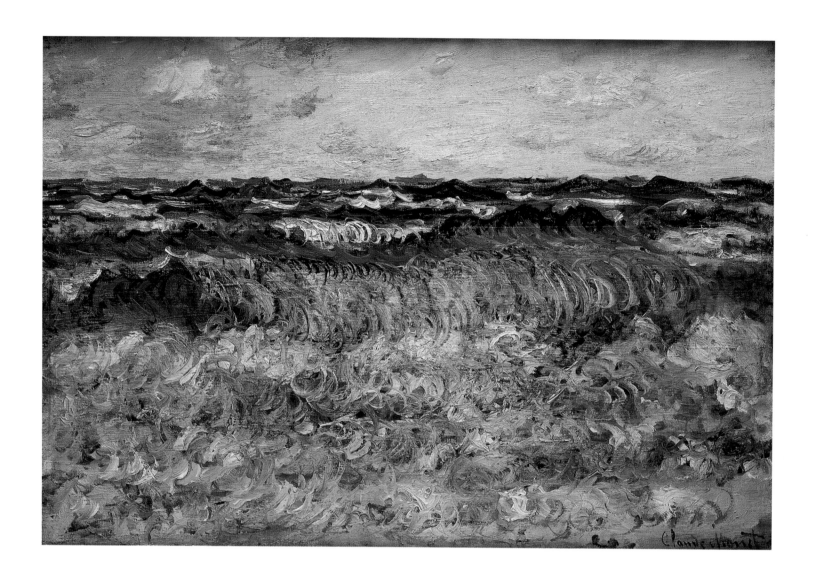

PLATE 106
Claude Monet
Seascape (Sea Study)
1881
Oil on canvas
19¹¹⁄₁₆ × 28¾ inches (50 × 73 cm)
Private collection

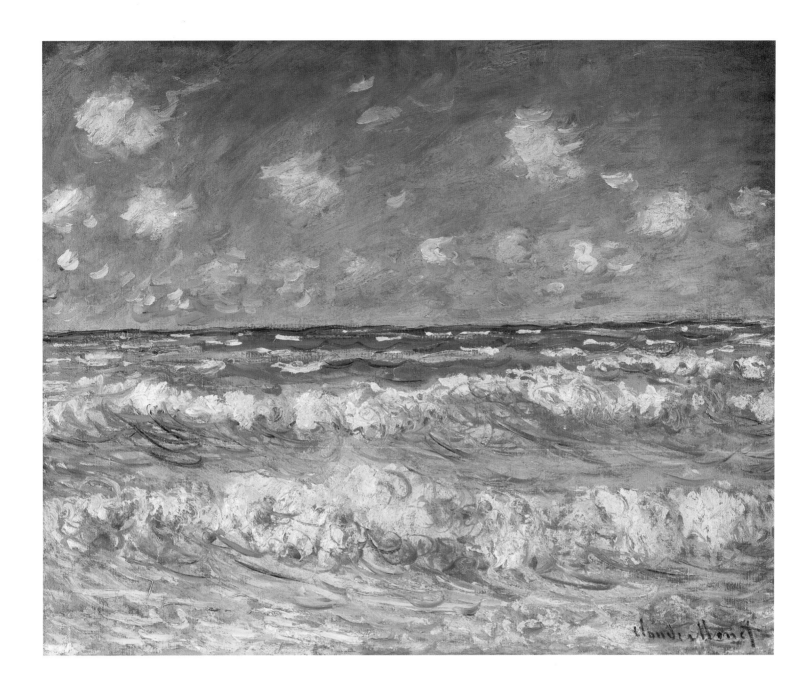

PLATE 107

Claude Monet

A Stormy Sea

1881

Oil on canvas

23⅝ × 29 inches (60 × 73.7 cm)

National Gallery of Canada, Ottawa. NGC 4636

After a period in the 1870s when Monet's attention was focused
on inland waterways and rivers, the sea regained a central position
as a subject in his art in the 1880s. In this work, as in *Waves Breaking*
(plate 105), he returns to a simple, elemental design he had first
used in the 1860s, reducing his canvas to the opposition of sea
and sky. The physical energy of his earlier work is still apparent
but is now enhanced by the vigor of his color combinations.

Berthe Morisot

BILL SCOTT

No other painter's career and accomplishments are as inextricably linked to Edouard Manet as are Berthe Morisot's. Manet himself once said that Morisot (1841–1895) would not have existed without him,[1] a terse assessment and yet one with which the highly self-critical Morisot may have agreed. Often erroneously referred to as his student, Morisot first met Manet in 1868, at the age of twenty-seven, and six years later married his brother, Eugène. She remained an admirer and staunch supporter of her brother-in-law's work, which she loved for its "vigor" as well as its "sureness of execution [and] technical mastery that overwhelm us all."[2]

Morisot relished his advice but sometimes accepted it warily because, as she said, "Manet always approves of the painting of people whom he likes."[3] Yet she would find, to her chagrin, that this was not necessarily true, for Manet once cavalierly repainted a large section of one of her canvases (*The Mother and Sister of the Artist* of 1869–70, National Gallery of Art, Washington, D.C.) moments before it was submitted to the 1870 Salon, prompting Morisot to state that she "would rather be at the bottom of the river than learn that her picture had been accepted."[4]

Nevertheless, it was Morisot, not Manet, who placed herself at the vortex of the avantgarde through her participation in the Impressionist exhibitions. Although Manet never joined the Impressionists—preferring instead to continue seeking recognition within the official Salon exhibitions—Morisot is often credited with opening his eyes to their use of brilliant fractured color and practice of painting *en plein air.*

Like Manet, Morisot's early mentor Camille Corot (1796–1875) often composed large paintings in his studio from sketches drawn *en plein air,* and he may have encouraged the young Morisot to do the same. She discovered, however, that she preferred to paint on location with a model, still life, or landscape in front of her. From the start, she was drawn to the undulating, abstract movements of water and tried to capture them in her work. At her 1864 Salon debut, for example, she exhibited *Remembrance of the Banks of the Oise River* (now destroyed), painted the previous summer near Auvers, and her first known painting of the Seine, *The Seine below the Pont d'Iéna* (private collection). Morisot often painted alongside the Seine, and in Paris she also frequently painted swans and boaters on the lakes and ponds in the Bois de Boulogne. Although she produced only a handful of seascapes during her career, they stand as some of her most important paintings.

We do not know if Morisot saw Manet's 1867 solo exhibition on the avenue de l'Alma, which included *The Battle of the U.S.S. "Kearsarge" and the C.S.S. "Alabama"* (plate 10) and other marines he painted in 1864 (see plates 12, 13, 16, 37). She surely would have seen these works the following year, however, along with his newer sea paintings—including *Moonlight, Boulogne; Jetty at Boulogne;* and *The Beach at Boulogne* (plates 28, 30, 32, respectively)—in Manet's rue Guyot studio while posing for the seated figure in *The Balcony* (Musée d'Orsay, Paris).

Opposite page: Berthe Morisot, *Harbor at Nice* (plate 114, detail)

Manet's seascapes likely had an impact on Morisot, for marine subjects first appear in her paintings in 1869. Her entry into sea painting was also no doubt influenced by her sister Edma's marriage, earlier that year, to Adolphe Pontillon, a naval officer. In early June, Morisot left Paris to visit her sister at Lorient, where, using Edma as a model, she painted *The Harbor at Lorient* (plate 108), her first known seascape and most successful attempt thus far to achieve her stated goal of painting "a figure in the outdoor light."[5] When the painting was later admired by her colleagues in Paris, she acknowledged that it had benefited from her use of Commander Pontillon's nautical knowledge.[6] (Fifteen years later, Morisot offered the Pontillons Manet's *Departure of the Folkestone Boat—The Large Study* [plate 45]. However, such was his expertise that Commander Pontillon refused the gift, citing Manet's placement of the captain standing on the bridge as erroneous and "a violation of the rules

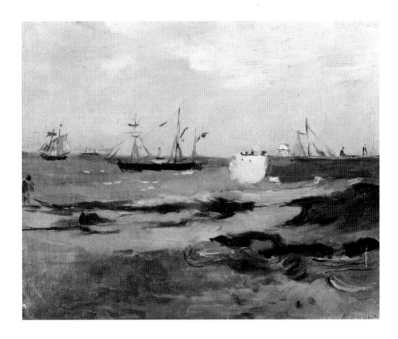

Fig. 68. Berthe Morisot, *Harbor Scene*, 1874. Oil on canvas, 13 × 16⅛ inches (33 × 41 cm). Musée Albert André, Bagnols-sur-Ceze, France

[that would be] more than he could endure."[7]) Upon her return to Paris, Morisot showed Manet *The Harbor at Lorient* and *Young Woman at a Window (The Artist's Sister at a Window)* (National Gallery of Art, Washington, D.C.). He told her that "without knowing it [she] had produced masterpieces," and she gave him *The Harbor at Lorient.*[8]

While visiting Edma in May of 1871 at her new home in Cherbourg, Morisot painted her next seascape, *Harbor at Cherbourg* (fig. 66), whose bird's-eye view may have been inspired by the similarly high vantage point of Manet's *"Kearsage" and "Alabama."* Yet with a few exceptions—such as the panoramic *View of Paris from the Trocadero* of 1871–72 (Santa Barbara Museum of Art), which echoes Manet's *The World's Fair of 1867* (Nasjonalgalleriet, Oslo)—Morisot rarely employed such a perspective again, later concluding that "views from above are almost always incomprehensible."[9]

She returned from an 1873 summer trip to Fécamp and Les Petites-Dalles on the Normandy coast with three small, boldly painted seascapes (see plate 109; fig. 67) depicting well-dressed figures promenading on the beach with ships in the distance. Back in Paris, Morisot undoubtedly would have shown these paintings to Manet, who would also have shared with her the dozen or so similar-size canvases he had done that same summer on the beach in Berck (see plates 57–64).

The following year, Morisot exhibited four oils, including *Harbor at Cherbourg*, at the first Impressionist exhibition in April.[10] Not long after the close of the show, the Morisot and Manet families vacationed together in Fécamp, where Morisot worked in pastel and watercolor and also painted six canvases of the beach and port, including *Harbor Scene* (fig. 68), whose palette, loose brushstrokes, and composition are reminiscent of Manet's *Bay of Arcachon* of 1871 (plate 50). Eugène Manet, who was an amateur artist, sometimes worked alongside Morisot on this trip, as when she painted *Boats under Construction* (plate 110), and by the end of the summer the two were engaged. As their December wedding approached, Morisot painted little but posed again for Edouard Manet while Eugène sought her attention. "I wouldn't mind at all," Eugène wrote her, "if you were to compliment me a bit on my painting."[11]

A trip to England in the summer of 1875 began with a stop on the Isle of Wight, where Morisot painted six views of the "extraordinary life and movement"[12] of the harbors in Cowes, Ramsgate, and Ryde (plates 111–12). At the time, she was discouraged and felt she was doing only "poor work."[13] On the Isle of Wight she painted five rapidly

executed watercolors: *Marine* (fig. 69), *Ships in the Harbor* (fig. 70), *Harbor Scene* (Sterling and Francine Clark Art Institute, Williamstown, Massachusetts), *Boat at the Quai* (Musée Marmottan Monet, Paris), and *Entry to the Midina in the Isle of Wight* (Fogg Art Museum, Cambridge, Massachusetts). Some of these Morisot painted while seated in a small boat to obtain a water-level vantage point, but she complained of the discomfort: "On a boat one has . . . difficulty. Everything sways, there is an infernal lapping of water; one has the sun and the wind to cope with, [and] the boats change position every minute."[14] Working from a window in her hotel's sitting room or on the pier was no better, she lamented: "People come and go on the jetty, and it is impossible to catch them. It is the same with the boats."[15]

Perhaps inspired by the speed at which she was forced to paint the watercolors, Morisot's compositions and brushstrokes in the series of oil paintings from the Isle of Wight seem increasingly improvisational and, when compared to works by her contemporaries, expressionistic.[16] Yet however loose and slapdash these works may appear, they were the product of intense contemplation and concentration. As a friend of Morisot's remembered, she "always painted standing up, walking back and forth before her canvas. She would stare at her subject for a long time (and her look was piercing), her hand ready to place her brushstrokes just where she wanted them."[17] This approach to painting not only allowed Morisot to capture the ceaseless motion and activity of the seascape and beach strollers, it also gave her works such a distinct look that it seems as if the process itself verged on becoming her primary inspiration.

Perhaps hoping to steer her toward paintings that would bring her recognition at the Salon, Manet had at times advised Morisot to give her works a more polished finish, urging her to redraw a model's head or to add "some touches to the bottom of the dress."[18] Morisot, however, continued her stylistic experiments, arriving at the flickering color, sketch-like quality, and calligraphic brushstrokes that gave her mature works an appearance of spontaneity that challenged the conventional notion of how a finished painting ought to look.

Like Manet, however, the critics often felt that Morisot's works lacked finishing touches. While they admired her "rare talent as a colorist," they roundly criticized her for quitting her work when her canvases were "only barely sketched."[19] Morisot, at the center of the artistic avant-garde, like Manet in more conservative circles, was not immune to brutal

Fig. 69. Berthe Morisot, *Marine*, 1875. Watercolor, 8⅛ × 5¾ inches (20.7 × 14.8 cm). Private collection

criticism. When she exhibited her Isle of Wight canvases, the critic Albert Wolf described the Impressionists as "five or six lunatics, one of whom is a woman." Of Morisot, he wrote: "There is also a woman in the group, as is the case with all famous gangs. Her name is Berthe Morisot, and she is interesting to behold. In her, feminine grace is preserved amidst the frenzy of a mind in delirium."[20] Whereas Eugène wanted to challenge Wolf to a duel, Morisot took the criticism in stride, writing to one of her aunts, "We are being discussed, and we are so proud of it that we are all very happy."[21]

Marine paintings next appear in Morisot's work in early 1882, when she, Eugène, and their daughter Julie (born in 1878) spent the winter months in Nice. Six of the Nice paintings (see plates 114, 115; fig. 71) depict the beach or

boats in the harbor, where she and Eugène sometimes painted together seated on a small boat.[22] Two of the works (plates 114, 115) were exhibited only weeks later in the seventh Impressionist exhibition. Morisot stayed in Nice while Eugène returned to Paris to select and then frame her works for the exhibition. Morisot often worried that viewers "see only the harshness and the effort" that went into making her paintings.[23] When Eugène wrote that her paintings had been placed on easels, she reminded him of her concern: "If my pictures are to be seen on easels, that is at very close quarters, [so] one must show things that do not appear grotesque."[24] Her anxiety about the exhibition did not diminish when Eugène reported, "Edouard . . . says that your pictures are among the best," for she quickly responded, "What does Edouard say of the exhibition as a whole?"[25]

After Manet's death in 1883, Morisot worked diligently to gain more recognition for her brother-in-law's accomplishments. "It is odd," she wrote, "that Edouard with his reputation as an innovator, who has survived such storms of criticism, should suddenly be seen as a classicist. It just proves the imbecility of the public, for he has always been a classic painter."[26] By the end of their lives, Morisot and her husband owned more than twenty paintings by Manet. Oddly, none of these was a seascape, despite the fact that in 1875 she acquired one of Claude Monet's marines and by the time of her death owned two more.

Morisot's own work never lacked praise from other artists. Interestingly, the majority of her Impressionist colleagues who acquired examples of her work selected her seascapes. In addition to Manet, to whom she had given *The Harbor at Lorient*, Edgar Degas owned an oil painting done at Fécamp, *In a Villa at the Seaside* of 1874 (Norton Simon Museum of Art, Pasadena); Henri Rouart owned an oil, *The Terrace* (Fuji Art Museum, Tokyo), and a watercolor, *Woman and Child on the Beach* (private collection), both painted at Fécamp in 1874; and Monet owned her *Steamboat* of 1875 (private collection), painted on the Isle of Wight.

Although Manet never officially exhibited with the Impressionists, through Morisot he enjoyed an even closer alliance with them. Early in their friendship, Manet had predicted success for her and encouraged her to push herself further as an artist.[27] He had also consoled Morisot's mother, who worried that her daughter "has not the kind of talent that has commercial value or wins public recognition; she will never sell anything done in her present manner, and she is incapable of painting differently."[28] In spite of later friendships with Monet, Degas, Renoir, and Mallarmé, Morisot was and is always associated foremost with Manet. In 1892, nine years after the death of Edouard Manet, and several months after that of Eugène, Morisot finally held her first solo exhibition. In reviewing the exhibition, one critic observed that her works "form an ensemble of a rare delicacy, one where Manet's impressionism lives on, carried to the even more refined, quintessential heights of taste and elegance."[29]

1. George Moore, *Modern Painting* (New York: Brentano, 1910), p. 236.

2. Denis Rouart, ed., *The Correspondence of Berthe Morisot*, trans. Betty W. Hubbard (New York: E. Weyhe, 1959), p. 120.

3. Ibid., p. 39.

4. Ibid., pp. 41–42.

5. Ibid., p. 32.

6. Ibid., p. 39.

7. Ibid., pp. 122–23. After the Pontillons refused the Manet painting, Morisot gave it to Edgar Degas.

8. Ibid., pp. 37, 39.

9. Ibid., p. 91. For an in-depth discussion of this painting, see Charles F. Stuckey and William P. Scott with the assistance of Suzanne G. Lindsay, *Berthe Morisot: Impressionist* (New York: Hudson Hills Press, 1987), pp. 39–41.

10. *Harbor at Lorient* has sometimes been misidentified as the marine painting Morisot included in the first Impressionist exhibition. See, e.g., Charles S. Moffett et al., *The New Painting: Impressionism 1874–1886*, exh. cat. (San Francisco: The Fine Arts Museums of San Francisco, 1986), p. 134; Alain Clairet, Delphine Montalant, and Yves Rouart, *Berthe Morisot, 1841–1895: Catalogue raisonné de l'oeuvre peint* (Montolivet: Centre d'études, de recherches et d'applications pour de nouveaux rapports sociaux, 1997), p. 120, no. 17.

For a detailed discussion of Morisot's entries in this exhibition, see Stuckey, Scott, and Lindsay, *Berthe Morisot: Impressionist*, pp. 54, 55, 57.

11. Rouart, *Correspondence*, p. 81.

12. Ibid., p. 89.

13. Ibid., p. 92.

14. Ibid., p. 91.

15. Ibid., p. 89.

16. Monet is usually credited with being the first artist to show a series of works depicting one motif, for his oils of the Saint-Lazare train station at the 1877 Impressionist exhibition. However, at the 1876 Impressionist exhibition, Morisot included five of her Isle of Wight seascapes, *View of England* (private collection), *West Cowes, Isle of Wight* (plate 111), *Harbor Scene, Isle of Wight* (plate 112), *The Jetty* (Virginia Museum of Fine Arts, Richmond), and *Steamboat* (private collection), plus two of the marines painted several years earlier in Fécamp (plate 110, fig. 67).

17. Monique Angoulvent, *Berthe Morisot* (Paris: Albert Morance, 1933), p. 70 (my translation).

18. Rouart, *Correspondence*, pp. 39–40.

19. Arthur Baignères, *L'Echo Universel*, April 13, 1876; A. de L. [Alfred de Lostalot], *La Chronique des arts et de la curiosité*, April 1, 1876; both cited in Moffet et al., *The New Painting*, p. 182.

20. Rouart, *Correspondence,* p. 98.

21. Ibid.

22. Julie Manet, *Journal (1893–1899)* (Paris: Librairie C. Klincksieck, 1979), p. 82.

23. Rouart, *Correspondence,* p. 160.

24. Ibid., p. 108.

25. Ibid., p. 110.

26. Philippe Huisman, *Morisot: Enchantment,* trans. Diana Imber (New York: French and European Publications, 1963), p. 64.

27. Rouart, *Correspondence,* p. 39.

28. Ibid., p. 72.

29. Alfred de Lostalot, *La Chronique des arts,* June 4, 1892, quoted in Clairet, Montalant, and Rouart, *Berthe Morisot, 1841–1895,* p. 100.

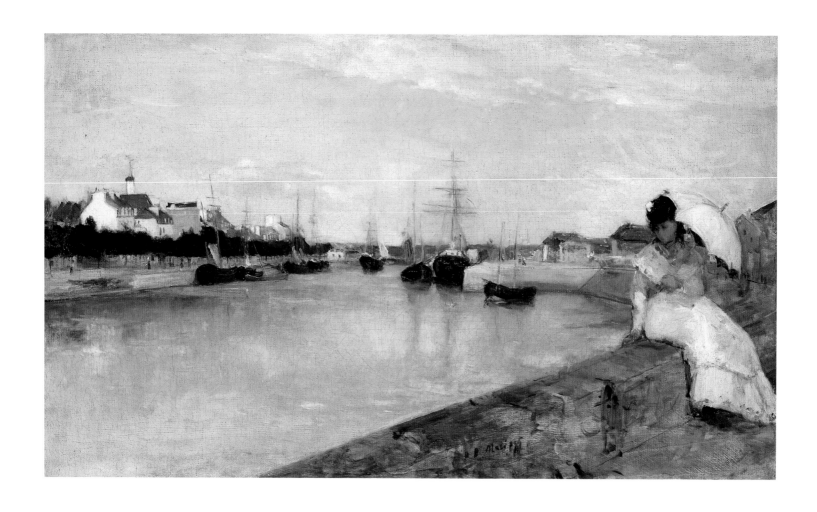

PLATE 108
Berthe Morisot
The Harbor at Lorient
1869
Oil on canvas
17⅛ × 28¾ inches (43.5 × 73 cm)
National Gallery of Art, Washington, D.C.
Ailsa Mellon Bruce Collection. 1970.17.48
AIC, PMA

PLATE 109
Berthe Morisot
On the Beach
1873
Oil on canvas
9½ × 19¾ inches (24.1 × 50.2 cm)
Virginia Museum of Fine Arts, Richmond.
Collection of Mr. and Mrs. Paul Mellon. 83.39
PMA, VGM

PLATE 110
Berthe Morisot
Boats under Construction
1874
Oil on canvas
12⁹⁄₁₆ × 16⅛ inches (32 × 41 cm)
Musée Marmottan Monet, Paris. 6013
AIC, PMA

PLATE 111
Berthe Morisot
West Cowes, Isle of Wight
1875
Oil on canvas
18⅞ × 14⅛ inches (48 × 36 cm)
Private collection

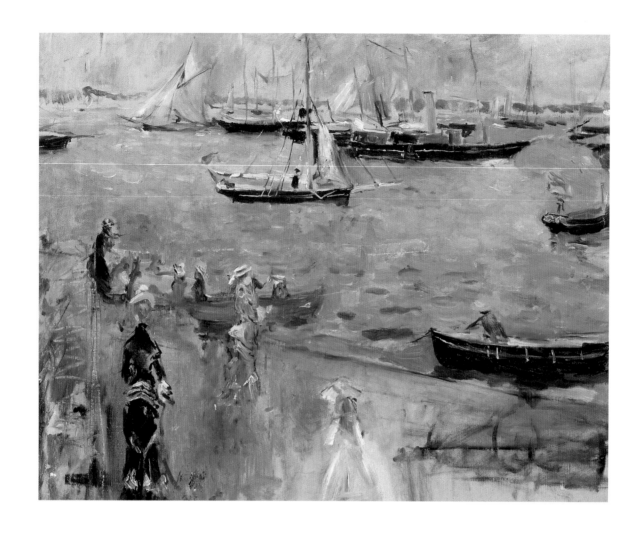

PLATE 112
Berthe Morisot
Harbor Scene, Isle of Wight
1875
Oil on canvas
15 × 18⅛ inches (38 × 46 cm)
Private collection

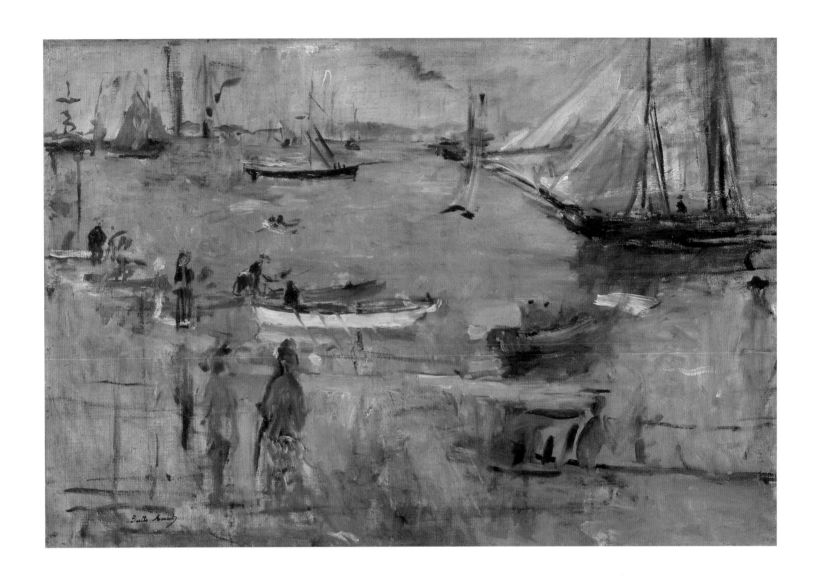

PLATE 113
Berthe Morisot
Harbor Scene, Isle of Wight
1875
Oil on canvas
17 × 25½ inches (43 × 64.8 cm)
Collection of The Newark Museum, New Jersey.
Gift of Mrs. Esther U. Johnson. 1979.6

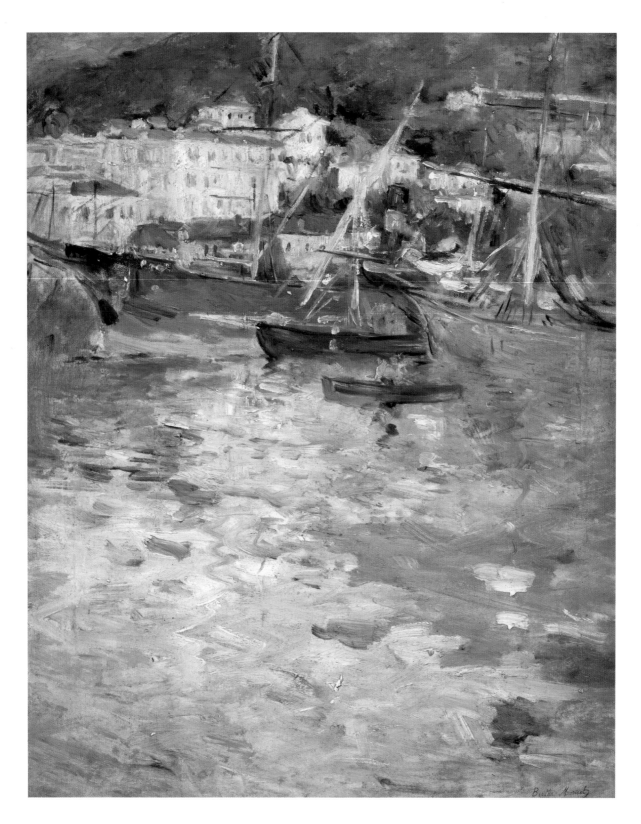

PLATE 114
Berthe Morisot
Harbor at Nice
1882
Oil on paper mounted on canvas
23¼ × 17 inches (59 × 43 cm)
Musée Marmottan Monet, Paris. 6010
AIC

Whereas Manet was admired for his use of black, white was perhaps the most important color in Morisot's palette. Whether as a model's dress, a china plate, or the spume on a breaking wave, it is present in some form in all her paintings. She mixed white with many of her colors to create shimmering, brushy gradations of pastel tones and whites anchored by earth tones. At times, the colors are so close, as in this painting from Nice, that when reproduced in black and white, a purple, a pink, and a blue will be indistinguishable.

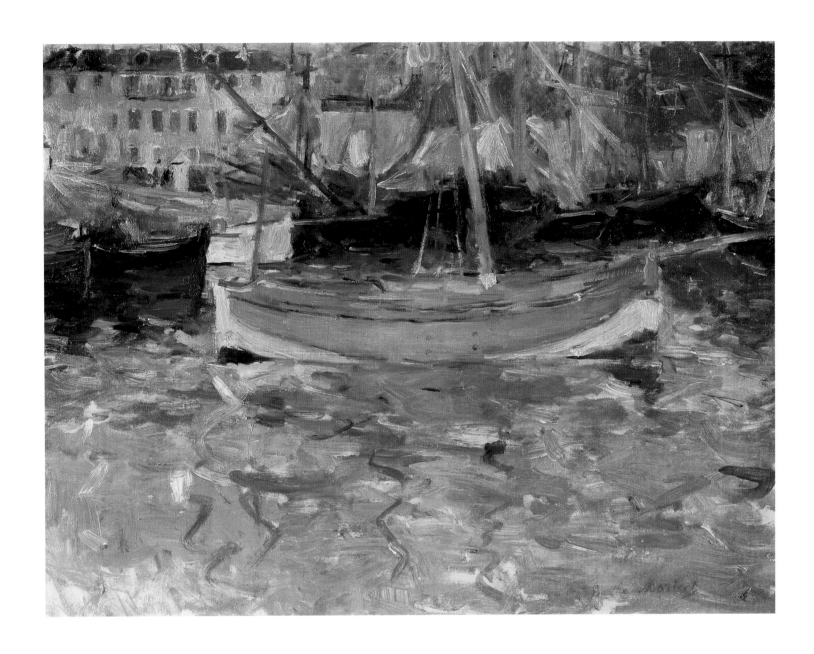

PLATE 115
Berthe Morisot
The Harbor of Nice
1882
Oil on canvas
16⅛ × 21⅝ inches (41 × 55 cm)
Wallraf-Richartz-Museum – Fondation Corboud, Cologne. FC 710

Pierre-Auguste Renoir

JOSEPH J. RISHEL

Seascapes are a modest element within the prolific artistic production of Pierre-Auguste Renoir (1841–1919), with perhaps twenty paintings that qualify as pure seascapes clustered throughout his long career. However, Renoir's marines serve as a rare gauge of his remarkably alert sensibility to all that was going on around him while providing, just by the very transient nature of the subject, some of his most delightfully effervescent and freely executed works.

Whether he was depicting bathers at La Grenouillère (in the company of Claude Monet), canoers on the Seine (in the company of nearly all of his artistic friends), or the lapping waves and trickling fountains that accompany his nudes (all of whom are water nymphs in some fashion), the play of reflections on water—always associated with pleasure for Renoir—was central to his work.[1] Yet, as aware as he was of the important role landscape (and by extension, seascape) played in the revolution of new painting beginning in the 1860s, it never dislodged his devotion to the grand tradition of French classical figure painting, whose subjects remain remote from a particular place and time. As late as 1892, he would write to Berthe Morisot from the beach resort of Pornic on the Brittany coast: "I should be painting landscapes. The country here is quite pretty and that is why I am so cross. To paint landscape is becoming for me an ever greater torture, all the more so because it is a duty: obviously this is the only way to learn one's craft a little, but to station oneself out of doors like a mountebank, this is something I can no longer do."[2]

"Place" or "site" meant something quite different for Renoir than it did for his friends Monet or Paul Cézanne. The formal and critical decision-making process that these artists employed in their choice of a subject—the "motif"—was of secondary concern for Renoir. An agreeable view, near somewhere he was happy, in the company of friends or on a summer outing with his family—these seem to have been the essential criteria for nearly all of Renoir's landscape and seascape selections.

From 1879 to 1885, Renoir regularly paid long summer visits to one of his most loyal patrons, Paul Berard, at his château of Wargemont, some ten miles (sixteen kilometers) east of Dieppe on the Normandy coast and an easy walk to the sea.[3] The works in this exhibition (plates 117, 118) depict that coastline. A trip south in the winter of 1881–82 produced views of the lagoon at Venice, the Bay of Naples, and one extraordinarily vigorous rough-sea view presumably done during a short trip to Capri that December. For five weeks in the fall of 1883 he was on the Channel Islands of Jersey and Guernsey, where he delighted in painting the English tourists playing in the surf (fig. 72). In the 1890s, he was attracted more to the beaches of Brittany than to the colder waters of Normandy, with visits in 1892 to the artist colony of Pont-Aven and the sheltered island of Noirmoutiers, off Pornic. He spent the winter and spring of 1899 in Nice and Cagnes-sur-Mer, and thereafter, albeit with much restless moving about, the Midi became his principal landscape subject. He rented the Villa de la Poste in Cagnes-sur-Mer from 1903 to 1908, the year he purchased Les Collettes, just outside the walls of the town, where he would live

243

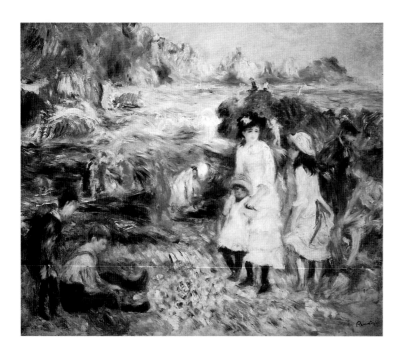

Fig. 72. Pierre-Auguste Renoir, *Beach Scene, Guernsey*, 1883. Oil on canvas, 21¼ × 25½ inches (54 × 65 cm). Barnes Foundation, Merion, Pennsylvania. BF 10

Fig. 73. Claude Monet, *Marine near Etretat*, 1882. Oil on canvas, 21½ × 29⅟₁₆ inches (54.6 × 73.8 cm). Philadelphia Museum of Art. Bequest of Mrs. Frank Graham Thomson. 1961-48-1

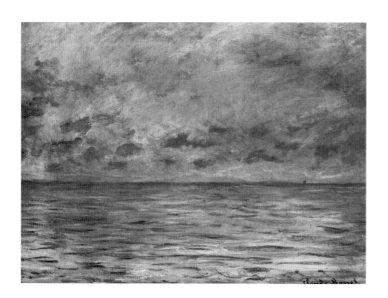

out the rest of his life. Despite his proximity to the coast, the sea retreated as an independent subject for Renoir in the 1890s and became a background element, glimmering through the trees in his landscapes or providing a dazzling blue field for his nudes.

Renoir's landscapes and seascapes hold a very specific place in the history of Impressionism. In part because of their relatively minor role in his oeuvre, they serve as a kind of weathervane indicating his relationships to those artists in his sphere for whom landscape was a more dominant genre.[4] While his landscapes are vigorously executed and important in their own right, they are more easily discussed in terms of the influences of other artists than are his figure paintings. This is nowhere more true than with the sea pictures.

In order to understand Renoir's attitude toward marine painting, we must first consider his very strong admiration of Gustave Courbet's marines, particularly the two large Etretat paintings shown at the 1870 Salon (figs. 52, 53), at which Renoir also exhibited two major figure paintings. Richard R. Brettell aptly notes, in discussing *The Wave* of 1882 (plate 118), that Renoir's attraction to Courbet's sea paintings may well have been reinforced by a visit to the large retrospective of Courbet's work at the Ecole des Beaux-Arts the previous year.[5] The churning sea crashing onto the Normandy beach and, especially in *Stormy Sea* (fig. 53), the specific focus on a single spiraling wave as the essential subject make a compelling comparison to the older artist. However, as John House notes in making the same comparison, the artists could not have been more different in their essential attitudes toward such similar subjects: "[Renoir] seems to have been more concerned [than Courbet] with the visual spectacle before him than with any weightier significance in the theme."[6]

Renoir's *Sunset at Sea* of 1879 (plate 116), however, brings to mind Monet's seascapes—for example, the stern, reductive grandeur of his *Marine near Etretat* of 1882 (fig. 73). Renoir's *Sunset* is not as stern and deliberate in its making, but rather pulses with a different kind of energy and delight in the swift, complex manipulation of color over the surface. These qualities of Renoir's work stem from something very different than the pursuit of optical veracity that drives Monet, something that descends from the complexity of Eugène Delacroix's palette. Renoir, like Delacroix, delights in opulent complexity, just as his application of paint takes on a dancing animation parallel to, but not necessarily dependent on, the subject at hand.

In this, Renoir the marine painter is closest to Manet, the artist of his immediate circle with whom he shares the most. This is perhaps nowhere more evident than in the choice of works by Renoir presented here, in the context of Manet's marines. Take, for example, the two versions of the *Escape of Rochefort* (plates 69, 71), where Manet's daring manipulation of paint—ranging through all the blues and purples and peaking in Naples yellow, pink, and salmon—is closest to Renoir's, verging on what, in the next century, would be called "pure" painting.

Renoir, the son of artisans, and Manet, the complete Parisian of the boulevards, were, of course, odd bedfellows in many

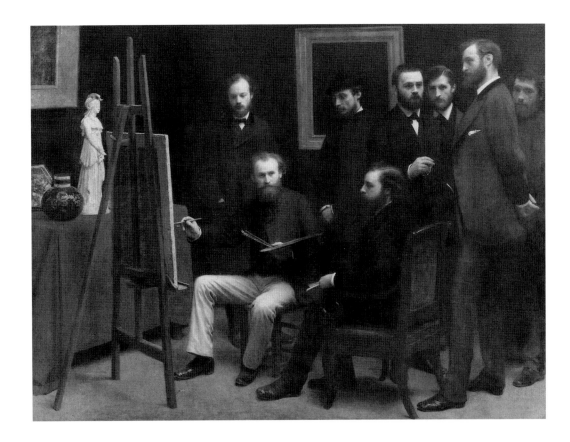

Fig. 74. Henri Fantin-Latour, *A Studio in the Batignolles (Homage to Manet)*, 1870. Oil on canvas, 80⁵⁄₁₆ × 107¹¹⁄₁₆ inches (204 × 273.5 cm). Musée d'Orsay, Paris. RF 729. Depicted, left to right, are Otto Scholderer, Edouard Manet (seated), Pierre-Auguste Renoir, Zacharie Astruc (seated), Emile Zola, Edmond Maître, Frédéric Bazille, and Claude Monet.

ways, both socially and temperamentally, yet their friendship was true and lasting. Henri Fantin-Latour understood this when he placed Renoir front and center in his 1870 homage to Manet, *A Studio in the Batignolles* (fig. 74). The artists' impromptu meeting in Monet's garden at Argenteuil in the summer of 1874, resulting in their dual paintings of Madame Monet and her son Jean, is one of the set anecdotes in the history of Impressionism, though Manet's jest in pretending not to recognize Renoir, whom he cautions to set aside painting as his craft, has certainly been much embellished.[7] Renoir's complete devotion to Berthe Morisot, Manet's sister-in-law, and to her daughter Julie, whom Renoir took in after the death of her mother in 1895, simply underscores the strength of his affection for and loyalty to that family.

Renoir's tender feelings toward his fellow artist are demonstrated in a letter he wrote to Manet from Capri in December 1881:

> I just happened to run across an old *Petit Journal* which reports with transports of delight the purchase of some paintings by the master Courbet, which made me extremely happy; not for Courbet, that poor old man who cannot enjoy his triumph, but for French art. . . . I was expecting . . . you to be appointed *chevalier* which would have made me applaud from my faraway island. But I hope it is only postponed, and that when I enter the capital, I will have to greet you as the officially recognized painter loved by all.[8]

Ironically, Manet did finally receive his much-postponed appointment as Chevalier of the Legion of Honor just two days after this was written, and before his friend's letter arrived.

1. See Christopher Riopelle, *Renoir: The Great Bathers* (Philadelphia: Philadelphia Museum of Art, 1990).

2. Denis Rouart, ed., *The Correspondence of Berthe Morisot,* trans. Betty W. Hubbard (New York: G. Wittenborn, 1957), p. 195.

3. Colin Bailey, *Renoir's Portraits: Impressions of an Age* (New Haven: Yale University Press, 1997), p. 209.

4. This notion of the landscapes of Renoir as a sort of trace element in the history of Impressionism comes from discussion with Christopher Riopelle, who kindly read and commented on this essay.

5. Richard R. Brettell, *Impression: Painting Quickly in France, 1860–1890* (New Haven: Yale University Press, 2000), p. 186.

6. John House, *Renoir: Master Impressionist* (Sydney: Art Exhibitions Australia, 1994), p. 76.

7. These two works—Manet's *The Monet Family in the Garden* (The Metropolitan Museum of Art, New York) and Renoir's *Madame Monet and Her Son* (National Gallery of Art, Washington, D.C.)—were most recently reunited in *Edouard Manet und die Impressionisten,* Staatsgalerie Stuttgart, 2002. See Ina Conzen, *Edouard Manet und die Impressionisten,* exh. cat. (Stuttgart: Staatsgalerie Stuttgart, 2002), nos. 106, 107.

8. Barbara Ehrlich White, *Renoir: His Life, Art, and Letters* (New York: Abrams, 1984), pp. 117, 118. See also Etienne Moreau-Nélaton, *Manet: Raconté par lui-même* (Paris: Henri Laurens, 1926), vol. 2, p. 88.

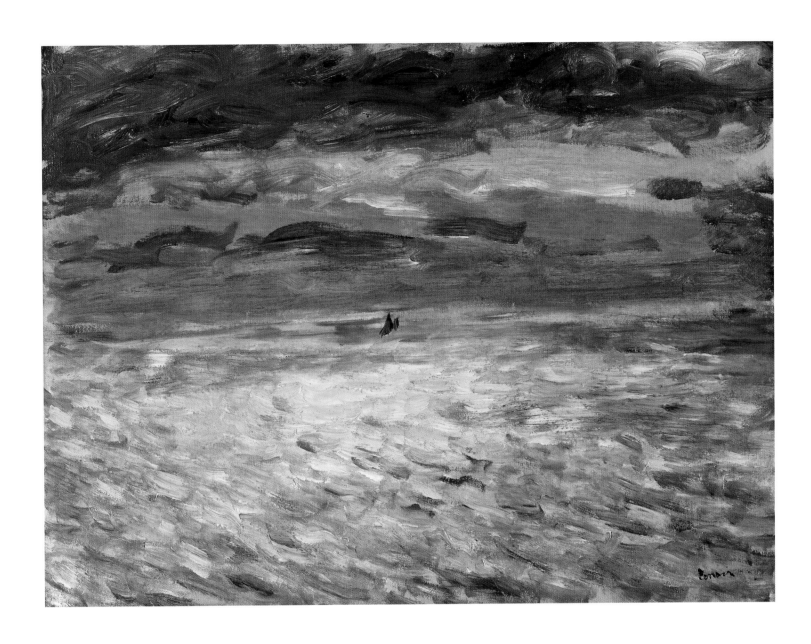

PLATE 116
Pierre-Auguste Renoir
Sunset at Sea
1879
Oil on canvas
18 × 24 inches (45.7 × 61 cm)
Sterling and Francine Clark Art Institute,
Williamstown, Massachusetts. 1955.602
AIC, PMA

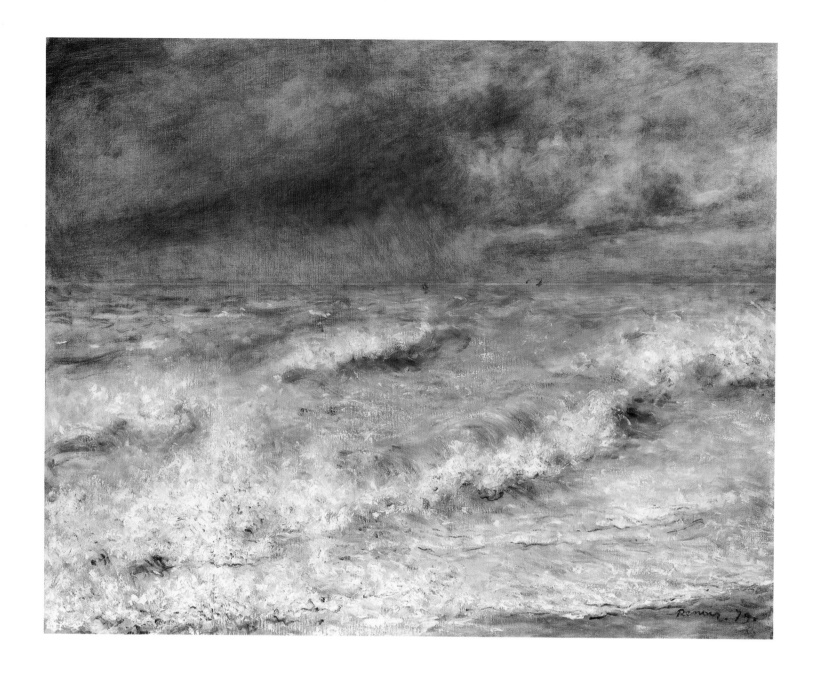

PLATE 117
Pierre-Auguste Renoir
Seascape
1879
Oil on canvas
25½ × 39⅟₁₆ inches (64.8 × 99.2 cm)
The Art Institute of Chicago. Potter Palmer Collection. 1922.438

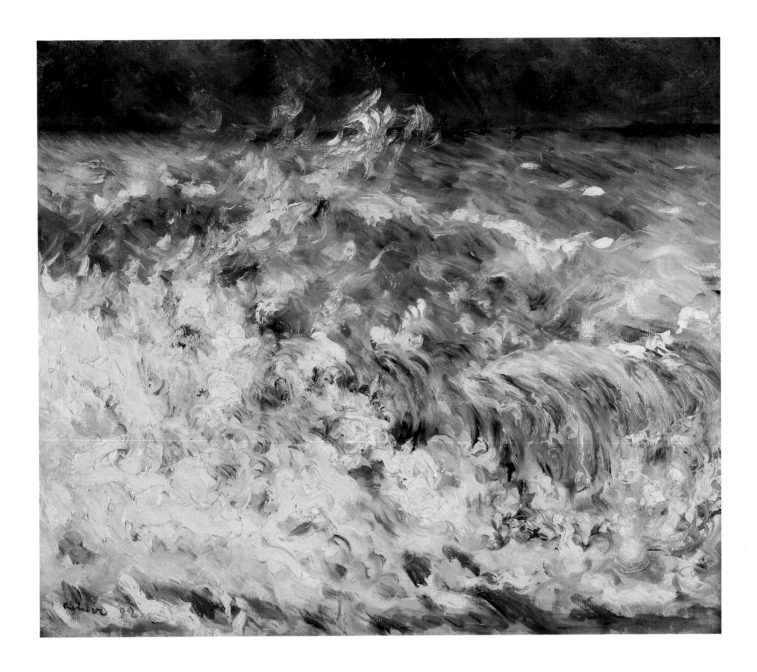

PLATE 118
Pierre-Auguste Renoir
The Wave
1882
Oil on canvas
21 × 25 inches (53.3 × 63.5 cm)
Collection of The Dixon Gallery and Gardens, Memphis,
Tennessee. Museum purchase from Cornelia Ritchie Bivins
and Ritchie Trust No. 4, provided through a gift from the
Robinson Family Fund. 1996.2.12

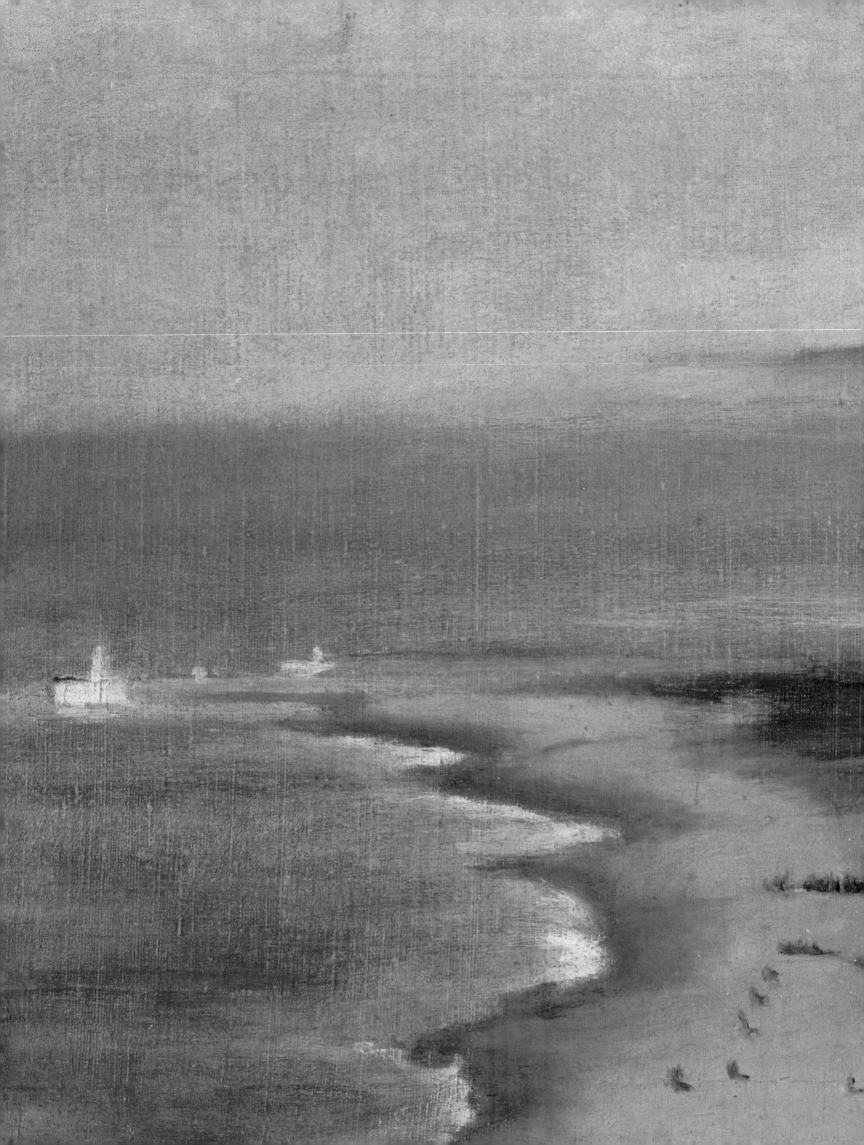

Eva Gonzalès

ANN TEMKIN

Eva Gonzalès is identified primarily by her status as the sole pupil of Edouard Manet, whose iconoclasm was otherwise at odds with any interest in pedagogy. Gonzalès first took lessons with Manet in 1869, at the age of twenty, and the two of them continued a close artistic dialogue during the years to come. Their association was dramatized by her untimely death in 1883, just fifteen days after that of Manet. Despite a richly varied body of work made during her brief career, Gonzalès's best-known works are those that relate directly to paintings by her famous teacher.[1] Like him, she preferred to exhibit at the Paris Salon and never joined an Impressionist exhibition.

Gonzalès grew up in a household deeply immersed in the arts. Her father, the novelist Emmanuel Gonzalès, was a prominent literary figure in Paris, and her mother was a talented musician. When Eva decided to study painting in 1866, she enrolled in the atelier of the fashionable painter Charles Chaplin, the best known of the many art schools for women in Paris, but left after just a year and a half. In 1869 the Belgian artist Alfred Stevens, a family friend, introduced her to Manet. At that point Manet was a highly controversial figure, and Gonzalès had to argue for her parents' permission to study with him. Her activity in Manet's studio at the rue Guyot is documented by Manet's *Portrait of Mlle. E.G.* of 1870 (National Gallery, London), a painting that depicts Gonzalès at work on a floral still life.

Despite her daring affiliation with Manet, Gonzalès tended to make paintings that stayed safely within the parameters set for a woman artist of her time: domestic scenes, portraits of women and children, still lifes. Her works often feature the image of her younger sister Jeanne, Gonzalès's primary model and also a painter. Gonzalès, like her peers Berthe Morisot and Mary Cassatt, depicted the woman's world as one of graceful leisure: tending to her toilette, amusing her children, enjoying tea, or playing a musical instrument. These scenes belie the serious discipline with which Gonzalès devoted herself to the task of painting. In her own time, such subjects would have forestalled any discomfort viewers may have felt about a woman's serious ambition, but they also contribute to the lasting misimpression of her as a privileged amateur. Many of Gonzalès's stylistic touches reflect the pronounced influence of Spanish painting on Manet's work, reinforced by the Spanish features of her sister. Like Manet, she was an especially strong painter of the still life, whether in small compositions or as a striking element in larger, more complex works.

Landscapes and seascapes are rare within Gonzalès's oeuvre of about 125 paintings and works on paper. The small painting *Beach at Dieppe* (plate 119) is one of a few panoramic seascapes by Gonzalès known to exist; most of her paintings made at the shore are closely observed compositions focusing on one or two figures. The bird's-eye view shows off the artist's skill in treating atmospheric effects of water and air, almost more in the spirit of watercolor than oil paint. Gonzalès's use of a high vantage point—a characteristic of Manet's marine paintings—leaves the details of beach and town to be suggested by small

Opposite page: Eva Gonzalès, *The Beach at Dieppe* (plate 119, detail)

strokes of the brush. It bears no inscription, and the lack of comparable works prevents sure dating on stylistic grounds. The catalogue raisonné of Gonzalès's work proposes a date of about 1871–72,[2] based on the Gonzalès family's sojourn in Dieppe during the Franco-Prussian War. But Gonzalès also stayed in Dieppe at various points during the rest of her career. After her marriage to Henri Guérard in 1879, she and her husband spent a significant amount of time there and in the Impressionist holiday towns of Grandcamp and Honfleur, where she frequently painted outdoors. This intriguing composition makes clear that much more remains to be learned of Gonzalès's life and work.

1. For example, *The Little Soldier,* 1870 (Musée des Beaux-Arts, Villeneuve-sur-Lot), an homage to Manet's *The Fifer,* 1866 (Musée du Louvre, Paris).

2. Marie-Caroline Sainsaulieu and Jacques de Mons, *Eva Gonzalès, 1849–1883: Etude critique et catalogue raisonné* (Paris: Bibliothèque des arts, 1990), p. 104, no. 34.

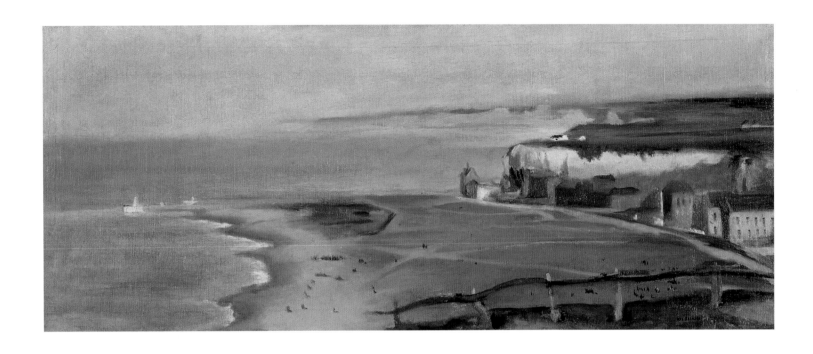

PLATE 119
Eva Gonzalès
The Beach at Dieppe
c. 1871–72
Oil on canvas
11¼ × 27½ inches (28.5 × 70 cm)
Le Château-musée de Dieppe. 973.15.1

Chronology

JENNIFER L. VANIM AND JOHN ZAROBELL

1819 May: Théodore Gericault's enormous marine painting *Raft of the Medusa* (fig. 11) creates a sensation at the annual Salon. Its unprecedented representation of the sea will influence French artists for generations.

 June 3: Johan Barthold Jongkind is born in Latrop, Holland.

 June 10: Gustave Courbet is born in Ornans.

1822 Eugène Delacroix makes his salon debut with *The Barque of Dante* (Musée du Louvre, Paris), a Romantic seascape.

1824 July 24: Eugène Boudin is born in Honfleur.

1827 November: James Fenimore Cooper's sea novel *Le Corsaire rouge* (English title, *Red Rover*) is published in France.

1832 January 23: Edouard Manet is born in Paris, the eldest son of Auguste Manet, an official in the Ministry of Justice, and Eugénie Désirée Manet (née Fournier), the daughter of a diplomat.

1834 July 11: James McNeill Whistler is born in Lowell, Massachusetts.

1840 November 14: Claude Monet is born in Paris.

1841 January 14: Berthe Morisot is born in Bourges.

 February 25: Pierre-Auguste Renoir is born in Limoges.

 June: Charles Baudelaire sets sail for India on the *Paquebot-des-mers-du-Sud*. Although he cuts his voyage to the tropics short in Mauritius, it will inspire much of his subsequent poetry.

1844–48 Manet studies at collège Rollin, where he begins his lifelong friendship with Antonin Proust. Manet's maternal uncle, Edouard Fournier, encourages his artistic aspirations by funding his attendance in a drawing class.

1848 February: King Louis-Philippe's government collapses. The Revolution of 1848 leads to the declaration of the Second Republic.

 July: Manet fails the annual Naval Academy entrance examination.

 December 9: Manet sets sail from Le Havre, bound for Rio de Janiero aboard *Le Havre et Gaudeloupe*.

 December 10: Louis-Napoléon is elected president of France.

1849 April 19: Eva Gonzalès is born in Paris.

 June 13: Manet returns to Le Havre.

July: Manet again fails the Naval Academy entrance examination, ending all possibility of a naval career.

1850 **September**: Manet and Proust enroll in Thomas Couture's studio; Manet continues to study there until 1856.

Eugène Isabey travels through Normandy with Jongkind. In Le Havre, Isabey encourages Boudin in his artistic ambitions. Boudin and Jongkind meet for the first time.

1851 Boudin receives a stipend to study in Paris and leaves Le Havre for two years.

June: Isabey and Jongkind make marine sketches together in Etretat.

December: Louis-Napoléon seizes power in a coup d'état and dissolves the Assembly.

1852 **September**: Delacroix visits Dieppe and later paints *The Sea at Dieppe* (fig. 12) from memory.

December 2: Louis-Napoléon is declared Napoléon III, Emperor of the French, inaugurating the Second Empire.

1853 **September–October**: Manet visits Venice and Florence with his brother Eugène.

Late October?: Manet takes a walking tour of the Normandy Coast with Couture, making studies from nature at Sainte-Adresse.

1854 **September**: Courbet visits Montpellier at the invitation of Alfred Bruyas and paints *Seacoast at Palavas* (plate 72).

September: Delacroix encounters Isabey at Dieppe, where both artists are vacationing and making studies.

1855 Manet visits Delacroix's studio with Proust and asks permission to copy Delacroix's *Barque of Dante* at the Musée Luxembourg.

May–October: The first Exposition universelle in Paris features twenty-five works by Théodore Gudin, proclaiming his status as France's preeminent "official" marine painter. Delacroix is decorated with highest honors. Courbet refuses to participate and establishes an independent pavilion across the street, where he exhibits some forty works. Jongkind's entries are rejected, and he returns to Holland despondent.

1857 Baudelaire's *Fleurs du mal* [Flowers of Evil] is published.

Manet meets Henri Fantin-Latour at the Louvre.

November–December: Manet travels in Italy.

1858 Boudin paints *Festival in the Harbor of Honfleur* (plate 82), his first depiction of a regatta, a subject that greatly attracted the Impressionists.

Summer: Boudin meets Monet in Le Havre and provides the young artist with his first painting lessons.

October: Whistler meets Fantin-Latour, who introduces him to numerous personalities in the Paris art world, including Courbet and Zacharie Astruc.

1859 Courbet visits Boudin in Honfleur. Baudelaire also meets Boudin in Honfleur and later praises Boudin's pastel sky studies in his *Salon de 1859*.

May: Manet's first Salon submission (*The Absinthe Drinker*, Ny Carlsberg Glyptotek, Copenhagen) is rejected despite Delacroix's support. Whistler exhibits two etchings but his painting *At the Piano* (The Taft Museum, Cincinnatti) is rejected. Courbet sees this painting at François Bonvin's studio and praises it. Boudin has a work accepted to the Salon for the first time.

1860 Edma and Berthe Morisot begin study with Camille Corot, continuing until 1862.

Boudin paints his first scenes of vacationers on the beach at Trouville.

1861 Manet's friend Charles Blanc publishes a biography of the seventeenth-century Dutch marine painter Ludolf Backhuysen, based on Arnold Houbraken's eighteenth-century work.

Jules Michelet's book-length meditation on the sea, *La Mer*, is published.

April: Selected by lottery for military service, Monet joins the First Regiment of African Chasseurs and is deployed in Algeria.

May: Manet's portrait of his parents (Musée d'Orsay, Paris) and *Spanish Singer* (The Metropolitan Museum of Art, New York) are accepted to the Salon. Whistler and Jongkind are rejected.

Summer: Whistler meets Manet in Paris. Monet returns from Algeria and meets Jongkind near Le Havre, where they paint together.

August: Whistler travels to Brittany and paints his first seascape, *The Coast of Brittany* (Wadsworth Atheneum, Hartford).

Before November: Renoir enrolls in the studio of Charles Gleyre.

December: Courbet begins taking students, among them Fantin-Latour.

1862 Monet, Alfred Sisley, and Frédéric Bazille join Renoir as students of Gleyre.

January: Whistler exhibits etchings of the Thames at Martinet's gallery in Paris.

February: Jongkind publishes *Views of Holland*, a collection of seven engravings, through Alfred Cadart.

May: Manet exhibits etchings at Alfred Cadart's print shop and studio. Baudelaire calls Manet, Legros, and Jongkind "pioneers of the etching revival."

May 31: The Société des aquafortistes is founded; its members include Manet, Jongkind, Whistler, Corot, Charles-François Daubigny, Alphonse Legros, and Jean-François Millet.

September: Jongkind visits Boudin in Trouville.

September 25: Manet's father dies in Paris.

September–October: Whistler paints *Blue and Silver: The Blue Wave, Biarritz* (fig. 61) and writes to Fantin-Latour about the difficulties of working outside directly from nature.

1863 **March**: Manet exhibits at Martinet's gallery.

May: Manet, Jongkind, and Whistler are rejected from the Salon but agree to exhibit in the Salon des refusés.

August: Jongkind goes to Honfleur and paints views of the town and port, including *Port of Honfleur at Evening* (plate 80).

August 13: Delacroix dies in Paris. Manet and Baudelaire attend the funeral.

October 28: Manet marries Suzanne Leenhoff in Holland.

1864 Victor Hugo's *Les Travailleurs de la mer* [Toilers of the Sea] is published.

May: In the annual Salon, Jongkind exhibits one engraving and two oils, Boudin exhibits one of his Trouville beach scenes, and Manet exhibits *Angels at Christ's Tomb* (The Metropolitan Museum of Art, New York) and *Episode from a Bullfight*. This year also marks the first Salon appearances by Renoir, who exhibits *La Esmerelda* (destroyed by the artist), and Morisot, who exhibits two landscapes. Whistler's Salon submissions are rejected; Courbet elects not to participate.

Late May: Monet travels to Honfleur with Bazille; he stays in Normandy until winter.

June 11: C.S.S. *Alabama* anchors at Cherbourg.

June 19: The battle between U.S.S. *Kearsarge* and C.S.S. *Alabama* takes place off the coast of Cherbourg.

Mid-July: Manet's *Battle of the U.S.S. "Kearsarge" and the C.S.S. "Alabama"* (plate 10) is exhibited in a window at Cadart's print shop and studio.

Mid-July–August: The Manet family stays in Boulogne, where Edouard sketches a variety of marine subjects, including U.S.S. *Kearsarge* anchored off the coast. Upon his return to Paris, he begins painting seascapes employing his studies made from life.

August: Jongkind paints with Monet in Honfleur. Boudin joins them there and then moves on to Trouville.

September: Courbet invites Monet and Boudin to supper in Deauville, where he is staying with the Comte de Choiseul.

October: Monet paints at Sainte-Adresse.

1865 **May**: Monet's Salon entries—*Mouth of the Seine at Honfleur* (fig. 63) and *The Pointe de la Hève at Low Tide* (plate 91)—are praised by critics, some of whom take them to be works by Manet. Manet, whose *Olympia* (Musée d'Orsay, Paris) causes a scandal at the Salon, is perturbed by the confusion and is quoted as saying: "Who is this urchin with his despicable pastiches of my painting?" Jongkind, Whistler, Courbet, Boudin, and Renoir also exhibit at the Salon.

August–September: Manet visits Spain.

August–November: Jongkind goes to Honfleur for the last time and visits Boudin in Trouville.

Fall: Courbet and Whistler paint together in Trouville, where they are joined by Boudin.

1866 Gonzalès enrolls in the French academic painter Charles Chaplin's atelier in Paris.

March 12: Whistler arrives in Valparaiso, Chile, to deliver torpedoes intended for use against the Spanish Fleet. He remains there until July and paints a number of harbor scenes, including *Crepuscule in Flesh Color and Green: Valparaiso* (plate 88) and *Valparaiso Harbor* (plate 89).

May: Manet is introduced to Monet by Zacharie Astruc in Paris. At the Salon, Courbet, Morisot, and Jongkind each exhibit two paintings. Renoir has a sketch accepted but declines to exhibit it. Although Manet's two Salon submissions are rejected, Emile Zola defends Manet's works in his *Salon de 1866*.

May–June: Manet exhibits in Bordeaux.

1867 **January**: Zola's biographical and critical study of Manet is published in *L'Artiste: Revue du XIXᵉ siècle*.

April: The Exposition universelle opens in Paris. Courbet and Manet set up independent pavilions at the Pont d'Alma. Courbet assembles 115 paintings, drawings, and sculptures; Manet exhibits fifty works, including *The Battle of the U.S.S. "Kearsarge" and the C.S.S. "Alabama"* and some of his Boulogne seascapes. Morisot, Boudin, and Jongkind also exhibit works.

Summer: Monet paints some twenty works at Sainte-Adresse, including *The Beach at Sainte-Adresse* (plate 97) and *Garden at Sainte-Adresse* (plate 98).

August: Manet visits Trouville with Proust.

September: Manet attends Baudelaire's funeral in Paris.

1868 **May**: Manet exhibits *Portrait of Emile Zola* (Musée d'Orsay, Paris) and *Woman with a Parrot* (The Metropolitan Museum of Art, New York) at the Salon.

Summer: Fantin-Latour introduces Berthe and Edma Morisot to Manet. Berthe poses for *The Balcony* (Musée d'Orsay, Paris).

June: The Exposition maritime internationale is held in Le Havre. Manet wins a second-class medal for *Dead Torreador* (National Gallery of Art, Washington, D.C.); Boudin, Monet, Courbet, and Daubigny also receive medals.

Summer: The Manet family stays in Boulogne, where Edouard executes many seascape studies and possibly some paintings.

Late July or Early August: Manet travels to London via steamboat.

Summer–Fall: Monet works at Sainte-Adresse, Le Havre, and Etretat.

1869 Manet, Degas, Renoir, Zola, and others frequent the Café Guérbois in Paris.

Gonzalès begins study with Manet, becoming his only pupil.

May: Manet exhibits *The Luncheon* (Bayerische Staadtsgemäldesammlung, Munich) and *The Balcony* (Musée d'Orsay, Paris) at the Salon; Jongkind, Boudin, Courbet, and Renoir have paintings accepted but Monet is refused.

June: Berthe Morisot visits her sister, Edma, at Lorient and paints *The Harbor at Lorient* (plate 108), which she gives to Manet upon her return to Paris.

1870 Jules Verne's *Vingt-Mille lieus sous les mers* [Twenty Thousand Leagues under the Sea] is published.

May: Manet's *Portrait of Mlle. E.G.* [Eva Gonzalès] (National Gallery of Art, London) and *Music Lesson* (Museum of Fine Arts, Boston) are accepted at the Salon. Courbet is lauded for two marine paintings: *Rough Sea* and *The Cliffs at Etretat after the Storm* (both at the Musée d'Orsay, Paris). Fantin-Latour exhibits his tribute to Manet: *A Studio in the Batignolles* (fig. 74). Morisot exhibits *Harbor at Lorient* (plate 108) and Gonzalès exhibits her first work at the Salon. Renoir exhibits two works. Monet is rejected.

June: Monet marries Camille Doncieux and they travel to Trouville for the summer. Monet paints pictures of his wife on the beach at Trouville (plates 100, 101).

July: In response to the outbreak of the Franco-Prussian War, Manet, Degas, and Renoir join the National Guard. Manet's wife and mother and Léon Leenhoff leave Paris for southwestern France. Gonzalès's family moves to Dieppe. Morisot's family stays in Paris.

Fall: Monet leaves for England.

1871 **January 26:** Paris is surrendered to Prussian forces after a siege and a famine.

February: Adolphe Thiers is elected president of a new French government. Manet leaves Paris to join his family in Oloron-Sainte-Marie.

March: The Paris Commune is declared and the city is cut off from the rest of France until the bloody suppression of the Commune in May–June.

March–April: The Manets stay in Bordeaux, where Edouard paints the harbor (plate 49), and Arcachon, where he paints seascapes *en plein air* for the first time, including *The Bay of Arcachon* (plate 50) and *Boats at Low Tide on the Bay of Arcachon* (plate 55).

May: Berthe Morisot visits Cherbourg and paints *The Harbor at Cherbourg* (fig. 66). The Manets stay in Le Pouligen for the month, but Edouard does not paint there.

May 21–28: Thousands of Communards are gunned down by troops in the streets of Paris during *la semaine sanglante.*

June: The Manets return to Paris. Monet paints scenes in Holland, including *View of the Voorzaan* (plate 103) and *Windmill near Zaandam* (plate 104). Courbet is imprisoned for the destruction of the Vendôme Column during the Commune.

December: Monet settles in Argenteuil.

1872 Manet buys Monet's *The Wooden Bridge* (Fondation Rau pour le Tiers Monde, Zurich) from the artist.

January: The art dealer and collector Paul Durand-Ruel purchases twenty-six paintings by Manet, including *The Battle of the U.S.S. "Kearsarge" and the C.S.S. "Alabama"* (plate 10) and another unidentified marine painting.

May: Manet borrows his battle painting from Durand-Ruel to exhibit at the Salon. Zola writes in praise of Jongkind, Manet, and Boudin, proclaiming Manet's battle scene one of the best works in the Salon. Gonzalès exhibits two paintings in the Salon.

May: Manet travels to Holland and paints *View in Holland* (plate 56).

July: Manet moves into a new studio on the rue Saint-Petersbourg near the Gare Saint-Lazare.

Summer: Renoir spends time at Argenteuil with the Monet family.

1873 **May:** Manet exhibits *Le Bon Bock* (Philadelphia Museum of Art) and *Repose: Portrait of Berthe Morisot* (Museum of Art, Rhode Island School of Design, Providence) at the Salon. Morisot exhibits at the official Salon for the last time. Gonzalès's submission is rejected but she shows it at the Salon des refusés. Renoir also exhibits one work at the Salon des refusés. Monet, Morisot, and Jongkind decline to participate.

Summer: Morisot travels to Les Petites-Dalles and paints *On the Beach* (plate 109). She later stays at Fécamp, where she paints two beach scenes (fig. 67).

July: The Manets visit Berck, where Edouard draws and paints *en plein air*. A number of canvases emerge from this trip (plates 57–64).

1874 **March:** Henri Rochefort escapes from the prison colony on the island of New Caledonia.

April: The first exhibition of the Société anonyme des artistes peintres, sculptures et graveurs—an event that would later be called the first Impressionist exhibition—is held at Nadar's studio on the boulevard des Capucines. The exhibition includes 165 works by thirty artists, among them Boudin, Monet, Morisot, and Renoir. Manet declines to participate in this and the six subsequent Impressionist exhibitions.

May: Manet exhibits *The Railroad* and the hand-colored lithograph *Polichinelle* (both in the National Gallery of Art, Washington, D.C.) at the Salon. The Manet and Morisot families vacation together in Fécamp (without Edouard). Berthe paints portraits and seascapes and is courted by Eugène Manet.

August: Manet stays at Monet's villa in Argenteuil, where he is joined by Renoir. Manet makes ink portraits of Monet and also depicts the artist working in his "studio boat," a floating studio that allowed him to paint from the middle of the river (Bayerische Staatsgemäldesammlungen, Munich, and Barnes Collection, Merion, Pennsylvania).

December 22: Eugène Manet and Berthe Morisot are married.

1875 Arthur Rimbaud's *Le Bateau ivre* [The Drunken Boat] is published.

March 25: An auction of works by Monet, Morisot, Renoir, and Sisley is disastrous, earning an average of 147 francs per work, while a crowd of detractors attempts to shout down the bidding. The highest price paid is 480 francs, for an interior by Morisot.

May: Manet exhibits *Argenteuil* (Musée des Beaux-Arts, Tournai) at the Salon, demonstrating his artistic interest in the new style of Monet and Renoir.

Summer: Morisot travels to West Cowes on the Isle of Wight with her husband, where she paints a number of seascapes, including views of the harbor (plates 111–13). She proceeds to London, where she meets the painter James Tissot.

October: Manet's travels in Venice with his wife and Tissot result in two paintings of the Grand Canal (plates 65, 66).

1876 Eugène Fromentin's *The Masters of Past Time* appears in installments in *Revue des deux mondes*, championing Dutch landscape and marine painting.

Edmond Duranty publishes *The New Painting*, in which he argues for the relevance and significance of Impressionist art and attacks Fromentin's ideas on landscape and his Orientalist paintings.

April: The second Impressionist exhibition is held at Durand-Ruel's house on the rue Le Peletier, this time with twenty artists and 252 works. Degas, Monet, Morisot, Pissarro, and Renoir are the central participants. Morisot exhibits many seascapes, including two

Fécamp paintings and five Isle of Wight oils. Manet, who is rejected by the Salon, holds an exhibition in his studio.

Summer–Fall: Manet and Monet stay with the Hoschedé family, bankers and art collectors, in their château in Montgeron.

1877 **April:** At the third Impressionist exhibition, Monet exhibits thirty-five works, Degas twenty-five, Pissarro twenty-two, Renoir twenty-one, and Morisot twelve.

May: Manet's *Portrait of Faure in the Role of Hamlet* (Städlische Kunsthalle, Mannheim) is exhibited at the Salon but *Nana* (Städlische Kunsthalle, Mannheim) is rejected.

December 31: Courbet dies near Vevey, Switzerland.

1878 Manet does not submit his work to the jury of the Exposition universelle held in Paris that year. He plans his own exhibition, which is not achieved.

Théodore Duret's *Les Peintres impressionistes* is published.

January: Monet and his family leave their house at Argenteuil and resettle in Paris.

March: Monet's son Michel is born; Manet signs the birth certificate as a witness.

November 14: Julie Manet is born to Berthe Morisot and Eugène Manet.

1879 **February:** Eva Gonzalès marries Henri Guérard. They travel to Grandcamp and Honfleur, where Gonzalès paints out of doors.

April: The fourth Impressionist exhibition is dominated by Degas, Monet, and Pissarro. Mary Cassatt and Paul Gauguin participate for the first time, while Morisot and Renoir abstain.

May: Manet exhibits *Boating* (The Metropolitan Museum of Art, New York) and *In the Conservatory* (Staatliche Museen zu Berlin – Preussischer Kulturbesitz, Nationalgalerie) at the Salon. Gonzalès exhibits a painting, prompting viewers to remark on her association with Manet. Renoir exhibits two paintings and two pastel portraits.

June: Renoir has his first solo exhibition at the offices of *La Vie moderne*, a new cultural journal launched by Georges Charpentier.

Summer: Renoir travels to Wargemont and Dieppe, where he executes a number of marine paintings, including *Seascape* (plate 117).

September–October: Manet goes to Bellevue for rest and treatment.

1880 **April:** The fifth Impressionist exhibition includes works by Degas, Morisot, and Pissarro; Monet and Renoir do not participate.

April: Charpentier holds a one-man show of Manet's work at the offices of *La Vie moderne*.

May: Manet exhibits two portraits at the Salon. Renoir exhibits four works including a seascape, *Mussel Fishers at Berneval* (location unknown). Monet exhibits one landscape. Gonzalès submits her most successful Salon entry, the pastel *The Maiden of Honor* (private collection).

June: Monet is given a solo exhibition at Charpentier's *La Vie moderne*.

July: Manet's doctor prescribes hydrotherapy and a rest in the country. The Manets rent a small house in Bellevue where Edouard paints watercolors, including *Young Woman by the Sea* (plate 67) and *Isabelle Diving* (plate 68), and sends them to Isabelle Lemonnier, Eva Gonzalès, and Zacharie Astruc.

September: Monet makes the first of a number of annual visits to the Normandy coast and creates studies at Les Petites-Dalles.

December: Manet meets Rochefort and his cohort Olivier Pain and begins work on a group of pictures featuring Rochefort's escape from New Caledonia (plates 69–71).

1881 **March:** Monet returns to Normandy to make more seascapes, which are in great demand. He stays in Fécamp and paints coastal scenes and rough seas (plates 105–7).

April: Degas, Morisot, and Pissarro participate in the sixth Impressionist exhibition; Monet and Renoir abstain.

May: Manet exhibits his *Portrait of M. Henri Rochefort* (Kunsthalle, Hamburg) at the Salon, instead of one of the two canvases featuring the escape. He also shows *Portrait of M. Petrusiet, the Lion Hunter* (Museu de Arte, Sao Paulo), for which he earns a second-class medal. Renoir shows two portraits as well.

1881–82 **Winter:** Morisot visits Nice and paints six oils, including two views of the harbor (plates 114, 115).

1882 **February:** The Paris stock market crashes.

March: Degas does not participate in the seventh Impressionist exhibition, but Monet and Renoir return. Morisot shows some recent seascapes from Nice. Monet's seascapes are the subject of much positive press.

March: Monet paints seascapes at Pourville.

May: Manet exhibits two works at the Salon, one of which is *A Bar at the Folies Bergères* (Courtauld Institute, London).

Summer: Monet returns to Pourville to paint.

September: Renoir travels to Dieppe with the Durand-Ruels and paints *The Wave* (plate 118).

1882–83 **October–January:** Renoir travels in Italy. He returns via Marseilles and stays with Cézanne.

1883 **April:** Renoir is given a solo exhibition at Durand-Ruel's gallery.

April 30: Edouard Manet dies in Paris. Philippe Burty, Duret, Monet, Proust, Alfred Stevens, and Zola are pall bearers at his funeral.

May 6: Gonzalès dies in Paris.

1884 **January:** The Manet retrospective exhibition at the Ecole des Beaux-Arts includes 179 works and a catalogue with a preface by Zola.

Bibliography

GENERAL

Bachelard, Gaston. *L'Eau et les rêves.* Paris: José Corti, 1942.

Balzac, Honoré de. *L'Enfant maudit.* Paris: Editions Albin Michel, n.d.

Baudelaire, Charles. *Art in Paris, 1845–1862: Salons and Other Exhibitions Reviewed by Charles Baudelaire.* Translated and edited by Jonathan Mayne. London: Phaidon, 1965.

———. *Correspondance.* Edited and annotated by Claude Pichois. Paris: Gallimard, 1973.

———. *Curiosités esthétiques.* Edited by Jean Adhémar. Lausanne: Editions de l'Oeil, 1956.

———. *Oeuvres complètes.* Edited by Y.-G. Le Dantec. Revised by Claude Pichois. Paris: Gallimard, 1961.

———. *Selected Poems from "Les Fleurs du Mal": A Bilingual Edition.* Translated by Norman R. Shapiro. Chicago: University of Chicago Press, 1998.

Bertuccioli, Americo. *Les Origines du roman maritime français.* 2d ed. Livorno: S. Belforte, 1937.

Boime, Albert. *The Academy and French Painting in the Nineteenth Century.* London: Phaidon, 1971.

Bomford, David, et al. *Art in the Making: Impressionism.* Exh. cat. London: The National Gallery, 1990.

Bowness, Alan. *Poetry and Painting: Baudelaire, Mallarmé, Apollinaire, and Their Painter Friends.* The Zaharoff Lecture, 1991–92. Oxford: Clarendon Press, 1994.

Bowron, Edgar Peters, and Mary G. Morton. *Masterworks of European Painting in the Museum of Fine Arts, Houston.* Princeton: Princeton University Press, 2000.

Brettell, Richard R. *Impression: Painting Quickly in France, 1860–1890.* Exh. cat. New Haven: Yale University Press in association with the Sterling and Francine Clark Art Institute, Williamstown, Massachusetts, 2000.

Brunet, Louis. *Villégiature et tourisme sur les côtes de France.* Paris: Librairie Hachette, 1963.

Castagnary, Jules. *Salon de 1861.* Illustrated by H. Linton. Paris: Aux Bureaux du Monde Illustré, 1861.

Champa, Kermit S., et al. *The Rise of Landscape Painting in France: Corot to Monet.* Exh. cat. Manchester, N.H.: Currier Gallery of Art, 1991.

Collier, Peter, and Robert Lethbridge, eds. *Artistic Relations: Literature and the Visual Arts in Nineteenth-Century France.* New Haven: Yale University Press, 1994.

Conrad, Joseph. *Notes on Life and Letters.* London: J. M. Dent, 1921.

Cooper, James Fenimore. *The Red Rover: A Tale.* 1827. Reprint, Albany: State University of New York Press, 1990.

Corbin, Alain. *The Lure of the Sea: The Discovery of the Seaside in the Western World, 1750–1840.* Translated by Jocelyn Phelps. Berkeley: University of California Press, 1994.

Cottin, François, and Françoise Cottin. *Le Bassin d'Arcachon à l'age d'or des villas et des voiliers.* Bordeaux: L'Horizon chimérique, forthcoming.

Couperie, Alain. *Voyage et exotisme au XIX siècle.* Paris: Hatier, 1986.

Cuttler, Charles D. *Northern Painting: From Pucelle to Bruegel.* New York: Holt, Rinehart and Winston, 1968.

Darras, Jacques. *La Mer hors d'elle-même: L'Emotion de l'eau dans la littérature.* Paris: Hatier, 1991.

Duret, Theodore. *Les Peintres français en 1867.* Paris: E. Dentu, 1867.

Eitner, Lorenz. *An Outline of Nineteenth-Century European Painting.* New York: Harper and Row, 1987.

Fischer, Hartwig. *Orte des Impressionismus: Gemälde und Fotografien.* Exh. cat. Basel: Kunstmuseum Basel, 2003.

Gautier, Théophile. *Abécédaire du Salon de 1861.* Paris: E. Dentu, 1861.

———. *Guide de l'amateur au Musée du Louvre.* Paris: G. Charpentier, 1899.

———. *Les Beaux-Arts en Europe.* Paris: Lévy frères, 1855.

Georgel, Pierre. "Le Romantisme des années 1860." *Revue de l'art,* no. 20 (1973), pp. 9–64.

Giltaij, Jeroen, and Jan Kelch. *Lof der Zeevaart: De Hollandse zeeschilders van de 17e eeuw.* Exh. cat. Rotterdam: Boymans van Beunigen Museum, 1997.

Goedde, Lawrence Otto. *Tempest and Shipwreck in Dutch and Flemish Art: Convention, Rhetoric, and Interpretation.* University Park: Pennsylvania State University Press, 1989.

Gracq, Julian, ed. *Chateaubriand, mémoires d'outre tombe.* Paris: Le Livre de Poche, 1992.

Herbert, Robert L. *Impressionism: Art, Leisure, and Parisian Society.* New Haven: Yale University Press, 1988.

Horn, Hendrick J. *The Golden Age Revisited: Arnold Houbraken's Great Theatre of Netherlandish Painters and Paintresses.* Doornspijk: Davaco, 2000.

Houbraken, Arnold. *De groote schouburgh der Nederlandische Konstschilders en Schilderessen.* 3 vols. Amsterdam, 1719–21.

House, John. *Landscapes of France: Impressionism and Its Rivals.* Exh. cat. London: Hayward Gallery, The South Bank Centre, 1995.

Ives, Colta Feller. *The Great Wave: The Influence of Japanese Woodcuts on French Prints.* Exh. cat. New York: The Metropolitan Museum of Art, 1974.

Keyes, George S. *Mirror of Empire: Dutch Marine Art of the Seventeenth Century.* Exh. cat. Minneapolis: Minneapolis Institute of Arts, 1990.

Mainardi, Patricia. *Art and Politics of the Second Empire.* New Haven: Yale University Press, 1987.

———. *The End of the Salon: Art and the State in the Early Third Republic.* Cambridge: Cambridge University Press, 1993.

Michelet, Jules. *The Sea.* New York: Rudd and Carleton, 1861.

Moffett, Charles S., et al. *The New Painting: Impressionism, 1874–1886.* Exh. cat. San Francisco: Fine Arts Museums of San Francisco, 1986.

Moore, George. *Modern Painting.* New York: Bretano, 1910.

Nord, Philip. *Impressionism and Politics: Art and Democracy in the Nineteenth Century.* London: Routledge, 2000.

Peisse, Louis. "Salon de 1841." *Revue des deux mondes,* 4th ser., vol. 1 (1841).

Petry, Claude, et al. *Autour de Claude-Joseph Vernet: La Marine à voile de 1650 à 1890.* Rouen: Musées de Rouen, 1999.

Prévost, Marie-Laure. *Victor Hugo, l'homme océan.* Exh. cat. Paris: Bibliothèque nationale de France, 2002.

Proust, Antonin. *L'Art sous la République.* Paris: Charpentier, 1892.

Reff, Theodore. "Copyists in the Louvre, 1850–1870." *Art Bulletin* 46 (December 1964), pp. 552–59.

Reynolds, Dee. *Symbolist Aesthetics and Early Abstract Art: Sites of Imaginary Space.* Cambridge: Cambridge University Press, 1995.

Roos, Jane Mayo. *Early Impressionism and the French State, 1866–1874.* Cambridge: Cambridge University Press, 1996.

———. *A Painter's Poet: Stéphane Mallarmé and His Impressionist Circle.* Exh. cat. New York: Bertha and Karl Leubsdorf Art Gallery, Hunter College of the City University of New York, 1998.

Rubin, James H. *Impressionism.* London: Phaidon, 2000.

Schama, Simon. *The Embarrassment of Riches: An Interpretation of Dutch Culture in the Golden Age.* New York: Alfred A. Knopf, 1987.

Schapiro, Meyer. *Impressionism: Reflections and Perceptions.* New York: George Braziller, 1997.

Schneider, Pierre. *Petite histoire de l'infini en peinture.* Paris: Hazan, 2001.

Stechow, Wolfgang. *Dutch Landscape Painting of the Seventeenth Century.* National Gallery of Art: Kress Foundation Studies in the History of European Art. London: Phaidon, 1966.

Tapié, Alain, et al. *Désir de rivage de Granville à Dieppe.* Exh. cat. Paris: Réunion des musées nationaux, 1994.

Thoré, Theophile. *Musées de la Hollande.* 2 vols. Paris: J. Renouard, 1858.

Tinterow, Gary, and Henri Loyrette. *Origins of Impressionism.* Exh. cat. New York: The Metropolitan Museum of Art, 1994.

Tippetts, Marie-Antoinette. *Les Marines des peintres: Vues par les littérateurs de Diderot aux Goncourt.* Paris: A. G. Nizet, 1966.

Tymieniecka, Anna Teresa, ed. *Poetics of the Elements in the Human Condition.* Vol. 1, *The Sea: From Elemental Stirrings to Symbolic Inspiration, Language, and Life Significance in Literary Interpretation and Theory.* Dordrecht, Netherlands: Reidel, 1985.

Valenciennes, Pierre-Henri. *Elémens de perspective pratique à l'usage des artistes, suivis de réflexions et conseils à un élève sur la peinture et particulièrement sur le genre du paysage.* 1800. Reprint, Geneva: Minkoff, 1973.

Verne, Jules. *Twenty Thousand Leagues under the Sea.* Translated by Walter James Miller and Frederick Paul Walter. Annapolis, Md.: Naval Institute Press, 1993.

Wheelock, Arthur K., Jr. *Dutch Paintings of the Seventeenth Century.* New York: Oxford University Press, 1995.

Zola, Emile. *Ecrits sur l'art.* Edited by Jean-Pierre Leduc-Adine. Paris: Gallimard, 1991.

MANET

Adler, Kathleen. *Manet.* Oxford: Phaidon, 1986.

Armstrong, Carol. *Manet Manette.* New Haven: Yale University Press, 2002.

Bataille, Georges. *Manet.* Introduction by Françoise Cachin. New York: Rizzoli, 1983.

Bazire, Edmond. *Manet.* Paris: A. Quantin, 1884.

Bowness, Alan. "A Note on 'Manet's Compositional Difficulties.'" *Burlington Magazine* 103 (June 1961), pp. 276–77.

———. "Manet and Mallarmé." *Philadelphia Museum of Art Bulletin* 62, no. 293 (April–June 1967), pp. 213–21.

———. "Manet at Philadelphia." *Burlington Magazine* 109 (March 1967), pp. 188–89.

Brombert, Beth Archer. *Edouard Manet: Rebel in a Frock Coat.* Boston: Little, Brown, 1996.

Cachin, Françoise. *Manet, Painter of Modern Life.* Translated by Rachel Kaplan. London: Thames and Hudson, 1995.

Cachin, Françoise, Charles S. Moffett, and Juliet Wilson-Bareau. *Manet, 1832–1883.* Exh. cat. New York: The Metropolitan Museum of Art, 1983.

Champa, Kermit Swiler. *Edouard Manet and the Execution of Maximilian.* Providence, R.I.: Brown University Press, 1981.

Conzen, Ina. *Edouard Manet und die Impressionisten.* Exh. cat. Stuttgart: Staatsgalerie Stuttgart, 2002.

Courthion, Pierre. *Edouard Manet.* New York: Harry N. Abrams, 1962.

———, ed. *Manet raconté par lui-même et par ses amis.* 2 vols. Geneva: Pierre Cailler, 1953.

Darragon, Eric. *Manet.* Paris: Fayard, 1989.

———. "Manet, 'L'Evasion.'" *Revue de l'art* 56 (1982), pp. 25–40.

Darragon, Eric, et al. *L'ABCdaire de Manet.* Paris: Flammarion, 1998.

Degener, David, and Juliet Wilson-Bareau. "Bellevue, Brussels, Ghent: Two Unpublished Letters from Edouard Manet to Eugène Maus." *Burlington Magazine* 142 (September 2000), pp. 565–67.

Dolan, Therese. "Edouard Manet's *Portrait-Charge* of Emile Ollivier." *Print Quarterly* 17 (March 2000), pp. 17–26.

———. "Manet, Baudelaire and Hugo in 1862." *Word and Image* 16 (April–June 2000), pp. 145–62.

Duret, Théodore. *Histoire de Edouard Manet et de son oeuvre avec un catalogue des peintures et des pastels.* Rev. ed. Paris: Bernheim-Jeune, 1919.

Eisenman, Stephen F. "Nonfiction Painting: Mimesis and Modernism in Manet's *Escape of Rochefort.*" *Art Journal* 46 (Winter 1987), pp. 278–84.

Fisher, Jay McKean. *The Prints of Edouard Manet.* Washington, D.C.: International Exhibitions Foundation, 1985–86.

Fried, Michael. *Manet's Modernism, or, The Face of Painting in the 1860s.* Chicago: University of Chicago Press, 1996.

———. "Manet's Sources: Aspects of His Art, 1859–1865." *ArtForum* 7 (March 1969), pp. 28–82.

Gonse, Louis. "Manet." *Gazette des Beaux-Arts,* 2d per., vol. 29 (1884), pp. 133–52.

Guérin, Marcel. *L'Oeuvre gravé de Manet.* Paris: Librairie Floury, 1944.

Hallberg, Karin. "Le Port de Bordeaux vu par Manet et Boudin." *L'Oeil,* no. 250 (May 1976), pp. 14–17.

Hamilton, George Heard. *Manet and His Critics.* New Haven: Yale University Press, 1954.

Hanson, Anne Coffin. *Edouard Manet, 1832–1883.* Exh. cat. Philadelphia: Philadelphia Museum of Art, 1966.

———. "A Group of Marine Paintings by Manet." *Art Bulletin* 44 (December 1962), pp. 332–36.

———. *Manet and the Modern Tradition.* New Haven: Yale University Press, 1977.

———. "Popular Imagery in the Work of Edouard Manet." In *French Nineteenth-Century Painting and Literature.* Edited by Ulrich Finke. Manchester, England: Manchester University Press, 1972.

Harris, Jean C. *Edouard Manet: The Graphic Work.* San Francisco: Alan Wofsy Fine Arts, 1990.

———. "Manet's Graphic Work of the Sixties." In *Manet and Spain: Prints and Drawings.* Edited by Joel Isaacson. Exh. cat. Ann Arbor: University of Michigan Museum of Art, 1969.

———. "Manet's Race-Track Paintings." *Art Bulletin* 48 (March 1966), pp. 78–82.

House, John. "Seeing Manet Whole." *Art in America* 71 (November 1983), pp. 178–87.

Jamot, Paul. "Etudes sur Manet." *Gazette des Beaux-Arts,* 5th per., vol. 15 (1927), pp. 27–50, 381–90.

Jamot, Paul, and Georges Wildenstein. *Manet.* 2 vols. Paris: Les Beaux-Arts, 1932.

Kloner, Jay Martin. "The Influence of Japanese Prints on Edouard Manet and Paul Gauguin." Ph.D. diss., Columbia University, 1978.

Leiris, Alain de. *The Drawings of Edouard Manet.* Berkeley: University of California Press, 1969.

———. "Manet: 'Sur la Plage de Boulogne.'" *Gazette des Beaux-Arts,* 6th per., vol. 57 (January 1961), pp. 53–62.

Locke, Nancy. *Manet and the Family Romance.* Princeton: Princeton University Press, 2001.

———. "New Documentary Information on Manet's 'Portrait of the Artist's Parents.'" *Burlington Magazine* 123 (April 1991), pp. 249–52.

Mallarmé, Stéphane. "Manet and the Impressionists." *Art Monthly Review,* September 30, 1876.

Manet, Edouard. *Lettres de jeunesse, 1848–1849: Voyage à Rio.* Paris: Louis Rouart et fils, 1928.

Manet, Julie. *Journal (1893–1899)*. Paris: Librairie C. Klincksieck, 1979.

Mauner, George. *Manet: The Still-Life Paintings*. New York: Harry N. Abrams, 2001.

Meller, Peter. "Manet in Italy: Some Newly Identified Sources for His Early Sketchbooks." *Burlington Magazine* 144 (February 2002), pp. 68–110.

Moreau-Nélaton, Etienne. *Manet graveur et lithographe*. Paris: Editions du "Peintre-Graveur Illustré," 1906.

———. *Manet raconté par lui-même*. 2 vols. Paris: Henri Laurens, 1926.

Musée de l'Orangerie, Paris. *Exposition Manet, 1832–1883*. Exh. cat. Preface by Paul Valéry. Introduction by Paul Jamot. Exh. cat. Paris: Musée de l'Orangerie, 1932.

Orwicz, Michael. "Reinventing Edouard Manet: Rewriting the Face of National Art in the Early Third Republic." In *Art Criticism and Its Institutions in Nineteenth-Century France*. Edited by Michael Orwicz. Manchester, England: Manchester University Press, 1994.

Perruchot, Henri. *La Vie de Manet*. Paris: Librairie Hachette, 1959.

Perussaux, Charles. "Manet, coupeur de toiles." *Les Lettres français*, September 15, 1955.

Perutz, Vivien. *Edouard Manet*. Lewisburg, Pa.: Bucknell University Press, 1993.

Pickvance, Ronald. *Manet*. Exh. cat. Martigny, Switzerland: Fondation Pierre Gianadda, 1996.

Proust, Antonin. "Edouard Manet (souvenirs)." *La Revue blanche* 12 (1897), pp. 125–35, 158–80, 201–7, 306–15, 413–27.

———. *Edouard Manet: Souvenirs*. Paris: Librairie Renouard, 1913.

———. "L'Art d'Edouard Manet." *The Studio*, supp. no. 28 (January 15, 1901), pp. 71–77.

Rebeyrol, Philippe. "Baudelaire et Manet." *Les Temps Modernes* 5 (1949), pp. 707–25.

Reff, Theodore. "Courbet and Manet." *Arts* 54 (March 1980), pp. 98–103.

———. *Manet: Olympia*. New York: Viking, 1977.

———. *Manet and Modern Paris*. Exh. cat. Washington, D.C.: National Gallery of Art, 1982.

———. "Manet's Portrait of Zola." *Burlington Magazine* 117 (January 1975), pp. 35–44.

———. "'Manet's Sources': A Critical Evaluation." *Artforum* 8 (September 1969), pp. 40–48.

Richardson, John. *Manet*. Oxford: Phaidon, 1982.

Roger-Marx, Claude. "Manet: Etcher, Lithographer and Illustrator." *Print Collector's Quarterly* 23 (October 1936), pp. 303–22.

Rosenthal, Léon. *Manet aquafortiste et lithographe*. Paris: Le Goupy, 1925.

Rouart, Denis, and Daniel Wildenstein. *Edouard Manet: Catalogue raisonné*. 2 vols. Lausanne: Bibliothèque des arts, 1975.

Sloane, Joseph C. "Manet and History." *Art Quarterly* 14 (1951), pp. 93–106.

Spencer, Robin. "Whistler, Manet, and the Tradition of the Avant-Garde." *Studies in the History of Art* 19 (1987), pp. 47–67.

Stuckey, Charles F., and Juliet Wilson-Bareau. *Edouard Manet (1832–1883)*. Exh. cat. Tokyo: Isetan Museum of Art, Shinjuku, 1986.

Tabarant, A. "Manet: A Propos de son centenaire." *Revue de l'art ancien et moderne* 61 (1932), pp. 19–34.

———. *Manet: Histoire catalographique*. Paris: Editions Montaigne, 1931.

———. *Manet et ses oeuvres*. Paris: Gallimard, 1947.

Tinterow, Gary, and Henri Loyrette. *Origins of Impressionism*. Exh. cat. New York: The Metropolitan Museum of Art, 1994.

Tinterow, Gary, et al. *Manet/Velázquez: The French Taste for Spanish Painting*. New Haven: Yale University Press, 2003.

Tucker, Paul Hayes, ed. *Manet's "Le Déjeuner sur l'herbe."* New York: Cambridge University Press, 1998.

Verdier, Philippe. "Stéphane Mallarmé: 'Les Impressionistes et Edouard Manet.'" *Gazette des Beaux-Arts*, 6th per., vol. 86 (1975), pp. 147–56.

Vollard, Ambroise. *Souvenirs d'un marchand de tableaux*. Rev. ed. Paris: Editions Albin Michel, 1948.

Wilson-Bareau, Juliet. *The Hidden Face of Manet: An Investigation of the Artist's Working Processes*. Introduction by John House. London: Burlington Magazine, 1986.

———. "L' Année impressioniste de Manet: Argenteuil et Venise en 1874." *Revue de l'art* 86 (1989), pp. 28–34.

———. *Manet dessins, aquarelles, eaux-fortes, lithographies, correspondance*. Paris: Huguette Berés, 1978.

———. *Manet, Monet and the Gare Saint-Lazare*. New Haven: Yale University Press, 1998.

———, ed. *Manet by Himself: Correspondence and Conversations, Paintings, Pastels, Prints and Drawings*. London: Macdonald, 1991.

Wilson-Bareau, Juliet, and Breon Mitchell. "Tales of a Raven: The Origins and Fate of *Le Corbeau* by Mallarmé and Manet." *Print Quarterly* 6 (1989), pp. 295–301.

Wilson-Bareau, Juliet, with David C. Degener. *Manet and the American Civil War: The Battle of U.S.S. "Kearsarge" and C.S.S. "Alabama."* Exh. cat. New York: The Metropolitan Museum of Art, 2003.

Wilson-Bareau, Juliet, with John House and Douglas Johnson. *Manet: The Execution of Maximilian. Painting, Politics and Censorship*. Exh. cat. London: The National Gallery, 1992.

Wright, Patricia. *Manet*. London: National Gallery Publications, 1993.

Other Artists

BACKHUYSEN

Blanc, Charles. "Ludolf Backhuysen." In *Histoires des peintres de toutes les écoles*. Vol. 2, *Ecole hollandaise*. Paris: Vve. Jules Renouard, 1861.

De Beer, Gerlinde. *Ludolf Backhuysen: Sein Leben und Werk*. Zwolle: Waanders Uitgevers, 2002.

BOUDIN

Bergeret-Gourbin, Anne-Marie, et al. *Boudin et les peintres à Honfleur*. Exh. cat. Tokyo: Musée des Beaux-Arts Bunkamara, 1996.

Cahen, Gustave. *Eugène Boudin: Sa vie et son oeuvre*. Paris: H. Floury, 1900.

Musée Eugène Boudin, Honfleur. *Eugène Boudin en Normandie*. Exh. cat. Honfleur: Sociéte des amis du Musée Eugène Boudin, 1998.

Schmit, Robert. *Eugène Boudin, 1824–1898*. 3 vols. Paris: Robert Schmit, 1973.

COURBET

Bordes, Philippe. *Courbet à Montpellier*. Exh. cat. Montpellier: Musée Fabre, 1985.

Courbet, Gustave. *Letters of Gustave Courbet*. Edited and translated by Petra ten-Doesschate Chu. Chicago: University of Chicago Press, 1992.

Faunce, Sarah, and Linda Nochlin. *Courbet Reconsidered*. Exh. cat. New York: Brooklyn Museum of Art, 1988.

Fernier, Robert. *La Vie et l'oeuvre de Gustave Courbet: Catalogue raisonné, vol. 1, 1819–1865*. Lausanne: Bibliothèque des arts, 1977.

Fried, Michael. *Courbet's Realism*. Chicago: University of Chicago Press, 1992.

Grand Palais, Paris. *Gustave Courbet*. Exh. cat. Paris: Editions de la Réunion des musées nationaux, 1977.

Ideville, Henri de. *Gustave Courbet: Notes et documents sur sa vie et son oeuvre avec huit eaux-fortes*. Paris: Alcan-Lévy, 1878.

Philadelphia Museum of Art. *Gustave Courbet, 1819–1877*. Exh. cat. Philadelphia: Philadelphia Museum of Art, 1959.

Reff, Theodore. "Courbet and Manet." *Arts* 54 (March 1980), pp. 98–103.

Riat, Georges. *Gustave Courbet: Peintre*. Maîtres de l'art moderne. Paris: H. Floury, 1906.

GONZALÈS

Bray, Xavier, Bill Scott, and Juliet Wilson-Bareau. *Mujéres impressionistas: La otra mirada*. Bilbao: Museo de Bellas Artes de Bilbao, 2001.

Sainsaulieu, Marie-Caroline, and Jacques de Mons. *Eva Gonzalès, 1849–1883: Etude critique et catalogue raisonné*. Paris: Bibliothèque des arts, 1990.

ISABEY

Curtis, Atherton. *Catalogue de l'ouevre lithographié de Eugène Isabey*. Paris: Prouté, 1939.

Miquel, Pierre. *Eugène Isabey (1803–1886): La Marine au XIXe siècle*. 2 vols. Maurs-La-Jolie: Editions de la Martinelle, 1980.

JONGKIND

Cunningham, Charles C. *Jongkind and the Pre-Impressionists: Painters of the Ecole Saint-Siméon*. Exh. cat. Williamstown, Mass.: Clark Art Institute, 1977.

Hefting, Victorine. *Jongkind: Sa vie, son oeuvre, son époque*. Paris: Arts et métiers graphiques, 1975.

———. *Jongkind d'après sa correspondance*. Utrecht: Haentjens Dekker and Gumbert, 1969.

MONET

Aitken, Geneviève, and Marianne Delafond. *La Collection d'estampes japonaises de Claude Monet à Giverny*. Paris: Bibliothèque des arts, 1983.

Elder, Marc. *A Giverny, chez Claude Monet*. Paris: Bernheim-Jeune, 1924.

Grand Palais, Paris. *Hommage à Claude Monet (1840–1926)*. Paris: Editions de la Réunion des musées nationaux, 1980.

Herbert, Robert L. *Monet on the Normandy Coast: Tourism and Painting, 1867–1886*. New Haven: Yale University Press, 1994.

House, John. *Monet: Nature into Art*. New Haven: Yale University Press, 1986.

Levine, Steven Z. *Monet and His Critics*. New York: Garland Publishing, 1976.

Spate, Virginia. *The Colour of Time: Claude Monet*. London: Thames and Hudson, 1992.

Wildenstein, Daniel. *Claude Monet: Biographie et catalogue raisonné*. 5 vols. Lausanne: Bibliothèque des arts, 1974–91.

MORISOT

Angoulvent, Monique. *Berthe Morisot*. Paris: Albert Morance, 1933.

Bataille, Marie-Louise, and Georges Wildenstein. *Berthe Morisot: Catalogue des peintures, pastels et aquarelles*. Paris: Les Beaux-Arts, 1961.

Clairet, Alain, Delphine Montalant, and Yves Rouart. *Berthe Morisot, 1841–1895: Catalogue raisonné de l'oeuvre peint*. Montolivet: Centre d'études, de recherches et d'applications pour de nouveaux rapports sociaux, 1997.

Hugues, Wilhelm, Sylvie Patry, and Sylvie Gache-Patin. *Berthe Morisot*. Exh. cat. Martigny: Fondation Pierre Gianadda, 2002.

Huisman, Philippe. *Morisot: Enchantment*. Translated by Diana Imber. New York: French and European Publications, 1963.

Manet, Julie. *Journal (1893–1899)*. Paris: Librairie C. Klincksieck, 1979.

Rouart, Denis, ed. *The Correspondence of Berthe Morisot*. Translated by Betty W. Hubbard. New York: E. Weyhe, 1959.

Stuckey, Charles F., and William P. Scott with Suzanne G. Lindsay. *Berthe Morisot: Impressionist*. New York: Hudson Hills Press, 1987.

RENOIR

Bailey, Colin. *Renoir's Portraits: Impressions of an Age*. New Haven: Yale University Press, 1997.

House, John. *Renoir: Master Impressionist*. Exh. cat. Sydney: Art Exhibitions Australia, 1994.

———. *Renoir at Guernsey*. Exh. cat. Guernsey: Guernsey Museum and Art Gallery, 1988.

Kern, Steven, et al. *A Passion for Renoir: Sterling and Francine Clark Collect, 1916–1951*. Exh. cat. New York: Harry N. Abrams, 1996.

Riopelle, Christopher. "Renoir: The Great Bathers." *Philadelphia Museum of Art Bulletin* 86, nos. 367–68 (Fall 1990), pp. 5–40.

White, Barbara Ehrlich. *Renoir: His Life, Art, and Letters*. New York: Harry N. Abrams, 1984.

WHISTLER

Dorment, Richard. "Contretemps at Prince's Gate." *New York Review of Books* 46, no. 10 (June 10, 1999), pp. 12–13.

Dorment, Richard, and Margaret F. MacDonald. *James McNeill Whistler*. Exh. cat. London: Tate Gallery, 1994.

MacDonald, Margaret F., Patricia de Montfort, and Nigel Thorp, eds. *The Correspondence of James McNeill Whistler, 1855–1903*. Online centenary edition at www.whistler.arts.gla.ac.uk. Glasgow: Centre for Whistler Studies, University of Glasgow, forthcoming.

Pennell, Elizabeth Robins, and Joseph Pennell. *The Whistler Journal*. Philadelphia: J. B. Lippincott, 1921.

Index of Names and Places

Primary treatment of selected artists, including color plates, is indicated by **bold** type. Endnotes are not indexed.

Montpellier, France, 159–60, 255
Moore, Albert, 190
Morel-Fatio, Antoine Léon, 20
Morisot, Berthe, xiii, 29, 82, 181, **226–41**, 243–45, 251, 254–62
Mozin, Charles, 75

N
Nantes, France, 57
Naples, 243
Napoléon I (Napoléon Bonaparte), 58–62
Napoléon III (Louis-Napoléon), 21, 26, 58–59, 73–74, 254–55
Nelson, Admiral Lord, 36
New Caledonia, 55, 86–89, 155, 260
Nice, France, 230–31, 240, 241, 243, 262
Noël, Jules, 75
Normandy, France, 24–30, 64, 159–61, 180, 201, 203, 207, 229, 244, 255–62

O
Ollivier, Emile, 70
Ornans, France, 46

P
Palavas, France, 159–60, 165
Paris, France, 1, 4, 9, 26, 55, 59, 67, 73–74, 85–86, 181–82, 189, 201, 227–29, 258–62
Patinir, Joachim, 5
Pissarro, Camille, 45, 260–62
Pont-Aven, France, 243
Porcellis, Jan, 5
Pornic, France, 243
Potter, Paulus, 10
Pourville, France, 201
Poussin, Nicolas, 35–36
Proust, Antonin (biographer), 10, 64, 68, 80, 88–89, 162–63, 173, 255, 258, 262

R
Ramsgate, England, 229
Randon, G. (caricaturist), 59, 66
Raphael, 206
Redon, Odilon, 35, 48–49
Rendez-Vous des Artistes (artist colony), 26
Renoir, Pierre-Auguste, xiii, xv, 55, 161, **242–49**, 254–62
Rimbaud, Arthur, 48, 260
Rio de Janeiro, 55–56
Rochefort, France, 57, 74
Rochefort, Henri, 55, 86–89, 155–57, 260–62
Rotterdam, Holland, 5, 11
Rouart, Henri, 232
Roudier, Paul, 72
Rouen, France, 174
Rousseau, Jean-Jacques, 4
Royan, France, 57, 74
Ryde, England, 229

S
Sainte-Adresse, France, 174, 203–4, 209, 215–17, 255–58
Sainte-Beuve, Charles-Augustin, 37
Saint-Nazaire, France, 57, 74
Sharp, Kevin, 48
Silvestre, Armand (critic), 59
Sisley, Alfred, 45, 256, 260
Spain, 4–5, 21, 190–91, 257
Sue, Eugène, 38
Swinburne, Algernon Charles, 187
Switzerland, 159–61

T
Tabarant, Adolphe (biographer), 79
Tasso, 36
Thoré, Theophile (critic), 10
Tissot, James, 260
Titian, 2
Toché, Charles, 56, 85
Tours, France, 74
Trouville, France, 159–63, 185, 188, 194, 197, 203–5, 218–20, 256–59
Troyon, Constant, 26, 173, 179
Turner, Joseph Mallord William, 17, 24, 27

U
United States, 11, 40, 61, 188–90

V
Valenciennes, Pierre-Henri, 36
Valparaiso, Chile, 190–92, 198, 199, 258
van de Cappelle, Jan, 7
van der Neer, Aert, 2
van de Velde, Willem the Younger, 6–11
van Wieringen, Cornelis Claesz., 4–5, 11
Venice, 55, 84–85, 90, 152, 153, 243, 255
Vermeer, Johannes, 10
Verne, Jules, 44–45, 258
Vernet, Claude-Joseph, 7, 18–19, 25–26, 36, 75
Versailles, France, 20, 27, 58
Verschuier, Lieve, xiii, 11–12
Virgil, 36
Vlieger, Simon Jacobsz. de, 5, 7
Vroom, Hendrick, 4–5

W
Whistler, James McNeill, 35, 47, 68, 160–62, 173, **186–99**, 254–58
Willaerts, Abraham, 5, 11
Wolf, Albert (critic), 230

Y
Yport, France, 201

Z
Zaandam, Holland, 80, 221–22
Zola, Emile, 39, 47, 162, 204, 258–59, 262

Photography Credits